The Masterworks of Charles M. Russell

The Charles M. Russell Center Series
on Art and Photography
of the American West

B. Byron Price, *General Editor*

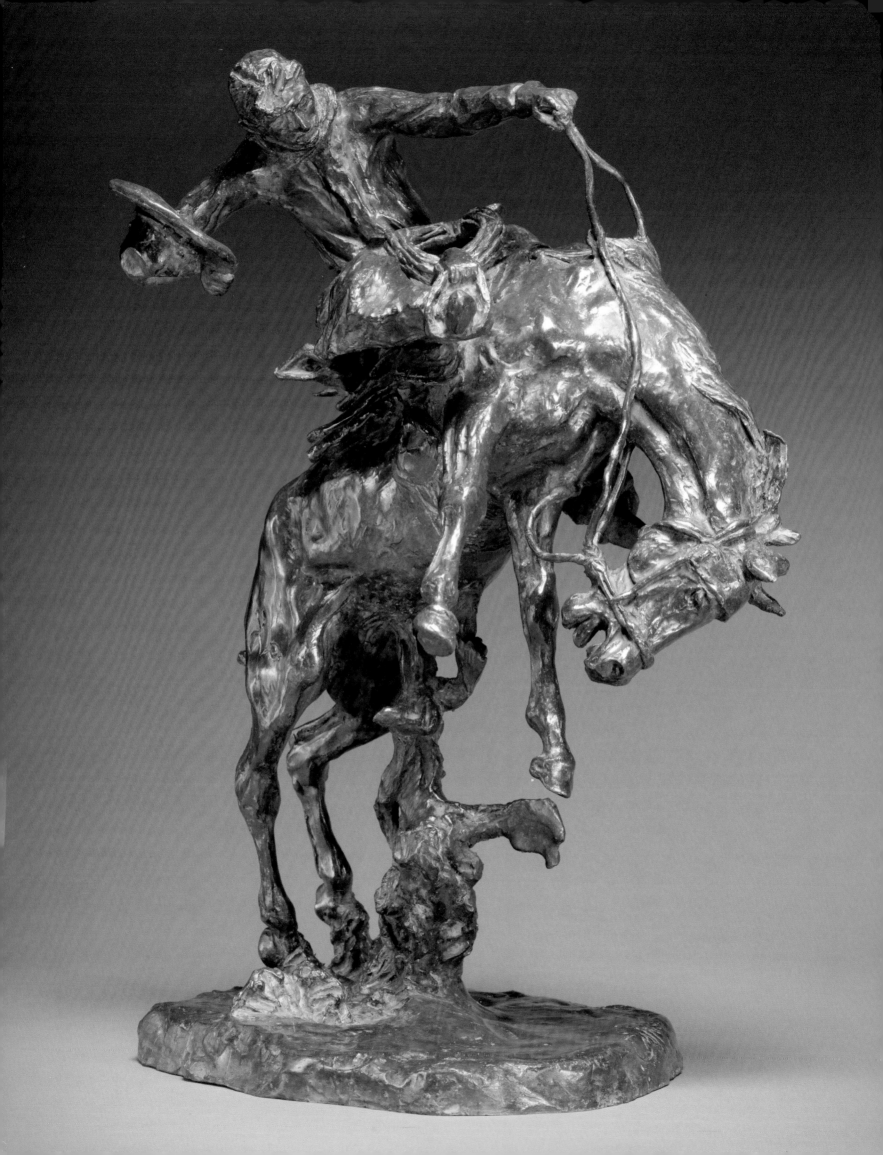

The Masterworks of
Charles M. Russell

A RETROSPECTIVE OF PAINTINGS
AND SCULPTURE

Edited by Joan Carpenter Troccoli
Foreword by Lewis I. Sharp and Duane H. King

University of Oklahoma Press : Norman
In Cooperation with the Denver Art Museum

Also by Joan Carpenter Troccoli

Jean Richardson: Plains Myths (New York, 1988)

Alfred Jacob Miller: Watercolors of the American West (Tulsa, 1990)

First Artist of the West: Paintings and Watercolors by George Catlin from the Collection of Gilcrease Museum (Tulsa, 1993)

Painters and the American West: The Anschutz Collection (Denver, 2000)

The exhibition "The Masterworks of Charles M. Russell: A Retrospective of Paintings and Sculpture" is organized by the Denver Art Museum and Gilcrease Museum.

Dates of the exhibition:
Denver Art Museum, October 17, 2009–January 10, 2010
Gilcrease Museum, February 6, 2010–May 2, 2010
The Museum of Fine Arts, Houston, June 6, 2010–August 29, 2010

Frontispiece: Charles M. Russell, *A Bronc Twister* (*The Weaver*), 1911 (detail)

The Masterworks of Charles M. Russell: A Retrospective of Paintings and Sculpture is Volume 6 in The Charles M. Russell Center Series on Art and Photography of the American West.

The paper in this book meets the guidelines for permanence and durability of the Committee on Production Guidelines for Book Longevity of the Council on Library Resources, Inc. ∞

Library of Congress Cataloging-in-Publication Data

Troccoli, Joan Carpenter.
 The masterworks of Charles M. Russell : a retrospective of paintings and sculpture / by Joan Carpenter Troccoli.—1st ed.
 p. cm.— (Charles M. Russell Center series on art and photography of the American West ; v. 6)
 Catalog of an exhibition held at the Denver Art Museum, Oct. 17, 2009-Jan. 10, 2010, Gilcrease Museum, Tulsa, Okla., Feb. 6, 2010–May 2, 2010, and The Museum of Fine Arts, Houston, Tex., June 6, 2010–Aug. 29, 2010.
 Companion volume to Charles M. Russell : a catalogue raisonné. 2007.
 Includes bibliographical references and index.
 ISBN 978-0-8061-4081-0 (hardcover : alk. paper) — ISBN 978-0-8061-4097-1 (pbk. : alk. paper) 1. Russell, Charles M. (Charles Marion), 1864–1926—Exhibitions. I. Russell, Charles M. (Charles Marion), 1864–1926. II. Russell, Charles M. (Charles Marion), 1864–1926. Charles M. Russell. III. Denver Art Museum. IV. Thomas Gilcrease Institute of American History and Art. V. The Museum of Fine Arts, Houston. VI. Title.
 N6537.R88A4 2009
 709.2—dc22

 2009011378

Major funding for the exhibition "The Masterworks of Charles M. Russell: A Retrospective of Paintings and Sculpture" and for the publication of this volume is provided by the Helen K. and Arthur E. Johnson Foundation.

Additional support is provided by The Adolph Coors Foundation Exhibition Fund, Wells Fargo, Sotheby's, Mr. and Mrs. Thomas A. Petrie, and the citizens who support the Scientific and Cultural Facilities District.

Dedicated to the memory of Cortlandt S. Dietler

Contents

Foreword

CHARLES M. RUSSELL is one of the most beloved artists of the American West. In his day, he was celebrated nationally as the Cowboy Artist, the only major painter and sculptor who had actually worked on the open range; he was also one of America's most sensitive artistic interpreters of Northern Plains Indian life. Russell's influence on his contemporaries was enormous, and echoes of his style and subject matter can be found in American western art right up to the present day. Russell is the subject of countless books and articles, and his works have appeared in many exhibitions, but until now superlative examples of his work in oil, bronze, and mixed-media sculpture have not been assembled in a full-dress retrospective.

In 2005, Gilcrease Museum and the Denver Art Museum forged a partnership with the ambitious goal of bringing together Russell's greatest paintings and sculptures and producing a catalog worthy of accompanying them. In the years since the exhibition was conceived in meetings at Gilcrease Museum, both institutions have experienced change, but our mutual commitment to the project and the professional goodwill of our respective staffs have never faltered.

Gilcrease Museum's holdings of Russell's paintings, watercolors, and bronzes is considered the finest collection of the artist's work assembled during his own lifetime. Thanks to unprecedented loans from two equally transcendent Russell collections—those of the Amon Carter Museum and the Montana Historical Society—as well as from numerous public institutions and private collectors, "The Masterworks of Charles M. Russell: A Retrospective of Paintings and Sculpture" is truly representative of the pinnacle of the artist's achievement.

Our pride in "The Masterworks of Charles M. Russell" is exceeded only by our gratitude for the contributions of the many people and organizations that played indispensable roles in its realization. We are deeply indebted to our lenders, without whose generosity there would be no exhibition; the individuals and corporate and foundation sponsors that provided funding for it; the Russell experts who served on the exhibition's advisory committee; the authors whose essays make up this catalog; and the University of Oklahoma Press, which shepherded this book from conception to completion.

We also wish to thank Joan Carpenter Troccoli, Senior Scholar in the Petrie Institute of

Western American Art, Denver Art Museum, who curated the exhibition and is the editor and principal author of this book, and Gilcrease Museum's Assistant Director, Gary Moore, and Collections Manager, Randy Ramer, for their roles in leading the staff effort on the exhibition at Gilcrease. Thomas A. Petrie, Denver Art Museum Trustee, merits our most profound appreciation for his unstinting support for the project, as do Randy Foutch and Hans Helmerich of the Gilcrease Museum National Board.

Finally, we dedicate this book and exhibition to the memory of Cortlandt S. Dietler, whose philanthropy changed Tulsa and Denver, the two communities he called home, decisively for the better. Cort, named a Distinguished Alumnus of the University of Tulsa in 1975, served on its Board of Trustees for twelve years, attaining emeritus status in 2000. His admiration for Gilcrease Museum knew no bounds. As a leading member of the Denver Art Museum's Board since 1983 and a founding member of the Advisory Board of the Petrie Institute of Western American Art, Cort generously supported every aspect of the museum's program in western art, and he applauded the Denver Art Museum's collaboration with Gilcrease on "The Masterworks of Charles M. Russell." We greatly miss Cort's acerbic wit and informed counsel; our fondest wish is that he could be here to see this exhibition and share his opinion of it with us.

Duane H. King, *Vice-President for Museum Affairs, Thomas Gilcrease Chair,*
University of Tulsa, and Executive Director, Gilcrease Museum
Lewis I. Sharp, *Frederick and Jan Mayer Director, Denver Art Museum*

Joan Carpenter Troccoli

Acknowledgments

"The Masterworks of Charles M. Russell: A Retrospective of Paintings and Sculpture" could not have been realized without the cooperation of many institutions and the assistance of dozens of people of enormous generosity and great goodwill.

First and foremost, I thank the individuals and institutions that have agreed to part with cherished works from their collections for the duration of the exhibition. Their willingness to do so is the foundation upon which the exhibition has been built. In addition to numerous objects from the holdings of Gilcrease Museum, "The Masterworks of Charles M. Russell" is composed of works from the following public collections, to whose boards and staff I extend my deep appreciation: Amon Carter Museum, Fort Worth, Texas, Ron Tyler, Director; Buffalo Bill Historical Center, Cody, Wyoming, Bruce Eldredge, Executive Director; C. M. Russell Museum, Great Falls, Montana, Anne Morand, Chief Curator, and Susan Johnson, Interim Chief Executive Officer; Eiteljorg Museum of American Indians and Western Art, Indianapolis, Indiana, John Vanausdall, President and Chief Executive Officer; The Harry Ransom Humanities Research Center, University of Texas at Austin, Thomas F. Staley, Director; Hood Museum of Art, Dartmouth College, Hanover, New Hampshire, Brian P. Kennedy, Director; Indianapolis Museum of Art, Maxwell Anderson, Director; Montana Historical Society, Helena, Montana, Richard Sims, Director; National Cowboy & Western Heritage Museum, Oklahoma City, Oklahoma, Charles P. Schroeder, Executive Director; JKM Collection, National Museum of Wildlife Art, Jackson Hole, Wyoming, James McNutt, Director; Sid Richardson Museum, Fort Worth, Texas, Jan Scott, Director; and the Stark Museum of Art, Orange, Texas, Sarah Boehme, Director. We have also drawn heavily on private collections, and I wish to express my heartfelt thanks to The Anschutz Collection, Denver, Colorado; The Duquesne Club Art Society, Pittsburgh, Pennsylvania, Lucian Caste, President; William C. Foxley, La Jolla, California; The JPMorgan Chase Art Collection, Lisa K. Erf, Director, Art Program, New York; Mr. and Mrs. Thomas A. Petrie, Denver, Colorado; the Frederic G. and Ginger K. Renner Collection, Paradise Valley, Arizona; Mr. and Mrs. William D. Weiss, Jackson Hole, Wyoming; and an anonymous lender. For their good efforts on behalf of the exhibition, I most sincerely thank Rick Stewart, Senior Curator of Western Painting and Sculpture,

Amon Carter Museum; Don Spitzer and Shawn Hessing, KPMG/LLP, New York; Eric P. Widing, Head of the American Department, Christie's New York; David Roderick; Jennifer Bottomly-O'looney, Curator of Collections, Montana Historical Society; Steve Grafe, Curator of American Indian Art, National Cowboy & Western Heritage Museum; James Nottage, Vice-President and Chief Curatorial Officer, and Suzan Campbell, former Gund Curator of Western Art, History and Culture, Eiteljorg Museum of American Indians and Western Art; Darlene Dueck, Curator, The Anschutz Collection; and Debra Armstrong-Morgan, Registrar, The Harry Ransom Humanities Center.

Magnanimous funders are indispensable to any project of this scope. I am deeply grateful for the extraordinary level of sponsorship granted to "The Masterworks of Charles M. Russell" by the Helen K. and Arthur E. Johnson Foundation. Additional support has been provided by The Adolph Coors Foundation Exhibition Fund, Wells Fargo, Sotheby's, and the generous donors to the Annual Fund Leadership Campaign. I also thank Mr. and Mrs. Thomas A. Petrie for the planning grant that got the ball rolling in 2005 on this ambitious undertaking.

From the beginning of my work on this project, I have repeatedly benefited from the vast knowledge, wise counsel, and sustained enthusiasm of a distinguished panel of advisers, all of whom have contributed in other critical ways to the exhibition and its catalog. For their untiring work, I am enormously grateful to Brian W. Dippie, Professor of History, University of Victoria, Victoria, British Columbia, Canada; Mindy Besaw, John S. Bugas Curator, Whitney Gallery of Western Art, Buffalo Bill Historical Center; Sarah Boehme; Peter H. Hassrick, Director, Petrie Institute of Western American Art, Denver Art Museum; Kirby Lambert, Outreach and Interpretation Program Manager, and Bill Mercer, Museum Manager/Director, Montana Historical Society; Anne Morand; B. Byron Price, Director, Charles M. Russell Center for the Study of the Art of the American West, University of Oklahoma, and Director, University of Oklahoma Press; Gary Moore, Assistant Director, and Randy Ramer, Collections Manager, Gilcrease Museum; Ginger K. Renner, Paradise Valley, Arizona; Jan Scott; and Rick Stewart.

I thank, too, the essayists whose research and insights grace the pages of this book. George P. Horse Capture, Sr., Senior Counselor to the Director Emeritus, National Museum of the American Indian, Smithsonian Institution, Washington, D.C.; James P. Ronda, H. G. Barnard Professor of Western History, Emeritus, University of Tulsa; and Emily Ballew Neff, Curator of American Painting and Sculpture, The Museum of Fine Arts, Houston, have joined exhibition advisers Anne Morand, Mindy Besaw, Brian W. Dippie, Kirby Lambert, and Peter H. Hassrick in making contributions of lasting value to Russell scholarship in this volume.

For their assistance with the research for my contributions to this book, I thank the wonderful staff of the Donald C. and Elizabeth M. Dickinson Research Center at the National Cowboy & Western Heritage Museum. Charles Rand, Director, and Archivists/Librarians Karen Spilman and Jennifer Wochner were tremendously helpful and hospitable to me during my visit there, as was Melissa Owens, the museum's Registrar. I extend my appreciation as well to Sharon McGowan, Librarian, for helping me explore the Archives of the C. M. Russell Museum in Great Falls and to Blake Milteer, Curator of 19th–21st Century American Art,

Colorado Springs Fine Arts Center, Colorado Springs, Colorado, for granting us permission to cite documents in the Helen E. and Homer E. Britzman Collection, which is held by his institution. Lisa K. Erf and Hsu-Han Shang of the JPMorgan Chase Art Collection graciously gave me access to their Russell files.

I am especially grateful to Peter H. Hassrick and Rick Stewart for acting as invaluable sounding boards for the ideas expressed in my essay and to Brian W. Dippie for critiquing my essay in detail on very short notice. It has been a privilege for me to pursue my work on Russell accompanied by these peerless guides.

At the University of Oklahoma Press, I thank Byron Price not only for agreeing to publish this book but also for sharing prepublication information from his *Charles M. Russell: A Catalogue Raisonné* as well as hundreds of images of Russell's works. The catalogue raisonné has been an indispensable resource in organizing the exhibition as well as writing and editing this book. Charles E. Rankin, Associate Director and Editor-in-Chief, has patiently tolerated my slowpoke perfectionism while keeping the project on track, always with great good humor. Alice Stanton, Special Projects Editor at the press, has been equally supportive, and Anna Maria Rodriguez has very capably dealt with the challenge of organizing all the images reproduced in this book. I thank our copy editor, Brent Winter, for his fine work, and I am also grateful for the observations and recommendations of the two anonymous peer readers of the manuscript. For facilitating our pursuit of illustrations for the book, Alma Gilbert-Smith, Director, Cornish Colony Gallery and Museum, Cornish, New Hampshire; Jerry L. Thompson; Michael Frost and Elizabeth Marrella of J. N. Bartfield Galleries, New York; and the Denver Public Library all deserve special mention.

My colleagues past and present in the Petrie Institute of Western American Art of the Denver Art Museum have provided invaluable assistance as well as unwavering moral support throughout the course of my work on "The Masterworks of Charles M. Russell." I thank Ann Scarlett Daley, Curator of the Mayer Collection, Denver, and former Associate Curator in the Petrie Institute, for the sure eye she brought to her critiques of the checklist. Mindy Besaw, former Curatorial Associate, assisted in every aspect of the development of the exhibition from its inception in 2005 until her departure for the Buffalo Bill Historical Center in 2007. Curatorial Assistant Nicole Parks has worked with unflagging energy and attention to detail on virtually every element of the project, and Department Assistant Holly Clymore has tackled the complex task of assembling the images for the book with her usual good cheer. I am grateful to Thomas Smith, Associate Curator, for his close reading of the manuscript of my essay, and I thank our interns Lucy Clark and Rachel Miller for their research assistance.

I owe a special debt to Peter H. Hassrick, Director of the Petrie Institute, for his steadfast support, sage advice, and, not least, his generosity in sharing his extensive research on Russell as well as his indispensable assistance in obtaining loans for the exhibition. His sense of humor, which Charlie Russell himself would have appreciated, is unfailing, and his friendship is tried and true.

In mounting "The Masterworks of Charles M. Russell" I have relied upon the hard work and expertise of many colleagues at the Denver Art Museum, starting at the top, with Lewis I. Sharp, Frederick and Jan Mayer Director, whose admiration for Russell has only grown in

the years since *In the Enemy's Country,* the museum's first major work by the artist, entered the collection in 1991. Michèle Assaf, Director, and Kara Kudzma, Exhibitions Project Manager, of the Exhibitions and Collections Services Department have supervised the organization of the exhibition with efficiency and skill. Lee Murray, Exhibition Designer, and Liz Larter, Graphic Designer, have created an installation worthy of the masterpieces in the show. Lori Iliff, Associate Director of Exhibitions and Collections Services/Registrar, Laura Paulick Moody, Associate Registrar for Exhibitions, and their staff have seen to the nuts and bolts of securing the loans and installing them in our galleries. Lisa Steffen, Master Teacher for Western American Art, has created innovative and enriching educational programming to accompany the exhibition, and Lisa Levinson, Senior Interpretive Writer, has applied her deft editorial hand to the composition of the exhibition's labels and text panels. Jeff Wells, the museum's Photographer, was quick to put his talents at our disposal as we approached publication deadlines, and Melanie Ulle, Megan Cooke, Sally Chafee, and Chiara Robinson led the charge on fund-raising for the exhibition.

This project was conceived in meetings with Joe Schenk, former Executive Director, and Gary Hood, former Senior Curator, at Gilcrease Museum, where I had the good fortune to serve as Curator of Art and Director in the late 1980s and early 1990s. I thank my former colleague, Assistant Director Gary Moore, for his dedication to our collaborative enterprise, and Duane H. King, Vice-President for Museum Affairs, Thomas Gilcrease Chair, University of Tulsa, and Executive Director, Gilcrease Museum, for picking up the baton when he joined Gilcrease's staff in 2008. Randy Ramer, Collections Manager, and David Newell, Coordinator for Special and On-line Exhibitions, have served on the team since the beginning, and I am pleased that Carole Klein, Associate Curator of Art, April Miller, Curator of Archives, Kimberly Roblin, Associate Curator, Eric Singleton, Assistant Curator, and Amanda Lett, Registrar, have since joined our cause.

My gratitude is also extended to The University of Tulsa and its President, Steadman Upham, along with the Trustees of the Thomas Gilcrease Institute of American History and Art, Dale McNamara, Chairman, and Kathy Taylor, Mayor of the City of Tulsa, and the individuals and organizations that constitute the Gilcrease Museum Founders Council: The Mervin Bovaird Foundation; the H. A. and Mary K. Chapman Charitable Trust; Mr. and Mrs. Walter H. Helmerich, III; the George Kaiser Family Foundation; The Anne and Henry Zarrow Foundation; and The Maxine and Jack Zarrow Family Foundation. I also gratefully acknowledge the exhibitions sponsors of Gilcrease Museum, including the Bank of Oklahoma; the H. A. and Mary K. Chapman Charitable Trust; the Joe and Kathy Craft Foundation; the George Kaiser Family Foundation; Pete and Nancy Meinig; Nadel and Gussman, L.L.C.; Samson; The William K. Warren Foundation; The Williams Companies, Inc.; and The Anne and Henry Zarrow Foundation.

It may have taken the combined resources of many people and institutions to carry it through to completion, but "The Masterworks of Charles M. Russell" would not have been initiated without the inspiring vision and tireless support of Denver Art Museum Trustee Thomas A. Petrie, who holds the most important collection of works by Russell in private hands. Tom's passion for the artist, his deep knowledge of Russell's life and art, and his ex-

traordinary generosity with his time, library and research files, financial support, contacts among collectors and dealers, and the works in his collection have been constants since day one. Tom and his wife, Jane, are the kind of museum benefactors that curators dream about, and I am proud to count them among my dearest friends. Finally, I thank my very best friend of all, my husband, Robert C. Troccoli, for his forbearance during the long gestation of "The Masterworks of Charles M. Russell" and his affectionate indulgence of my every scholarly whim.

The Masterworks of Charles M. Russell

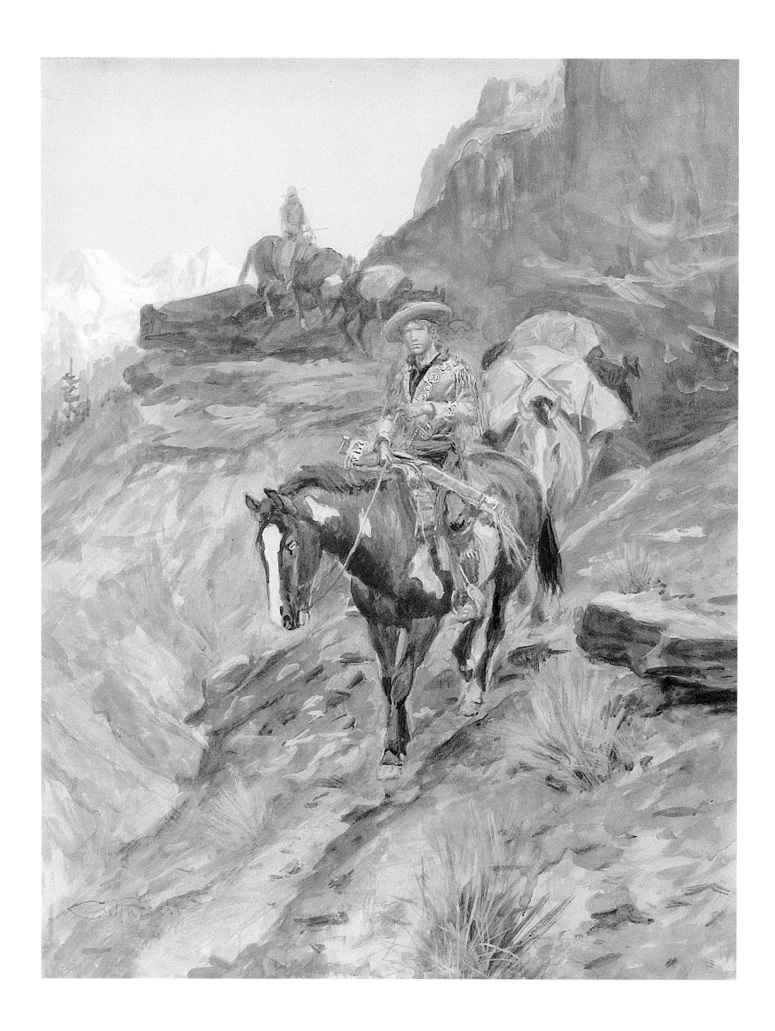

Joan Carpenter Troccoli

Introduction

CHARLES MARION RUSSELL's life began in St. Louis, Missouri, thirteen months before the close of the Civil War; it ended in Great Falls, Montana, at the height of the Roaring Twenties. He was an indulged son of a prosperous family with deep roots in St. Louis, which had been a launching ground for grand western enterprises since before the Louisiana Purchase. St. Louis functioned as a way station for westerners and raw materials bound for the East and for explorers, businessmen, emigrants, and manufactured goods headed west. Charles Silas Russell and his wife, Mary Elizabeth Mead Russell, were well-placed in St. Louis society, but their son "Chas" was inclined to identify with those of his relatives who had abandoned a more settled existence in favor of life beyond the frontier, such as his paternal relations William and Charles Bent, pioneer traders on the Santa Fe Trail.

In 1880, just before Russell turned sixteen and after he had accumulated a long record of school truancy and boyish pranks, his parents finally acceded to his desire for a firsthand taste of western adventure: they permitted him to accompany Wallis L. W. Miller, a family acquaintance, to his ranch in Montana Territory. The Russells hoped that the discomforts of the frontier would quickly extinguish their son's childhood fantasies, derived from dime novels and stimulated by his observation of traders and boatmen from upriver on the St. Louis waterfront. Instead, the teenager embraced the experience. Russell soon quit Miller's employ to make his own way in Montana, living with mountain man Jake Hoover for two years and working as a night herder on the cattle range for eleven years more. He acted out every American boy's dream of life in the wild West before making art his full-time profession in 1893.[1]

Russell received virtually no formal artistic training, and for many years he was regarded as a cowboy who happened to employ his considerable talents as a draftsman and spontaneous creator of tiny sculptures in wax and clay to amuse himself and his friends or to close out his bar tab, not as an artist concerned with technical and aesthetic problems. Many of Russell's admirers saw his art, especially his early work, as an unstudied, almost instinctive response to his western environment, an extension of his experience rather than an end in itself. They dated his turn to serious, successful art-making to the late 1890s, after he married the humbly born but ambitious Nancy Cooper, who enforced regular working hours in his studio and aggressively marketed his pictures.

(facing)

When I Was A Kid, 1905
Watercolor and gouache on paper,
14¼ × 11 inches, Frederic G. and
Ginger K. Renner Collection,
Paradise Valley, Arizona

3

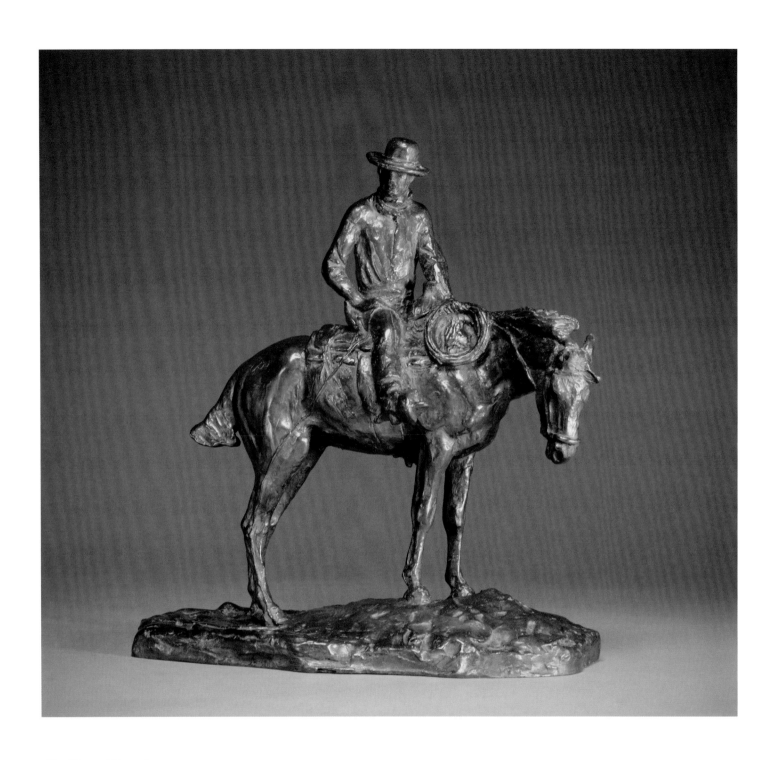

The Horse Wrangler, 1924
Bronze, 13½ × 13⅛ × 7¾ inches,
Petrie Collection, Denver, Colorado

During Russell's lifetime and for many years after his death in 1926, most analysis of his work amounted to an appreciation of his undeniable charisma and a favorable verdict on his fidelity to the details of his subjects' real-life trappings and characteristics. In the eyes of his early critics, the greatest virtues of his art were the accuracy and authenticity conferred upon it by his work as a cowboy, his close relationship with American Indians, and his residence in Montana. Combined with a fascination with Russell's seductive persona, these beliefs led to the conviction that his was a pure, organic artistic genius that grew and flourished in near-total isolation from the academy and a cosmopolitan community of fellow artists. These assumptions were not without a basis in fact, but however great a genius Russell may have been, he was, like every other professional artist, affected by external influences and motivated by personal aspiration.

Since the 1980s, a group of scholars headed by Brian W. Dippie, Peter H. Hassrick, and Rick Stewart has carried out extensive, innovative research on Russell. This group has introduced contemporary critical and art-historical analysis to the study of Russell's work and its place within the larger history of American art and culture of the late nineteenth and early twentieth centuries. Their studies, built on the foundations of Russell scholarship established by Frederic G. Renner, Harold McCracken, Ramon F. Adams, and Homer E. Britzman and upon the memoirs of the artist's acolyte Joe De Yong and nephew Austin Russell, have transformed the field.[2] They have been joined in their enterprise by John Taliaferro, who published the first modern biography of Russell in 1996;[3] Raphael Cristy, a specialist in Russell's distinctive use of the spoken and written word;[4] and, most recently, B. Byron Price, who supervised the 2007 publication of the catalogue raisonné of Russell's paintings, works on paper, and mixed-media sculpture.[5]

The detective work, academic rigor, and connoisseurship of Dippie, Hassrick, and Stewart, as well as the biographical revelations of Taliaferro, were initially greeted with alarm in some camps.[6] By digging deeper into archives and testing the hallowed concepts of Russell's accuracy, authenticity, and originality, however, these scholars made the artist more appealing to a new generation of researchers and more interesting in general without dispelling any of his magic. By focusing on the material qualities of Russell's art as well as the narratives writ large in its iconography and embedded in its details, they have shown his work to be richer and more nuanced in theme, more sophisticated in composition and technique, and more incisive in social commentary than most of his earlier partisans ever imagined.

Given Russell's longstanding popularity, it is surprising that "The Masterworks of Charles M. Russell: A Retrospective of Paintings and Sculpture" is the first large-scale exhibition of superlative works by Russell in oil, bronze, and mixed media.[7] The retrospective, jointly organized by Gilcrease Museum in Tulsa, Oklahoma, and the Denver Art Museum, opens in Denver in October 2009. The exhibition will subsequently travel to Gilcrease and to The Museum of Fine Arts, Houston. This book serves as the exhibition's catalog—every object in the show is illustrated here—and it is also intended to stand alone as a survey of Russell's work and a series of in-depth studies of selected aspects of his art.

"The Masterworks of Charles M. Russell," the exhibition, is organized into six sections of major works, supplemented with a small group of watercolors, illustrated letters, and a bronze that present the artist in his own words and images. It opens with the works for which

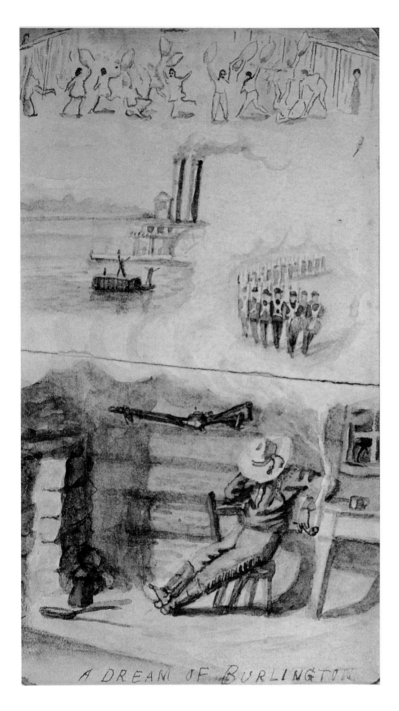

Russell is best known: his depictions of cowboys in action on the trail, in roundup camps, and on sorties to frontier towns. Paintings of outlaws and those who would foil them make up the second section of the exhibition. These reflect the ambivalent streak in Russell's own personality, revealed in his art as early as 1880 in his watercolor *A Dream of Burlington*. Here he portrayed himself, loafing on a cabin porch, as the independent westerner he so ardently wished to be; yet he was dreaming still of the regimental routine at the military academy to which his parents had sent him in a last-ditch attempt to impose discipline upon him before releasing him into the wilds of Montana.

From the beginning of his time in Montana, Russell observed the meeting and mixing of Native and white Americans, and the third section of the exhibition is devoted to his interpretations of their interactions. Unlike his contemporaries Frederic Remington and Charles Schreyvogel, Russell was genuinely sympathetic to Indians, and he often composed his pictures of Northern Plains peoples' dealings with whites from the Native viewpoint. The fourth and largest section of the exhibition consists of paintings and sculptures of Indians. Native American subjects predominate in Russell's work as a whole, particularly in the later stages of his career. Divisions within this section present the development of Russell's most frequent theme, the Indian buffalo chase, and his depictions of Northern Plains Indian domestic life before it was fatally disrupted by the arrival of white miners, ranchers, and masses of emigrants from the East.

It seems no coincidence that Russell's growing command of light and color in service of a nostalgic mood corresponded with his increasing devotion to what he called "the West that has passed"—the golden age that began with the reintroduction of the horse to North America

A Dream of Burlington, 1880
Graphite and watercolor on paper,
5 × 2¾ inches, Petrie Collection,
Denver, Colorado

and ended with its agricultural settlement by whites. This attitude may be captured best in Russell's depiction of Indian men as chivalrous warriors and lords of the plains. At the same time, Russell moved beyond older stereotypes of Indian women as sex objects and domestic drudges to depict them as full and noble partners in assuring the survival and prosperity of their communities.

"The West That Has Passed" (a title Russell applied to a number of his one-man exhibitions beginning in 1911) was also the domain of the free trappers of the Rocky Mountains, whose enterprises flourished from the mid-1820s to the early 1840s. They are represented in

Scalp Dance, 1905
Bronze, 13½ × 9 × 6¾
inches, Petrie Collection,
Denver, Colorado

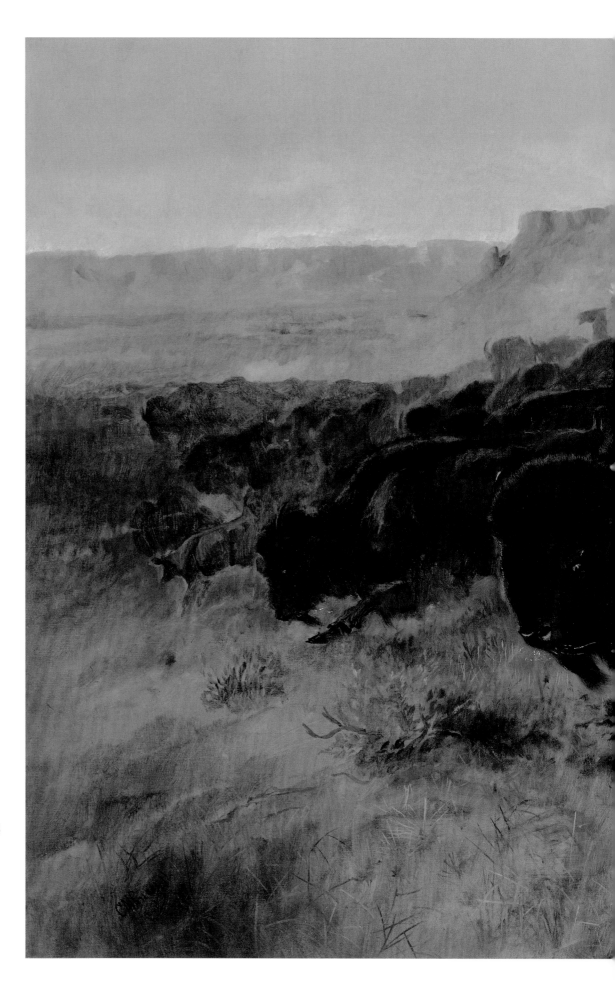

Buffalo Hunt [No. 7], ca. 1895
Oil on canvas, 21⅞ × 34⅜ inches,
Petrie Collection, Denver, Colorado

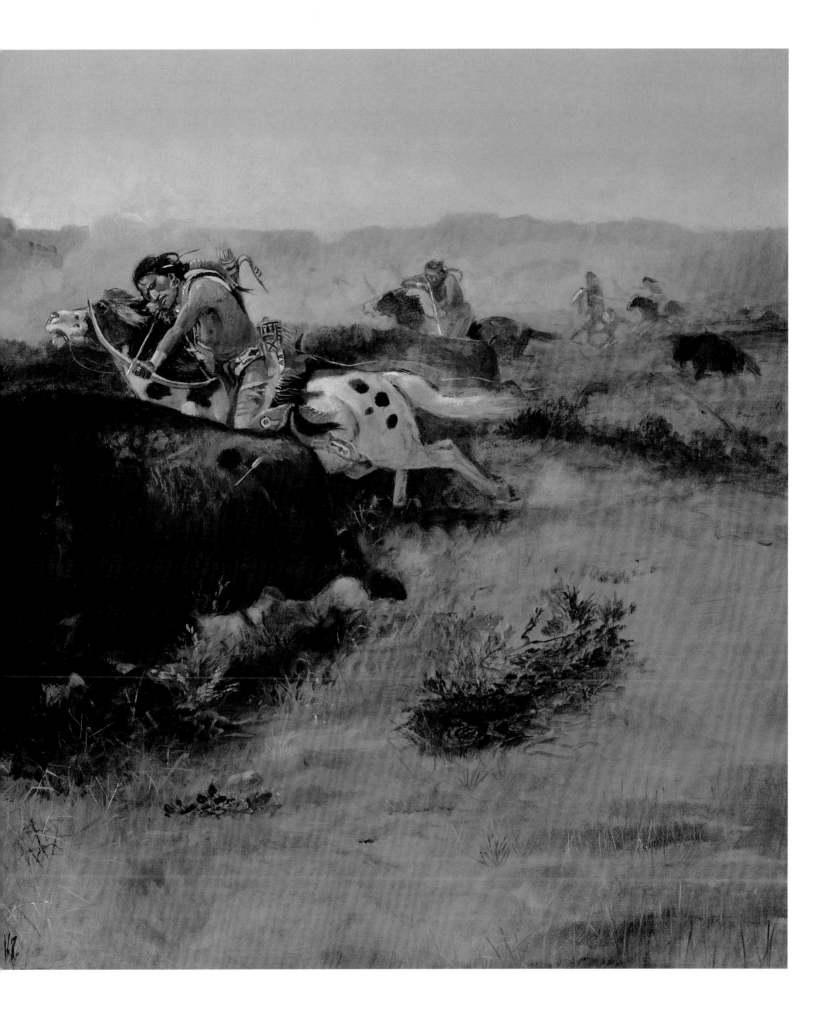

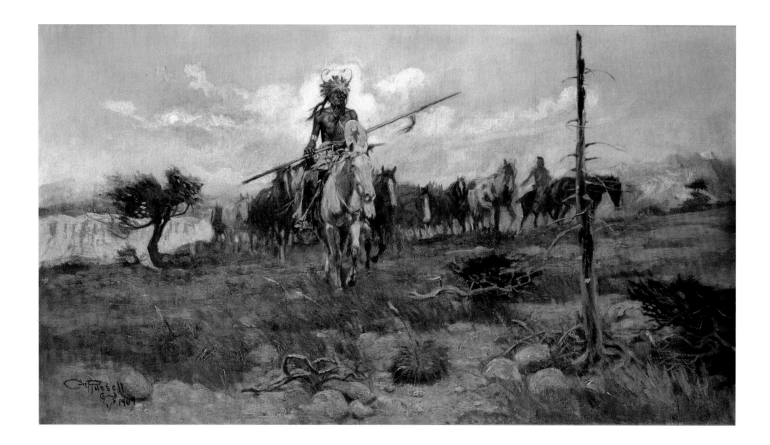

Bringing Home the Spoils,
1909

Oil on canvas, 15⅛ × 27¼ inches,
Buffalo Bill Historical Center,
Cody, Wyoming (19.10)

the fifth section of the exhibition, which also includes paintings of sport hunters of the art-
ist's own time, whom Russell presented very differently. Russell's modern sportsmen pursue
their quarry in settings as magnificent as those traversed in his pictures by the mountain men
of yore, but they often find themselves in dangerous or bewildering situations in which nature
confounds modern technology.

The exhibition concludes with Russell's ultimate expression of "The West That Has
Passed"—his paintings and sculptures of bears, bison, and wolves in a sublime, unpeopled
wild. American culture has long been concerned with wilderness and its loss, and Russell's
yearning to reconnect with nature was not uncommon in the United States around 1900.
However, Russell arrived in Montana when it was still an open range and mining frontier, al-
lowing him to comment with greater authority (and dismay) than any other artist of his gen-
eration on the urban and industrial development of the West.

Although the organization of the exhibition outlined above may suggest otherwise, Rus-
sell did not proceed in lockstep from one neatly delineated formal and thematic period to
the next. The overall trajectory of Russell's work represents a retreat from a dynamic present
portending a mechanized future to a primeval, sunset-gilded paradise of wild creatures and
unspoiled landscapes. The sections into which the exhibition is divided correspond to this
trend in Russell's art. His increasing alienation from modern American society and growing
devotion to nature create the principal unifying concept for the exhibition.

In Russell's work, nature and natural values do not equate with wilderness, although wil-
derness is certainly an aspect of his vision. Russell's sense of the natural encompassed an

empathetic, often wry understanding of the fundamental human needs and drives of diverse western peoples, a quest for humility and spiritual authenticity, and a profound, deeply personal desire for the union of nature and humanity. Russell's idyllic natural realm exists in opposition to modern urban civilization. To Russell, the latter was the domain of the artificial, the hypocritical, the constrained, and every other component of the impersonal, profit-driven march of progress. Russell vigorously dissented on Prohibition, winked at prostitution, sympathized with outlaws, and habitually viewed the world from the perspective of the weaker party, be it human or animal. The Native peoples of the northern plains were Russell's ideal. He noted their weaknesses—which were, after all, only human—but considered their failings all but canceled out by their tragic fate. Disregarding orthodox punctuation (as was his wont), but in well-metered iambs and anapests, Russell summed up Indians' enviable concord with nature: "their God was the sun / their Church was all out doors / their only book was nature / and they knew all its pages."[8]

In focusing his art on nature, Russell gave voice to contemporary Americans' deep-seated misgivings about the consequences of urbanization and industrial development, which exploded in the decades after Russell's birth. His anxiety was hardly unique in his day. In the United States around 1900, it was not uncommon to reject modern technology and the city or to celebrate Indians as the first and only "real" Americans. What made Russell unusual was his firsthand knowledge of those displaced by progress and his outspoken defense of them.

The exhibition's other major theme is the striking degree to which Russell played the role of cultural intermediary in his work. He did so for the cowboys who, despite their heroic stature in the popular imagination, were disdained by polite society. He did the same—with greater seriousness, and sometimes to the point of public protest—for Indians. Russell's remarks on the gap between white Americans' professed ideals and the reality of their behavior were often sweetened with humor, but they never lacked bite.

In enlarging upon these themes and analyzing key aspects of Russell's art, I am joined by a distinguished group of scholars. In "Memories of Charles M. Russell among my Indian Relatives," George P. Horse Capture, Sr., recounts incidents of Russell's personal relationships with the Gros Ventres of northeastern Montana. The respect and mutual affection that characterized these relationships are evident in Russell's art. In "Charles M. Russell: Creative Sources of a Young Artist Painting the Old West," Anne Morand tracks the origins of Russell's imagery in the visual culture of St. Louis and the ways in which he adapted the compositions of earlier artists to his own ends. Morand makes the point that although Russell was self-taught, his formative practice of copying the works of others was a traditional element of conventional academic training.

Tiny animal figures fashioned from wax purloined from his sister's craft supplies were among Russell's earliest works. For the remainder of his career, he continued to make models in wax, plaster, and a variety of other materials to be used as accompaniments to his storytelling, lay figures for studio use, gifts for friends, and for the whimsical installations he planted in the woods around his summer cabin in Glacier National Park. In "Charlie Russell in Wax," Mindy A. Besaw discusses four of his major efforts in this vein and places them within the larger history and context of wax as an artistic medium.

Much American western art has been dismissed as anecdotal illustration, but the scholarly

His Heart Sleeps, 1911
Oil on canvas, 6⅞ × 11⅞ inches, Buffalo
Bill Historical Center, Cody, Wyoming
(89.60.1)

respect recently bestowed upon rhetorical strategies in painting mandates a fresh look at Russell's self-acknowledged devotion to storytelling in every aspect of his work. Russell was a beguiling and influential writer as well as a painter and sculptor, and the narrative complexity of his visual art is one of its most distinctive features. In "'What a Pair to Draw to': Charles M. Russell and the Art of Storytelling Art," Brian W. Dippie explores how Russell's use of narrative devices that demand the imaginative participation of the viewer began with his earliest illustrations and postcards, ripened into the "paired paintings" of his early maturity, and culminated in his great "predicament pictures" of the second decade of the twentieth century.

James P. Ronda, whose publications have transformed perceptions of the Lewis and Clark expedition from a tale of heroic wilderness conquest by a hardy band of Anglo-Saxons to an account of crucial cooperation between the explorers and indigenous peoples,[9] describes Russell's take on the Corps of Discovery in "Charlie Russell Discovers Lewis and Clark." Long before historians caught up with him, Russell depicted the explorers from the perspective of the Indians, who viewed them either as short-term interlopers who were often in pitiable need of assistance or as potentially useful collaborators who could help their Native hosts and guides accomplish their own objectives.

The American fur trade boomed in the wake of Lewis and Clark. Thanks to his family history, Russell felt a special kinship with such legendary characters of that era as Jim Bridger and Kit Carson, a relative by marriage of Charles Bent. Russell's painting *Carson's Men* (1913) has long been viewed as an icon of that connection. However, the title of that great work has led to some confusion about the identities of the figures depicted. In "Who Are Carson's Men?" Emily Ballew Neff discusses the significance of the painting's name and discusses its relationship to a series of illustrations designed by Russell for a semifictional autobiography by Walter Cooper, who was associated with Carson in his youth.

Many regard *When the Land Belonged to God* (1914) as Russell's masterpiece. In "Montana's Magnificent Russell," Kirby Lambert details the genesis of the painting and its eventual acquisition by the state of Montana. He also touches upon the irony inherent in the origins of Russell's greatest image of the primeval West: a commission from The Montana Club, an organization that represented the very forces that, in the artist's opinion, had helped obliterate the world depicted in *When the Land Belonged to God*.

For all his identification with Montana, Russell traveled coast to coast to improve and sell his work, and in the process he came into contact with the artistic avant-garde of the early twentieth century. Russell also made one trip abroad—to England, with a brief foray into France—that is imaginatively chronicled in some of his best illustrated letters. In his essay "Russell Meets Russolo," Peter H. Hassrick analyzes Russell's account of his meeting with his apparent artistic opposite, Italian Futurist Luigi Russolo, at the Doré Gallery in London, where both had exhibitions on view in the spring of 1914.

Will Rogers, who belonged to the old school of Russell criticism, wrote one of the earliest posthumous appraisals of the artist in his introduction to *Good Medicine* (1929), a compilation of Russell's illustrated letters edited by his widow Nancy. "I always felt that all that Painting gag was just a sort of sideline with Charlie," Rogers wrote. He considered Russell's art as an incidental benefit of his more valuable (and entertaining) contributions as a "Philosopher" and "great Humorist," a sentiment that is not surprising given Rogers's own line of work.

Rogers went on to say, "I think every one of us that had the pleasure of knowing him is just a little better by having done so, and I hope everybody that reads some of his thoughts here will get a little aid in life's journey by seeing how it's possible to go through life living and let live. He not only left us great living Pictures of what our West was, but he left us an example of how to live in friendship with all mankind."[10]

Although we have moved far beyond Rogers in our analysis of Russell, his observations are nevertheless still relevant. In the essays that follow, the qualities of Charles M. Russell and of his art that informed Rogers's appraisal—the supremacy of narrative, the formal and symbolic significance of detail, the generous humanity that was essential to Russell's unique representation of the West—are given their due. If my fellow authors and I occasionally fall victim to the old, simplistic view of Russell, I can offer no better apologia than the comments of contemporary artist Michael Heizer, whose mammoth earth-moving projects in the Nevada desert cannot be dismissed as either sentimental or anecdotal. In February 2005, the chief art critic of the *New York Times* reported that "the cowboy paintings of Charles Russell and Frederic Remington [are] just about the only American art Heizer now volunteers to praise. . . . He keeps handy an old book of Russell's paintings of the West. 'I love these artists because they're so precise and faithful,' he says."[11] We cannot disagree, especially if we understand "faithful" to include Russell's lifelong devotion to an ideal vision of the American experience.

Notes

1. For Russell's family history and early life, see Taliaferro, *Charles M. Russell: The Life and Legend of America's Cowboy Artist*, 12–28, 29–43, 47–48, 51–52; Austin Russell, *C. M. R.*, 12–83; and Woodcock, "The St. Louis Heritage of Charles Marion Russell."

2. The contributions of Brian W. Dippie, Peter H. Hassrick, and Rick Stewart to the Russell literature are too numerous to list in full here. Dippie's *Remington and Russell; Looking at Russell; Charles M. Russell, Word Painter;* "Charles M. Russell and the Canadian West"; and "'It Is a Real Business'" are essential reading, as are Hassrick's *Charles M. Russell; Remington, Russell, and the Language of Western Art;* and "Charles Russell, Painter," and Rick Stewart's *Charles M. Russell, Sculptor* and "Modeling in Clay, Plaster, and Wax." Rick Stewart is currently preparing the first major study of Russell's watercolors.

3. Taliaferro, *Charles M. Russell: The Life and Legend of America's Cowboy Artist*.

4. Cristy, *Charles M. Russell: The Storyteller's Art*.

5. Price, ed., *Charles M. Russell: A Catalogue Raisonné*.

6. Vivian Paladin's one-page review of Brian Dippie's *Looking at Russell* ("*Looking at Russell* by Brian W. Dippie") epitomizes the negative response in a nutshell.

7. Janice K. Broderick organized a pioneering, comprehensive examination of the artist, "Charles M. Russell: American Artist," for the Jefferson National Expansion Historical Association in 1982. The exhibition's catalog is relatively brief, but it contains a number of important essays on the artist and his work.

8. Dippie, ed., *"Paper Talk,"* 124.

9. See James P. Ronda, *Lewis and Clark among the Indians* (Lincoln: University of Nebraska Press, 2002).

10. Will Rogers, "Introduction," in Nancy C. Russell, ed., *Good Medicine*, 13, 14, 16.

11. Michael Kimmelman, "Art's Last, Lonely Cowboy," *The New York Times Magazine*, February 6, 2005, 39.

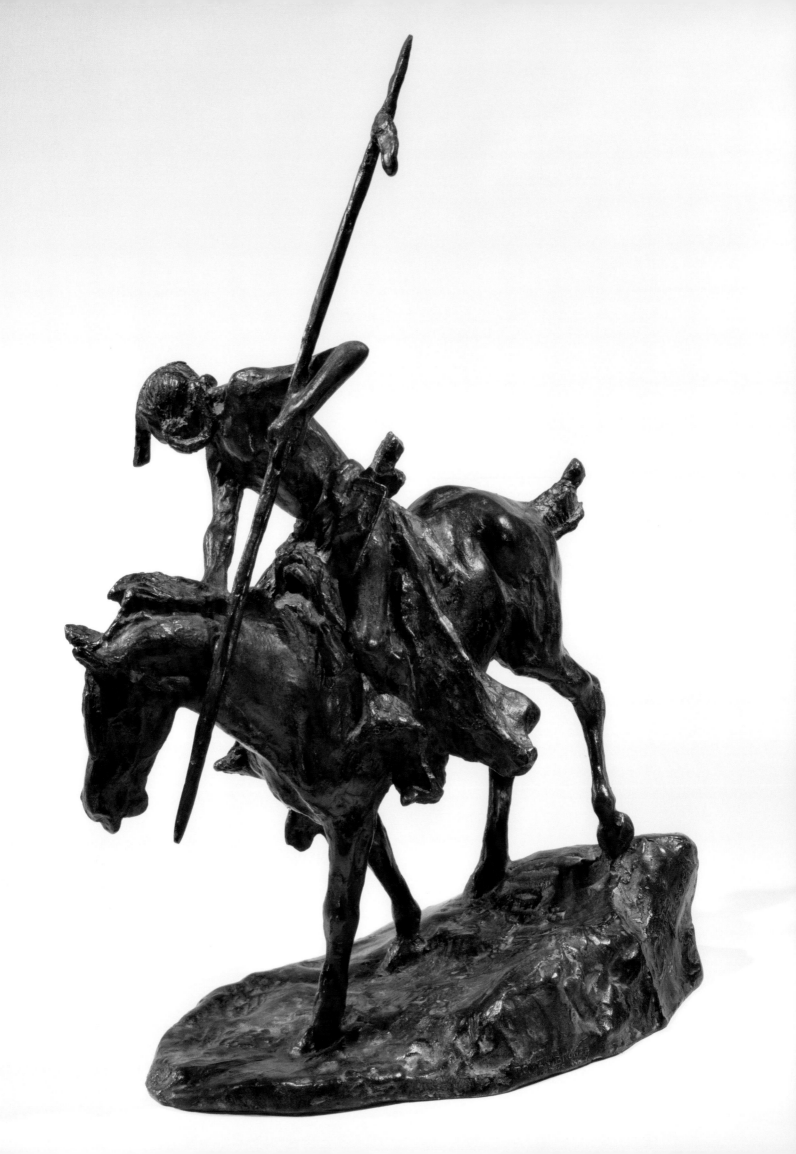

Joan Carpenter Troccoli

Poetry and Motion in the Art of Charles M. Russell

Any attempt to survey Charles M. Russell's painting and sculpture can quickly bog down in the richness of individual works, but to gloss over the details would be to neglect the very elements of his art that are essential to its aesthetic and iconographic success. Much meets the eye in any encounter with Russell's work, and what we see carries a further burden of metaphor that defies pithy summation by all but the most disciplined writer—a writer who would have to be as adept and economical with words as the artist himself.

My principal focus in this essay will be the two poles of Russell's expression—the active and the contemplative—and the engaging, ambivalent mode poised between them. Russell's representation in his work of the transmission of information by a myriad of nonverbal means—which include trail sign, animal tracks, cattle brands, knots, scents, shadows, sunlight flashing off mirrors, smoke signals, pictographs, petroglyghs, sign language, and human footprints—is integral to my argument. These elements serve not only to advance the story told in the painting or sculpture but also to complicate it and even render it unreadable to those outside his world. Russell's use of such devices particularizes his unusually diverse cast of western characters, and it is tied to his employment of the *border*—in both its literal and figurative senses—as a place where alien cultures meet, mix, and collide, where ambiguity is exploited, and where moral and legal clarity breaks down.

Russell is best known to the public for cowboy action pictures like *The Camp Cook's Troubles*, which the casual observer may understand as celebrating purely athletic values rather than intellectual or emotional ones; but he was, at heart, a literary painter. Russell was also a storyteller and writer, and his art contains numerous parallels with literature. To achieve his pictorial poetics, Russell used methods peculiar to his medium—form and color—as well as narrative. The more subtle aesthetic qualities of his work, such as his confident handling of paint, precise control of light and shade, and nuanced, saturated color, are perhaps more immediately apparent in pictures in his contemplative, nostalgic mode, such as *Piegans*. In action paintings like *The Camp Cook's Troubles*, it is his astonishing draftsmanship that grabs the eye. To those for whom Russell is cowboy first and artist second, *The Camp Cook's Troubles* is

(facing)

The Enemy's Tracks, 1920
Bronze, 12⅞ × 10½ × 5¾ inches, Amon Carter Museum, Fort Worth, Texas (1961.75)

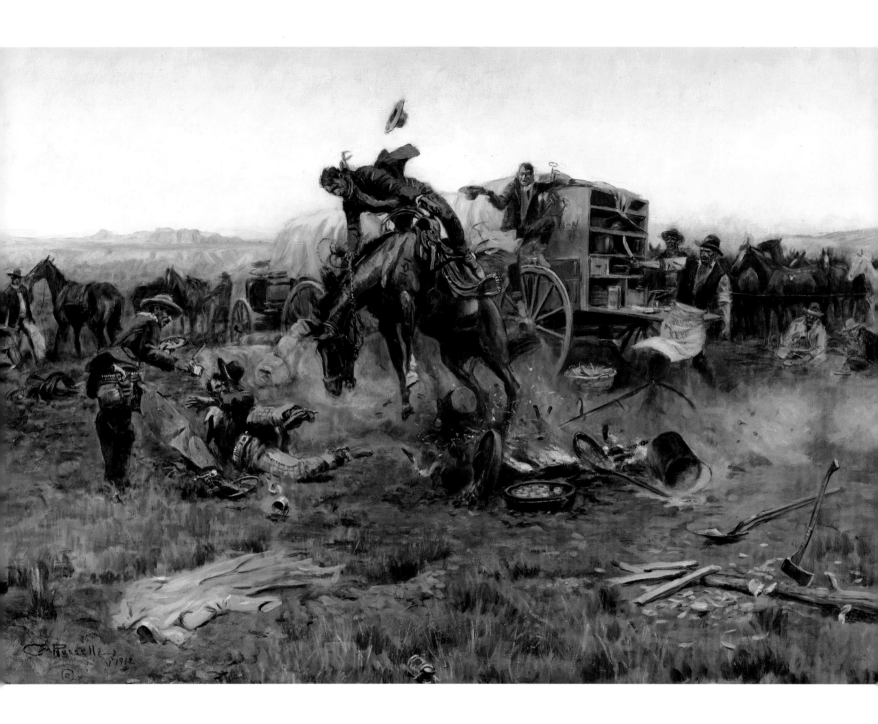

The Camp Cook's Troubles, 1912

Oil on canvas, 29 × 43 inches, Gilcrease
Museum, Tulsa, Oklahoma (0137.913)

proof of his intimate knowledge of the details of the roundup camp and the explosions of violence that occur when humans attempt to impose order on half-wild creatures that are often contrary and sometimes completely beyond control.[1]

Motion came first in Russell's art. Many of Russell's subjects and formal devices, including challenging motifs and compositions anticipatory of *The Camp Cook's Troubles,* were present from the very beginning.[2] The germ of *The Camp Cook's Troubles* can be found in one of Russell's earliest oils, *Breaking Camp,* which records his experience of working cattle in Montana in the 1880s. In this painting, discrete clusters of figures with little to connect them (besides the fact that all are cowboys struggling with uncooperative mounts) are scattered across a broad horizontal field. At this point in his career, well before he turned to art full time in 1893, Russell truly was a cowboy artist, and his subjects were his compadres on the Utica roundup in Montana's Judith Basin,[3] who also served as his first, appreciative audience. However, Russell sent *Breaking Camp* to be exhibited at the St. Louis Art Exposition in 1886,[4] thus announcing to a circle well beyond his friends that he might harbor serious artistic ambitions.

There is perhaps too much action in *Breaking Camp,* the open-range equivalent of a morning-rush-hour pileup on the expressway. In defense of Russell, we might note that while "rounding up" is a process that brings focus and order to a situation involving many active players, "breaking camp" is just the opposite. Thus, the diffuse nature of *Breaking Camp*—if not its surfeit of bucking horses—is true to life, at least as it was recorded by Russell's friend, the early Montana photographer L. A. Huffman,[5] in *Round-up [Outfit] Breaking Camp.* Moreover, amateurish as it is, *Breaking Camp* contains the seeds of many successful action

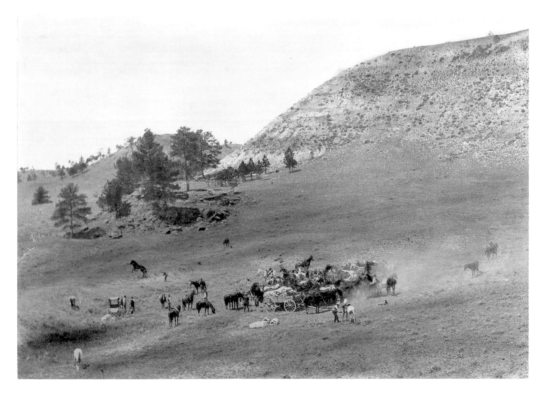

L. A. HUFFMAN
(AMERICAN, 1854–1931)
Round-Up [Outfit] Breaking Camp, neg. date ca. 1886
Hand-colored collotype, Buffalo Bill Historical Center, Cody, Wyoming (P.100.3624), gift of Thomas Minckler

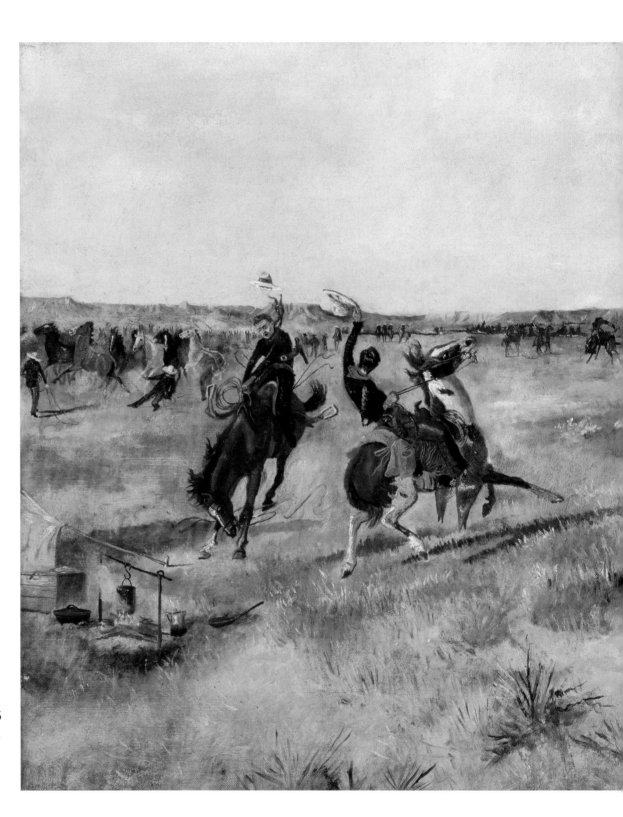

Breaking Camp, ca. 1885
Oil on canvas, 22 × 39 inches,
Amon Carter Museum,
Fort Worth, Texas (1961.145)

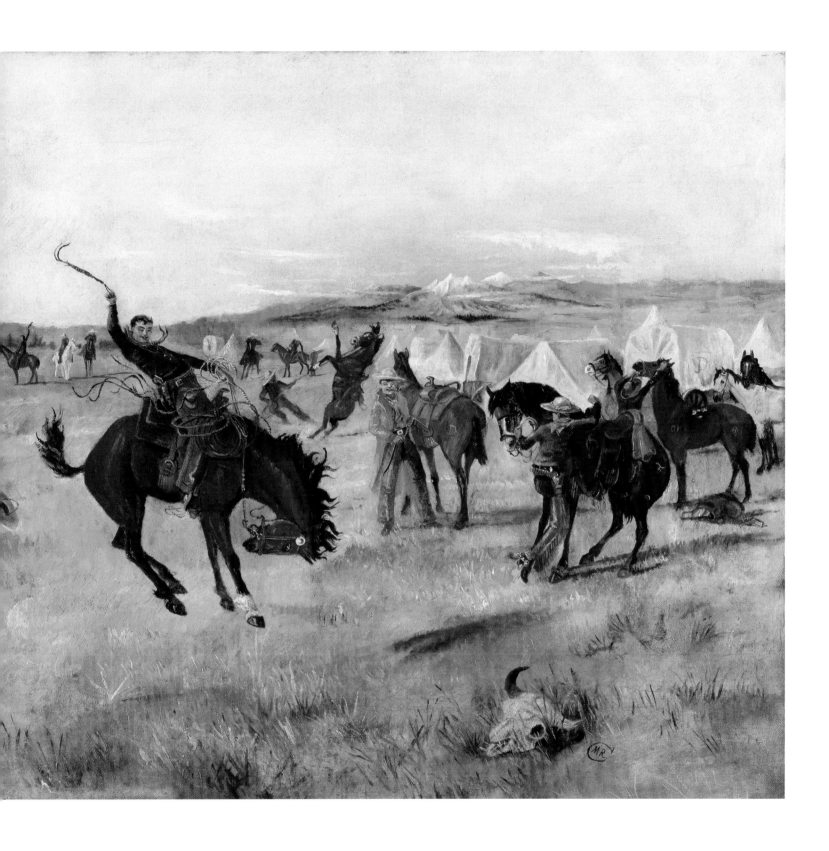

A Bronc Twister (The Weaver), 1911
Bronze, 18⅛ × 14½ × 11¼ inches, Petrie Collection, Denver, Colorado

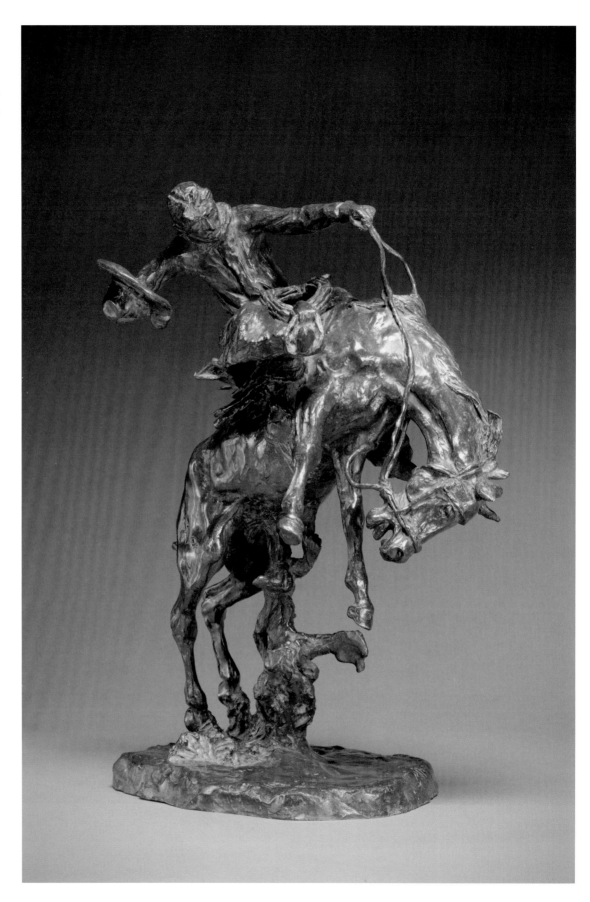

paintings to come, including *The Camp Cook's Troubles, When Horses Talk War There's Slim Chance for Truce,* and *A Bad One,* and the bronzes *A Bronc Twister* and *Where the Best of Riders Quit* (1921–22).

Russell laboriously reworked parts of the panoramic *Breaking Camp,* as evidenced by its extensive underdrawing and numerous pentimenti.[6] He also produced a number of compositions in extended series, striving for improvement with each new iteration.[7] The painting *A Strenuous Life* is typical of this pattern.[8] By this time, Russell had achieved greater dramatic unity in his pictures by concentrating compositional energy in fewer, more centrally located groups of figures. All the movement in *A Strenuous Life* cascades toward the imperiled cowboy in the foreground, and the viewer cannot help but attend to his struggles to free himself and the attempts of his three would-be saviors to rescue him. The influence of Frederic Remington, a master of formal distillation, is clearly evident here. The painting's title, which was probably assigned to it by an early publisher of the image,[9] evokes the invigorating outdoor life promoted by Theodore Roosevelt, among others, as an antidote to any weaknesses inherent in the American male of Anglo-Saxon descent. The title also links the painting to Remington, whose illustrations for Roosevelt's *Ranch Life and the Hunting Trail,* first published in *The Century* magazine in 1888, were certainly known to Russell.[10]

In accord with Roosevelt's celebration of the cowboy as the epitome of modern American masculinity,[11] *A Strenuous Life* presents the risks faced daily by the men of the open range, which Russell's friend Andy Adams chronicled in his semiautobiographical *The Log of a Cowboy* (1903). Owen Wister created the quintessential cowboy hero in his best-selling novel *The Virginian* (1902), although the title character spends surprisingly little time with cattle. Like Remington and a host of other contemporaries, Wister took the superiority of the chivalrous Anglo-Saxon for granted and in his essay "The Evolution of the Cow-Puncher" made a rather tortured argument for the ultimate issue of that "race" in the American cowboy. The essay was published, with illustrations by Remington, in *Harper's Monthly* in September 1895.[12] Although Russell made a number of works that seem to concur with Wister's vision of the cowboy as a latter-day cavalier, the trope was by no means uncommon at the time, and Russell was miles ahead of Wister and Remington in his acceptance of the heterogeneous assortment of people who actually populated the late-nineteenth-century American West.

In *The Broken Rope,* Russell focused the energy in *A Strenuous Life* still further by eliminating the rider on the right, whose troubles with his own rearing horse prevent him from taking part in the rescue and who obscures the clarity of our view of the downed cowboy and his mount. Now the longhorn is not just aiming to gore the horse, as in Russell's earlier renditions of the subject; in this painting it has actually moved in for the kill. The most distant rider no longer merely speeds in to help but is already half out of the saddle even as his horse gallops toward us. Lives truly do hang in the balance (or lack thereof) here.

Russell intensified the drama in *The Broken Rope* by making the violence more graphic and by situating the action in a far more interesting and varied setting than that of *A Strenuous Life,* thus enlisting the landscape in the storytelling. The most important new feature is the hollow in the foreground that partially encloses the central figure group. The cut banks on either side may have contributed to the upset of the downed cowboy's horse, and they threaten

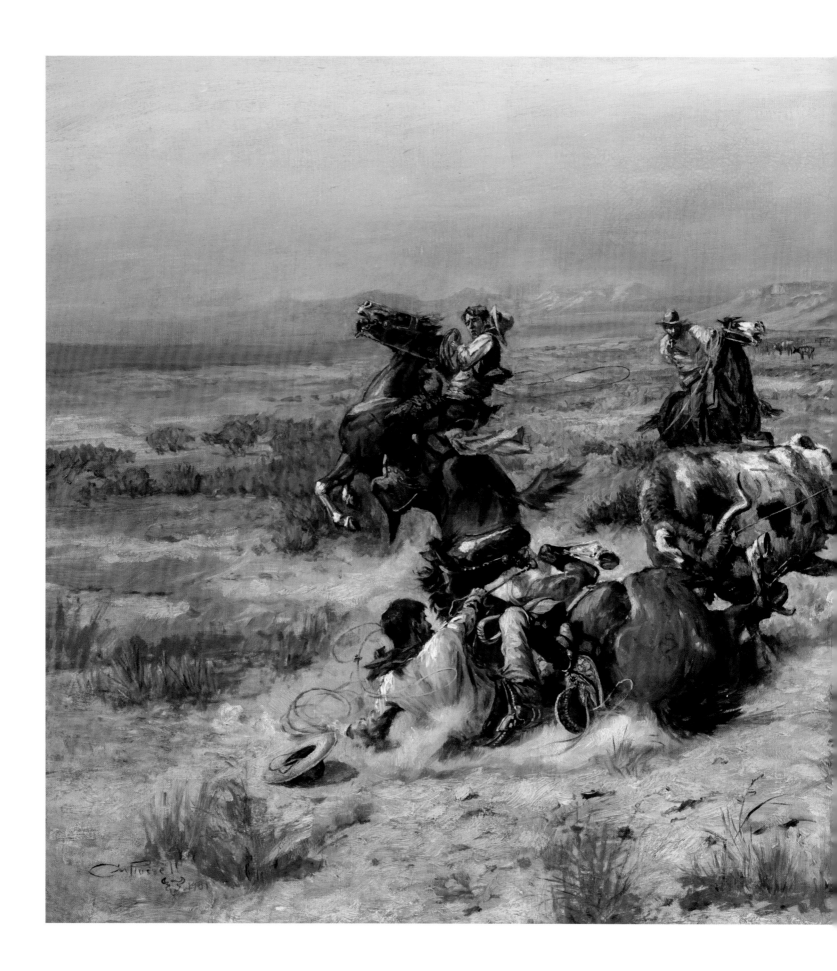

A Strenuous Life, 1901
Oil on canvas, 24¼ × 36¼
inches, Gilcrease Museum,
Tulsa, Oklahoma (0137.908)

The Broken Rope, 1904
Oil on canvas, 24 × 36 inches,
Petrie Collection, Denver, Colorado

to trip up the horse of the rescuer on the right. As Russell matured, he enlarged his foregrounds and enriched them with more botanical and geological detail, although he also painted them progressively more freely than the rest of his canvases, to the eventual point of near-abstraction. Since at least 1900 (see, for example, *The Buffalo Hunt* [No. 29], pp. 146–47), Russell had also organized his foregrounds along different perspectival lines from the rest of his compositions. Not only do the ground planes in Russell's pictures become more scenographically effective; they also dip down toward the viewer's feet, effectively admitting him to the field of action.

The Broken Rope represents one of Russell's notable periodic advances in technical skill and confidence, which usually occurred after better-trained painters visited his home in Great Falls or his cabin, Bull Head Lodge, in Glacier National Park, or after he was exposed to art and artists in urban settings.[13] In this case, the catalyst was Russell's first trip to New York, where he and his wife Nancy spent six weeks in January and February of 1904.[14] The journey's objective was to secure commissions from the illustrated periodicals based in the city. There were fewer immediate takers than the Russells had hoped,[15] but the trip paid off in different and far more valuable ways.

Russell had first met New York–based illustrators John Marchand and Will Crawford in 1903, when both were visiting Montana to gather material and inspiration. They traveled with the Russells to New York and intro-

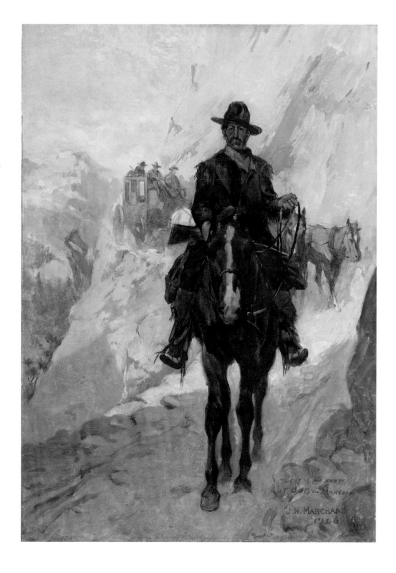

JOHN N. MARCHAND
(AMERICAN, 1875–1921)
The Narrow Pass, 1906
Oil on canvas, 26 × 18½ inches, Petrie Collection, Denver, Colorado

duced Charlie to magazine editors and fellow illustrators and artists, including Philip Goodwin, a specialist in wildlife and sporting scenes who would influence Russell's treatment of those themes and his use of color. Goodwin became a close friend, at least for a time; he visited Russell at Bull Head Lodge on several occasions.[16] Russell also met painter and sculptor Charles Schreyvogel, who steered Russell to Roman Bronze Works, the Brooklyn fine art foundry where the Montanan's first bronze, *Smoking Up*, was cast in 1904 (after being modeled in John Marchand's studio).[17]

After Russell observed his new friends at work and visited New York galleries and museums, he paid greater attention to finishing the foregrounds of his pictures,[18] a change that is readily apparent in *The Broken Rope*. He also made a turn toward brighter and more varied hues in his earth-tone-dominated palette, first in his watercolors and more gradually in his oil paintings.[19] Will Crawford's skill in gentle caricature, droll humor, sense of fantasy, and expressive, economical use of line influenced and reinforced those strengths and tendencies in Russell's art.

A prerequisite for success as a professional illustrator was the ability to single out and play

PHILIP R. GOODWIN
(AMERICAN, 1881–1935)

Blazing the Trail, 1911

Oil on canvas, 23⅓ × 32 inches,
Petrie Collection, Denver,
Colorado

up the most critical moments in a story, and Russell's exposure to Crawford, Marchand, and their friends may have honed his innate dramatic instincts. For example, the Cowboy Artist had shown hats gone airborne as part of the consequences of a mishap before he painted *The Broken Rope;* but here the emphatic shadow, clearly indicating that the hat has not yet hit the ground, enhances the impression of the immediacy of the incident depicted and the rapid-fire reactions of those involved.

Russell would return to New York often, although apparently never with tremendous enthusiasm. In a letter written to his neighbor Albert Trigg, a highly literate Great Falls saloon keeper, Russell complained that "New York is as noisy as ever an baring Bronks and Central Park [which both had zoos where he could sketch animals] I don't find much to amuse me."[20] However, Russell would continue to be influenced by what he saw in New York and become more involved with his artist friends and commercial galleries there even as his subject matter and sensibility became progressively more divorced from modern times.

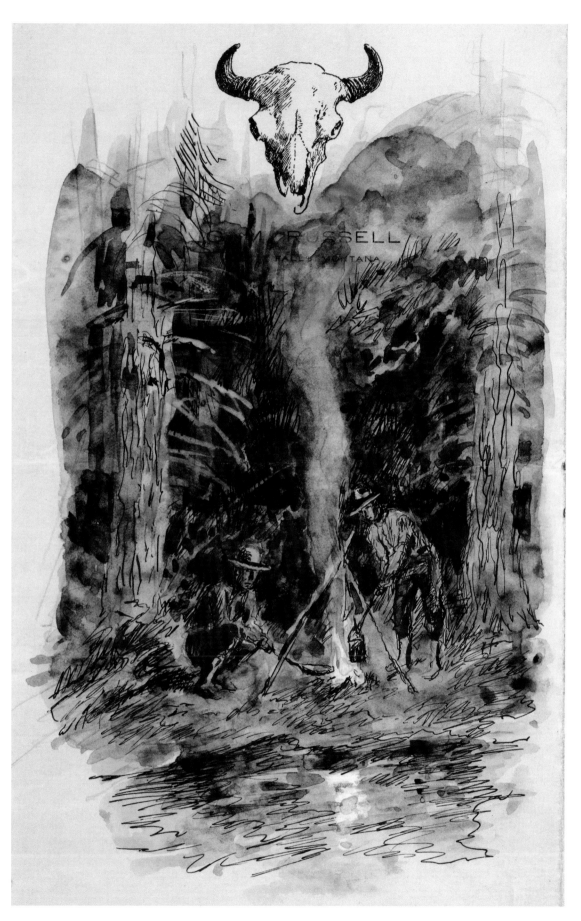

*Letter to Friend
Goodwin [Philip R.
Goodwin],* 1910

Pen, ink, and watercolor
on paper, 7¾ × 10 inches,
Stark Museum of Art,
Orange, Texas (11.106.23)

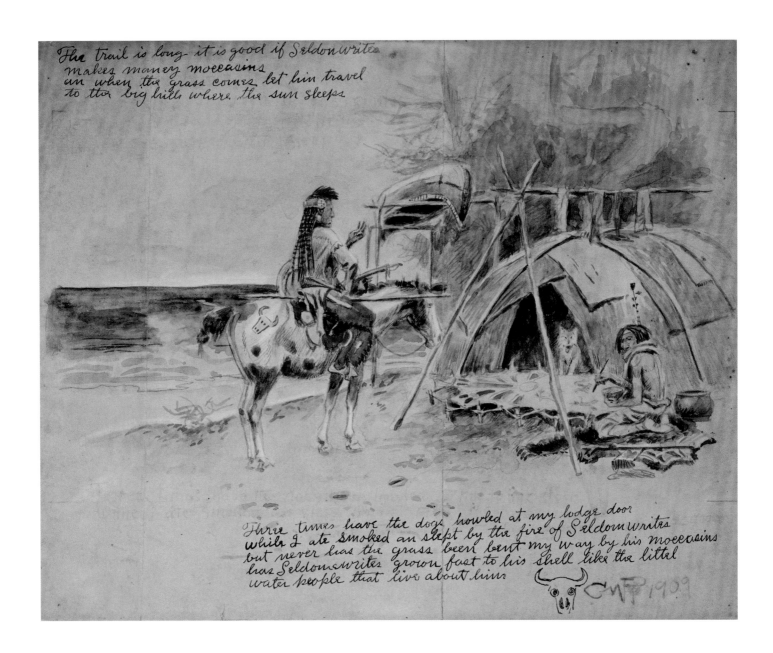

The trail is long it is good if Seldom writes
makes maney moccasins
an when the grass comes let him travel
to the big hills where the sun sleeps

Three times have the dogs howled at my lodge door
while I ate smoked an slept by the fire of Seldom writes
but never has the grass been bent my way by his moccasins
has Seldom writes grown fast to his shell like the littel
water people that live about him

C M R 1909

The Trail Is Long [Letter to
Will Crawford], 1909
Pen, ink, and watercolor on paper,
7¹³⁄₁₆ × 9¾ inches, Stark Museum of Art,
Orange, Texas (11.106.27)

(facing)
Friend Trigg [Albert J. Trigg],
April 20, 1907
Watercolor and pen and ink on paper,
6¹¹⁄₁₆ × 10¹¹⁄₁₆ inches, C. M. Russell Museum,
Great Falls, Montana, Trigg Permanent
Collection (953-1-53)

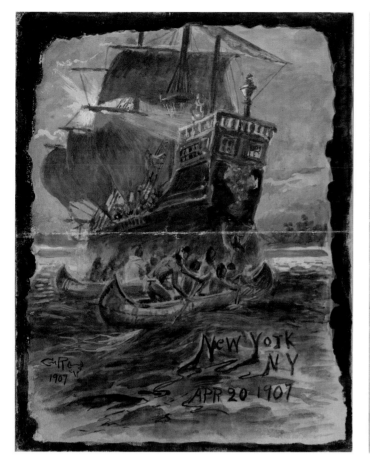

NEW YORK
NY
APR 20 1907

Friend Trigg
 I received your
letter and was plenty glad
to here from you
New york is as noisy as
ever an baring Bronks
and Central Park I dont find
much to amuse me
last Sunday we went to
the beach an took a look
at the Atlantic this little
strip of water aint changed
much I guess shes roling
about the same as She did
when old Hudson an his
dutch crew sighted shore

but I dont think old Henery
would know the place if hed
see her now the camps bilt
up considerbul since he was
here an theres more savages
I was out at Bronks a
few days ago an stayed
all day they have quite a
few new animals since I was
here this is one of them
aint he Sweet

if its right that man
came from monkey I savy
where Baldy the bar keep
got his complextion
of corse this is with all do
respect to the monk

well Trigg as talking is
easeyer for me than writing
an I expect to see you
pritty soon Ile close
with best wishes to all
 your friend
 C M Russell

Although Russell learned much from his new professional colleagues, they clearly detected some enviable qualities in their western friend. In 1903, even before Russell's visit to New York, Marchand confessed to an interviewer that "I have just been in a 'cow country' and have been attempting to do what [Russell] does. I don't think there is anyone who can 'touch' him on his subjects."[21] In 1904, Russell's work may have fallen short technically, but he was a close observer and a tireless worker who was constantly on the lookout for ways to render the challenging subjects he chose and who ultimately was far more talented than his New York colleagues.

Russell would have been the first to admit that he could not perform the maneuvers of highly skilled cowboys,[22] but he had no desire to rival their physical tours de force. Nor did Russell want to achieve the seamless finesse of an academically trained artist. Russell's goal was to capture the movements peculiar to his subjects, which by orthodox artistic standards were ungainly, if not downright bizarre. In that he was similar to classically trained French painter Edgar Degas, who used his hard-won discipline to depict the awkward postures of real life rather than artificial perfection, the contingent attitudes of the rehearsal studio rather than the precise choreography of the staged performance. For Russell, as for Degas, the moves of practiced professionals were a stimulus for creative activity and a reminder of the artist's obligation to excel at his own craft. The self-taught Russell evolved his own ways of fulfilling that responsibility, which in the end were not much different from those of traditionally schooled artists. He used live models (including himself) on occasion, but he also fashioned three-dimensional miniatures and jointed cardboard figures—the equivalent of the academic artist's lay figures—of men and animals arranged in poses (like those of a bronc rider and his mount) that are physically impossible to hold. Many of Russell's sketches are classic gesture drawings, flurries of overlapping lines from which emerge the contours of recognizable figures and dynamic or stable vectors that indicate the direction of movement and anchor his subjects in space.[23]

One can see why veterans of the cattle range considered Russell's representations of cowboy life superior to those of Frederic Remington, whom Russell may have met in New York in 1905.[24] *The Broken Rope* has a close analogue in Remington's *A Critical Moment*, a

Untitled (Horse), n. d.

Pencil on paper, 9 × 3⅛ inches, National Cowboy & Western Heritage Museum, Oklahoma City, Oklahoma (1971.025.18A)

From the effects of
Charles M. Russell –,
Estate of Nancy C. Russell
June 1941

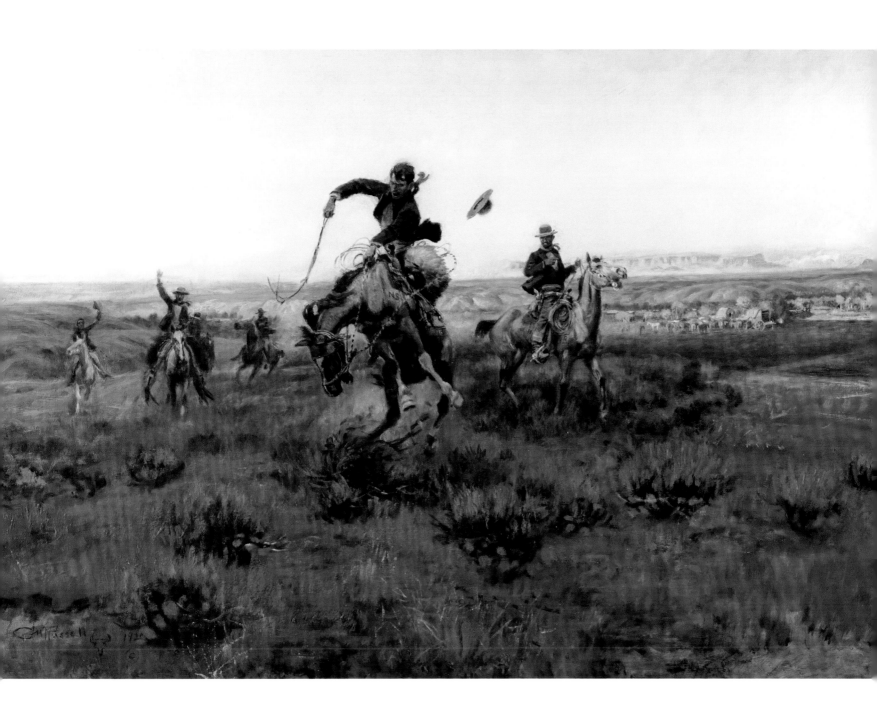

A Bad One, 1920
Oil on canvas, 24¼ × 35½ inches,
Gilcrease Museum, Tulsa, Oklahoma
(0137.910)

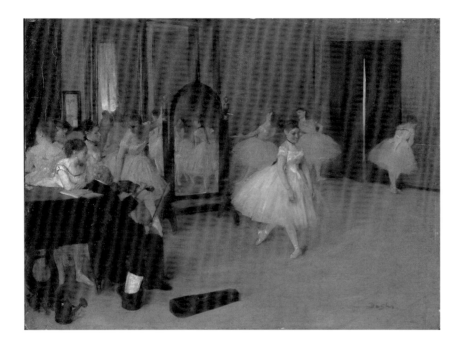

EDGAR DEGAS
(FRENCH, 1834–1917)

*The Dancing Class
[Le Foyer]*, ca. 1872

Oil on wood, 7¼ × 10⅝ inches,
The Metropolitan Museum of
Art, New York, H. O. Havemeyer
Collection (29.100.184), bequest
of Mrs. H. O. Havemeyer, 1929,
image © The Metropolitan
Museum of Art

painting commissioned by the Smith and Wesson Arms Company and published as a promotional lithograph and in an advertisement in *Collier's Weekly* in 1902.[25] Even Russell's most primitive renditions of this subject urgently register the need for a split-second response. By contrast, Remington's cowboy and longhorn appear to stare one another down almost at their leisure; only the horse seems panicked. It is also significant to the experienced cattleman that, unlike *A Critical Moment*, *The Broken Rope* takes place not within the confines of a corral but on the open range, miles away from the main herd, where a cowboy would be more likely to get into such a fix with an unruly cow.[26]

By the time he painted *Jerked Down*, which is almost baroque in comparison to *The Broken Rope*, Russell was more than able to successfully incorporate multiple figure groups into his pictures. Every one of the energetic cowboys and fractious cows in *Jerked Down* is positioned off center; twisting figures and animals head off in different directions, contributing to an overall instability that is just barely resolved by the taut, angular geometry of the rope that ties the opposing forces in the foreground action together.

Thirteen years later, Russell perfected this composition in *A Tight Dally and Loose Latigo*, which represents the zenith of his accomplishment as an observer and painter of the strenuous side of cowboy life. The furious activity and microbursts of dust in the middleground are balanced by the placid horizontality and sunlit clarity of the panoramic setting, distinguished by the subtle striping of shadow cast on the Montana plains by the clouds above. Landmarks of the Judith Basin, where Russell had worked cattle in his youth, appear in the distance.[27]

A similar process of trial and improvement took place in Russell's development of his principal American Indian action subjects, the buffalo chase and surround. However, while Russell started observing cowboys running down and rounding up cattle in 1882, he did not see a bison chase until 1908, when he participated in the Pablo-Allard buffalo roundup, which

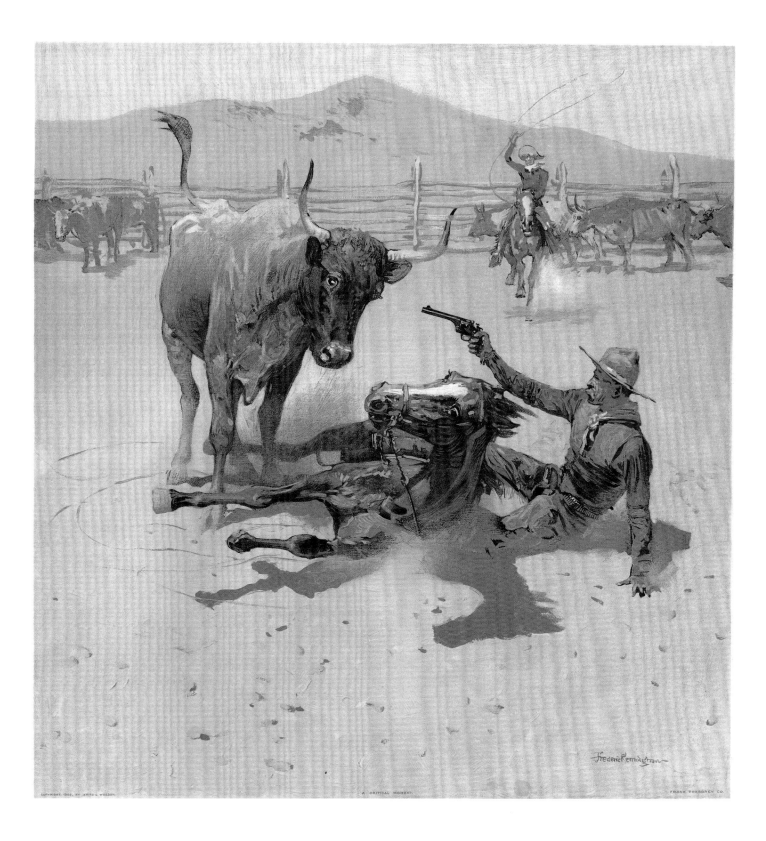

UNKNOWN LITHOGRAPHER AFTER FREDERIC
REMINGTON (AMERICAN, 1861–1909)

A Critical Moment, 1902

Black-and-white lithograph, 15 × 14 inches,
Smith and Wesson Arms Company print,
courtesy of Roy Jinks Collection

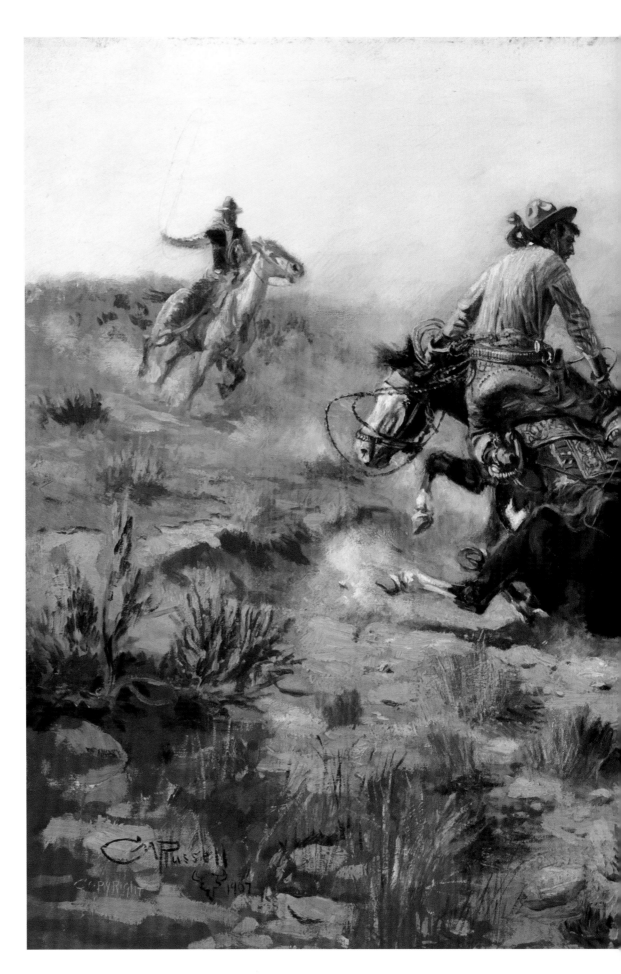

Jerked Down, 1907
Oil on canvas, 22½ × 36½ inches,
Gilcrease Museum, Tulsa,
Oklahoma (0137.2246)

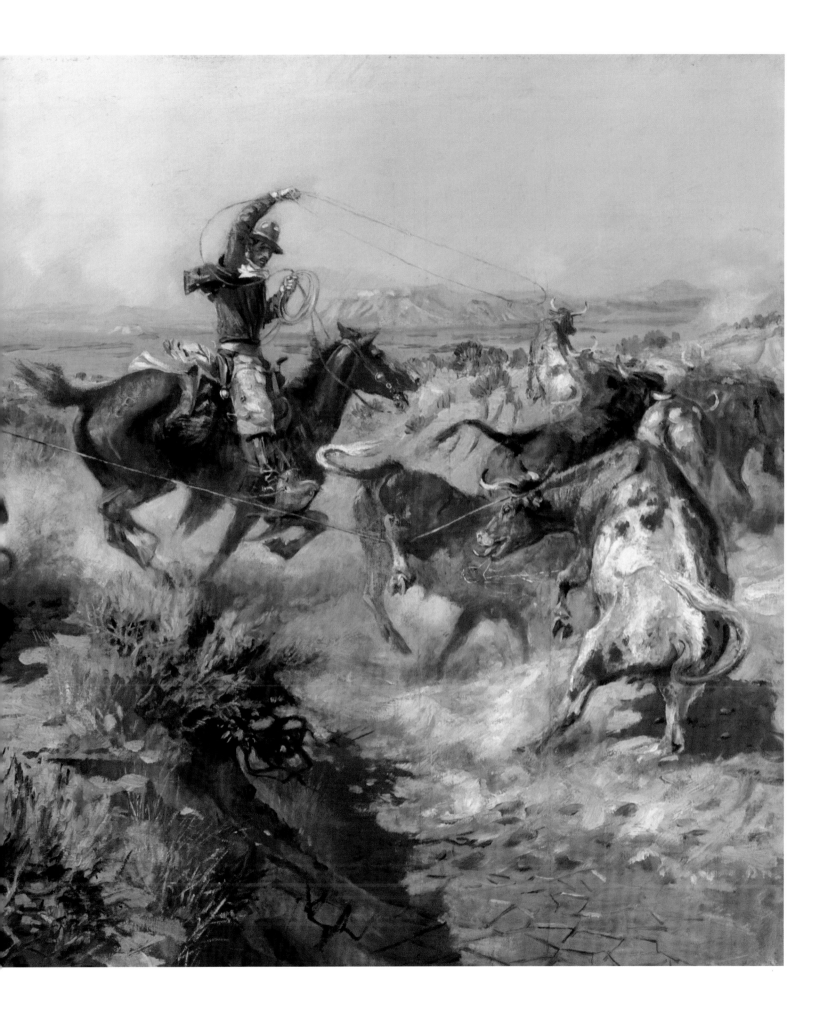

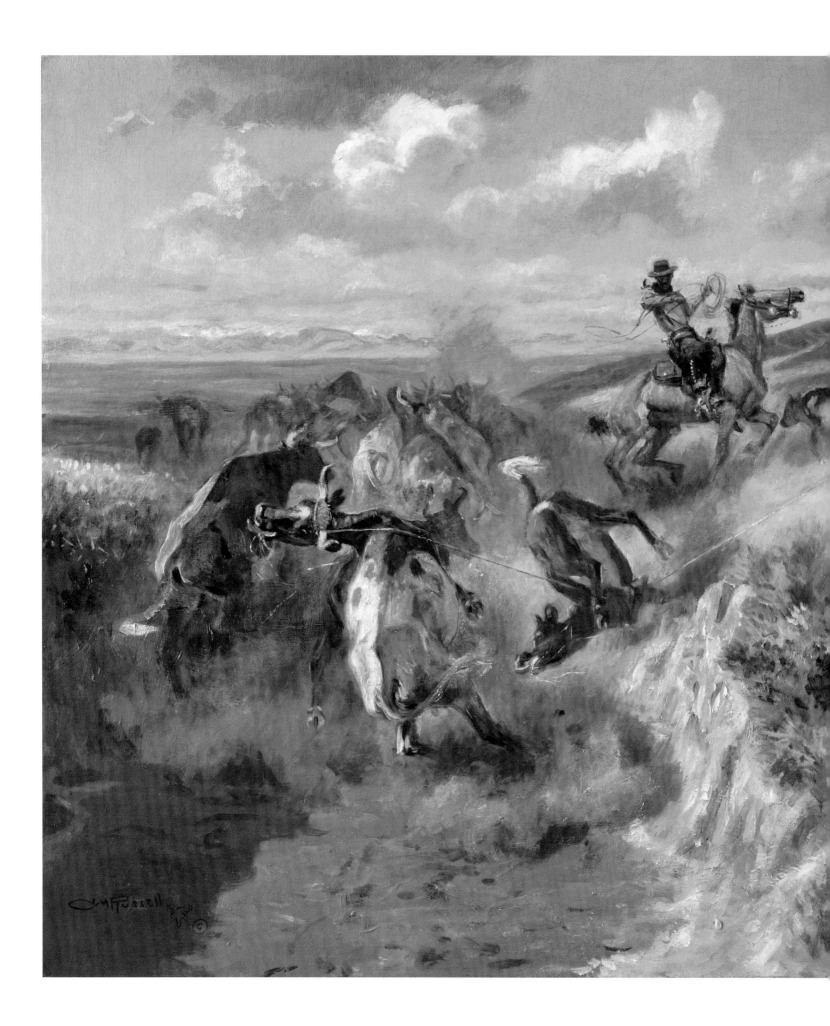

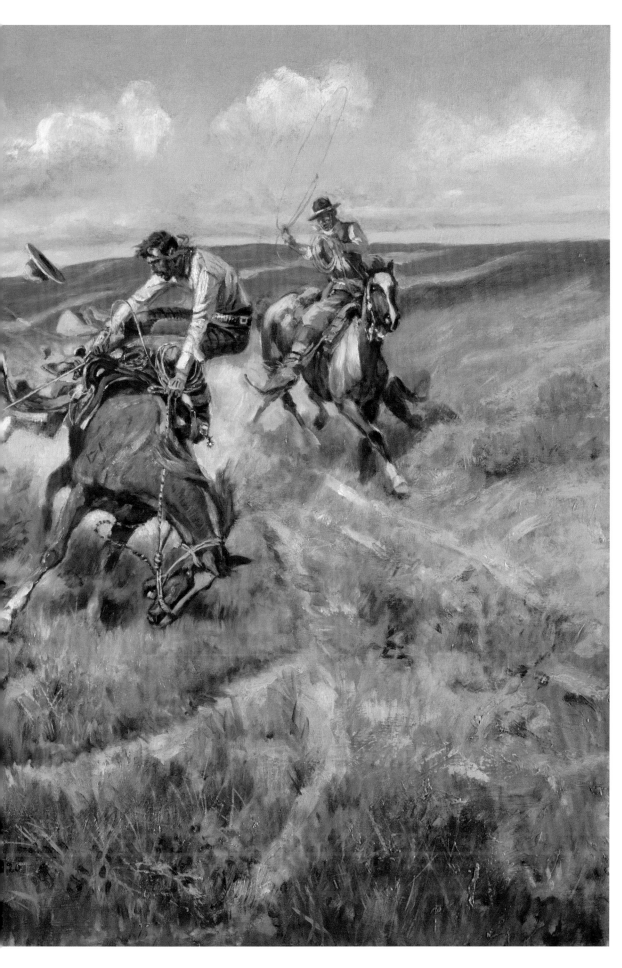

A Tight Dally and a Loose Latigo, 1920

Oil on canvas, 30¼ × 48¼ inches, Amon Carter Museum, Fort Worth, Texas (1961.196)

in any event was not a true Indian hunt but only a distant approximation of the genuine, old-time thing.[28] As Anne Morand explains in her essay in this volume, Russell's buffalo hunts originated in the images of George Catlin and Carl Wimar, and in his early treatments of the theme, hunters and bison are portrayed two-dimensionally, in profile, hewing closely to the picture plane or lined up parallel to it. Russell's development of these compositions was thus largely dependent on his imaginative extrapolations of cattle roundups and the purely artistic process of searching out the most effective form that is recorded in his gesture drawings. This evolution culminated in two great paintings of 1919, *Buffalo Hunt* [No. 39] and *Buffalo Hunt* [No. 40] (see p. 149),[29] in which the surrounded animals are packed into chaotic, whirling vortices of dust, horns, hooves, and curly brown hides. In the case of *Buffalo Hunt* [No. 39], the maelstrom has generated enough centrifugal force to spin off a calf that makes directly for the viewer's space.

In his most ambitious bronze, *Meat for Wild Men,* Russell's dynamic solution to the representation of the buffalo surround reached its logical conclusion, which could only be achieved in sculpture. Casting a bronze of this size and complexity is an additive process; fifty-seven separate molds were required to make *Meat for Wild Men.*[30] Despite its multitude of crisp details, the endlessly interesting *Meat for Wild Men* is cohesive, held tightly together

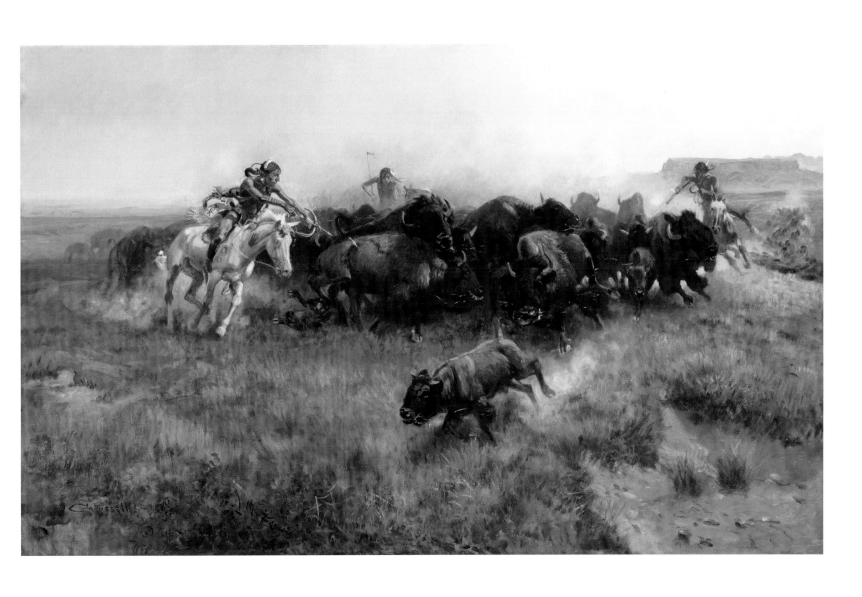

Buffalo Hunt [No. 39], 1919
Oil on canvas, 30⅛ × 48⅛ inches,
Amon Carter Museum, Fort Worth,
Texas (1961.146)

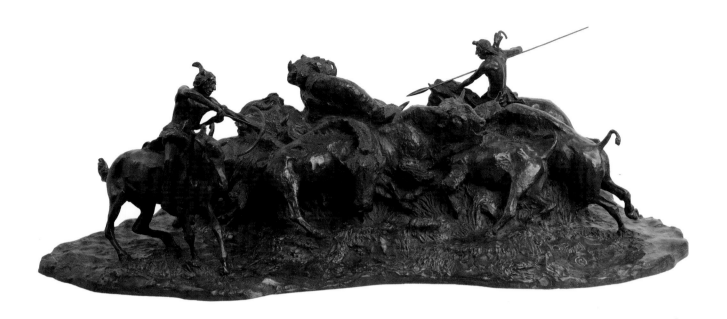

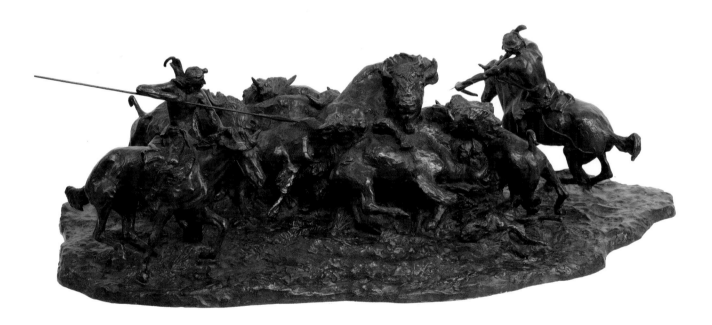

Meat for Wild Men, 1924
Bronze, 11½ × 37⅝ × 20⅝ inches,
Petrie Collection, Denver, Colorado

by its all-over texture (created in part by the imprint of the artist's fingers and thumbs) and its relentless circular movement. Nancy Russell maintained that her husband's inspiration for *Meat for Wild Men* was a bronze by Remington, presumably the older artist's most ambitious treatment of the theme, *The Buffalo Horse*.[31] The figures in *The Buffalo Horse* circulate in space, like those in Russell's *Meat for Wild Men,* but Remington's choice of a vertical orientation seems forced, and the result is not entirely successful.

As Brian Dippie demonstrates elsewhere in this volume, Russell continually petitioned the viewer to participate vicariously in the proceedings on his canvases, and early in his career he designed pictures meant to be read sequentially, rather like comic strips. By the time he painted *When Horses Talk War There's Slim Chance for Truce* in 1915, however, Russell's skill in the representation of human and animal anatomy and psychology was so advanced that he could compress past, present, and future into a single image containing virtually no physical action at all. *When Horses Talk War* is the prelude to a scene like that depicted in *The Camp Cook's Troubles,* but in contrast to that painting, it is centered on almost nothing, a near-void occupied only by a loose rope about to be stretched to the breaking point as the eye-to-eye communication between a cowboy and his obstreperous horse concludes in the violent expression of a major difference of opinion. *When Horses Talk War* exemplifies Russell's empathic ability to telegraph equine attitude through details of stubborn, locked-joint stance, the precise positions of ears and tail, and even the disgusted, imperious exhalation of breath.[32] The painting also showcases his skills as a landscapist. We feel the foreboding discomforts of this wet dawn on the range in that sliver of a sunrise, reflected in streaks and splotches of yellow on the surface of brackish puddles, and we read a history of the horse's recalcitrance in the muddy ground and flattened foliage underfoot. New Yorker Malcolm Mackay, who owned *When Horses Talk War* as well as a Montana ranch, said of the painting that "the whole thing vibrates with meaning to any one [*sic*] who has ridden the range."[33] As we shall see, the in-between state of *When Horses Talk War,* which is poised between a tense calm and the total disintegration of order, is a place Russell liked to occupy.

Cowboys were only too happy to periodically abandon the herds for incursions into little towns along the trail. Their invasions of these tiny bastions of frontier civilization ranged in character from rambunctious to violent, as would be expected of young men far from home

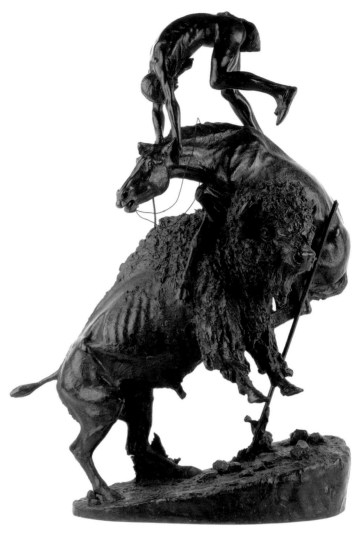

FREDERIC REMINGTON
(AMERICAN, 1861–1909)
The Buffalo Horse, 1907
Bronze, 35 × 26¼ × 15¼ inches, Gilcrease Museum, Tulsa, Oklahoma (0827.51)

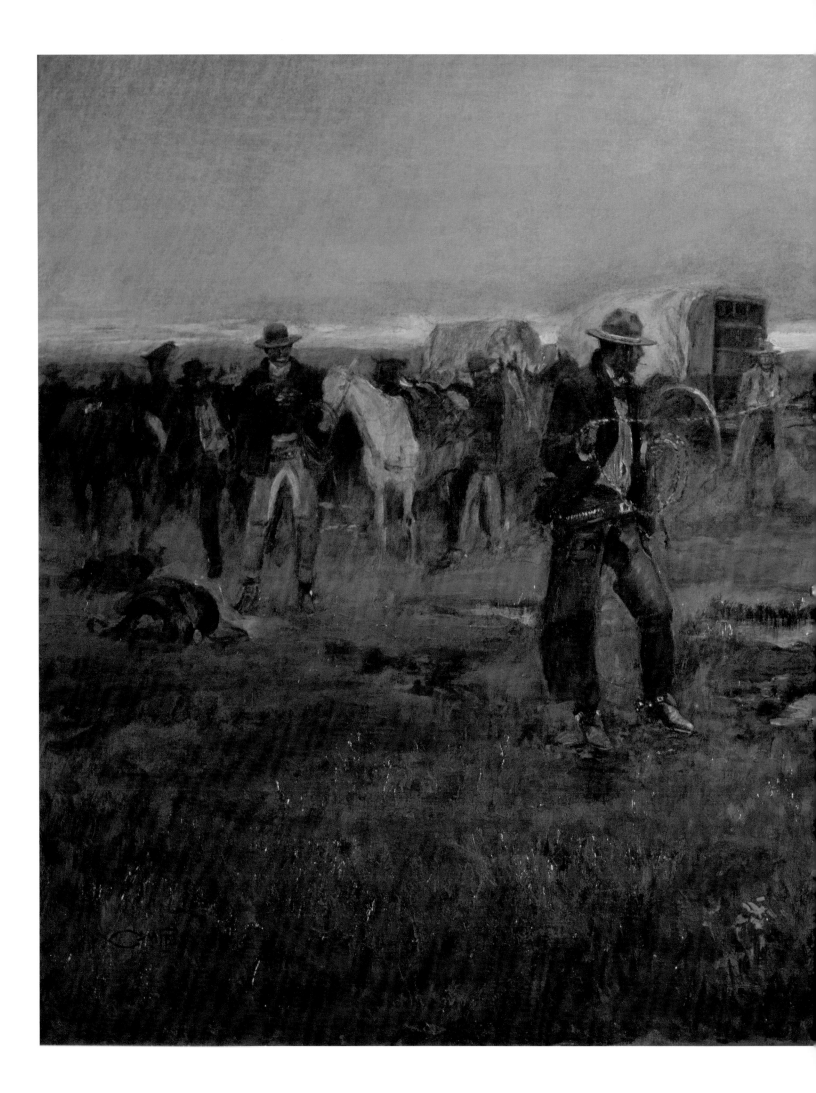

When Horses Talk War There's Slim Chance for Truce, 1915
Oil on canvas, 24¼ × 36½ inches,
Montana Historical Society, Helena,
Mackay Collection (x1952.01.08)

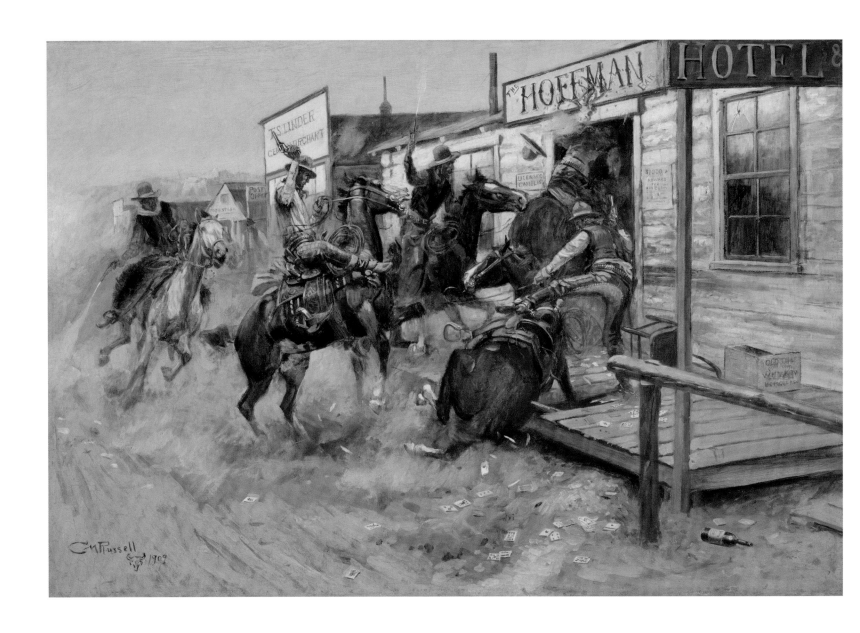

In Without Knocking, 1909

Oil on canvas, 20⅛ × 29⅞ inches,
Amon Carter Museum,
Fort Worth, Texas (1961.201)

whose work was not only physically—even mortally—challenging but also lonely and frequently monotonous.[34] *In Without Knocking* depicts an actual event,[35] but it is also an icon of a kind of behavior that was rehearsed often in accounts, fictional and otherwise, of cowboy life. (The exquisitely detailed bronze *Smoking Up* is an even more concise expression of the same alcohol-fueled ebullience.) Edward C. "Teddy Blue" Abbott's classic account of Montana cowboy life, *We Pointed Them North,* and Andy Adams's *Log of a Cowboy* are both punctuated by boisterous assaults on frontier saloons. An early chapter of Owen Wister's *The Virginian* contains an extended description of nocturnal mayhem instigated by the title character on a visit to the little railhead of Medicine Bow, Wyoming, and in *Ranch Life and the Hunting Trail* Theodore Roosevelt relates a story for which *In Without Knocking* could have served as an illustration.[36]

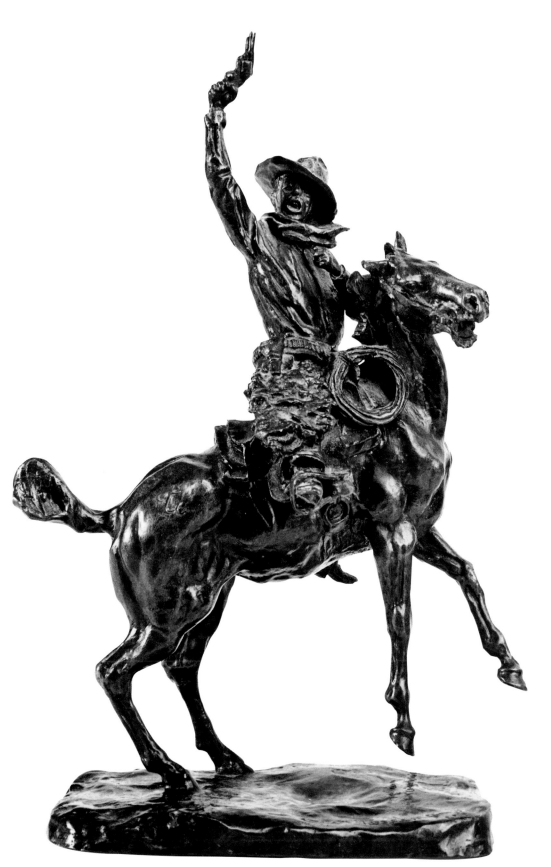

Smoking Up, 1904
Bronze, 13 × 7½ × 5 inches,
Frederic G. and Ginger K.
Renner Collection, Paradise
Valley, Arizona

Cowboys have always enjoyed an elevated position in American popular culture, a status due in part to their rebellion against the strictures of polite society, but in real life they were occupants of a lowly rank in the class structure, poorly paid seasonal workers with short careers and utterly insecure prospects for retirement.[37] Even as they sat around the campfire and shared their longing for conventional domestic life, cowboys were quite literally isolated from mainstream America. Wister's Virginian lives out a collective cowboy fantasy of advancing, by dint of his physical power and shrewd judgment, beyond his hardscrabble origins and riotous youth to win the heart of a respectable woman (from the East!) and, unlike most cowboys, become a major property owner and leading citizen of Wyoming. (Russell's post-cowboy trajectory toward material success was similar, except that he came from a good family and married down.)[38]

The frustrating length of the Virginian's extended courtship of his sweetheart, a running theme of the novel, is entirely due to class and sectional prejudice against cowboys. In a number of his pictures, Russell alluded to cowboys' alienation from eastern society and the defenses they constructed against the disdain of their social betters. The pistol-packing cowpuncher in *The Tenderfoot* [No. 1], for example, takes out his resentment against easterners on a greenhorn as part of a universally applied tradition of hazing that invariably began with some form of physical intimidation.[39]

Russell included himself as one of the onlookers in *The Tenderfoot,* although he based his composition on an illustration by Frederic Remington in *The Century* magazine in October 1888.[40] Even when he did not paint himself into his works, Russell often assumed the roles of observer and subtle commentator, acting as an intermediary between cowboy culture and the uninitiated audience to whom his art was at least partially addressed once he became an established professional. If Russell was not quite as brutally direct as the protagonist of *The Tenderfoot,* he nevertheless continually played on the tension between insiders and outsiders in the American West.

This tension carries over to the experience of viewing Russell's art. Many of Russell's admirers, particularly those who know something about the West or western art, delight in the multiplicity of his details, but the uninformed viewer misses out on half the fun. The ability to untangle the complicated maneuvers in Russell's action paintings requires a familiarity with the ways of the cowboy that confers on the knowledgeable spectator an authentic connection with the "real" historical West, affirming the viewer's status as a real westerner, too.

A cowboy's words sometimes required just as much deciphering as his deeds did. What, for example, are a "tight dally" and a "loose latigo," and what do they have to do with the chaotic activity in Russell's painting? According to Ramon F. Adams's *Cowboy Lingo,* a book devoted entirely to the colorful patois of the cowpuncher, to dally is to "[take] a simple turn or two around the saddle-horn with the home end of the rope after a catch" of a cow, as opposed to tying the rope "hard and fast," always taking care not to amputate a finger or thumb in the process. A "dally man" used a longer rope than a "tie man." Texas cowboys were usually tie men; Californians preferred the dally, as did Russell himself, who remarked that "I think it takes a better man to use [a] long rop an dally than [a] short one and tie." Adams defines "latigo" as "a long leather strap" attached to the end of a "cinch," which itself is a

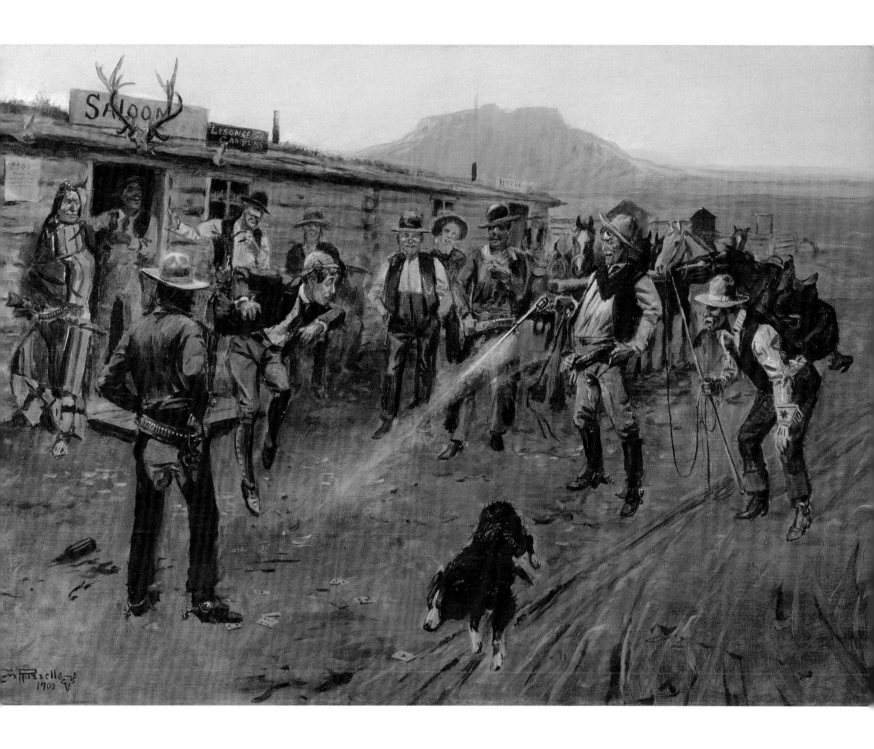

The Tenderfoot [No. 1], 1900
Oil on canvas, 14⅛ × 20⅛ inches,
Sid Richardson Museum,
Fort Worth, Texas (1947.1.0.73)

"broad, short band, made of woven horsehair, canvas, or cordage" that runs underneath a horse's girth behind its front legs and helps hold a stock saddle in place. The "act of fastening the saddle upon the horse's back by drawing the 'cinch' up tight by the 'latigo' straps was called 'cinching up'—the cowboy never merely 'cinched.'" When a dally is tight and a latigo loose, a contrary cow attached to the business end of the rope can jerk a cowboy's saddle off his horse's back.[41]

"Dally," "latigo," and "cinch" are all Spanish in origin,[42] as are many of the words in the cowboy lexicon. American cowboy culture—an amalgamation of British, Arabian, Spanish, South American, Central American, and Native American practices[43]—has a rich heritage that is reflected not only in its vocabulary but also in many elements of its dress and equipage. Regional distinctions can also be read in an American cowboy's terminology, clothing, and equipment. You can see by his outfit not only that he is a cowboy, but also whether he hails from Texas, California, Oregon, or Montana.[44] In *The Story of the Cowboy* (1897), Emerson Hough, who formed a mutual admiration society with Russell, devoted a chapter of twenty pages to his description of "The Cowboy's Outfit" and its geographical permutations.[45]

In painting and sculpting the cowpuncher, Russell adopted an ambivalent stance. On the one hand he explicated American cowboy life to easterners and Europeans by delineating and naming situations, animal and human types, and a myriad of clothing, tools, and accessories; on the other, he risked alienating his potential audience by insisting on the particularity of his hard-won inside information to the point of opacity. One can't help but think that Russell knew he was sowing confusion among some parties when he gave his works titles like *A Tight Dally and a Loose Latigo*. Just as he forced reporters from eastern newspapers to pry information out of him (or turn to his wife for answers to their questions),[46] despite the fact that he was one of the most assured and entertaining interpreters of the American western experience who ever lived, Russell demanded some effort from those who would enjoy his art.

Russell's ambiguity is also a distinguishing feature of his representation of malefactors bent on more serious business than trashing saloons. Although some, including Wister, may have viewed the expression of high spirits depicted in *In Without Knocking* as an indicator of the healthy state of Anglo-Saxon masculinity, others—including aggrieved property owners and the public in general—tended to register such activities on a spectrum of dissolute behavior that began with excessive drinking, gambling, patronage of prostitutes, and violent practical jokes and accelerated through a scale of criminality that included vandalism, theft, gunplay, and murder.[47]

In *The Story of the Outlaw: A Study of the Western Desperado* (1905), Emerson Hough surveyed the slippery slope downward from respectable rancher and honest cowboy to cattle rustler, horse thief, and outright gunslinging bad man on the open range, where natural resources were regarded as free for the taking and government law enforcement was sparse. As far as Hough was concerned, lawlessness was an inevitable concomitant of the freedom of the frontier; it just came with the territory. Hough devoted an entire chapter of *The Story of the Cowboy* to rustling,[48] and for good reason: cowboys were continually faced with the temptation to improve their dismal financial situation by assembling their own herds from the cattle and horses—they too were turned loose when not needed—scattered far and wide on the range.

Branding livestock was essential to conducting business on the open range, and brand books and the livestock associations that published and enforced them, as well as the "reps" who rode from camp to camp to round up their employers' property, were all part of the scene that Russell came to know well during his cowboy days. Both Russell and his friend Teddy Blue Abbott served as reps; it was an inherently sociable job, which they welcomed as a break from a cowboy's usual solitary routine.[49]

The clear-cut sign of ownership represented by a brand could be rendered obscure in a number of ingenious ways that Hough sketched out in *The Story of the Cowboy*.[50] When running irons—straight metal rods that, once heated in a fire, could easily transform one brand into another—were outlawed,[51] rustlers resorted to an essential piece of equipment that no lawman could confiscate: the circular cinch ring of a saddle. The rustler on the right in *The Cinch Ring*, who is tangled up with the calf he had hoped to appropriate, has just loosened his grip on a red-hot example of this makeshift tool as he reaches for his gun, although it will avail him little in the confrontation with the regulators who have materialized on the bluff behind him and his partner.

The Cinch Ring, 1909
Oil on canvas, 24 × 36 inches, The Anschutz Collection, Denver, Colorado, photograph courtesy of William J. O'Connor

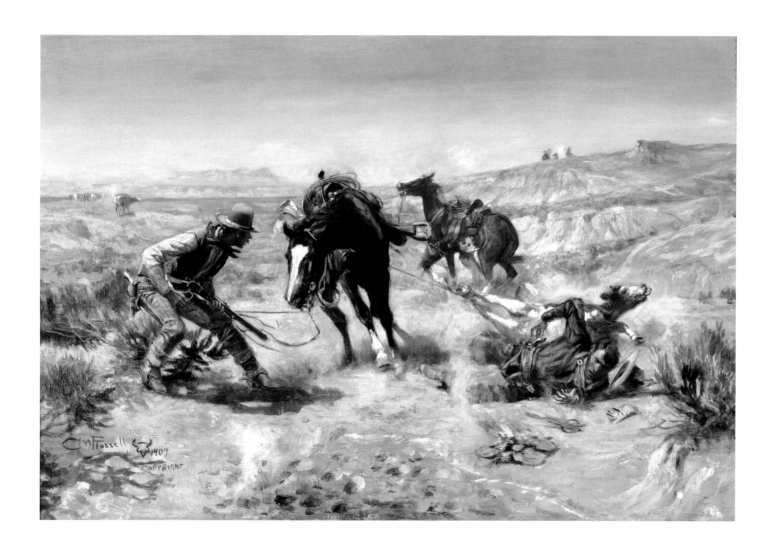

Stealing horses was a more heinous offense than collecting a maverick calf here and there, although the corpse-littered field of battle in Frederic Remington's painting *What an Unbranded Cow Has Cost* (1895)[52] may lead one to think otherwise. Given the desperate nature of the gunplay set amid a bleak, blasted foreground of dead trees and bare rock in Russell's *When Horseflesh Comes High,* the consequences seem serious indeed. Retribution for the thieves in *The Cinch Ring* is a few seconds further off; Russell depicts their initial confusion and upset upon realizing that their crime has been discovered. If they were hardened recidivists, the thieves in *When Horseflesh Comes High* and *The Cinch Ring* were probably facing an imminent encounter with vigilantes and, if they survived, an invitation to a necktie party. (In Russell's *Paying the Fiddler* [1916], the execution has taken place before a rustler has even finished branding a stolen calf.) Both Hough and Wister viewed vigilantism as a legitimate form of peacekeeping on the mining and cattle frontier, as did Granville Stuart, Montana's most celebrated early rancher and a collector of Russell's work.[53]

Hough, Wister, and Stuart presented official law enforcement in the Wyoming and Montana territories as inadequate, ineffective, and often corrupt, thus justifying the activities of vigilance committees, which seem, at least by their definition, to have been composed of upright citizens acting in the public good. However, things did go wrong on occasion. In *Ranch Life and the Hunting Trail*, Theodore Roosevelt wrote that his bailiwick, Dakota Territory, had for a time been home "to a class that always holds sway during the raw youth of a frontier community, and the putting down of which is the first step towards decent government." The environs of Medora, near Roosevelt's ranch, had endured

> more than its full share of shooting and stabbing affrays, horse-stealing, and cattle-killing. But the time for such things was passing away; and during the preceding fall the vigilantes—locally known as "stranglers," in happy allusion to their summary method of doing justice—had made a clean sweep of the cattle country along the Yellowstone and that part of the Big Missouri around and below its mouth. Be it remarked, in passing, that while the outcome of their efforts had been in the main wholesome, yet, as is always the case in an extended raid of vigilantes, several of the sixty odd victims had been perfectly innocent men who had been hung or shot in company with the real scoundrels, either through carelessness and misapprehension or on account of some personal spite.[54]

Thus was crime compounded upon crime in the frontier West, where, as Hough succinctly put it, "Property was unstable, taxes impossible, and any corps of executive officers difficult of maintenance."[55]

In making his equivocal remarks on vigilantism, Theodore Roosevelt knew whereof he spoke, because he had served as a deputy sheriff while running his Dakota ranch. As part of a county police force consisting of just three people—himself, another deputy sheriff, and the sheriff, who was one of his own employees—it was plain to Roosevelt that government-certified legal officers, most of whom held down other jobs, were greatly outnumbered by the criminals in their districts. The splendid landscape in Russell's *Call of the Law* represents the principal challenge that confronted the frontier lawman: the vast extent of the territory for

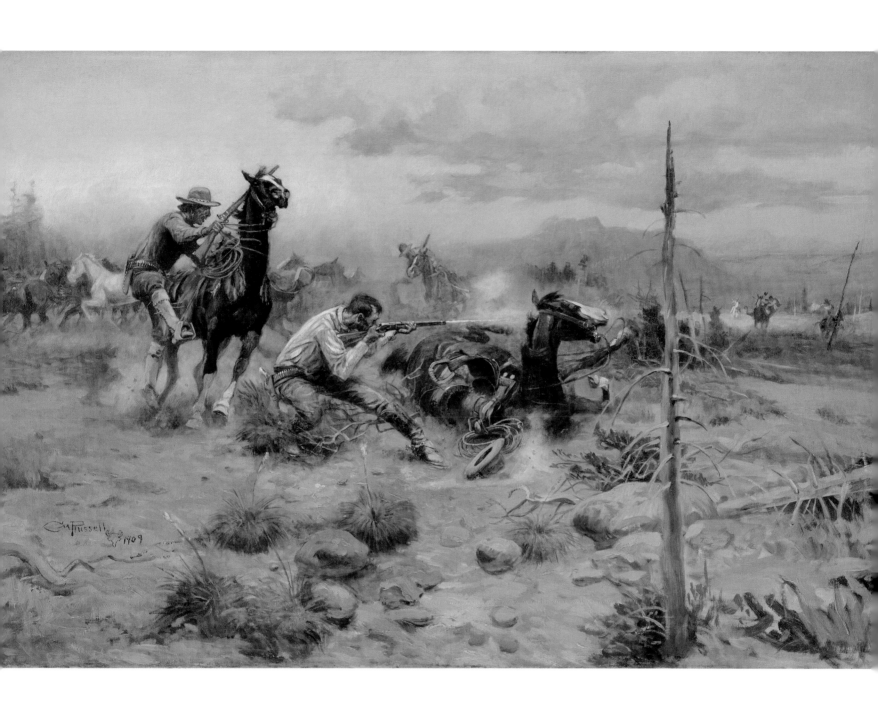

When Horseflesh Comes High,
1909
Oil on canvas, 23½ × 35¼ inches,
Petrie Collection, Denver, Colorado

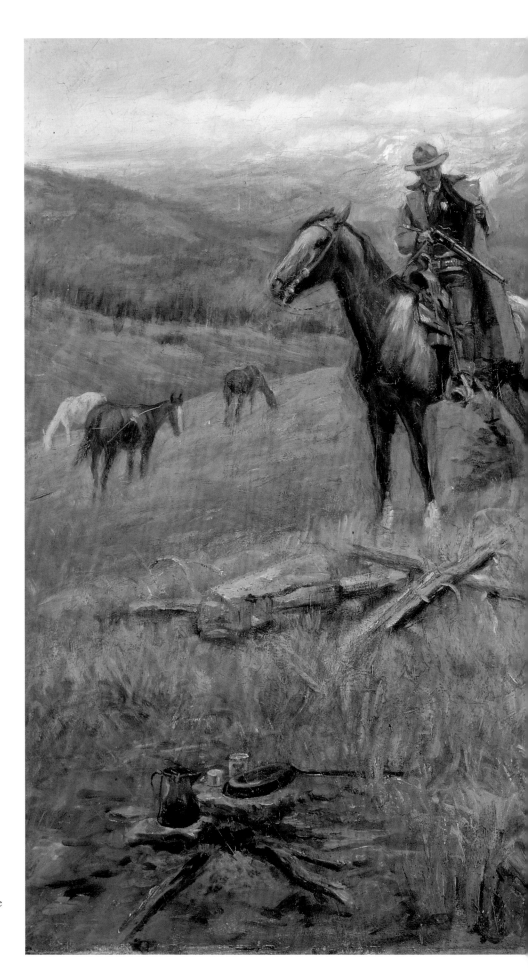

Call of the Law, 1911

Oil on canvas, 24 × 36 inches,
National Cowboy & Western Heritage
Museum, Oklahoma City, Oklahoma
(1975.20.01)

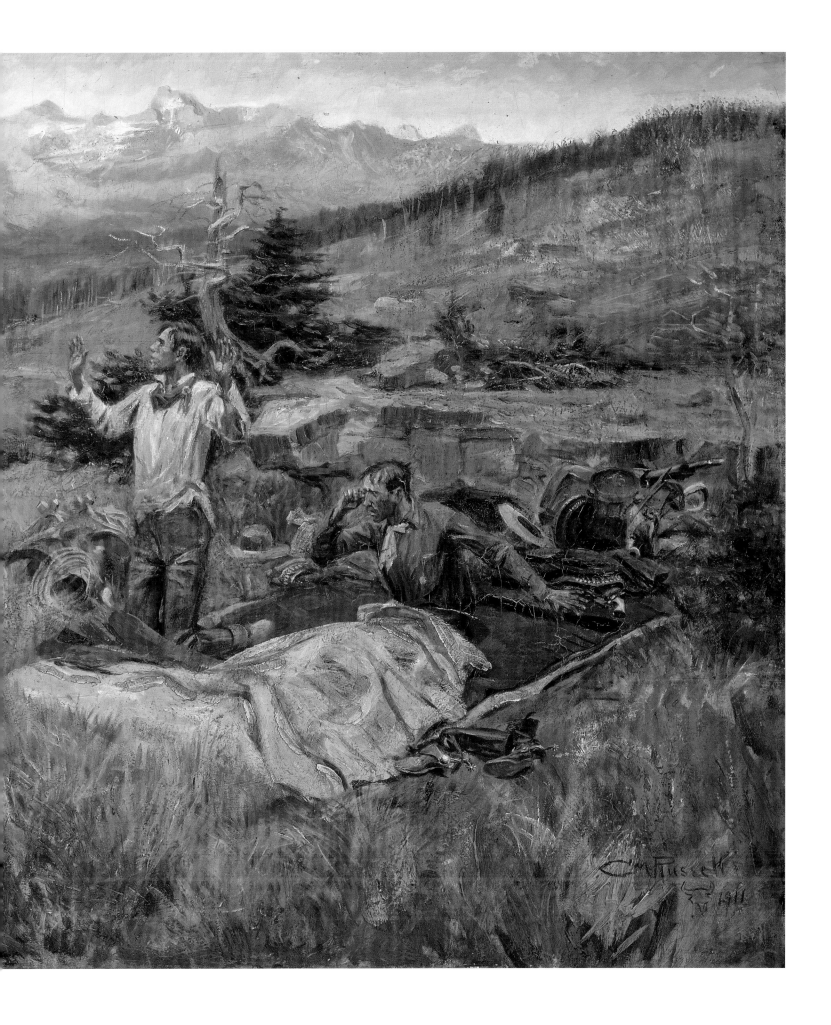

which he was responsible. The sheriff in *Call of the Law* may be outmanned, but he is hardly overwhelmed. Arriving at an outlaw camp at dawn, he has the element of surprise on his side, not to mention his sawed-off shotgun and the badge on his vest. The sheriff's upright posture and the roseate alpine panorama behind him enhance his stature just as surely as the outlaws' disheveled clothing and scattered belongings diminish theirs. *Call of the Law* is a consummate portrait of "the typical frontier sheriff," a collective type rather breathlessly described by Hough in *The Story of the Outlaw* as "the good man who went after bad men, and made it safe for men to live and own property and to establish homes and to build up a society and a country and a government."[56]

The thieves in *When Horseflesh Comes High, The Cinch Ring, Paying the Fiddler,* and *Call of the Law* are indistinguishable from Russell's law-abiding cowboys. However, Russell also painted identifiable historical figures who ranked more highly on Hough's scale of "bad men," including the notorious robber and murderer "Big Nose George" Parrott, who terrorized Wyoming, South Dakota, and eastern Montana in the 1870s.[57] In *The Hold-Up*—one of Russell's most accomplished paintings of the turn of the century in its intricately worked, jewel-colored forest backdrop—Parrott levels his rifle at a lineup of unfortunate passengers on the Miles City–Deadwood stage.[58] In case we miss what he is aiming at, two fallen trees in the foreground lead the eye directly toward an assemblage of western types that includes a preacher, a schoolteacher, and a gambler as well as real people known to Russell—"the widow Flannagan, who ran the Miles City boardinghouse, and Mr. Isaac Katz, who had come west from New York City to open a clothing store" with his cash sewn into his clothing[59]—and to the stage's strongbox, which has been tossed to the ground.[60] Russell's humorous characterization of Big Nose George's victims, whom we regard from a point of view that makes us Parrott's confederate, renders the crime less than serious.[61]

Innocent Allies also depicts the robbery of a stage by highwaymen. Were it taking place in a more heavily wooded setting, it could be the very same event Russell painted in *The Hold-Up*. However, the overall mood has changed from comic to melancholy. *The Hold-Up* and *Innocent Allies* exemplify the degree to which Russell's choice of vantage point determined not only the formal structure of his pictures but also their emotional content. Russell had been depicting identical events from different points of view since the 1880s. In his pen-and-ink drawing *Dudes,* for example, six mounted figures follow a guide down a mountain trail that has been exposed by a recent burn; in its pendant, *Game Country,* their progress is observed by a group of mule deer. As a professional observer himself, Russell clearly enjoyed the notion of one group surreptitiously or openly regarding another. He used this device, which often requires the viewer to look over the shoulders of figures that have their backs to the picture plane (as in *The Hold-Up*), to involve us in whatever drama is ostensibly the picture's subject and to elicit our identification with those who helplessly watch. Although we know from Russell's other works that horses can generate plenty of bad behavior on their own, in *Innocent Allies* they are merely dumb, unoffending accomplices to a crime, patiently awaiting their next nefarious assignment. The wistful tenor of *Innocent Allies* is considerably enhanced by its color scheme, which is suffused with the lavenders, blues, and purples of early evening. The

(above)
Dudes, 1887

Pen and ink on paper, 6½ × 10½ inches
(sight), Petrie Collection, Denver,
Colorado

(right)
Game Country, 1887

Pen and ink on paper, 10 × 10 inches
(sight), Petrie Collection, Denver,
Colorado

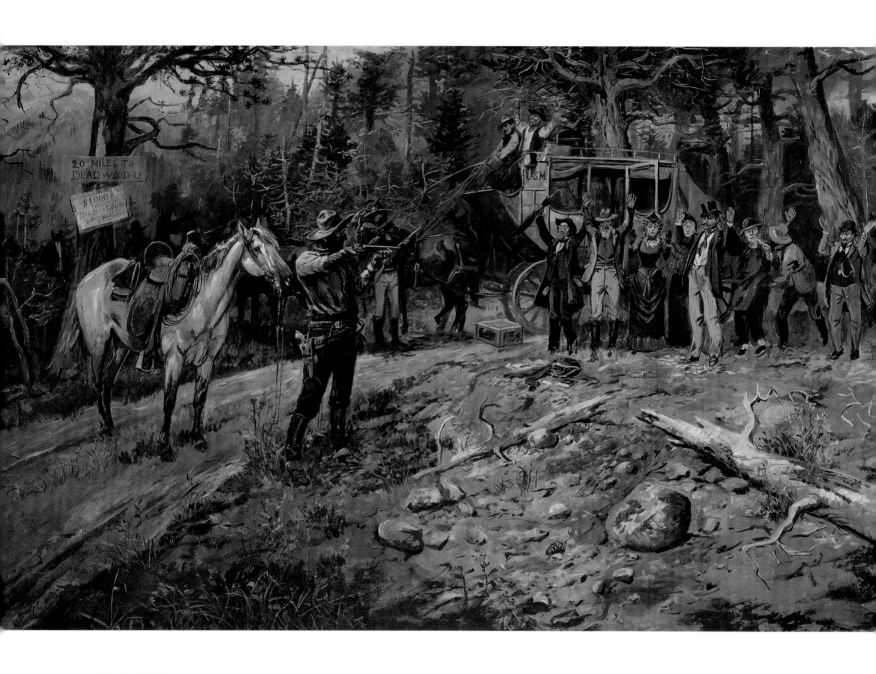

The Hold-Up, 1899
Oil on canvas, 30 × 48 inches,
Petrie Collection, Denver,
Colorado

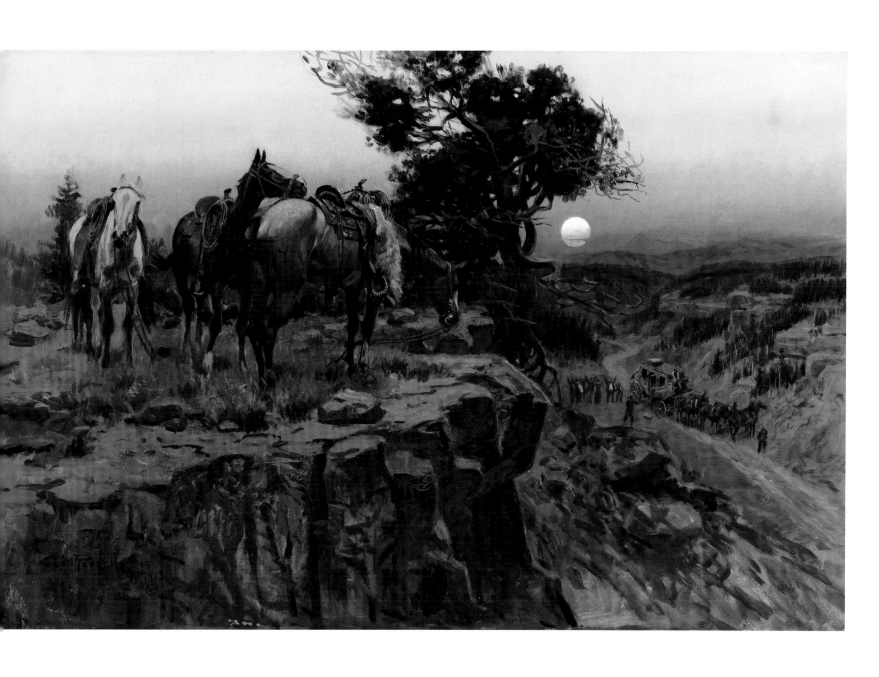

Innocent Allies, 1913
Oil on canvas, 24 × 36 inches, Gilcrease
Museum, Tulsa, Oklahoma (0137.2324)

horses stand on a bluff rendered in near-abstract slabs of color that anticipate the work, four decades later, of Abstract Expressionists like Clyfford Still.

Russell also chose a nocturnal palette for *Wolf and the Beaver,* a succinct statement of his ambivalent attitude toward criminals, which reflected contradictions in his own personality. The canvas is split diagonally between a frigid, inhospitable foreground and a distant view of the moon rising over an inviting refuge from the Montana winter. The last rays of the setting sun illuminate a snowy bluff, where an outlaw's horse gingerly picks its way past a dead tree bearing a wanted poster for its owner (an explanatory detail Russell also included, somewhat superfluously, in *The Hold-Up*), who gazes down at the snug cabin and modest ranch of an upstanding citizen. It is significant that in this painting Russell adopted the viewpoint of the "wolf," aligning himself, as he often did, with a figure on the margins of society.[62]

Although Russell became the busiest of beavers ensconced in his cozy home and studio in Great Falls, he preserved within himself that streak of rebellious nonconformism that had propelled him from suburban St. Louis to frontier Montana as a teenager. Nancy Russell steadily peeled away his time-consuming early associates as part of her enforcement of the discipline that ultimately led to his artistic and commercial success, but she could erase neither his past nor his personality. Russell possessed a charm and fundamental decency that redeemed even his most outrageous behavior, but he never claimed to be a saint, which makes his comments on the hypocrisy of the self-righteous all the more legitimate.[63]

Russell's sympathy for and partial identification with outlaws is consistent with the views of his contemporaries Wister and Hough, who considered the outlaw the final repository of the independent spirit of the Old West. Wister concluded "The Evolution of the Cow-Puncher" with a lament for the disappearance of the cowboy, "this latest outcropping of the Saxon," by the forces of "Progress. . . . His old courage and frankness still stick to him, but his peculiar independence is of necessity dimmed. The only man who has retained this wholly is the outlaw, the horse and cattle thief, on whose grim face hostility to Progress forever sits."[64] For his part, Hough stated unequivocally that rustlers were "wrong," but he also acknowledged that "there is a certain picturesqueness in their story, intimately blended as it is with the story of the cattle trade and of the cowboy, a romantic interest which we should not overlook. It was the rustler who held the last pinnacle in the fight for the old days and the old ways of the West."[65]

Russell's portrayal of outlaws as at least partially admirable dead-enders in the war against stifling social convention had roots in literary sources high and low. The dime novels he consumed in his youth were filled with the exploits of charismatic bad actors like Jesse James and Deadwood Dick.[66] A bit later in life, he could have turned to Walter Scott's novel *Rob Roy* for a more elevated and nuanced, though no less exciting, portrait of an outlaw.[67] Scott's antihero, based on the historical Rob Roy MacGregor (1671–1734), is a Highland drover who is at once rugged cowboy, brazen cattle thief, heroic rebel persecuted by an unjust government, and, as head of his clan, a tribal chief that some American commentators likened to an Indian leader.[68] The narrator of Scott's novel, Francis Obaldistone, a prosperous young Londoner with a poetic soul who gets entangled in Rob Roy's violent affairs while in Scotland on family

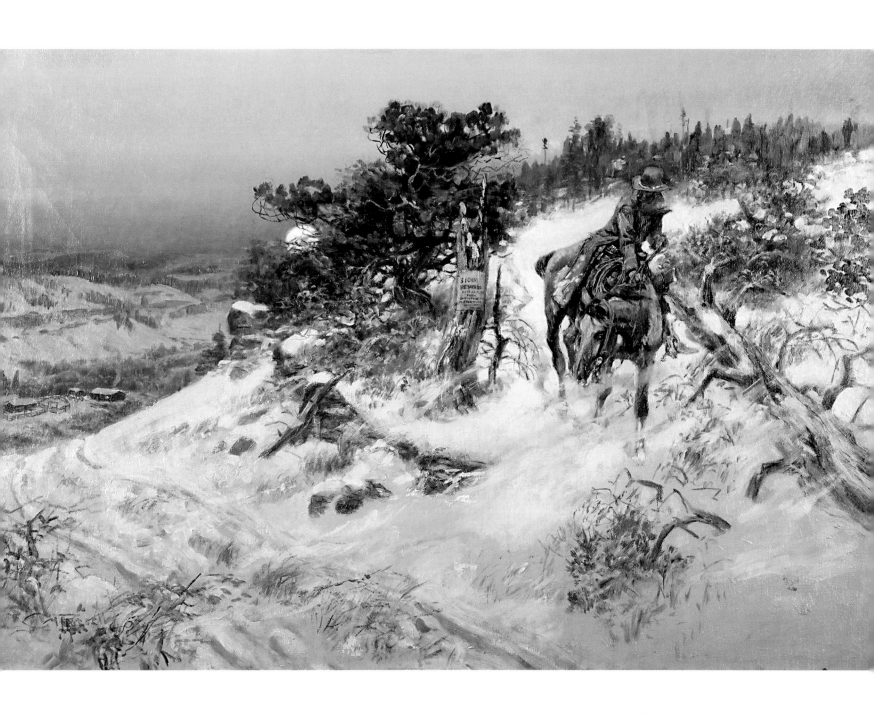

Wolf and the Beaver, 1921
Oil on canvas, 23½ × 35½ inches,
Courtesy of R. D. and Joan Dale
Hubbard, private collection

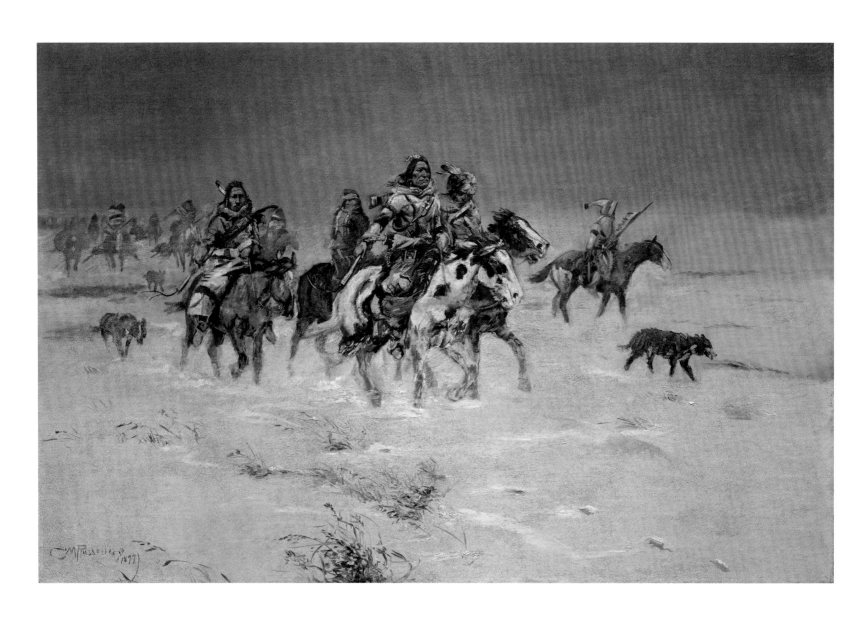

Whoop-Up Trail, 1899

Oil on canvas, 24½ × 36½ inches, Image
courtesy of William I. Koch Collection,
Palm Beach, Florida

business, is like Russell in his equivocal position as outsider, insider, and interested observer of the activity swirling about him.

Scott's work was hugely popular in the United States, and Americans' conception of their own frontier and its colorful, violent "border life" was influenced by Scott's *Rob Roy* and his other novels set in the Scottish Borders, which separate the wild, romantic Highlands from the civilized precincts of Edinburgh and points farther south. Moreover, many residents of America's own "borders," including Kit Carson, were descendants of the Scots-Irish, whose origins lay in that troubled region between Scotland and England.[69] In "The Evolution of the Cow-Puncher," Wister described the dangers to which western cowboys were daily exposed and proclaimed, "Among these perils the cow-puncher took wild pleasure in existing. No soldier of fortune ever adventured with bolder carelessness, no fiercer blood ever stained a border. If his raids, his triumphs, and his reverses have inspired no minstrel to sing worthily of him who rode from the Pecos to the Big Horn, it is not so much the Rob Roy as the Walter Scott who is lacking."[70]

Montana's own "border country"—the territory near its international boundary with the province of Alberta, Canada—was conducive to the sort of ambiguity about outlaws that inflects many of Russell's paintings.[71] Cattle and horse thieves went to Canada to escape capture and sell their booty, and cowboys and ranchers regularly crossed the forty-ninth parallel to profit from differences in the legal and tax codes of the United States and Canada as well as to encourage their livestock to feed on Canadian grass.[72] Chief Joseph led the Nez Percés from Oregon to Montana's Canadian border in 1877 to escape forced relocation to reservations; the Sioux leader Sitting Bull found sanctuary in Canada.[73] The border thus signified freedom as well as lawlessness, demonstrating the artificial, arbitrary nature of the line distinguishing honorable citizen from common criminal.

Despite international efforts to curb criminal activity, the border regions of Montana and Alberta were prime territory for clashes between a number of groups. The 210-mile "Whoop-Up Trail," which connected Fort Benton, Montana, to Fort Hamilton, Alberta, was thick with commercial and military traffic, especially in its heyday between 1874 and 1883, before railroads caused its gradual abandonment. Fort Hamilton was dubbed "Fort Whoop-Up" because its traders exchanged alcohol as well as food and manufactured goods for furs and buffalo robes brought in by Blackfeet. The name came to be applied to the trail, which was frequented by Americans smuggling whiskey to Canada because its sale to Indians was forbidden in the United States.[74]

The subjects of Russell's *Whoop-Up Trail* appear intent on nothing more than discovering and killing some game on a freezing winter day.[75] The painting's most notable feature is its muted palette of icy blue, gray, brown, and tan, accented with strategically placed strokes of bright red. *Whoop-Up Trail* stands as an early indication of the mastery of color and atmospheric effect that would become increasingly evident in Russell's art after 1900.

Jumped, on the other hand, portrays the lawlessness for which the Whoop-Up Trail was famous. In *Jumped,* Russell depicts an Indian raid on a traders' whiskey train[76] as the violent intersection of two lines of force: the lateral rush across the canvas of the Indians and the strong diagonal of the trail, which leads the viewer's eye from the lower left foreground deep

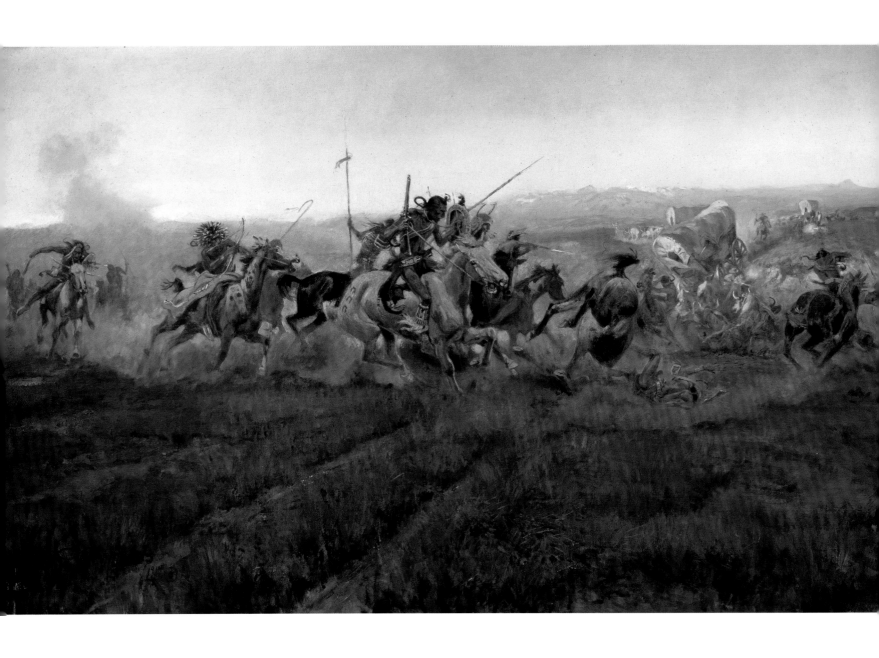

Jumped, 1914
Oil on canvas, 29½ × 48 inches,
William C. Foxley Collection,
La Jolla, California

into the distance at upper right. The chaotic collision between the wagon train and the Indian warriors who swing into its path is structured as a spiral. In its warm, late-day coloration, *Jumped* bears comparison to Frederic Remington's *Indian Warfare.* Remington's painting is similar in subject matter and composition, but it lacks the spatial and dynamic complexity of *Jumped.*

Jumped represents an unusual choice of subject for Russell in 1914; by that time, he tended to avoid themes involving outright violence between Indians and whites. Earlier in his career, when his aspirations were more directed toward action, Russell had worked through a series of "last stand" compositions culminating in *Caught in the Circle. Caught in the Circle* is heir to the many hectic pictorial renditions of Custer's Last Stand that circulated widely in the late nineteenth century; the downed figure and his horse in the right foreground seem particularly indebted to John A. Elder's *Custer's Last Charge* of 1884.[77] It is significant that the besieged group in *Caught in the Circle* is composed of trappers rather than soldiers. According to his nephew Austin, Russell "never, except on order, painted American soldiers killing American Indians," although a few such pictures did escape his studio without benefit of a commission.[78]

As was his custom, Russell used figures and objects set diagonally on the ground plane to direct the viewer's eye into the center of *Caught in the Circle*, and he connected virtually every

FREDERIC REMINGTON
(AMERICAN, 1861–1909)
Indian Warfare, 1908
Oil on canvas, 29½ × 50 inches,
Gilcrease Museum, Tulsa,
Oklahoma (0127.2307)

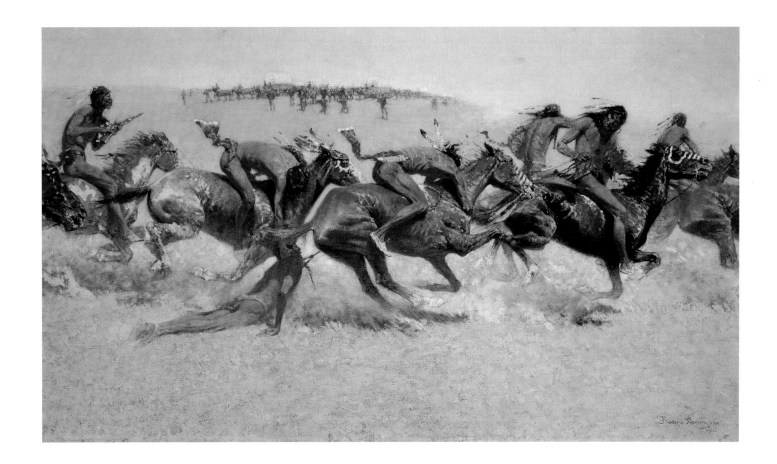

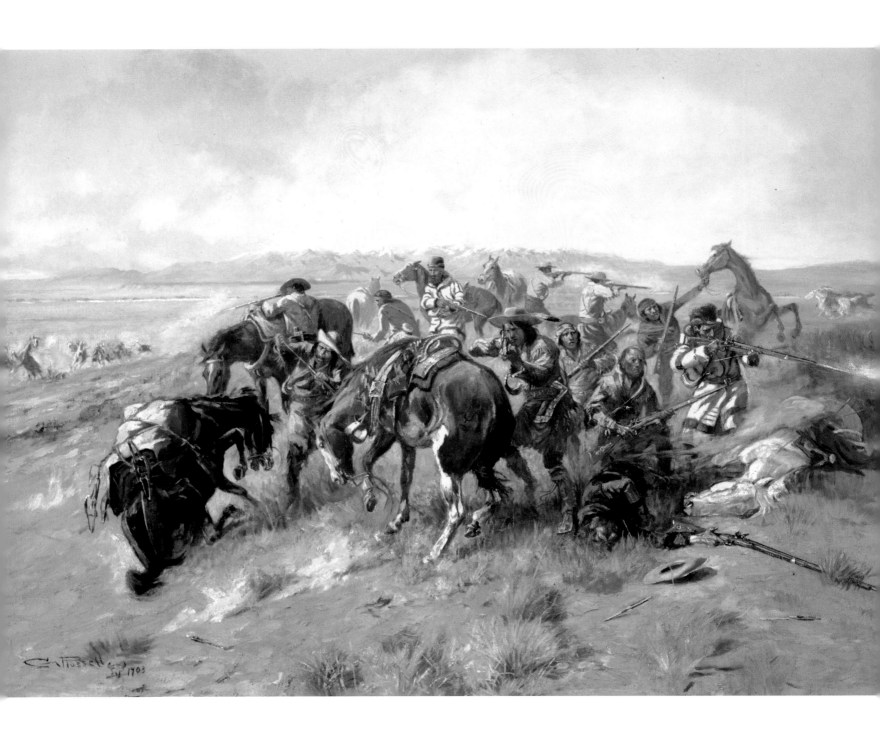

Caught in the Circle, 1903
Oil on canvas, 24 × 36 inches, National
Cowboy & Western Heritage Museum,
Oklahoma City, Oklahoma (1975.020.9)

figure to another by the strategic placement of the barrel of its gun. However, because we as spectators are outside the circle, these connecting motifs, especially the gun aimed straight at us by the figure at center right, push us out as much or more than they lead us in.

Russell became a greater master of a more sophisticated and inclusive circular composition, one that draws us into a microcosm of a complete culture rather than alternately attracting and repelling our observation of an isolated group under siege. Russell's great painting *Single-Handed* is one of his finest renderings of the encounter of white and Native civilization on the northern plains. Despite first impressions, it is also expressive of his role as an interme-

Single-Handed, 1912

Oil on canvas, 29⅞ × 32⅞ inches, Loan from Mr. and Mrs. William D. Weiss, image courtesy of Buffalo Bill Historical Center, Cody, Wyoming

diary between whites and Indians. The ultimate source of this composition may be George Catlin's *Mandan war party in Council*, one of the illustrations in his *Letters and Notes on the Manners, Customs, and Conditions of the North American Indians*, first published in 1841. Russell used a very similar structure in his *War Council on the Plains* in 1896,[79] and it also appears in pictures of roundup camps such as *The Camp Cook's Troubles,* in which the viewer has a metaphorical place on the yellow slicker in the left foreground, whose previous occupant has abandoned it for safer ground.

Government law enforcement in western Canada was generally considered to be superior to that on the American frontier. Although that belief has been challenged recently,[80] there were no more impressive figures of authority on the northern plains than the officers of Canada's North-West Mounted Police. They supplied the subject of one of Russell's earliest important works, *Canadian Mounted Police Bringing in Red Indian Prisoners* (1888), as well as four pictures—of which *Single-Handed* is the best—painted at the pinnacle of his career. Not surprisingly, given its Anglo-American theme, Russell exhibited *Single-Handed* for sale

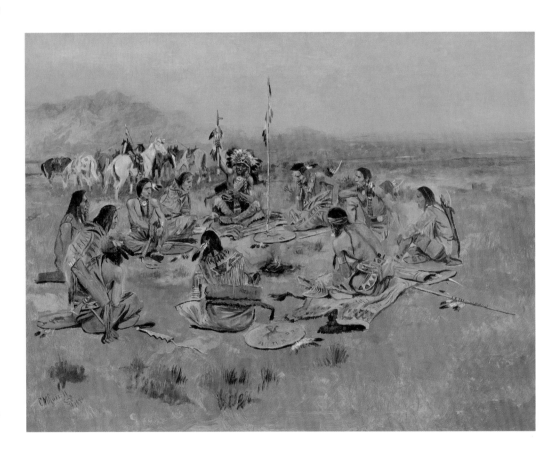

at the Winnipeg Stampede in Manitoba, Canada, in 1913, as well as in his one-man show at London's Doré Gallery the following year.[81]

Single-Handed is virtually square, a format that compresses the action and heightens the viewer's sense of the dangerous position of the central protagonist, who has courageously pursued his suspect into the heart of his own community, undoubtedly armed with the confidence of the Mounties' reputation for doing right by Indians and whites alike. Russell draws the spectator's eye into the picture by placing the principal action within a circle of seated figures whose poses and possessions direct our attention to the potentially explosive main event. Completing the circle in the foreground is a striped blanket implied to be our own ringside seat, and we witness the drama from the Indians' vantage point.

Peter Hassrick has said of *Single-Handed* that Russell "bestowed a sense of dignity on all those present, including even the apprehended suspect."[82] Few artists even-handedly apportioned humane qualities to all players in the American West with Russell's consistency and sincerity, especially during the most brutal decades of the Indian Wars, from the late 1860s until their tragic conclusion at Wounded Knee in December 1890; yet Russell did so during that period in such pictures as *Caught in the Act.*

Caught in the Act was the first painting by Russell to be reproduced in a nationally circulated periodical. It appeared in *Harper's Weekly* on May 12, 1888, accompanied by a brief article explaining that "in Montana, during the winter, Indians suffer greatly from hunger," which on this occasion

> has made [them] desperate. They know they are liable to arrest and imprisonment, but nothing that the soldiers or cattle men can do has any terrors for them now. They must eat, or die of starvation. The tall buck is making the sign of hunger, at the same time pointing to the squaws and children. Nearly all cow-boys and ranchmen are familiar with the sign language used by the North American Indians.
>
> The cow-boys understand the situation at once. They have no love for an Indian, but in this instance they are moved to pity. . . . One cow out of a big herd will never be missed. The wealthy "cow man," who is probably spending the winter in New York or Chicago, will be none the wiser.
>
> Mr. Russell, the artist, has sketched a subject with which he is entirely familiar. . . . [He] has caught the exact dreariness of it all—the long stretches of the plain, that mournful aspect of a winter scene in Montana. Anyone acquainted with frontier life will at once appreciate the truthfulness of the picture.[83]

One can't help but feel that Russell himself was the source of the sentiment expressed in the article, although its anonymous author declares that the Indians are out wandering in search of food "hundreds of miles from the reservation" when a group of tipis is visible in the background. Raw and empathetic, *Caught in the Act* exemplifies Russell's ability to identify with both sides in a situation in which strict compliance with the law precludes compassionate behavior. It also presages Russell's later public defense of a group of homeless Indians whose miserable encampments on the outskirts of Great Falls aroused the ire of his fellow citizens.[84]

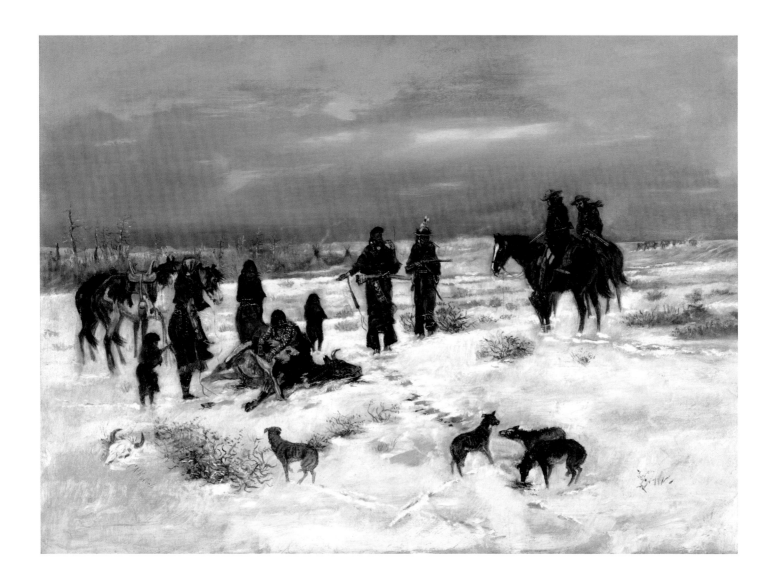

Caught in the Act, 1888

Oil on canvas, 20½ × 28¼ inches, Montana Historical Society, Helena, Mackay Collection (x1952.03.03), photograph by John Smart

The grim realism of *Caught in the Act* is characteristic of a number of Russell's depictions of Indians of the 1880s, including *Wanderers of the Trackless Way* (ca. 1887, see p. 141), another painting of Indians trespassing in a land no longer their own. Russell's lack of technical finesse at this early point in his career suited these ugly subjects. However, the disheartening conception of Northern Plains Indians exemplified by *Caught in the Act* was not to last long in Russell's paintings, although he never retreated from his real-life—and unpopular—support for the welfare of the Indians of his own time.[85] Within a month of the publication of *Caught in the Act* in *Harper's Weekly*, Russell was traveling in Alberta, on his way to enjoying a lazy summer in which he was to observe Blackfeet, Sarcee, Stoney, Blood, and Piegan Indians at close range for an extended period for the first time.[86] In the years to come, Russell would progressively devote more of his paintings and sculptures to Indian subjects, and he would also set these themes further back in time.

Russell's firsthand observation of the gloomy present and future prospects of Montana's

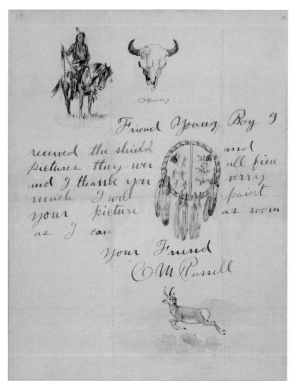

Friend Young Boy, March 1, 1902

Ink and watercolor on paper, letter,
8½ × 11 inches, envelope, 3⁹⁄₁₆ x 6⅜ inches,
Gilcrease Museum, Tulsa, Oklahoma
(0237.1583.1-2)

Native peoples, along with the heroic conception of Plains Indians he may have absorbed from George Catlin's *Letters and Notes on the Manner, Customs, and Conditions of the North American Indians* (which contains an extended protest against the cruelty of U.S. government Indian policy), may have predisposed him to be sympathetic to Indians. However, it must also be noted that the dime novels he read in his youth painted a much more savage picture of them. Moreover, Russell dismissed as hopelessly naïve James Fenimore Cooper's glowing portrayals in his novels of such perfect Indian characters as Uncas in *The Last of the Mohicans*.[87]

Whatever their source, Russell's feelings about Indians were conditioned by his observation of tragic scenes like that depicted in *Caught in the Act* and by his friendships with men like Young Boy, a Cree who occasionally modeled for him. After Young Boy gave Russell a shield, Russell thanked him in an illustrated letter that features an antelope, from which Russell's "Indian" name, Ah Wah Cous, was derived, supplementing his written signature.[88]

Russell began visibly identifying himself with Indians—or, more precisely, individuals of mixed Cree–French Canadian heritage—early in his Montana career. In 1882, he bought a brightly colored woven sash[89] made by a people that he later described, in a caption to one of his sketches of western types, as "French Canadian half breed[s] of the Red River district, known as the Red River Breed." The "Red River Breeds" were also called Métis. The Métis leader Louis Riel settled in Montana with a group of his followers after they failed in their fight for a homeland in Canada in 1876.[90] In making his "half breed" sash a permanent part

of his wardrobe, Russell may have been expressing a sort of solidarity with Mary, Robert, George, and Charles Bent, the half-Cheyenne children of William Bent.[91]

Although Russell's live-and-let-live philosophy—concisely expressed in "I Savvy These Folks" (1907; see p. 187)—extended to just about every resident of the frontier West, there can be little doubt that the gap he wanted most to close was that between Indians and whites. *Cowboy Bargaining for an Indian Girl* is an oddly touching example of that desire, although it represents a step in racial reconciliation that Russell did not take himself.

Cowboy Bargaining for an Indian Girl, though far less crude than *Caught in the Act,* is nonetheless a work of straightforward naturalism. Unlike earlier images of wilderness nuptials that were overtly Romantic and faintly (or patently) ridiculous, such as Alfred Jacob

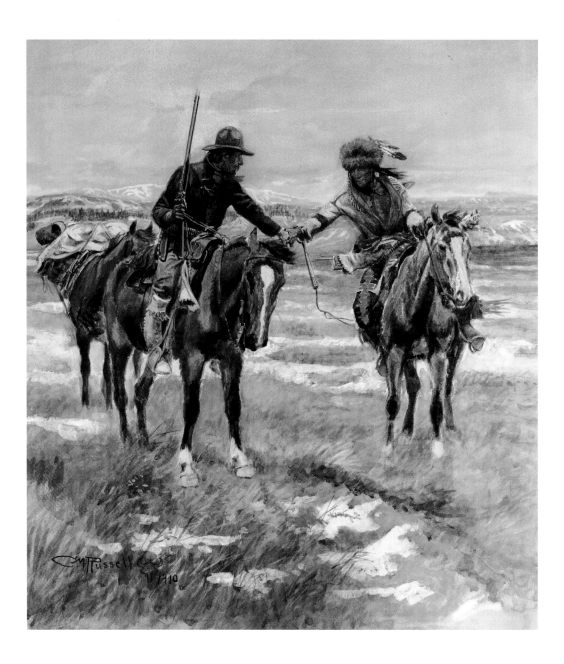

A Doubtful Handshake,
1910
Watercolor on paperboard,
30 × 27 inches, Gilcrease
Museum, Tulsa, Oklahoma
(0237.1450)

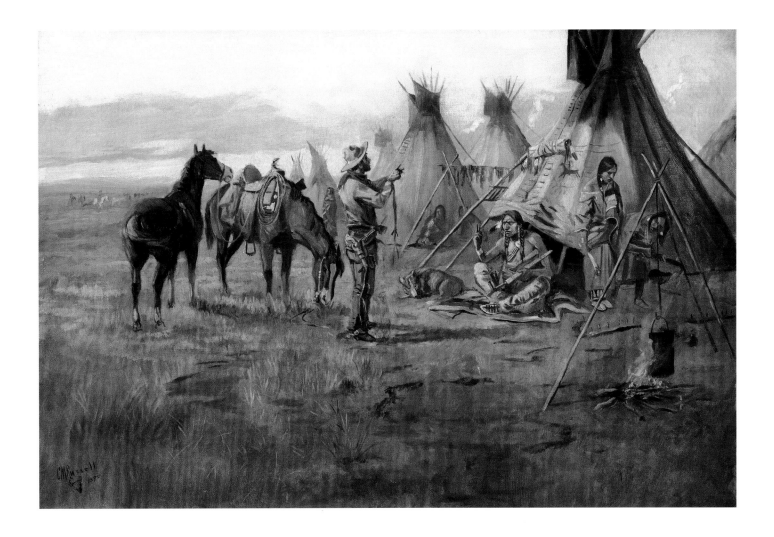

Miller's *The Trapper's Bride* (which was apparently modeled on Old Master paintings such as Raphael's *Marriage of the Virgin* [1504] and Peter Paul Rubens's *Judgment of Paris* [1639]),[92] *Cowboy Bargaining for an Indian Girl* possesses the air of an event that really happened. Despite the similarity of some of its elements to Russell's "erotic" art, such as the notorious *Joy of Life* (ca. 1895), *Cowboy Bargaining for an Indian Girl* does not necessarily portray an assignation scene.

As we have seen, at times Russell was deliberately ambiguous, and *Cowboy Bargaining for an Indian Girl* can certainly be taken in more than one way. Its subject has been interpreted as both a purely venal transaction[93] and as the penultimate chapter in a respectful courtship.[94] The young cowboy and his bashful bride project an innocent appeal that suggests that the latter interpretation is closer to the artist's intention. The hopeful bachelor has also arrived with a horse, the same kind of gift that an Indian beau would present to the father of his intended, which would not be the case if the cowboy's suit were the prelude to a one-night stand.

A number of prominent early Montanans, including rancher Granville Stuart and Teddy Blue Abbott, married full-blooded or mixed-race Indians. Such happy legal unions are evoked formally as well as symbolically in *Cowboy Bargaining for an Indian Girl*. The cowboy, his

Cowboy Bargaining for an Indian Girl, 1895

Oil on canvas, 19⅛ × 28¼ inches, Hood Museum of Art, Dartmouth College, Hanover, New Hampshire (P961.261), gift of J. Shirley Austin, Class of 1924

ALFRED JACOB MILLER
(AMERICAN, 1810–1874)

The Trapper's Bride, 1850

Oil on canvas, 30 × 25 inches,
Joslyn Art Museum, Omaha,
Nebraska (1963.612)

horses, and the open range where he earns his living occupy about half of the canvas; the Indians and their tipis fill the rest. The divide between the Indian and white worlds is conjoined by the cowboy's right arm and hand as he earnestly converses in sign with the father of his potential future bride.

However, Russell did not completely abandon the older western iconography (most prominent in the work of Miller) in which Indian women are presented as exotic objects of white male fantasy, the American equivalent of the alluring Near Eastern odalisques of J. A. D. Ingres and other European painters. *Waiting and Mad* is the most sophisticated and fluently

painted of a series of Russell's pictures in this Orientalist vein, which began in 1896 with *Keeoma*, for which his wife Nancy served as model. However, in contrast to other paintings in the *Keeoma* series, the figure in *Waiting and Mad*, though supine, wears a frankly confrontational expression that is the perfect embodiment of that state of boredom and irritability that the French critic Charles Baudelaire called "spleen." She is also set in the most opulent environment of any of the *Keeoma* pictures. The still-life elements in *Waiting and Mad* are as eye-catching as the figure.

Russell painted *Indian Maid at Stockade* in 1892, several years before Nancy arrived on the scene. Like *Waiting and Mad,* the figure in *Indian Maid at Stockade* issues a challenge to the male gaze analogous to that of Edouard Manet's implacable modern courtesan *Olympia*. The figure in *Indian Maid at Stockade* assumes a more assertive pose than the recumbent Keeoma and her sisters. Unlike Olympia, she has no need of a servant to deliver flowers; she is clothed in a multitude of trade items that are, no doubt, gifts from her white admirers. In her self-assurance if not her lack of association with family values, she anticipates Russell's later presentation of Indian women as strong and capable as well as sexually attractive. *Indian*

Waiting and Mad, 1899

Oil on board mounted on masonite, 11⅞ × 17¾ inches, Indianapolis Museum of Art, Indianapolis, Indiana (73.104.5), gift of the Harrison Eiteljorg Gallery of Western Art

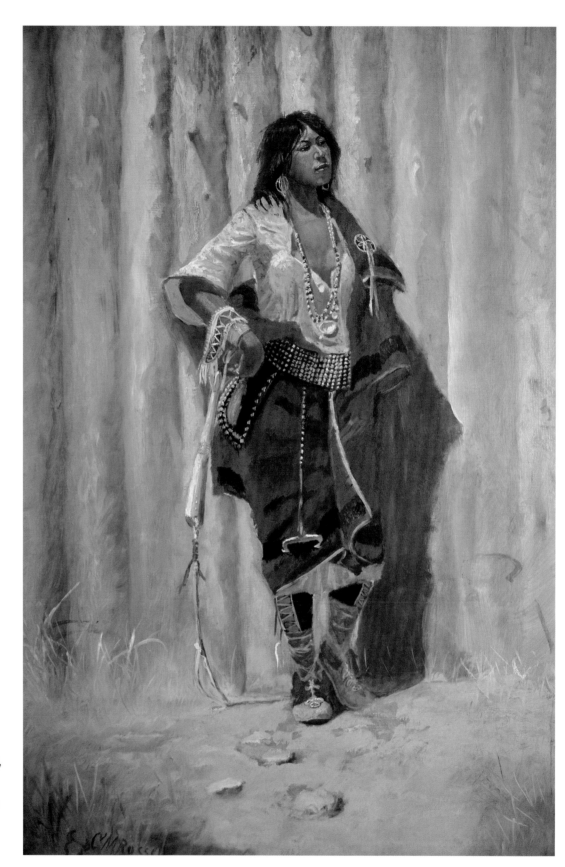

Indian Maid at Stockade,
1892

Oil on canvas, 30 × 20 inches,
JP Morgan Chase Art
Collection (23002)

Maid at Stockade is also precociously fine from a technical standpoint. The painting exhibits Russell's eye for detail, his mastery of light and shadow, and his ability to convincingly render characteristic physical attitudes at an early stage in his career.

Russell advanced notably beyond earlier artists' conceptions of Indian women in his portrayal of their vital importance to their communities. To be sure, Russell's native women belong to a well-defined domestic sphere, and they often appear in passive roles, as in *Her Heart Is on the Ground.* Like *Waiting and Mad, Her Heart Is on the Ground* is one of a series of images related to an older iconography of Indian women as dependent for their identity on their husbands and male offspring.[95] Here, according to Nancy Russell, a disconsolate and rather fetching young widow is sunk in despair on a rocky outcrop that zigzags its way up to the body of her husband, which is exposed to the elements beside a tripod bearing his "finest robes and 'medicine.'" His favorite war horse lies slain on the talus of the bluff, and his widow has slashed her forearms in a ritualized expression of her grief. In one of her descriptions of the image, Nancy Russell added that "Charlie has taken the sting of sadness from the composition [by showing] the little child standing at its mother's back. Its babyhood suggests a

EDOUARD MANET
(FRENCH, 1832–1883)
Olympia, 1863
Oil on canvas, 51 × 74⁵⁄₁₀ inches, Musée d'Orsay, Paris, France, photograph courtesy of SCALA/ Art Resource, New York (RF 644)

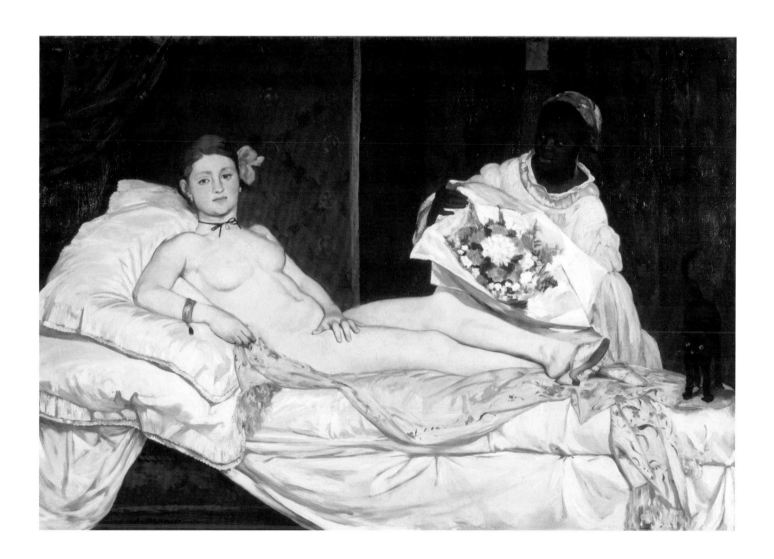

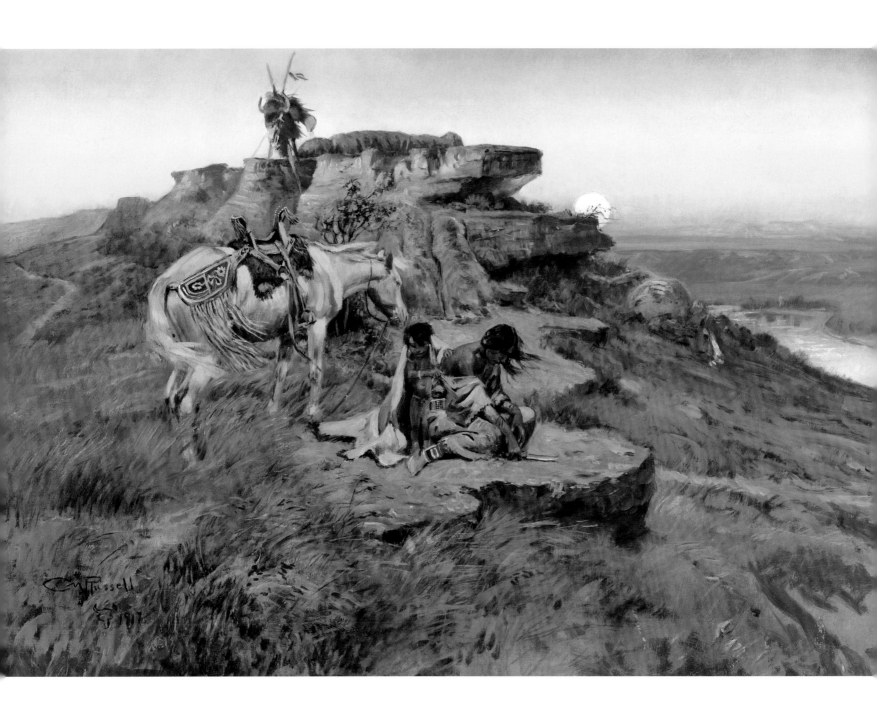

Her Heart Is on the Ground, 1917
Oil on canvas, 23¾ × 35¾ inches,
Gilcrease Museum, Tulsa, Oklahoma
(0137.907)

future and her dejected position is held in check by the suggestion that she must carry on and guide the child to manhood."[96]

The best-known contemporary analogue of *Her Heart Is on the Ground* is George de Forest Brush's *Mourning Her Brave* (1883), but in form it recalls a painting by English artist Joseph Wright of Derby, *The Widow of an Indian Chief watching the Arms of her deceased husband*. Wright belonged to a generation of British and French artists who introduced a post-Rococo seriousness to the portrayal of women in the late eighteenth century. These artists painted women as successors to an antique ideal, drawn from Republican Rome, of wives and mothers as pillars of domestic strength and self-sacrifice. An engraving of Wright's painting was published in 1789,[97] but whether Russell knew of it is very much open to question. However, *Her Heart Is on the Ground* shares with *The Widow of an Indian Chief* its basic compositional structure and the conceit of the landscape as a reflection of the bereaved woman's emotions. Wright never visited North America, and his inclusion of an erupting volcano, a raging thunderstorm, and roiling oceanic waters as environmental barometers of his protagonist's feelings is perhaps somewhat over the top. But Russell's twilight coloration, intended to connote acceptance of a natural cycle of birth, maturation, and death, springs from the same Romantic tradition.

Nancy Russell described the locale of *Her Heart Is on the Ground* variously as "[h]igh on the rimrocks overlooking Milk River" and "on the Missouri River in Montana,"[98] but Russell

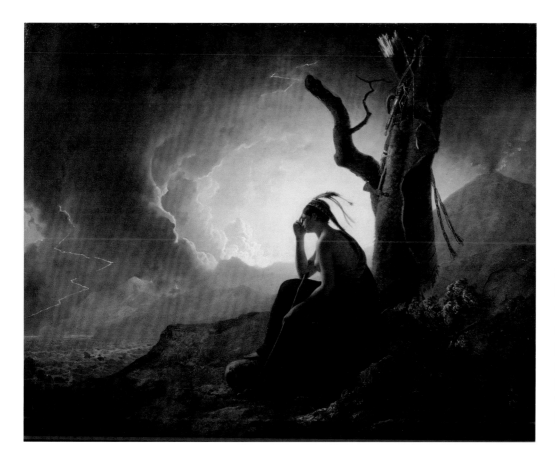

JOSEPH WRIGHT OF DERBY
(BRITISH, 1734–1797)
The Widow of an Indian Chief watching the Arms of her deceased husband, 1785
Oil on canvas, 39½ × 49⅝ inches, Derby Museums and Art Gallery, The Strand, Derby, England (1961-508/6)

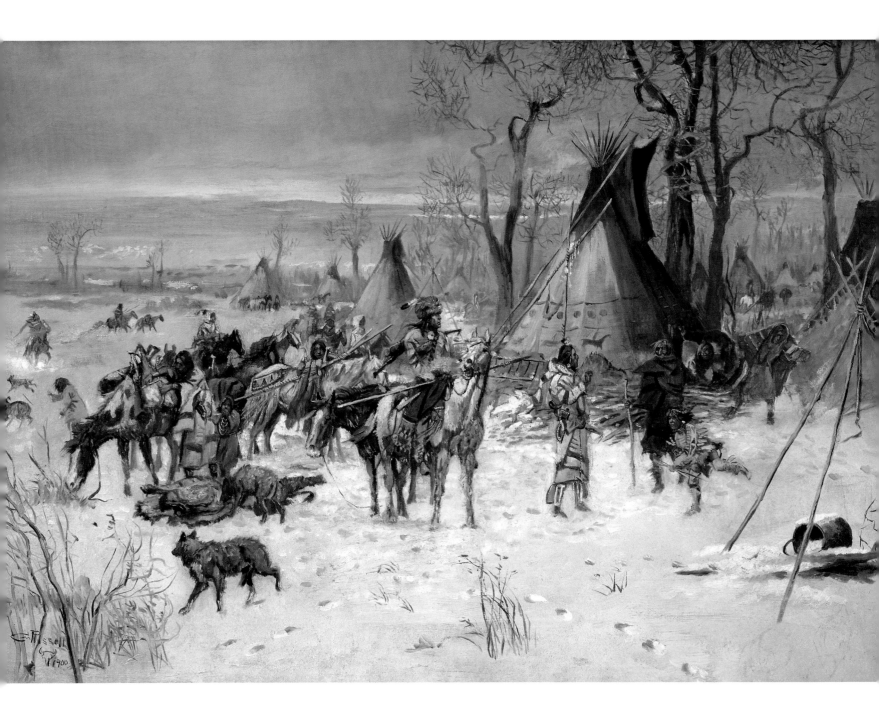

Indian Hunters' Return, 1900
Oil on canvas, 23¾ × 35½ inches,
Montana Historical Society, Helena,
Mackay Collection (x1954.02.01)

may have received his original inspiration for it during his stay in Alberta in 1888. (The painting was commissioned by a Canadian patron, William B. Campbell, in 1914.)[99] Russell's visits to Blackfeet villages that summer also undoubtedly played a role in his conception of his early masterpiece *Indian Hunters' Return,* in which Indian women play an active, fully integrated role.[100]

Possible sources of individual motifs for and parallels to the overall composition of *Indian Hunters' Return* can be found in Karl Bodmer's aquatints *A Skin Lodge of an Assiniboin Chief, Encampment of the Piekann Indians,* and *Winter Village of the Minatarres,* as well as an illustration by an unknown artist, *Indian Village,* published in 1879 in William F. Cody's *Life of Buffalo Bill.* Russell parts ways with these earlier artists in his particularized attention to each member of the foremost group of figures, as well as the somewhat grubby, unsanitized appearance of the scene as a whole. Blood and footprints mar the pristine white of the snow. Dogs tug at the fresh hides that women are unloading from pack animals, and a disused kettle lies overturned on the ground at right. Although the principal part of the composition is organized into a triangle that rises from the horse nosing the dried grass at lower left to the apex of the tipi at upper right, its subsidiary parts are filled with purposeful activity suggesting the vitality of real life. Its impressive ambition and lack of idealization impart an integrity to *Indian Hunters' Return* that prefigures Russell's later, more elegiac treatments of Native life on the northern plains.

The loving enumeration of every domestic detail in *Indian Hunters' Return* culminates in Russell's *In the Wake of the Buffalo Runners* (1911; see p. 179), his magisterial summation of women's crucial role within native life on the northern plains. *In the Wake of the Buffalo Runners* is by far the greatest representation of this theme, not only in Russell's oeuvre but indeed in the work of any American painter.

Plains Indian women were responsible for almost every aspect of transforming bison into food, shelter, clothing, and trade goods except for the hunt and kill. Their ceaseless labor was noted by many nineteenth-century travelers in the West, who took Indian men to task for shifting so much of the burden for the welfare of their communities onto their wives. *In the Wake of the Buffalo Runners* presents an alternative view of the issue that is characteristic of Russell's admiration for Plains Indian life before the coming of the white man. Rather than focusing on the drudgery associated with a woman's lot within the confines of a village or encampment, Russell presents the subjects of *In the Wake of the Buffalo Runners* in the open air, dramatically situated on a high point within an expansive landscape and against a cloudless sky. The women awaiting the outcome of the hunt rise from the lengthening shadows of twilight to face the setting sun. The central figure, who kneels straight up in her saddle, one hand on the reins and the other resting on the strap that fastens a cradleboard to her back, is as heroic as any of Russell's Indian horsemen.

INDIAN VILLAGE.

AFTER UNKNOWN ARTIST
Indian Village, 1879
The Life of Hon. William F. Cody, 257
Image courtesy of Denver Public Library, Denver, Colorado

Its iconic composition, structured to enhance the noble stature of the maternal figure at its center, is relatively simple, but *In the Wake of the Buffalo Runners* is rich in details that attest to Russell's observation of Indian life in all its complexity. The characters of the three principal figures—the handsome young mother, the curious boy perched on her travois, and the older woman, who is the only adult not fixated on the hunters below—are deftly conveyed by the specifics of their dress and gestures. The vectors established by the travois poles create a circuit within the composition, guiding the viewer's eye from the main figure group to the plains below and the distant landscape beyond before returning it to the nursing foal, an explicitly symbolic touch that appears entirely natural in Russell's hands. The painting is unified by the complementary colors that capture the fading light of day and the onset of evening.[101]

In 1911, the year Russell painted *In the Wake of the Buffalo Runners*, his series of one-man exhibitions, collectively titled "The West That Has Passed," was inaugurated at the Folsom Galleries in New York. The Cowboy Artist was certainly not done with cowboys or action, but his contemplative mode was now firmly in the ascendant, and poetry would increasingly dominate his expression. In a letter of May 13, 1919, to his longtime cowboy pal Teddy Blue Abbott, Russell observed that "Old Ma Nature was kind to her red children and the old time cow puncher was her adopted son." Russell preferred to recall the pastoral side of a business that had depended on industrial technology, and especially on railroads, for its existence. Like

C. M. Russell to E. C. "Teddy Blue" Abbott, May 13, 1919

Watercolor and ink on paper, 10 × 17 inches, Eiteljorg Museum of American Indians and Western Art, Indianapolis, Indiana, The Gund Collection of Western Art, Gift of the George Gund Family (2002.15.50)

mining and oil drilling, raising cattle on the open range was an extractive, ultimately unsustainable industry, and though it presented a more chivalrous aspect than the other two pursuits, it too paved the way for the future of the West as the most modern region of the United States.[102]

Russell had worked with roundup outfits on the Musselshell River in Montana,[103] where, as in the Judith Basin, open-range cattle ranching gave way to mixed agricultural settlement by 1890.[104] Russell memorialized Montana's open range in *Round-Up on the Musselshell,* in which he melded the dust and imbalance of his earlier cowboy action pictures with the twilight atmosphere of his more contemplative late paintings. In *The Log of a Cowboy,* Andy Adams described the Musselshell River from the vantage point of the campground of an outfit trailing a herd through Montana:

From this divide there was a splendid view of the surrounding country as far as eye could see. To our right, as we neared the summit, we could see in that rarefied atmosphere the buttes, like sentinels on duty, as they dotted the immense tableland between the Yellowstone and the mother Missouri, while on our left lay a thousand

Round-Up on the Musselshell, 1919

Oil on canvas, 24 × 36 inches, William C. Foxley Collection, La Jolla, California

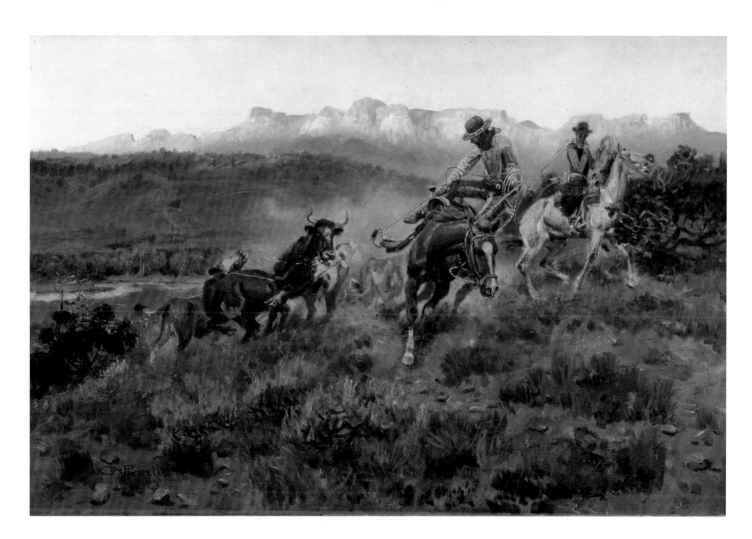

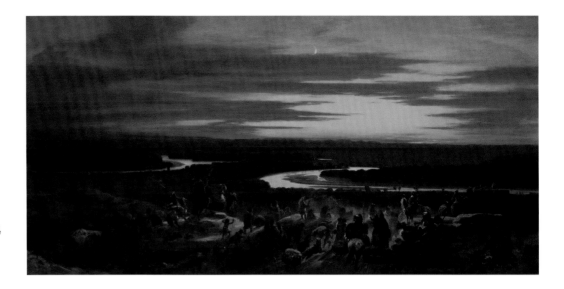

CHARLES (CARL) FERDINAND
WIMAR (AMERICAN, BORN
GERMANY, 1828–1862)

*Indians Approaching
Fort Union,* ca. 1859

Oil on canvas, 24 × 48⁷⁄₁₆ inches,
Mildred Lane Kemper Art
Museum, Washington University,
Saint Louis, Missouri (WU 3410),
gift of Dr. William Van Zandt,
1886

hills, untenanted save by the deer, elk, and a remnant of buffalo. Another half day's drive brought us to the shoals of the Musselshell. . . . Long before the advent of the white man, these shoals had been in use for generations by the immense herds of buffalo and elk migrating back and forth between their summer ranges and winter pasturage.[105]

As late as the 1930s, Teddy Blue Abbott thought the rougher terrain along the Musselshell looked "just the way it did a thousand years ago."[106] It was, in other words, very much like the primeval paradise Russell depicted in *When the Land Belonged to God* (1914; see p. 223), an appropriate backdrop for an elegy to the cowpunchers of yore.

The open-range cattle business was born, boomed, and went bankrupt in the span of three decades, and it was long gone well before 1919. Russell's nostalgia for it was exceeded only by his longing for the lost world of the Indians of the northern plains, and it was toward this ideal realm that he increasingly turned his attention. Russell was a cultural relativist, and his view of Indians was a textured one, not an all-out celebration of the mythic superiority of the Noble Savage. The Indians of his later works were not necessarily better than whites; they were just luckier—that is, if they had had the good fortune to have been born at the right time.

In *Salute to the Robe Trade,* the Blackfeet who fire their guns to announce their approach as they exuberantly descend toward Fort MacKenzie, forty miles above the Great Falls of the Missouri,[107] exemplify the last of those fortunate generations. The Blackfeet forbade white trappers to enter the territory under their control, but they welcomed the traders from St. Louis who conducted their business in isolated posts along the Upper Missouri River, and the profits of British and American fur companies depended on native hunters and trappers. Many of the goods the Blackfeet received in trade, such as cotton and woolen cloth, blankets, glass beads, ribbons, awls, knives, brass kettles, and guns, raised their standard of living, most visibly in the opulent dress associated with Northern Plains peoples in the popular imagination. Ultimately, however, these overpriced consumer items—especially the most pernicious

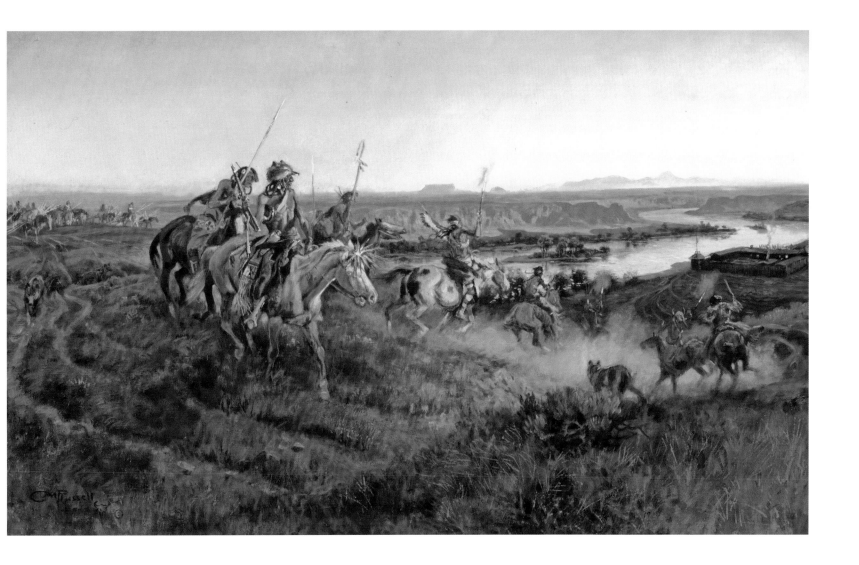

of them, alcohol—destroyed many individuals as well as a collective way of life. *Salute to the Robe Trade,* then, is one of Russell's portrayals of an in-between state, a momentary balance of power between Indians and whites that is destined to be resolved in the white man's favor. By 1830, American free trappers, such as those represented in Russell's *Carson's Men* (1913; see p. 210), would increasingly invade Indian country to do the trapping themselves. In the process, they helped extend American control over the entire far West.[108]

As Brian Dippie has noted, *Salute to the Robe Trade* is "in conception and execution a salute not just to the fur trade, but to [Carl] Wimar," the German-born and -trained St. Louis painter whose work was a lifelong influence on Russell.[109] Wimar's picture *Indians Approaching Fort Union* is almost the same size as *Salute to the Robe Trade* and shares with it a sunset coloration.

Since the late 1890s, Russell had been gradually moving away from the earth tones that dominated his early work in oil, and by the second decade of the twentieth century he had mastered an evocative twilight palette. *Piegans,* for example, is a work of timeless peace, a

Salute to the Robe Trade,
1920

Oil on canvas, 29½ × 47¼ inches, Gilcrease Museum, Tulsa, Oklahoma (0137.1625)

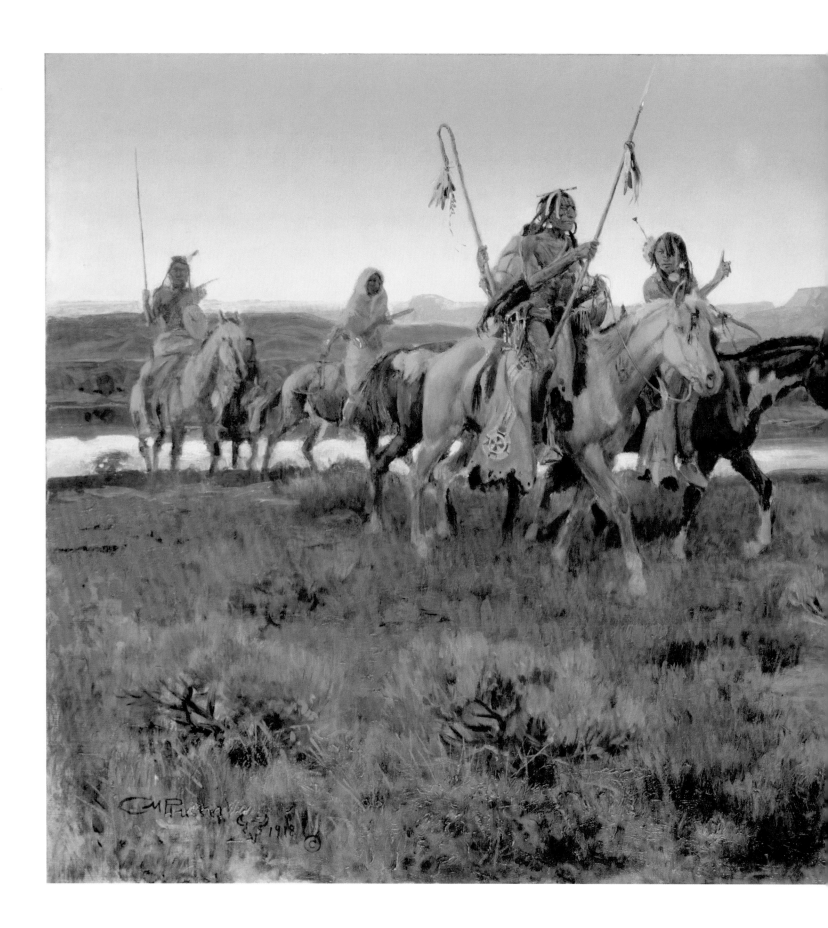

Piegans, 1918
Oil on canvas, 24 × 36 inches,
Petrie Collection, Denver, Colorado

construction of an unrecoverable past to which Russell was not a witness. In *Piegans,* Russell took minute account of Northern Plains Indian beadwork and feathered ornament, the vegetation of a high, dry land, and the exact tint of the Montana sky as the sun dips beneath the horizon; but all detail functions in service of conveying the off-handed, nearly heartbreaking assumption on the part of the participants in this western idyll that their world will proceed just as it has, from one sunset to another, for all time.

Two of the foremost figures—the adolescent on the pinto horse and the older man just behind him, who is almost completely hidden by a warrior mounted on a white horse—are conversing in sign. Typically, Russell used this device to both engage and, to a certain extent, frustrate the viewer, or at least leave him with an unresolved issue to ponder. The white horse partially obscures the sign made by the young man, who could be referring to himself as a boy deserving a man's role within his community or, in a related move, simply complimenting one of his elders on his accomplishments.[110] One need not be fluent in sign language, however, to understand the tragic principal message here: the oncoming night in *Piegans* signals the end of an ideal existence to which there is no return except in the imagination.

Russell's evolution as a colorist was as impressive as his development as a draftsman.[111] As with other facets of his technique, Russell's manipulation of color was helped along by his observation of the work of other artists, including John Marchand and Philip Goodwin, and the Cowboy Artist made no secret of his admiration for commercial artist and illustrator Maxfield Parrish (1870–1966), whose work was ubiquitous virtually from the moment that mass reproduction of color images became possible.[112] By 1904, when Parrish's nocturne of three shepherds gazing in wonder at the star of Bethlehem appeared on the cover of the December 3 issue of *Collier's,*[113] magazine and book covers, illustrations, and advertisements designed by Parrish were difficult to avoid. Russell's own considerable production of Christmas imagery, including *Joshing Moon,* undoubtedly owes a debt to Parrish's holiday fantasies, but Parrish's influence on Russell extended far beyond that.

The purple, rose, lavender, and golden hues that warm the late-afternoon winter sky and create a unifying atmosphere for the disparate activity in *Indian Hunters' Return* began to appear consistently in Russell's work around 1900, but he did not fully exploit the possibilities of twilight color until about ten years later, in such pictures as *Innocent Allies.* At about the same

MAXFIELD PARRISH
(AMERICAN, 1870–1966)

Christmas Cover, 1904

Collier's, December 3, 1904,
General Research Division, The
New York Public Library, Astor,
Lenox, and Tilden Foundations

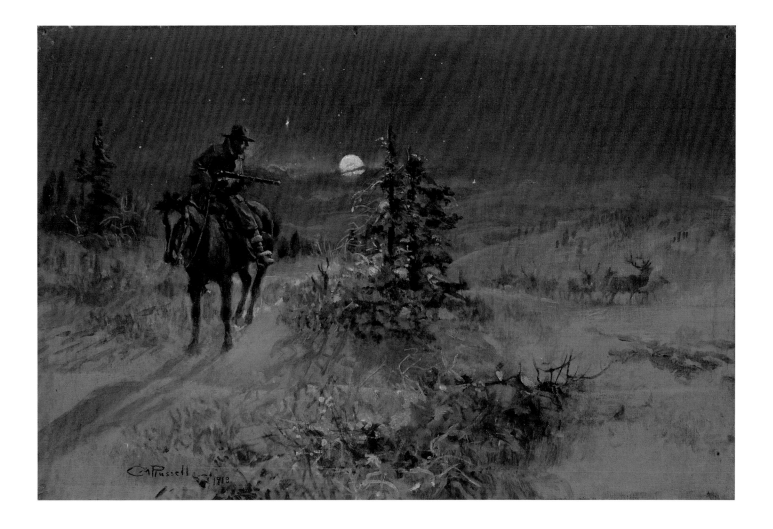

time, Russell mastered one of the most challenging phases of a sunset in the northern plains and Rockies—the suffusion of the sky just above the horizon with yellow—which he expertly coordinated with the complementary blues and purples that precede and follow its brief appearance in the heavens. He painted this moment in works including *Piegans*, *Salute to the Robe Trade, Her Heart Is on the Ground,* and *Carson's Men.* In 1921, Russell affirmed that Parrish had given him the courage to paint such numinous but nonetheless natural effects.[114] Parrish also taught Russell a thing or two about backlighting,[115] which the Cowboy Artist put to particularly effective use in *Piegans* by outlining the figures with a thin bead of yellow and orchestrating a complex play of yellow and pink reflections on the river visible in the background between the horses' legs.

Russell's color also derives from other sources, about some of which we can only speculate. For example, *The Scout* recalls Parrish's juxtapositions of blues, purples, oranges, and golds, but its painterly surface, enlivened by an all-over network of varied strokes, is nothing like Parrish's layering of glazes from which every trace of the brush has been expunged. Although Russell derided Impressionism as "smeary,"[116] *The Scout* demonstrates that it influenced him,

Joshing Moon, 1918
Oil on canvas, 8½ × 13½ inches,
Petrie Collection, Denver,
Colorado

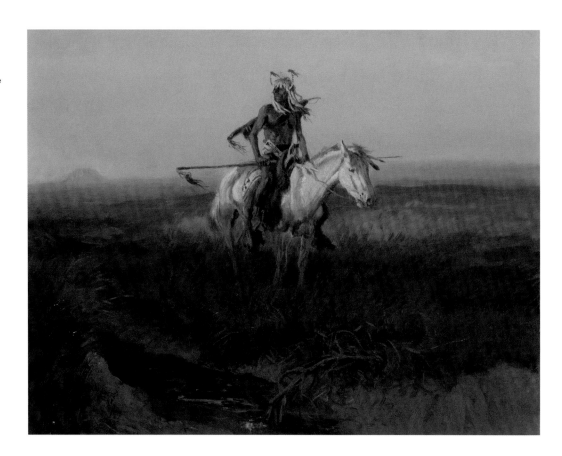

The Scout, 1915
Oil on canvas, 16¾ × 21½ inches,
Petrie Collection, Denver,
Colorado

if only at second hand, through such agents as the paintings of Ashcan School artist William Glackens (Russell was personally acquainted with the artist's older brother, cartoonist and illustrator Louis Glackens).[117] William Glackens's *Skaters, Central Park* of about 1912, though perhaps more "smeary" than *The Scout,* nevertheless shares similar qualities of color and facture with it, as well as an element that Americans regarded as the sine qua non of French Impressionism: purple shadows.

The figure in *The Scout,* surely one of Russell's finest essays in pure painting, assumes a motionless, watchful position, but little else in the picture is still. A breeze gently pushes the grasses to the right and animates the fringe and feathers in the dress, equipment, and trappings of the figure and his mount. This general sweep to the right is countered by the leftward twist of the figure's head, a *contrapposto* position reinforced by the intensity of his gaze in that direction. The foreground grasses and parts of the stream that runs diagonally from the left middleground to the center foreground are defined by delicate raised strokes that project slightly from the canvas; here and there, they catch the fading illumination of the setting sun. Thus, although the foreground is in deep shadow, it is overlaid with a tracery of reflected light. Russell worked his canvases all over simultaneously, stepping in to dab in color and then back to appraise its effect.[118] That practice is abundantly evident in *The Scout:* echoes of the most highly colored part of the picture—the mounted figure silhouetted against a brilliant backdrop of orange, gold, and chartreuse that plays off the lavender and pink near the

horizon and dissolves into the pale aqua of the sky—can be discovered in tiny touches of the brush throughout the canvas.

Paintings like *Joshing Moon, The Scout, Where Tracks Spell Meat,* and *The Fireboat* are Russell's responses to the nocturnes of Frederic Remington, which, like many of Parrish's images, were published in color in *Collier's.* Russell seldom painted near-total darkness, as Remington did from about 1900 until his death in 1909. Remington's night light, as opposed to his representation of sunset, in such pictures as *Coming to the Call* (ca. 1905; see p. 217), is dominated by cold greens and blues; the small patches of warm colors he used to represent firelight and brightly lit cabin windows only serve to accentuate the overall chill. By contrast, Russell's twilight darks contain many more warm, saturated hues, along with cool blues. Nowhere is the inner glow of Russell's late-day pictures better illustrated than in *The Fireboat,* in which a group of warriors discuss the import of the appearance of a steamboat chugging up the Missouri River far below them. The pattern of gnarled branches and their shadows which breaks up the brilliant reflection of the sunset on the rocks in the foreground recalls the cloisonné effects sought by Post-Impressionist painters like Paul Gauguin. This technique also brings to mind the stained-glass lamps produced and sold by Tiffany and Company, in which the leading circumscribes pieces of colored glass cut into organic shapes and illuminated from within. Russell's bronzes were sold at Tiffany in New York,[119] and there can be little doubt that he saw the company's other luxury products.

Parrish's work was undeniably the single greatest influence on Russell's color, but there is something cramped and perverse in much of his art that is inimical to the wide-open spaces and essentially healthy disposition of the Cowboy Artist's world.[120] However, another aspect of Parrish's work—his adroit exploitation of the medievalized fairy-tale imagery that was enormously popular in the late nineteenth and early twentieth centuries[121]—was completely in tune with Russell's vision of The West That Has Passed.

Where Tracks Spell Meat, 1916

Oil on canvas, 30⅜ × 48⅜ inches,
Gilcrease Museum, Tulsa,
Oklahoma (0137.914)

The Fireboat, 1918
Oil on board, 15½ × 24½ inches,
C. M. Russell Museum, Great Falls,
Montana (956-2-1), gift from the
Trigg Collection

CLARA DRISCOLL (AMERICAN, 1861–1944),
DESIGNER FOR TIFFANY AND COMPANY

"Wisteria" table lamp, ca. 1902–1938
Bronze and glass, 18-inch-diameter shade on
tree base; overall 18 × 27 inches, Collection of
the New-York Historical Society, New York
(N84.130)

Parrish's large-scale compositions—like the eight-by-thirty foot *Old King Cole and His Fiddlers Three,* painted in 1906 for the bar of New York's Hotel Knickerbocker at Broadway and Forty-second Street, just down the street from the studio of Russell's friends John Marchand and Will Crawford[122]—tend to be static and symmetrical. However, his *Pied Piper Mural,* painted for the men's bar in the Palace Hotel in San Francisco and also published as a lithograph,[123] is a departure from his norm. Although most of its members must bend or crouch to clamber over the rocky foreground, the Pied Piper's procession at least possesses some forward momentum, and, more important, an innate pageantry like that seen in Russell's paintings *The Medicine Man*[124] (1908; see p. 178) and *In the Enemy's Country.*

The subjects of Russell's "trailing pictures"—his compositions of noble figures of the western past making their stately way across magnificent plains panoramas that terminate in distant mountains—include old-time cowboys (*Men of the Open Range*, 1923) and free trappers (*Carson's Men*) as well as Indians.[125] However, Russell's trailing pictures of Native Americans are the most lavishly detailed and the most overtly chivalrous in character. Although Russell's cowboys are indeed cavaliers by virtue of their courage and horsemanship, Northern Plains Indians like those depicted in *In the Enemy's Country* were Russell's seigneurial ideal. They inhabit a mythic dimension as distant and irrevocably lost (and thus as open to imaginative recreation) as the twelfth-century England of *Ivanhoe,* the hugely popular novel by Walter Scott. The publication of *Ivanhoe* in 1819 kicked off a craze for all things chivalrous that was still going strong a century later. Castles, knights, suits of armor, and brightly caparisoned palfreys were everywhere, from the illustrations of Parrish and N. C. Wyeth to World War I recruiting posters and 1920s Hollywood movies. Even cowboys, when they first got together to test their roping and riding skills against others, called their competitions "tournaments," not rodeos.[126]

From childhood on, Russell liked knights and all who attended them, as can be seen in his

MAXFIELD PARRISH
(AMERICAN, 1870–1966)
The Pied Piper Mural,
ca. 1909
Oil on canvas laid down on board, 84 × 192 inches, Collection of the Sheraton Palace Hotel, San Francisco, California, photograph courtesy of Alma Gilbert Smith

In the Enemy's Country, ca. 1921

Oil on canvas, 24 × 36 inches, Denver
Art Museum, Denver, Colorado, gift of
the Magness Family in memory of Betsy
Magness (1991-751)

Miss Josephine Trigg
		Dear Miss Josephine I want to
thank you for the nice birth day card
you sent and your Shamrock has brought
luck as I feel much better to day
not that Iv been sick but I havent felt
real good that card was shure a
Paddys greeting maby Im not Irish
but my fondness for that Race makes one
belive Im a breed.
You said the verse was not all yours
but I know the feeling was and thats the
best part of it.
Miss Josephine California is not the country
that Brethart knew but thes moovie
people still make romance
the English words you see on the screen
at the Liberty or any other show house
are realy live Oaks of Cal

*Miss Josephine Trigg/
Dear Miss Josephine,*
March 24, 1926

Watercolor, pen and ink on paper,
11 × 7¼ inches, C. M. Russell
Museum, Great Falls, Montana
(953-1-63), gift from the Trigg
Collection

illustrated letters, especially those written from England in 1914, when he also got in touch with his inner Friar Tuck.[127] If Russell's pictures of outlaws have an air of *Rob Roy* about them, *The Medicine Man* and *In the Enemy's Country* are permeated with the spirit of *Ivanhoe,* a novel in Russell's own library. Russell's neighbor Josephine Trigg, a librarian by profession, often read to him while he painted, and historical novels were his favorite entertainment. Judging from the miniature models he made of medieval characters, including knights, Joan of Arc, and a court jester, as well as illustrated letters he wrote to Trigg, many of the books she read to him must have been chivalrous in theme.[128]

Like the characters in *Rob Roy*, the protagonists in Scott's *Ivanhoe* are complex, and many are not what conventional stereotypes might lead us to expect. The fool in a Saxon court is wiser than his master, the novel's villain is more vigorous and compelling than the eponymous hero, and the most admirable figure is a quintessential outsider in medieval England, a Jewish woman who conquers hearts while navigating an ocean of anti-Semitism. The transgressive and satirical qualities of *Ivanhoe* must have appealed to Russell as much as its wealth of convincing detail and thrilling episodes of knightly combat.

Russell's trailing pictures correspond to the narrative structure of *Ivanhoe,* which Scott's imitator James Fenimore Cooper employed in *The Last of the Mohicans* (1826), a novel with which Russell was also familiar. The characters in *Ivanhoe* literally progress through the landscape, pausing to engage in exciting set pieces that include the tournament at Ashby de la Zouche, the siege and destruction of the castle at Torquilstone, and the final showdown between Ivanhoe and his nemesis, the lapsed Templar Brian de Bois-Guilbert, at Templestowe. A single painting such as *In the Enemy's Country* cannot, of course, contain all the action packed into a novel like *Ivanhoe,* but it was Russell's genius to suggest an extended narrative in this elaborately detailed image.

In a recent discussion of *In the Enemy's Country,* Brian Dippie makes clear that the picture represents one episode in a long series of events; it is filled with evidence of its protagonists' earlier experiences and with suggestions of what may lie in store for them. Dippie quotes from a 1923 exhibition catalogue that explains that Russell's subjects are Kootenai Indians who must traverse territory controlled by hostile Blackfeet to reach a good buffalo range. In

an effort to pass unnoticed, they have draped their horses with buffalo robes and are walking beside them rather than riding. "'At a distance they resembled a small band of buffalo. Old bulls traveled in small bands, and no Indian cared for bull meat. Therefore they were not molested.'"[129] Dippie adds, "Notice the verdant foreground; it is spring or early summer on the plains, and the buffalo will be fat. Thus the Kootenai incursion into Blackfeet country. Notice the spear pointing at the ground, so that no light flashes off its metal tip and betrays the intruders' presence. The need for silence is conveyed by the figure on the left communicating in sign language instead of spoken words."[130] *In the Enemy's Country,* with a gorgeous backdrop flooded with the hues of sunset and a foreground that is at once naturalistic and so freely brushed that it conveys the artist's pleasure in the act of painting itself, belongs to Russell's late poetic mode, but it also brings to mind his earlier paeans to action. The frantic combat in *When Blackfeet and Sioux Meet* and the bronze *Counting Coup* [No. 1] is exactly what the Kootenai hoped to avoid through their elaborate subterfuge.

Russell first treated the subject of *When Blackfeet and Sioux Meet* in a 1902 painting commissioned by a patron who had earlier purchased a watercolor "showing a Kootenai hunting party in Blackfeet country walking their horses to avoid detection."[131] According to Russell,

In the Enemy's Country, ca. 1921, detail of left foreground

Oil on canvas, 24 × 36 inches, Denver Art Museum, Denver, Colorado, gift of the Magness Family in memory of Betsy Magness (1991-751)

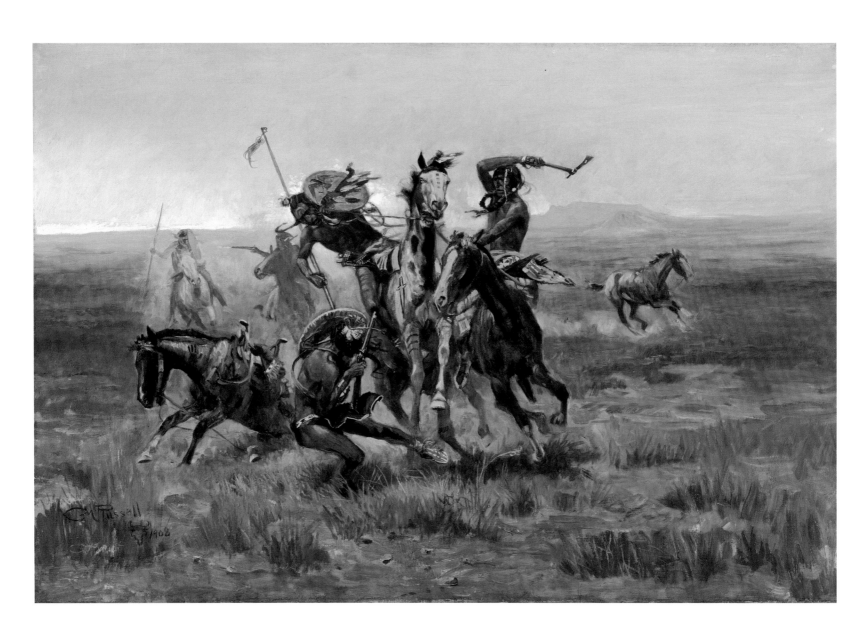

When Blackfeet and Sioux Meet, 1908
Oil on canvas, 20½ × 29⅞ inches,
Sid Richardson Museum, Fort Worth,
Texas (1949.2.1.42)

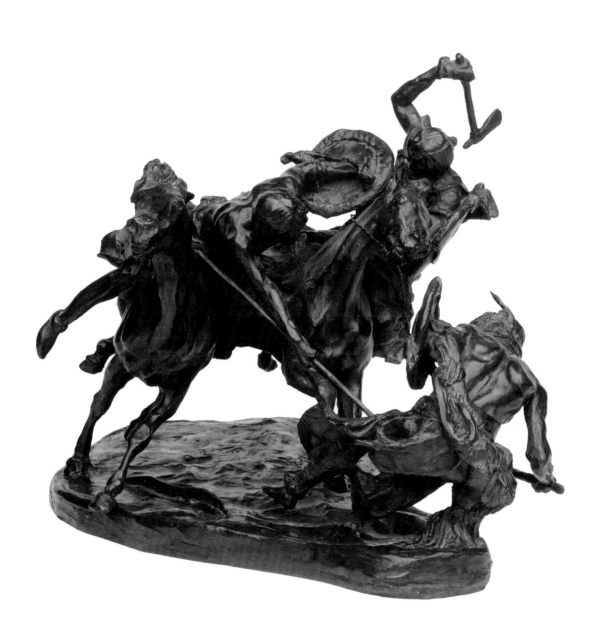

Counting Coup [No. 1], 1905
Bronze, 11 × 17¾ × 12 inches, Gilcrease
Museum, Tulsa, Oklahoma (0837.19)

the theme was drawn from the reminiscences of Medicine Whip, a member of the Blood branch of the Blackfeet, who shared with Russell his memories of a titanic battle with Sioux warriors when the artist was in Canada in 1888. Russell published the tale, considerably embellished with the commentary of his first-person narrator Rawhide Rawlins, as "The War Scars of Medicine Whip" in 1908.[132] Although the body count in the war story was substantial, what mattered more than who won or lost that day was Medicine Whip's feat of "counting two coup at once against a pair of Sioux by touching the man on foot with his lance and the mounted man with his shield," which is the action recorded in Russell's bronze.[133] One counted coup not just by killing one's enemy but also by touching or striking him at close range. There was a hierarchy of such gestures, analogous to the codes of personal honor that motivated the knights of old, and Medicine Whip tallied three coups that day (he also killed a Sioux who had taunted him).[134] Of Russell's multiple representations of the story, it is the bronze that makes the most effective case for the similarity (or perhaps even superiority) of the Indians of the Northern Plains to the valiant warriors of the Middle Ages.

Russell's much-quoted diatribe, supposedly delivered in 1925 to a Montana civic organization, in which he purportedly defined a pioneer as "a man who comes to a virgin country, traps off all the fur, kills off all the wild meat, cuts down all the trees, grazes off all the grass, plows the roots up, and strings ten million miles of wire" has been shown to be apocryphal.[135] However, there is no question that he expressed similar feelings about progress in a tribute to fellow Montana artist Edgar S. Paxson on the occasion of Paxson's death in 1919: "Civilization is nature's worst enemy. All wild things vanish when she comes. Where great forests once lived, nothing now stands but burned stumps—a black shroud of death. The iron heel of civilization has stamped out nations of men, but it has never been able to wipe out pictures, and Paxson was one of the men gifted to make them."[136]

As Raphael Cristy has shown, the twentieth-century world appears often in Russell's writing,[137] and it shows up in his art as well, although rarely in his major work. Among the very few exceptions are the murals he painted for Edward L. Doheny, in which a few oil derricks inch into the final panel. A particular bête noire was the automobile. Russell never learned to drive, although he did remark, with characteristic ambiguity, that "I hope you don't have aney trouble with your car and remember they will go where a horse wont" in a letter to Joe De Yong of about 1916.[138] Russell's antipathy toward the car was well-known to Philip G. Cole, who owed his fortune, which enabled him to become the greatest early collector of Russell's work, to the tire pressure gauge, on which his father held the patent. In a handwritten postscript to a May 1926 letter to Russell, Cole said he supposed "that you & Nancy have had to lower yourselves to the automobile and have one at home. I am sending . . . a little package of valve accessories—'insides' 'caps' 'gauges' etc to carry for spare if you ever need them. Even the Best of Riders Quit when they get a flat tire."[139] Many in Russell's time saw the automobile as a threat to wilderness preservation,[140] and Russell's personal stand against the car was undoubtedly motivated by his agreement with this view, although his position was somewhat compromised by the fact that his wife owned and enjoyed an automobile.

Even with regard to Montana's wild creatures, as with much else in his art and life, Russell

assumed an ambivalent stance. Some of Russell's earliest action paintings depict cowboys on horseback roping grizzly bears as well as wolves; it was a form of range management that also made for thrilling sport.[141] Russell continued to paint such subjects throughout his career, but at the same time he was capable of creating far more nobly conceived portraits of wildlife, such as *To the Victor Belong the Spoils*.

Grizzly bears are large, aggressive predators, and American travelers in the West from Lewis and Clark on described encounters with them as terrifying in the extreme. In the late nineteenth century, Americans viewed the gradual eradication of the grizzly as a gauge of progress made in the ongoing conquest of the West. But, just after the century turned, the grizzly received a public relations makeover when Theodore Roosevelt, who had earlier cultivated an image as a grizzly slayer, refused to shoot a captive black bear during a "hunt" in Mississippi in 1902. With the rise to mass popularity of the stuffed teddy bear toy inspired by the incident, the grizzly's repuation was conflated with that of a comforting, vaguely patriotic plaything that could be safely installed in any child's nursery.[142]

To the Victor Belong the Spoils, 1901

Oil on canvas, 31½ × 44½ inches, National Museum of Wildlife Art, Jackson Hole, Wyoming, JKM Collection (J0987.126)

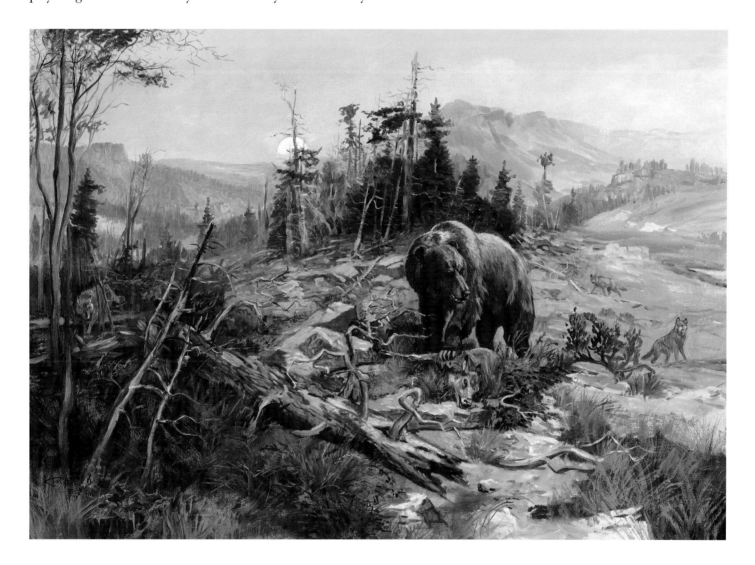

One would hope that Russell found all this distasteful, given his knowledge of the difference between the relatively small black bear and the enormous grizzly, as well as of the bloody havoc the latter could wreak. He recorded the aftermath of a very close call with a grizzly in *The Price of His Hide* (1915; see p. 188), an unusually graphic painting that was based on an actual occurrence.[143] In any event, *To the Victor Belong the Spoils* predates the teddy bear, although it does not precede Ernest Thompson Seton's *Biography of a Grizzly,* published in 1900. Seton, whom Russell met in New York in 1904,[144] anthropomorphizes his subject, a grizzly named Wahb. Wahb's mother " 'was just an ordinary silvertip, living the quiet life that all Bears prefer, minding her own business . . . asking no favors of any one excepting to let her alone,' " until she and four of her cubs were killed by a rancher. With this outrage as motivation, Seton's ursine hero justifiably goes on to behave just as real grizzlies do, becoming quite fond of " 'the hot, bloody juices [of his victims] oozing between his teeth.' "[145] Russell modeled many anthropomorphic bears and their families to be cast in bronze,[146] but he also designed a number of harrowing illustrations of men attacked by grizzlies. The subject of *To*

Letter to Philip Cole,
September 26, 1926

Ink and watercolor on paper,
8½ × 11 inches, Gilcrease
Museum, Tulsa, Oklahoma
(0237.1583.1-2)

the Victor Belong the Spoils, one of Russell's earliest ambitious wildlife paintings, is depicted as the ferocious beast it is, a creature intimidating both to us and to the wolves who loiter furtively in hopes of gleaning a few scraps once its dinner is finished.

Russell treated the grizzly and the elk, as depicted in a letter to Philip G. Cole,[147] with respect, but the bison was supreme in his wilderness pantheon. Kirby Lambert does full justice to *When the Land Belonged to God* (1914; see p. 223) later in this volume, but this forceful statement of Russell's sensibility and style warrants a few comments here. Naturalists and travel writers remarked with awe upon the huge populations of bison and other wildlife present in North America in the early nineteenth century. In Kentucky in 1813, John James Audubon described skies so congested with passenger pigeons that "the light of noon-day was obscured as by an eclipse." In 1832 George Catlin observed bison gathering "into such masses in some places as literally to blacken the prairies for miles together," but he lamented that the animal was "so rapidly wasting [from overhunting] . . . that its species is soon to be extinguished."[148] In *The Oregon Trail* (1849), Francis Parkman marveled at the sight of a vast bison herd: "The face of the country was dotted far and wide with countless hundreds of buffalo. They trooped along in files and columns, bulls, cows and calves. . . . They scrambled away over the hills to the right and left; and far off, the pale blue swells in the extreme distance were dotted with innumerable specks. . . . The prairie teemed with life. . . . There was nothing in human shape amid all this vast congregation of brute forms."[149]

There are pictorial precedents aplenty for *When the Land Belonged to God:* Karl Bodmer's aquatint *Herd of Bisons on the Upper Missouri,* based on studies made in 1833–34; Carl Wimar's *Buffalo Crossing the Platte;*[150] John Mix Stanley's *Herd of Bison, near Lake Jessie* (1855–61), published as an illustration in the Pacific Railroad Survey reports;[151] and William Jacob Hays's painting *The Herd on the Move,* which was circulated in a color lithograph of 1862.[152]

The seemingly infinite herds had been wiped out by the time Russell came to the far West, so such images would have been instructive to him. But the precedent for *When the Land Belonged to God* that is perhaps most telling in terms of sentiment, if not of form, is Russell's very early *Sceine [sic] on the pacific Rail Road* from his *Boyhood Sketchbook.* In this work, which may have been based on another artist's published image,[153] a small group of bison files under telegraph wires and across railroad tracks in advance of a distant locomotive. A number of drawings in the *Boyhood Sketchbook* appear to refer to the adventures of Buffalo Bill (whose moniker derived from his efficiency in slaughtering bison to feed the crews building the transcontinental railroad across the Great Plains in the 1860s), so one might take *A Sceine on the pacific Rail Road* as an allusion to the benefits of this signal event in the history of modern technology, which ushered in the unification, mass settlement, and industrialization of the American West. Yet in view of the rapidity with which the railroad facilitated the near-extinction of the bison, along with the destruction of the Plains Indians who depended upon it, it is hard not to view *A Sceine on the Pacific Rail Road* as the most melancholy of Russell's early works.

Thanks in large part to the railroad, *When the Land Belonged to God,* like *Piegans* and *In the Enemy's Country,* is a work of the imagination; yet it exceeds in power any of its pictorial

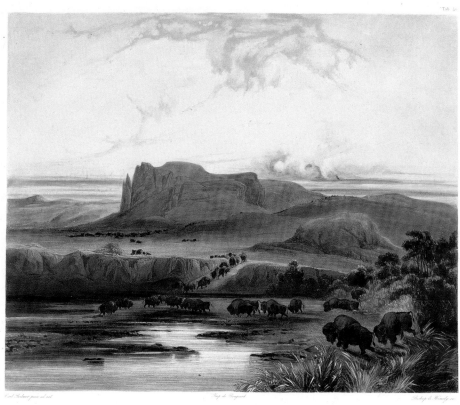

BISONHEERDE TROUPEAU DE BISONS
am obern Missouri. *sur le haut Missouri.*
HERD OF BISONS
on the upper Missouri.

a Sceine on the pacific Rail Road.

(above)
WILLIAM JACOB HAYS
(AMERICAN, 1830–1875)
The Herd on the Move, 1862
Hand-colored toned lithograph,
17¹³⁄₁₆ × 35⅝ inches, Amon Carter
Museum, Fort Worth, Texas
(1967.40)

(left)
*A Sceine on the pacific Rail
Road, Boyhood Sketchbook,*
late 1870s
Pencil on paper, 7 × 8 inches
Petrie Collection, Denver, Colorado

predecessors, all of which were based on personal observation. This power is due to its size but also to its haunting strangeness. The color, more moody and nuanced than anything by Maxfield Parrish, turns the Montana topography familiar from Russell's other paintings into a landscape out of time, almost from another planet. But what is most disconcerting about the picture is the directness with which we are confronted by its disheveled, dripping subjects. The shadowed foreground, filled with naturalistic incident, drops precipitously into the viewer's space just as the vanguard of the shaggy herd, still soaking wet,[154] crests a bluff after emerging from the Missouri River. These creatures are truly alien; they are visitors from the land of death whose arrival in our presence constitutes a mute reproach for the destruction Americans have wrought on their own most precious possession: the wilderness wealth that seemed so limitless to Audubon and Parkman.

Wolves accompany the buffalo in *When the Land Belonged to God;* they are a seemingly inevitable presence in Russell's western wilderness, as they once were in its natural cycle. They picked off the weaker members of other animal populations and helped dispose of the dead. If nature is truly predicated on survival of the fittest, the patient and resourceful wolf is better equipped than most mammals to prevail, a fact the Blackfeet recognized in calling the men who led their traveling parties "wolf men," according to a descriptive text written by either Charles or Nancy Russell for Philip Cole. "They knew the country and the best camping places. . . . If a Blackfoot said a man was a 'wolf' it was no insult—it meant that the man was very smart. In the sign language 'wolf' and 'smart' are the same."[155]

Wolves appear in Russell's earliest picture to garner wide attention, the tiny watercolor *Waiting for a Chinook* (1886; see p. 181), a composition he reprised in *Last of Five Thousand* and *Wolves Attacking in a Blizzard.* They figure most stunningly in his valedictory bronze, *The Spirit of Winter.* In this extraordinary work, modeled just six months before Russell's death, wolves eagerly accompany a draped skeletal figure pressing forward in a blizzard. He is the ghost of a Piegan warrior, who, according to Nancy Russell's description,

> had no luck. When on a hunting party he would get no game. If he joined a war party, he would be wounded and do no damage to the enemy. His people did not like him and were not kind to him. When he died he was buried on a scaffold. The sun, wind and rain mumified [*sic*] him. Winter came with heavy snows and no food to speak of for the wolves. Smelling what they hoped was food, they pushed and rubbed around the scaffold until it fell. Then starting to pull the old buffalo robe about [him], the Indian came to life as a mummy [,] thereafter leading the wolves in the fierce storms . . . when his people heard the wind blowing, the snow drifting and the wolves howling, they said it was 'bad medicine' and were afraid.[156]

Russell's representation of a deathly freeze in *The Spirit of Winter* is just as convincing as that conveyed by *The Norther,* Frederic Remington's 1900 bronze of a cowboy and his horse buffeted by a frigid gale. The deep shrouding of the figure in *The Spirit of Winter* also recalls Augustus Saint-Gaudens's *Adams Memorial,* an over-life-sized bronze in Washington, D.C.'s Rock Creek Cemetery that marks the grave of Clover Adams, who died a suicide in 1885.[157]

The *Adams Memorial* was influenced by Buddhist philosophy and art as well as the Sybils

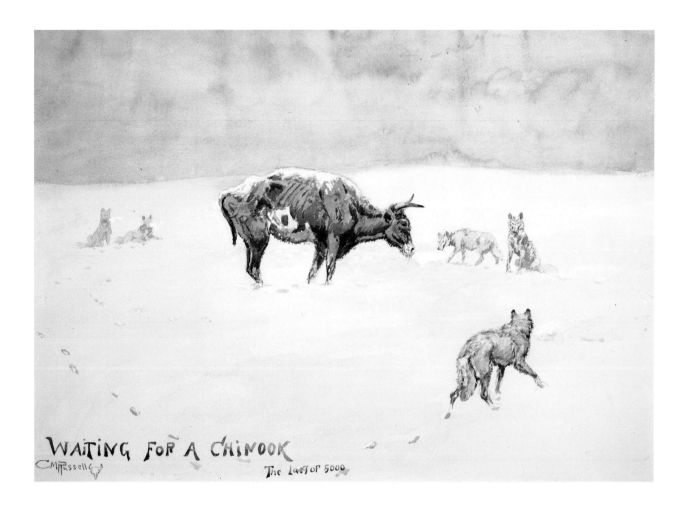

WAITING FOR A CHINOOK

C M Russell

The Last of 5000

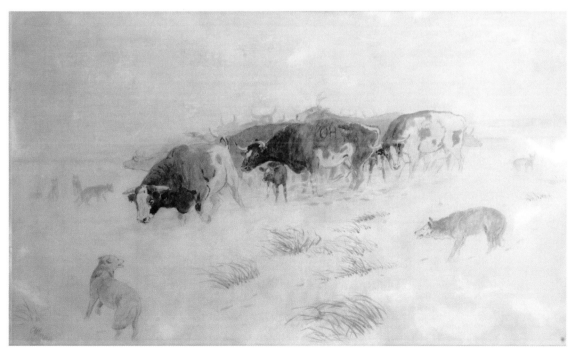

(above)
*Last of Five Thousand
(Waiting for a Chinook),*
1903
Watercolor on paper,
20½ × 29 inches, Buffalo Bill
Historical Center, Cody,
Wyoming (88.60)

(left)
*Wolves Attacking in a
Blizzard,* ca. 1890
Watercolor on paper,
20 × 30 inches, National Cowboy
& Western Heritage Museum,
Oklahoma City, Oklahoma
(1977.035)

in Michelangelo's ceiling frescoes in the Sistine Chapel,[158] but the monument has no program; it is an abstract meditation on death and what lies beyond, and its draped figure appears lost in thought. It shares an ominous mystery with *The Spirit of Winter,* but not the element of sheer terror that Russell conveyed through his vigorous modeling of the vengeful spirit's face and every detail of his howling retinue. Russell's shade is on a mission, and while the artist was not the ghost's specific target, he knew that death was coming for him nonetheless, and shortly.

A month after modeling *The Spirit of Winter,* Russell fashioned *Secrets of the Night.* Like *The Spirit of Winter, Secrets of the Night* is based on Blackfeet legend and is concerned with death, but its message is more hopeful. A beleaguered Piegan warrior, his resources exhausted, has received a visit from an owl, the "ghost bird" capable of bearing messages from the Shadow Land. Those who have passed over give the warrior the guidance he needs to thwart his enemies.[159] Russell incorporated movement into *Secrets of the Night:* in alighting on the figure's shoulder and pressing its head to the warrior's ear, the owl has blown the figure's hair to the right. Still, *Secrets of the Night* is much less aggressive than *The Spirit of Winter.*

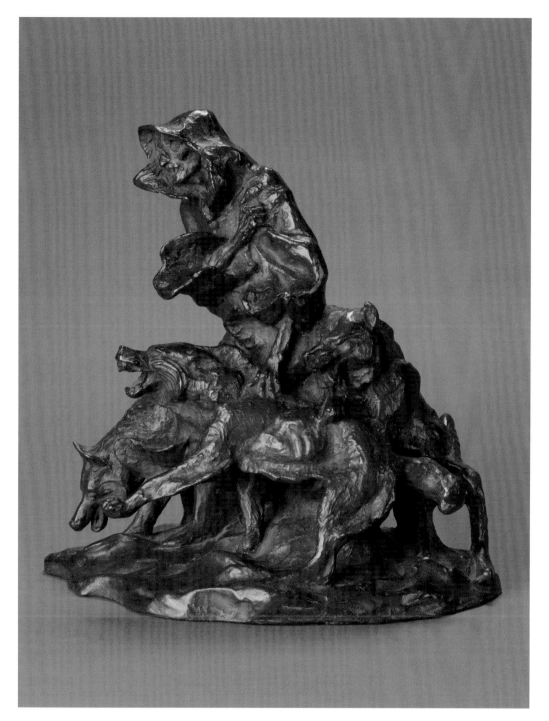

The Spirit of Winter, 1926
Bronze, 10⅛ × 10⅛ × 6½ inches,
The Harry Ransom Humanities
Research Center Art Collection,
The University of Texas at Austin
(Dobie 17)

The dynamism of the bird's landing is emphatically countered by the extended vertical of the figure's lance.

These bronzes are the best works of Russell's final year. By returning to his first medium, modeling, and some of his earliest iconography, wildlife, he had come full circle. Ceaselessly creative since early childhood, Russell retained a youthful sense of play almost until the end of his life, although the ruckus of his younger days was increasingly tempered by retrospection as he matured. By the mid-1910s, Russell was capable of true gravitas. He mourned the passing of the last vestiges of the early-nineteenth-century West that was his imaginative home, and this regret led to his resolve *not* to grow up with the country. His final works express his disappointment that inevitably—and, for many, tragically—it moved on regardless.

Notes

1. Regarding the subject of this painting, see Stewart, *The Grand Frontier,* 22, and Dippie, "Charles M. Russell and the Canadian West," 19. *The Camp Cook's Troubles* was originally known as *Bronc to Breakfast,* the title of a related watercolor of 1908 now in the Mackay Collection of the Montana Historical Society. Nancy C. Russell changed the name of the painting to *The Camp Cook's Troubles* at Philip Cole's request when he purchased it in 1933. See The Helen E. and Homer E. Britzman Collection, Colorado Springs Fine Arts Center, Colorado Springs, Colorado (hereafter Britzman Collection, CSFAC), c.5.83.

2. For examples of Russell's early imagery, see Warden, *C. M. Russell Boyhood Sketchbook,* and Dentzel, "The Roots of Russell."

3. Frederic G. Renner, *Charles M. Russell: Paintings, Drawings, and Sculpture in the Amon Carter Museum,* 43, 47.

4. Stewart, *Charles M. Russell,* 16; Stewart, *The Grand Frontier,* 4.

5. Dippie, *Looking at Russell,* 63, n. 51.

6. Stewart, *The Grand Frontier,* 4.

7. [Hoeber], "Cowboy Vividly Paints the Passing Life of the Plains," n.p.: "So vividly does [Russell] feel and know what he depicts that his work never fully satisfies him."

8. Other paintings in this series include *Cow-punching Sometimes Spells Trouble, When Cowboys Get In Trouble,* and *A Dangerous Situation.* See Dippie, *Remington and Russell,* 70–71, 118–19.

9. Brian W. Dippie, personal communication, November 20, 2008. According to Yost and Renner (comps., *A Bibliography of the Published Works of Charles M. Russell,* 240), the painting's first appearance in print as *A Strenuous Life* was in a series of stamps promoting western travel that was issued by the Great Northern Railway between 1914 and 1920, on stamp number 3 in the See America First Series. In *Cowboys of the Americas,* Richard W. Slatta quotes from an article addressing the virtues of the cowboy that appeared in the *Denver Republican* on December 9, 1890: "He breaks the savage and almost untamable [*sic*] ponies to the saddle, and then rides them. His work is swift and vigorous, and his charges are the great, strong, free bulls and cows that have never known the touch of the human hand. He lives and endures hardships with others of his kind, and his pleasures are as fierce as his work. His is the strenuous life" (186). Theodore Roosevelt made the phrase his own when he presented a speech titled "The Strenuous Life" at the Hamilton Club in Chicago on April 10, 1899. It was published in 1900 in Roosevelt's *The Strenuous Life: Essays and Addresses* (New

York: The Century Co.). As Peter Hassrick has noted, Roosevelt also extolled the virtues of the strenuous life in his book *The Wilderness Hunter* (New York: A. P. Putnam's Sons, 1900). See Hassrick, "Charles Russell, Painter," 70, 111 n. 9.

10. For a thorough discussion of Remington's influence on Russell, see Dippie, *Looking at Russell,* 11–52.

11. Taliaferro, *Charles M. Russell: The Life and Legend of America's Cowboy Artist,* 97–99.

12. *Harper's Monthly,* September 1895, 602–17.

13. See Hassrick, *Charles M. Russell,* 45–46, 95–98, and Hassrick, "Charles Russell, Painter," 70.

14. Dippie, ed., *Charles M. Russell, Word Painter,* 3.

15. McCracken, *The Charles M. Russell Book,* 190–93. However, it was not a completely dry hole, as McCracken suggested. *Scribner's Magazine* published "Some Incidents of Western Life," illustrated with four reproductions after Russell and two pen-and-ink sketches by Will Crawford, in February 1905. For Russell's editorial contacts during this trip, see Stewart, *Charles M. Russell,* 34.

16. Stewart, *Charles M. Russell,* 34, 45; Adams and Britzman, *Charles M. Russell,* 168; Dippie, ed., *Charles M. Russell, Word Painter,* 4, 91–93; Austin Russell, *C. M. R.,* 153–59; and Cave, "Recreation Men IV," 11–13.

17. Stewart, *Charles M. Russell,* 35.

18. Peterson, *Philip R. Goodwin,* 21. As Peter Hassrick notes ("Charles Russell, Painter," 70), another positive influence on Russell's work around this time was the criticism contained in Kathryne Wilson's article "An Artist of the Plains," published in *Pacific Monthly* in December 1904.

19. Ibid. See also Hassrick, *Charles M. Russell,* 81–82.

20. Dippie, ed., *Charles M. Russell, Word Painter,* 81–82. See also Austin Russell, *C. M. R.,* 95–102, although the author incorrectly dates Charles and Nancy Russell's first trip to New York to 1903.

21. "Russell's Works at St. Louis Fair," *Great Falls Daily Tribune,* October 9, 1903, 8.

22. Charles M. Russell, "A Few Words About Myself," in *Trails Plowed Under,* xxix.

23. Frederic G. Renner remarks in *C. M. Russell Boyhood Sketchbook* that the artist's "visualization of the scene and action of a large painting was a slow process. He sketched over and over with a pencil the positions the figures and groups would assume in a picture. He said there were so many ways an object could be pictured that he tried them all in pencil on any scrap of paper at hand. He did sketching of figures and groups from memory and imagination. . . . Such action could be worked out best in small pencil sketches. . . . He could not remember when he was not drawing horses. . . . He liked to model little figures in wax. . . . The little models were helpful in determining desired form and lighting effects" (4). See also Stewart, *Charles M. Russell,* 25–26.

24. Taliaferro, *Charles M. Russell: The Life and Legend of America's Cowboy Artist,* 148, 159–60.

25. I thank Tom Petrie for drawing this comparison to my attention. For information on Remington's *A Critical Moment,* see Rattenbury, *The Art of American Arms Makers,* 25–26, 92–93.

26. For Russell's greater authenticity as a painter of the American West, see "Frank B. Linderman's Tribute to Russell the Cowboy Artist," *Great Falls Tribune,* October 21, 1956, 3, in which Linderman is quoted as stating that Remington "couldn't paint with Charlie Russell. Remington didn't know, and couldn't feel the West as Charlie did, because he wasn't part of it." See also Dippie, *Looking at Russell,* 35, for the relative dramatic intensity of Remington's and Russell's work. For a full discussion of the Remington-Russell "rivalry," see Hassrick, *Remington, Russell, and the Language of Western Art.*

27. Frederic G. Renner, *Charles M. Russell: Paint-*

ings, Drawings, and Sculpture in the Amon Carter Museum, 235.

28. See MacTavish, "The Last Great Round-Up," especially 26, 33. According to Austin Russell (*C. M. R.,* 221–23), "Peblo's [*sic*] riders were all either breeds or full bloods—a wild looking bunch."

29. Russell did not number his pictures of buffalo hunts; Frederic G. Renner assigned them numerical tags to make them easier to track and identify.

30. Stewart, *Charles M. Russell,* 287.

31. Nancy C. Russell to James Rankin, January 17, 1939 (Britzman Collection, CSFAC, c.10.321).

32. J. Frank Dobie notes Russell's genius as an interpreter of animal psychology in his essay "Charles M. Russell" in *An Exhibition of Paintings and Bronzes By Frederic Remington [and] Charles M. Russell,* n. p.

33. Malcolm S. Mackay to "My dear Mrs Russell" [Nancy C. Russell], October 1, 1915 (Britzman Collection, CSFAC, c.4.454).

34. Elofson, *Frontier Cattle Ranching,* 97–101, 164–66; Slatta, *Cowboys of the Americas,* 121–22.

35. Stewart, *The Grand Frontier,* 46.

36. See, for example, chapter 3, "Wild Days of the Seventies . . .," in Abbott and Smith, *We Pointed Them North,* 23–30. In *The Log of a Cowboy* (191–209, 258–74, 334–46, and elsewhere), Andy Adams recounts episodes of cowboy misbehavior. In a passage on p. 191, an experienced trail foreman advises the younger cowboys heading into Dodge City, Kansas, that "Dodge is one town where the average bad man of the West not only finds his equal, but finds himself badly handicapped. The buffalo hunters and range men have protested against the iron rule of Dodge's peace officers, and nearly every protest has cost human life. Don't ever get the impression that you can ride your horses into a saloon, or shoot out the lights in Dodge; it may go somewhere else, but it don't go there. So I warn you to behave yourselves. You can wear your six-shooters into town, but you'd better leave them at the first place you stop. . . . And when you leave town, call for your pistols, but don't ride out shooting; omit that." For the Virginian's high jinks, see Wister, *The Virginian,* 29–32. In *Ranch Life and the Hunting Trail,* Theodore Roosevelt notes that "[o]ne evening at Medora a cowboy spurred his horse up the steps of a rickety 'hotel' piazza into the bar-room, where he began firing at the clock, the decanters, etc., the bartender meanwhile taking one shot at him, which missed. When he had emptied his revolver he threw down a roll of bank-notes on the counter, to pay for the damage he had done, and galloped his horse out through the door, disappearing in the darkness with loud yells to the rattling accompaniment of pistol shots interchanged between himself and some passer-by who apparently began firing out of pure desire to enter into the spirit of the occasion" (91). See also Slatta, *Cowboys of the Americas,* 148–58.

37. Slatta, *Cowboys of the Americas,* 82–84, 93, 95–99, 101–103.

38. Despite the fact that Russell contributed illustrations to a 1911 edition of *The Virginian,* he was not a fan of the book. See Austin Russell, *C. M. R.,* 142–43. For his part, Wister did not especially admire Russell. For details of their professional relationship, see Dippie, " 'It Is a Real Business,' " 21, 23, 63, n. 48; and Dippie, "From Frog Lake to Saskatoon," 10–16. Nancy Russell's refusal to allow Wister to write the introduction for *Trails Plowed Under,* a compilation of her husband's stories published in 1927, is discussed in Cristy, *Charles M. Russell,* 221–22, and chronicled in her correspondence with H. W. Maule, an editor at Doubleday, Page & Company, in Britzman Collection, CSFAC, c.6.369, c.4.484, c.4.485, and c.4.486. I thank Brian W. Dippie for discussing this subject with me (personal communication, November 20, 2008).

39. Elofson, *Frontier Cattle Ranching,* 107–109; Dippie in this volume, 164–65, 185.

40. Dippie, *Looking at Russell,* 31–35; Dippie, *Remington and Russell,* 124.

41. Adams, *Cowboy Lingo,* 60, 43. Russell's preference for "dally men" is stated in an undated note to Joe De Yong, De Yong/Flood Collection, box 008, folder 029. The terms are also defined in Blevins, *Dictionary of the American West,* 114–16, 215. Rick Stewart clearly explains the entire situation in the painting in *The Grand Frontier,* 51.

42. Adams, *Cowboy Lingo,* 43, 60.

43. See Slatta, *Cowboys of the Americas,* for a detailed account of the cowboy's multicultural origins.

44. Ibid., chapter 3, "Cowboy Character and Appearance," 28–54; Elofson, *Frontier Cattle Ranching,* 112–14. More discussion of the topic can be found in Rollins, *The Cowboy,* 103–73, and Clayton, Hoy, and Underwood, *Vaqueros, Cowboys, and Buckaroos.* Russell himself had more than a few words to say on the subject; see, for example, his "The Story of the Cowpuncher," *Trails Plowed Under,* 6.

45. Hough, *The Story of the Cowboy,* 50–69.

46. [Hoeber], "Cowboy Vividly Paints the Passing Life of the Plains," n. p.; Dippie, ed., *Charles M. Russell, Word Painter,* 4.

47. Elofson, *Frontier Cattle Ranching,* 81–95, 63–74; Slatta, *Cowboys of the Americas,* 45–46; Hough, *The Story of the Cowboy,* 233–35; Stewart, *Charles M. Russell,* 143.

48. Hough, *The Story of the Cowboy,* 272–99. See also Elofson, *Frontier Cattle Ranching,* chapter 6, "Rustling," 81–95.

49. Austin Russell, *C. M. R.,* 170–71; Abbott and Smith, *We Pointed Them North,* 86–89, 143. In many of his pictures, Russell depicted specific, recognizable brands on horses and cattle. He also personalized works for some patrons in this fashion. See, for example, Nancy Russell's letter of November 21, 1919, in response to James W. Bollinger's request that Russell put a Circle S brand on a horse: "I have ordered a new frame for a 'Dangerous Cripple' and Chas. is branding the horse today so it will be O.K.

for you by Christmas" (Britzman Collection, CSFAC, C.3.210 and C.2.98).

50. Hough, *The Story of the Cowboy,* 295–97. See also Joe De Yong's manuscript, "Worked Over Brands," which devolves into a denunciation of plagiarism, in De Yong/Flood Collection, box 009, folder 011.

51. Hough, *The Story of the Outlaw,* 160–64.

52. As Dippie notes (*Looking at Russell,* 45), Remington's *What an Unbranded Cow Has Cost,* which was published by *Harper's Monthly* in September 1895 as an illustration for Owen Wister's "The Evolution of the Cow-Puncher," was known to Russell and influenced his painting *Bested* of the same year.

53. Stuart also wrote the text for an edition of *Studies of Western Life,* a selection of reproductions of Russell's early oils. For Stuart's version of his involvement in vigilantism, see Stuart, *Forty Years on the Frontier,* vi, x–xiii, 195–210. Milner II and O'Connor provide a more thorough and reliable account of Stuart's vigilante activities in *As Big as the West,* 219–48. Milner and O'Connor (*As Big as the West,* xiv) compare Stuart to the hero of Owen Wister's *The Virginian,* whose enforcement of vigilante justice extends to his execution of his own best friend, which was one of the aspects of the novel that Russell found objectionable (Austin Russell, *C. M. R.,* 142). Stuart's justification for his vigilantism is also very similar to that of the Virginian's employer, Judge Henry, a former federal judge (no less) who feels forced by government incompetence and venality to take the law into his own hands (see Wister, *The Virginian,* especially 336–41). McCracken describes Stuart's leadership of "an armed party of 150 cowboys and cattlemen in destructive warfare against horse thieves and cattle rustlers" in the Judith Basin in 1884 (*The Charles M. Russell Book,* 90–91).

54. Roosevelt, *Ranch Life and the Hunting Trail,* 114–15.

55. Hough, *The Story of the Outlaw,* 155.

56. Roosevelt, *Ranch Life and the Hunting Trail,*

111–29; Elofson, *Frontier Cattle Ranching*, 66; Nancy C. Russell to Dr. Philip G. Cole, July 1929, Britzman Collection, CSFAC, c.5.491; Hough, *The Story of the Outlaw*, 202–203.

57. Historians disagree on Big Nose George's surname. For a concise account of Parrott's career and the grisly saga of his human remains, see Carl W. Breihan, "Big Nose George Parrott," in *The Branding Iron* (Los Angeles: Los Angeles Westerners Corral, 1955) 2, 6. I thank Tom Petrie for sharing his archive of articles on Big Nose George with me.

58. Stewart, *The Grand Frontier*, 29.

59. Bruce, "Charles Russell's Home Turf," 130.

60. Hassrick, *Charles M. Russell*, 62–66.

61. Dippie, *Remington and Russell*, 100.

62. See Dippie, ed., *Charles M. Russell, Word Painter*, 51. As Dippie notes ("'It Is a Real Business,'" 49), it is ironic that the original owner of *Wolf and the Beaver* was Edward L. Doheny, a central figure in the Teapot Dome scandal of the early 1920s. Doheny and his confederates hatched and nearly succeeded in a scheme to appropriate the U.S. Navy's petroleum reserves in Wyoming and California for their private exploitation, an example of the kind of lawless behavior that Emerson Hough believed was fostered by the frontier notion that natural resources in the West were "free." See Laton McCartney, *The Teapot Dome Scandal* (New York: Random House, 2008).

63. For just one example among many, see Russell's letter to Edward "Kid" Price of June 1, 1917, in which the artist relates the experience of his friend Henry Keeton, who "leesed his ranch to an honest prohibition farmer. and while Hanks in town shovling coal in the furnis and sweeping of the frunt porch, Mr Prohibit is busy mooving Hanks ranch. he dont get the fences caus the posts are froze down, but every thing thats loos like stoves, harness oats, tools, was his he eaven rounded up the china nest eggs that Henry had to fool the hens with. all this goes to pruve that this Honest Prohibition-

ist would take aney thing but a drink" (Dippie, *Charles M. Russell, Word Painter*, 1).

64. Wister, "The Evolution of the Cow-Puncher," 52–53.

65. Hough, *The Story of the Cowboy*, 298–99.

66. See Slotkin, *Gunfighter Nation*, 127–39, 143–46.

67. Absolute proof that Russell knew *Rob Roy* is lacking, but Brian Dippie notes that "Russell's taste in fiction ran to western adventures and the historical romances of Alexander Dumas, James Fenimore Cooper, Gilbert Parker, Lew Wallace, Mayne Reid, and Sir Walter Scott" (Dippie, *Looking at Russell*, 94).

68. See, for example, "French Exhibition of Works of Art," *The Boston Daily Atlas*, May 24, 1847, 2. In describing Théodore Gudin's *Jacques Cartier Discovering the St. Lawrence*, the newspaper's Paris correspondent remarks "that the feature of the picture, for which the rest is but a frame-work, is a conical rocky island, rising directly up in the centre, on which stand, like the supernumeraries, when the chieftain whistles in *Rob Roy*, a dozen Indians."

69. Dunlay, *Kit Carson and the Indians*, 24–25.

70. Wister, "The Evolution of the Cow-Puncher," 50.

71. Cristy notes that Landusky in north central Montana, where Russell set his story "Johnny Reforms Landusky" (*Trails Plowed Under*, 79–81), was described "as being the center of a wild, lawless border country, far removed from the more civilized sections of Montana" ("Finding Modern Times in Charlie's Published Writings," 155).

72. Elofson, *Frontier Cattle Ranching*, 82–84, 92–94; Slatta, *Cowboys of the Americas*, 67; Stuart, *Forty Years on the Frontier*, 224–25.

73. Dippie, ed., *Charles M. Russell, Word Painter*, 2.

74. Paul F. Sharp, *Whoop-Up Country*, 3–9, 43–46; Frederic G. Renner, *Charles M. Russell: Paintings, Drawings, and Sculpture in the Amon Carter Museum*, 231 overleaf.

75. Dippie, *Remington and Russell*, 106. The central part of the composition is derived from

one of Frederic Remington's illustrations for Roosevelt's *Ranch Life and the Hunting Trail* (Dippie, *Looking at Russell,* 15–16).

76. Hassrick, *Charles M. Russell,* 121.

77. See Frost, *The Custer Album,* 10.

78. Some examples are listed in Adams and Britzman, *Charles M. Russell,* 289, 311.

79. Dippie notes this connection (*Looking at Russell,* 57–60).

80. Elofson, *Frontier Cattle Ranching,* 3–5, 81–95, 63–80, 186–88. The older view is expressed in Slatta, *Cowboys of the Americas,* 109, 145–46, 170, 201. See also Dippie, "One West, One Myth," 533–34, n. 10.

81. Dippie, *Looking at Russell,* 4–5; Price, ed., *Charles M. Russell: A Catalogue Raisonné* (subscription-only Web-site reference number CR.PC.476); Taliaferro, *Charles M. Russell: The Life and Legend of America's Cowboy Artist,* 215.

82. Hassrick, *Remington, Russell, and the Language of Western Art,* 108.

83. Taft, *Artists and Illustrators of the Old West 1850–1900,* 347, n. 2; "Caught in the Act," 340.

84. Taliaferro, *Charles M. Russell: The Life and Legend of America's Cowboy Artist,* 187, 293, n. 2. In this regard, one can't help but note the contrast between *Caught in the Act* and an illustration by Frederic Remington, *Arrest of a Blackfeet Murderer,* that appeared in *Harper's Weekly* on March 31, 1888, just six weeks before Russell's image was published. In Remington's picture, there is no question that the soldiers whose galloping horses flank that of the accused party are in the right, nor does the viewer doubt that the artist's sympathies lie with them. See Hassrick, *Remington, Russell, and the Language of Western Art,* 107–108, and Hassrick, "Charles M. Russell, Painter," 75.

85. Regarding Russell's depiction of the distress of the Indians of Montana in the late nineteenth and early twentieth centuries, see Brian Dippie's essay in this volume. See also Cristy, "Charlie Russell's Hidden Agenda."

86. Russell's claim to have "lived six months with the Blackfeet" has been shown to be false. See Dempsey, "Tracking C. M. Russell in Canada, 1888–1889." However, during the summer of 1888, Russell did indeed "make his first sustained contact with Indians while in Alberta, and visited in their camps, listening to stories about life long ago. The Blackfeet, Sarcee, and Stoney reserves were in close proximity to High River to the north, while the Bloods and Piegans often passed through on visits from the reserves to the south" (Dippie, "Charles M. Russell and the Canadian West," 6).

87. Wilson, "An Artist of the Plains," 343.

88. Adams and Britzman, *Charles M. Russell,* 99–101, 323.

89. Dippie, ed., *Charles M. Russell, Word Painter,* 3.

90. Taliaferro, *Charles M. Russell: The Life and Legend of America's Cowboy Artist,* 54, 135.

91. Ibid., 14–16; Austin Russell, *C. M. R.,* 19–26; Mac, "The Heritage of Charlie Russell," 9–10; Brian Dippie, personal communication, March 24, 2009. As Dippie points out, Russell's motives may not have been entirely political: the Cowboy Artist believed the sash "would keep his waistline in check" (*Charles M. Russell, Word Painter,* 3). In a letter to Paul Eldridge of November 10, 1914 (Petrie Collection, Denver), Joe De Yong described the sash as "one of those knit sashes like you see in pictures of Mexicans."

92. See Lisa Strong, *Sentimental Journey: The Art of Alfred Jacob Miller* (Fort Worth, Tex.: Amon Carter Museum, 2008), 129.

93. Taliaferro, *Charles M. Russell: The Life and Legend of America's Cowboy Artist,* 79.

94. Hassrick, *Remington, Russell, and the Language of Western Art,* 99.

95. Other pictures in the series, which Russell may have begun as early as 1889 (Brian Dippie, personal communication, February 16, 2009), include an oil from about 1896, now in the Petrie Collection, Denver, and a watercolor of 1899,

which, according to Rick Stewart (personal communication, May 18, 1993), may have been a Christmas gift from Russell to his wife (see photograph, Britzman Collection, CSFAC, D.5.112).

96. Nancy C. Russell, "Descriptions of Photographs Sent Dr. Cole/May 14, 1930" (Britzman Collection, CSFAC, C.5.505); "Her Heart Is on the Ground" (Britzman Collection, CSFAC, C.8.158).

97. Honour, *The European Vision of America*, 210.

98. "Descriptions of Photographs Sent Dr. Cole/May 14, 1930" (Britzman Collection, CSFAC, C.5.505); "Her Heart Is on the Ground" (Britzman Collection, CSFAC, C.8.158).

99. Brian Dippie, personal communication, October 22, 2008.

100. *Montana The Magazine of Western History* 52 (Winter 2002): 1.

101. Ginger K. Renner discusses *In the Wake of the Buffalo Runners* in "Charlie and the Ladies in His Life," 150. I thank her for sharing her insights on the painting with me in personal conversations and formal presentations.

102. Richard White, *It's Your Misfortune and None of My Own: A New History of the American West* (Norman: University of Oklahoma Press, 1991), 620–21. See also William E. Rebsame, ed., *Atlas of the New West: Portrait of a Changing Region* (New York: W. W. Norton, 1997).

103. Stewart, *Charles M. Russell*, 17.

104. McCracken, *The Charles M. Russell Book*, 141.

105. Adams, *The Log of a Cowboy*, 348–49.

106. Abbott and Smith, *We Pointed Them North*, 119.

107. They also discharged their firearms for another reason, according to a letter Nancy Russell wrote to Philip Cole on January 30, 1931: "In old times, an Indian would not be allowed to enter a stockade with a loaded gun so as they rode towards the stockade, they would empty their guns in the air as a salute of friendship" (Britzman Collection, CSFAC, C.5.518).

108. For the history of the Blackfeet trade at Fort MacKenzie, see Lepley, *Blackfoot Fur Trade on the Upper Missouri*, 92–143. See also William H. Goetzmann, *Exploration and Empire: The Explorer and the Scientist in the Winning of the American West* (New York: Alfred A. Knopf, 1966; repr., New York: W. W. Norton, 1978), 105–45.

109. Dippie, "Two Artists from St. Louis," 30–31.

110. Ginger K. Renner, "Piegans," in *The Coeur d'Alene Art Auction*, Lot 116, n.p. (Reno, Nev.: Coeur d'Alene Art Auction, July 30, 2005). Renner's source for this information is Iron Eyes Cody, *How: Sign Talk in Pictures* (Hollywood, Calif.: Homer H. Boelter Lithography, 1952). I thank Brian Dippie for pointing out the complexities of the action in *Piegans* to me (personal communication, February 16, 2009).

111. Lee Silliman summarizes the various phases of Russell's color in "The Cowboy on Canvas," 41, 43–44.

112. In a 1919 newspaper article about an exhibition of Russell's work in Minneapolis, he is quoted as stating that "Maxfield Parrish, I reckon, is my favorite painter. . . . He's kind of fancy but he can draw. I like his bright colors. My own colors are kind of stout." See Dippie, *Looking at Russell*, 69, and Taliaferro, *Charles M. Russell: The Life and Legend of America's Cowboy Artist*, 238. Russell also expressed his admiration for Parrish in "Just Kinda Natural to Draw Pictures, I Guess, Says Cowboy Artist in Denver to Exhibit Work," *Rocky Mountain News*, November 27, 1921, n.p.

113. *Collier's*, December 3, 1904.

114. Hassrick, *Charles M. Russell*, 139.

115. Ibid., 130. See also Silliman, "The Cowboy on Canvas," 42.

116. [Hoeber], "Cowboy Vividly Paints the Passing Life of the Plains," n.p.

117. Dippie, ed., *Charles M. Russell, Word Painter*, 71; Will Crawford to Homer E. Britzman, June 9, 1941, Britzman Collection, CSFAC, C.10.310. William Glackens and most of his

fellow Ashcan artists were newspaper illustrators who moved from Philadelphia to New York around the turn of the century for the same reason Russell visited the city in 1904: to find more outlets for their illustrations and advance their careers as fine artists. From 1898 to 1911, Russell exhibited at New York's Macbeth Galleries, which was the venue for the first (and only) group exhibition of the works of the Ashcan group, also known as The Eight, in 1908. Glackens frequently exhibited at Macbeth in later years. Glackens and the other members of the group painted all facets of modern life and made a particular specialty of representing athletic activities ranging from polo, tennis, and golf to professional boxing and wrestling. In other words, they depicted the urban version of Theodore Roosevelt's "strenuous life," and they were praised by critics for presenting a virile alternative to the "feminine" refinements of the academic art of the period. See Zurier, Snyder, and Mecklenburg, *Metropolitan Lives*, 64–66, 73–74, and 203–205; and Tottis et al., *Life's Pleasures*, 36–39, 149–50, 198.

118. Peggy Samuels, Harold Samuels, Joan Samuels, and Daniel Fabian, *Techniques of the Artists of the American West* (Secaucus, N.J.: Wellfleet Press, 1990), 189. In a note to his pupil Joe De Yong, Russell wrote, "I think its better to work all over your picture—not finish one figer and then another it rests you" (quoted in Hassrick, *Charles M. Russell,* 116).

119. "Charlie Russell, Montana's Cowboy Artist," *Butte Evening News,* Christmas Number, 1905, section 2, 9.

120. After Russell's death, Parrish opened up his work to a certain degree; he painted more landscapes, but these were as overtly artificial as his early pictures. See Ken Johnson, "Kitsch Meets the Sublime," *Art in America,* March 1996, 80–83.

121. For an entertaining history of the entire phenomenon, see Girouard, *The Return to Camelot.*

122. Old King Cole and his retinue were moved to the St. Regis Hotel on East Fifty-fifth Street off Fifth Avenue in the 1930s. See Glenn Collins, "King Cole, a Grimy Old Soul, Heads for a Cleaning," *New York Times,* January 17, 2007, A20; Glenn Collins, "King Cole is Cleaner; Pipe and Bowl Are Next," *New York Times,* March 27, 2007, C12.

123. See Lawrence S. Cutler, Judy Goffman Cutler, and the National Museum of American Illustration, *Maxfield Parrish and the American Imagists*, 300–301, and Yount, *Maxfield Parrish,* 95. One can't help remarking the fact that major paintings by Parrish were on permanent view in bars in New York and San Francisco, just as many of Russell's works were displayed in saloons in Great Falls. See Devore, "Saloon Entrepreneurs of Russell's Art."

124. For an excellent, concise description of this painting, see Stewart, *The Grand Frontier,* 42.

125. Silliman describes the disposition of figures in Russell's trailing compositions as a "wedge," "a triangular arrangement" in which "the dominant character is nearest to the foreground [,] and the supporting figures behind . . . [lead the eye] back into the distance" (Silliman, "The Cowboy on Canvas," 42). Dippie has noted the similarity between Russell's trailing compositions and Orientalist depictions of caravans (*Looking at Russell,* 95). Another possible source is the chromolithograph drawn by R. T. Bishop after John Mix Stanley's painting *On the War Path*, published by the Calvert Lithographing Company, Detroit, in 1872. See Marzio, *The Democratic Art*, 79–82 (the chromolithograph is reproduced on p. 81).

126. I thank James McNutt for drawing this to my attention. See Slatta, *Cowboys of the Americas,* 130–31.

127. In 1876, Russell's bas-relief of a knight in armor won a blue ribbon at the St. Louis Agricultural and Mechanical Fair (Stewart, "Modeling in Clay, Plaster, and Wax," 118). See

Dippie, ed., *Charles M. Russell, Word Painter,* for examples of Russell's many illustrated letters and watercolors with chivalrous and Arthurian subjects.

128. See Dippie, *Looking at Russell,* 94–95. I thank Brian Dippie for discussing his research on the artist's library and Russell's taste in books with me.

129. Quoted by Dippie in "In the Enemy's Country," 14.

130. Dippie, "In the Enemy's Country," 15.

131. Dippie, *Charles M. Russell and the Art of Counting Coup,* 9.

132. The story was reprinted in Russell, *Trails Plowed Under,* 177–86. See also Cristy, *Charles M. Russell,* 59–65. Hugh A. Dempsey points out some inconsistencies in Russell's accounts of his audience with Medicine Whip and questions whether the warrior was a real person or the artist's literary creation ("Tracking C. M. Russell in Canada, 1888–1889," 224–25).

133. "The Treasures of Gilcrease," double special issue, *American Scene* 3, nos. 28–29 (1978): 66.

134. "The War Scars of Medicine Whip," in Russell, *Trails Plowed Under,* 184–86; Dippie, *Charles M. Russell and the Art of Counting Coup,* 10.

135. Taliaferro, "Charles M. Russell and 'Piano Jim,'" 58–61.

136. Paxson, *E. S. Paxson,* 87.

137. Cristy, "Finding Modern Times in Charlie's Published Writings," 141–71.

138. "Friend Joe," Charles M. Russell to Joe De Yong, September 6, 1922, De Yong/Flood Collection, box 008, folder 009.

139. Philip G. Cole to Charles M. Russell, May 11, 1926 (Britzman Collection, CSFAC, c.5.132).

140. See Paul S. Sutter, *Driven Wild: How the Fight Against Automobiles Launched the Modern Wilderness Movement* (Seattle: University of Washington Press, 2002).

141. Russell's paintings of cowboys roping grizzlies include *Capturing the Grizzly* (1901),

Loops and Swift Horses Are Surer Than Lead (1916), and *The Stranglers* (1920). Russell's watercolor *Roping a Grizzly* (1903) was exhibited at the Louisiana Purchase Exposition in 1904 as *Roping a Rustler.* Cowboys roping wolves figure in Russell's early, bracingly rustic *Cowboy Sport—Roping a Wolf* (1890) and the later, oddly elegant *Fatal Loop* (1912). According to Ginger K. Renner, Russell depicted "the act of two or three cowboys trying to rope a wild wolf" in "more than twenty [compositions] in both watercolor and oil" (*The Coeur d'Alene Art Auction,* Lot 100, 84 [Reno, Nev.: Coeur d'Alene Art Auction, July 26, 2008]).

142. Gelo, "The Bear," 133, 142–44, 148, 150–51.

143. Devore, "Saloon Entrepreneurs of Russell's Art."

144. Frederic G. Renner, *Charles Marion Russell, Greatest of All Western Artists,* 16; Stewart, *Charles M. Russell,* 34–35.

145. Ernest Thompson Seton, *Biography of a Grizzly* (New York: Century, 1900), quoted in Gelo, "The Bear," 151, 153.

146. Stewart, *Charles M. Russell,* 197–200, 226–29, 274–76, 291–94, 308–11. In "Modeling in Clay, Plaster, and Wax," Stewart notes that "Russell often maintained that bears were like humans" (131), a belief that was not uncommon. See Gelo, "The Bear," 134–35.

147. This letter, written a month before Russell's death, was produced after repeated—and, in retrospect, highly insensitive—requests from Cole, including a letter to Nancy Russell of July 1, 1926, in which he twice states his disappointment that "Charley has not seen fit to send me the water color illustrated letter that was promised" (Britzman Collection, CSFAC, c.5.129).

148. John James Audubon, *Writings and Drawings* (New York: Penguin Putnam, 1999), 262–67 (the quotation is on p. 263); Catlin, *Letters and Notes,* 1:249, 261.

149. Parkman, *The Oregon Trail,* 124–25.

150. Another precedent for *When the Land Belonged to God* in Wimar's work is *Buffaloes Crossing the Yellowstone* (1859). See Dippie, "Two Artists from St. Louis," 27–28.

151. Taft, *Artists and Illustrators of the Old West,* 16.

152. Ibid., 47–48; Barsness, *The Bison in Art,* 60–61.

153. Brian Dippie, personal communication, February 16, 2009.

154. Russell saw a similar scene at the Pablo-Allard roundup, during which the bison were driven into the Pend d'Oreille River: "[The] buffaloes rush headlong into this unfamiliar element, snorting and blowing, and almost obscuring themselves in a mass of foam and spray. . . . The swift current carries the whole herd down a hundred feet below the chute. . . . Now, however, they are crawling out on the opposite shore . . . dripping wet and panting as if almost spent" (MacTavish, "The Last Great Round-Up," 26).

155. Britzman Collection, CSFAC, C.5.390.

156. Britzman Collection, CSFAC, C.5.527. For a fuller description of Indian legends related to *The Spirit of Winter,* see Stewart, *Charles M. Russell,* 86, 303–305.

157. In *Winter,* an illustration for George T. Marsh's "The Moods," published in *Scribner's Magazine* in December 1909, N. C. Wyeth depicted an Indian in billowing drapery standing on an icy mountaintop that is somewhat similar in form to *The Spirit of Winter.* See Jennings, *N. C. Wyeth,* 31; and Douglas Allen and Douglas Allen, Jr., *N. C. Wyeth,* 58, 61.

158. Dryfhout, *The Work of Augustus Saint-Gaudens,* 189.

159. Stewart, *Charles M. Russell,* 85–86, 312–13.

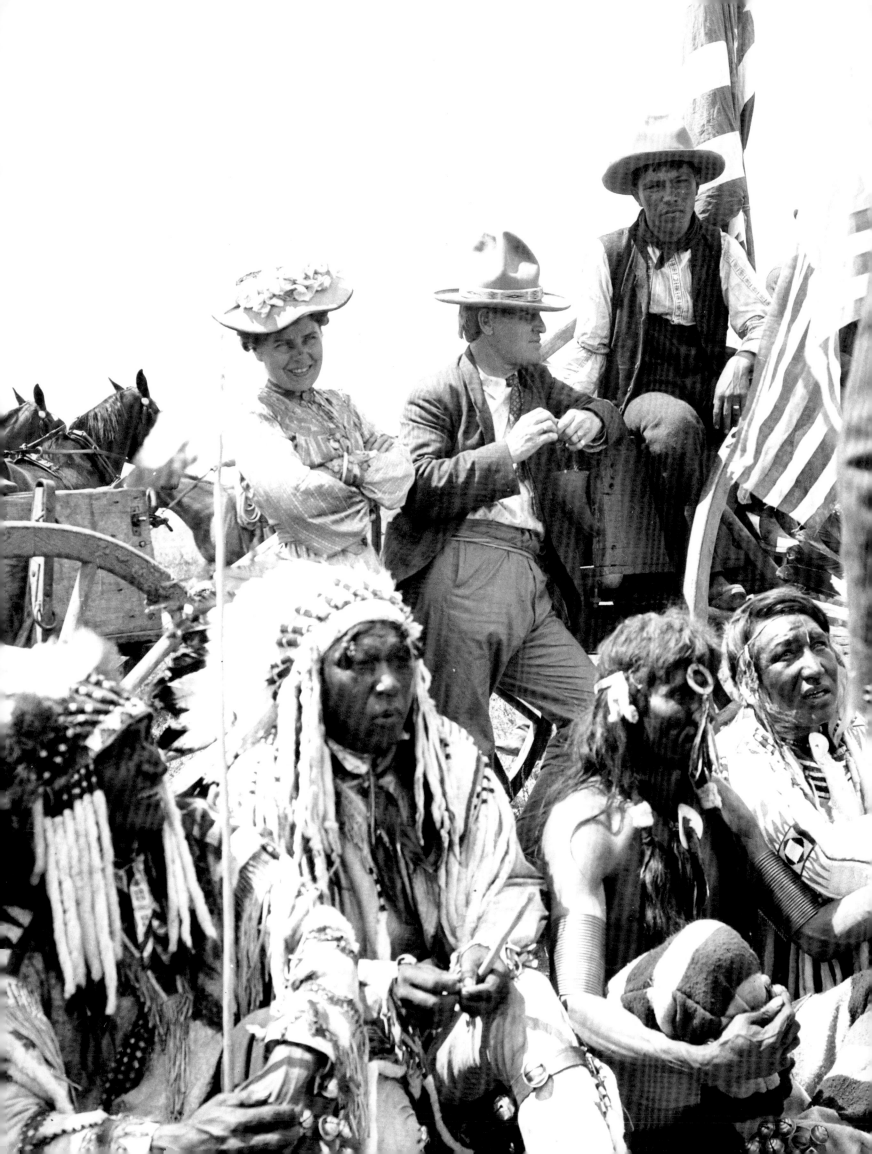

George P. Horse Capture, Sr.

Memories of Charles M. Russell among My Indian Relatives

WHEN WHITE MEN FORCIBLY brought the exclusive Native occupancy of this country to an end in what would become the state of Montana, they used the mighty Missouri River as their vehicle. Some did trek into the "wilderness" of Montana on foot or horseback, but keelboats and steamboats hauled tons of people and supplies to the interior at every opportunity, accelerating the invasion. The Native people often followed the course of the waterway as well, so most tribes of the region became familiar with the "fireboats" and their passengers, "the White Eyes."

Many of the early travelers to this region recorded their colorful impressions of the people and countryside they encountered, and we admire their artistic and historiographic gifts to this day. We all know Lewis and Clark used the river (1804–1806), as did the artists George Catlin (1832), Karl Bodmer (1833–34), John James Audubon (1840s), Rudolph F. Kurz (1851), and John Mix Stanley (1853), among others. From its headwaters at Three Forks to its confluence with the Yellowstone River at Fort Union in the east, the Missouri crosses most of the state, and in its course it passes within sight of the Fort Belknap Indian Reservation, established in 1888, where I was born. It appears that none of these travelers left any lasting memories among our tribes, with one exception: there are still earthy stories of the unforgettable Charles Marion Russell, who first came our way in 1880.

The sixteen-year-old adventurer from Oak Hill, Missouri, must have realized his boyhood dreams of the romantic West and its "Cowboys and Indians" when, with family friend Wallis L. W. "Pike" Miller, he at last broke away from home and made his way west. With the subsequent work of the successful C. M. Russell proliferating everywhere in the western art market today, one might easily believe he is still in his Great Falls studio with his wife, Nancy, cranking out his great artwork, but he died more than eighty years ago. When we place him in his true historical framework, we can more fully appreciate him and his contributions.

We must remember that when Russell started out for Montana, the so-called Indian wars were still taking place, and Montana and the surrounding territories had not yet achieved statehood. Chief Sitting Bull would surrender one year after Russell arrived in Montana, and ten years later the U.S. Army inflicted unspeakable horrors upon the Indian people in the

(facing)
SUMNER W. MATTESON
(AMERICAN, 1867–1920)
Nancy C. Russell and Charles M. Russell at Fort Belknap Reservation, 1905 (detail)
Glass plate, 3 × 4 inches, Milwaukee Public Museum, Milwaukee, Wisconsin (M112049)

★ Reservation Agency

*Map of Fort Belknap
Indian Reservation,
Montana*
Montana State Library,
Helena

massacre at Wounded Knee. Forced onto reservations, with the buffalo nearly exterminated, the Indian people saw their traditional life and freedom become but a fading dream. The stockman's phase of conquest closely followed that of the explorer, fur trapper, and miner, allowing cowboys and others to move west for their life's adventures, including C. M. Russell.

Time and technology ushered in drastic changes, creating great confusion for everyone. Although the Missouri River still flowed, different modes and routes of transportation replaced standard steamboat travel. Russell and Miller rode trains from back east to Red Rock, Montana Territory, then took a stagecoach to Helena, and finally rode horseback to the Judith region in central Montana, where the large stockman outfits grazed their cattle. The herds would eventually be moved north across the Missouri River to the Milk River country for better grazing, bringing them closer to the Fort Belknap Indian Reservation, whose northern border is the Milk River. This was the home of my tribe, the A'aninin Gros Ventre and the Assiniboine.

Whether for recruiting purposes, security, or as a good-neighbor policy, the stockman had relationships with the Indian people. Given Russell's lifelong romantic attraction to the Native people of the West, it was inevitable that Russell, the young cowboy and budding artist, would seek them out and have exchanges with them. Our memories of some of these exchanges survive to this day. One of the most striking visual depictions of these meetings is Russell's painting of Powder Face, casually astride his pony, in full dress highlighted by a Gros Ventre hairstyle. An Arapaho by birth, Powder Face married a Gros Ventre woman and moved north to Fort Belknap, where they settled. The highly respected Powder Face had no difficulty at his new home because the Arapaho and the Gros Ventre had come from the same tribe several hundred years ago, and he eventually became the reservation's chief of police. Russell probably did many paintings on this reservation, but we cannot be sure how many; when the subjects are not named (as some of his are not), it can be difficult to differentiate between the various Northern Plains tribes.

Tribal ways are nearly impossible to maintain in this world of electronic gadgets and de-stroyed traditions, but no one questions the fact that Charlie Russell visited our reservation many times. The oral tradition says that he would come and visit my great-grandfather Horse Capture, the one who was later photographed by the famous Edward S. Curtis. The stories say that when Russell came, he would visit the old man, who lived in the southern part of the reservation. He would visit in the hot summer and they would sit together on the northern side of the house, where it is coolest, and sign-talk with each other. Russell was quite good at sign-talking. They would spend hours there smoking, talking, laughing, and telling old stories. My eldest son, George Junior, who keeps our sacred tribal pipe, says he hears stories that Horse Capture's brother, named Thick, received many postcards from Russell and placed them around the edges of his mirror for safekeeping. Soon after my great-grandfather Thick passed away, the relatives wondered whatever happened to those pretty, colorful postcards that had pictures of Indians painted on them. They were gone too.

No doubt Russell visited most of Montana, particularly the Blackfeet and Gros Ventre country, and he met every outsider VIP that came his way. Back then every outsider of note seemed to know each other, forming a social network. In 1905, several of them gathered in Great Falls, where Russell lived, to prepare to attend a large Sun Dance on the Fort Belknap Reservation.

EDWARD S. CURTIS
(AMERICAN, 1868–1952)
Horse Capture—Atsina,
1909
Paper and ink photogravure,
17½ × 12⅛ inches, *The North American Indian,* vol. 5,
plate 170 (Cambridge, Mass.:
The University Press, 1909),
Denver Art Museum, Denver,
Colorado, Native Arts acquisition funds (1937.428.10.24)

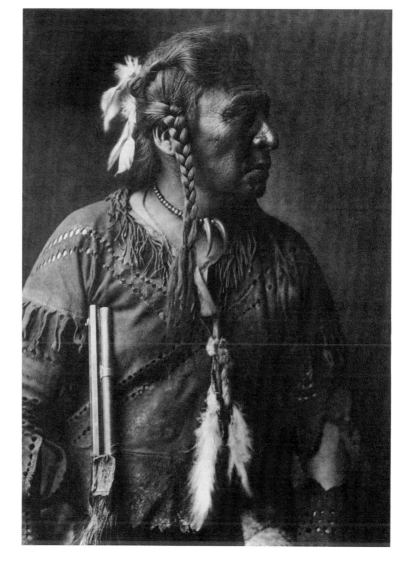

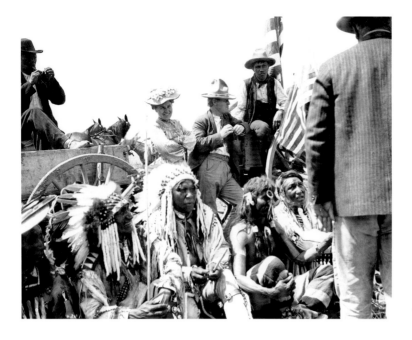

Major Logan, superintendent of Fort Belknap, invited Russell and a number of others to witness the exciting ceremonies, including an itinerant photographer from Milwaukee named Sumner Matteson and a government official named John G. Carter. Fortunately both Matteson and Carter recorded their experiences in photographs or the written word.

There are several photographs of Russell and his wife watching the Sun Dance and one of Russell riding with Major Logan. The camera also captured several images of an elder "Buffalo Indian" who called himself, among other things, Bill Jones. There is a story of how a full-blooded Indian carried a non-Indian name; but there are many stories about names. Although Bill Jones is now but a vague memory, he does have quite a history. Frank Bird Linderman wrote a fictionalized version of Bill Jones's life called "Wolf and the Winds" in 1935, but his real story is much more interesting.

SUMNER W. MATTESON
(AMERICAN, 1867–1920)

Nancy C. Russell and Charles M. Russell at Fort Belknap Reservation, 1905

Glass plate, 3 × 4 inches,
Milwaukee Public Museum,
Milwaukee, Wisconsin (M112049)

John G. Carter spent some time at Fort Belknap and kept a diary in which he recorded aspects of Indian life that are little known today. On page 302 of the "Fort Belknap Notes" in his diary, he writes:

Bill Jones Son of a Bitch.
An aged Gros Ventre whose real name was Ice. The cowboys gave him the name of Son of a Bitch as a joke, and he was very proud of his white name, and would

SUMNER W. MATTESON
(AMERICAN, 1867–1920)

Charles M. Russell and Major Logan, Superintendent of Fort Belknap, 1905

Glass plate, 5 × 7 inches,
Milwaukee Public Museum,
Milwaukee, Wisconsin (M44031)

repeat it on all occasions with pleasure regardless of the company he was in. Bill was reputed to be very old, and said he remembered seeing the first steamboat come up the Missouri River when he was a young man. But he said he felt young again when he mounted a horse. The first steamboat into Fort Benton, from Fort Union at the mouth of the Yellowstone, was in 1859, which was fifty years before [that is, fifty years before the date when Carter was writing, 1909]. That would not make Bill any Centenarian by any means, and many of these Indians look much older than they really are, and none of the old time Indians have a very good head when it comes to remembering time. Charlie Russell, the cowboy artist, who punched cows (he was really a night wrangler, or night herd) for Kaufman in this part of the country told me of an incident with Bill Jones. One day Charlie said he was riding across the Reservation, and a rain came up. He saw a lodge ahead of him, down in a small valley, so he rode up to it, dismounted, announced himself at the door by a couple of coughs, and when told to enter, went in and took the seat that the owner seated in the rear of the lodge pointed out to him. He said how, and the owner, Bill Jones, said how. The rain continued for some time, and Charlie took out his paint box and brushes, and

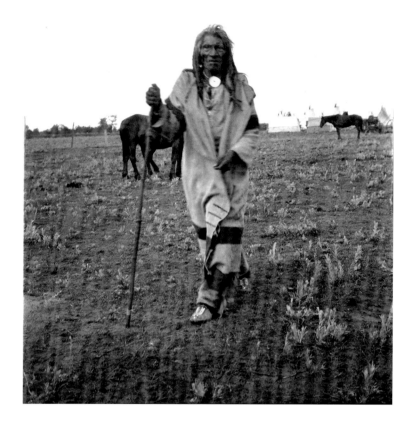

SUMNER W. MATTESON
(AMERICAN, 1867–1920)

Bill Jones (A'aninin [Gros Ventre Indian]) Walking,
1905
Glass plate, 3 × 4 inches,
Milwaukee Public Museum,
Milwaukee, Wisconsin (M112069)

did a water color of Bill Jones to pass the time. When he finished the water color Bill reached out, and Charlie handed it to him. Bill examined the work closely, and then pointed to some brass beads on a braid of hair on the left side of the painting, and to the same braid on the left side of his head, and explained by signs to Charlie that he had only three beads there in the painting, whereas Bill actually had five beads in that braid of hair. Charlie corrected the error at once, and gave the painting to Bill as a present. As it had stopped raining, Bill and Charlie shook hands, and Charlie mounted his horse and went on his way. A year later, Charlie continued, he was again passing over the reservation, and passed a lodge. Out of the lodge stepped Bill Jones Son of a Bitch and beckoned to Charlie, making signs for him to dismount and come into his lodge. Charlie had forgotten all about the painting he had made of Bill. When seated, Bill signed to one of the women, who brought out a large bundle that looked like a medicine bundle to Charlie. It was carefully unwrapped by Bill. The wrappings were fur, pieces of felt cloth, and other wrappings valued by Indians. The final wrapping revealed a board on which was tacked Charlie's watercolor of Bill. Bill

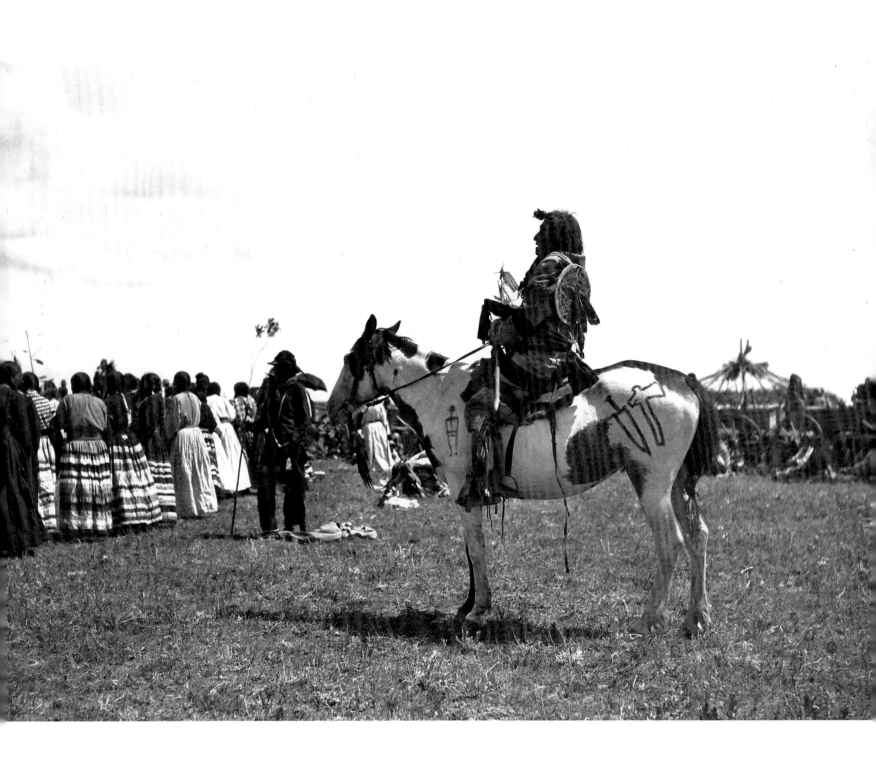

SUMNER W. MATTESON (AMERICAN, 1867–1920)

*Bill Jones (A'aninin [Gros Ventre Indian]),
Fort Belknap,* 1905

Glass plate, 5 × 7 inches, Milwaukee Public Museum,
Milwaukee, Wisconsin (M43779)

solemnly pointed at it, and said to Charlie all the English he knew: "Son of a Bitch, Big Man." They shook hands cordially, and Charlie departed. It is my guess that when Bill died an original Russell painting, now of value, was buried with him.

It is probable that many such encounters took place between the First People and the Newcomers. The Indian people gave beautiful gifts to Russell as well; exchanging gifts is a custom among us.

Russell's artwork deeply enriches Montana and is testimony of the good relations between the cowboy artist and the Indian people. These treasures preserve warm memories of the ideal past, but the world has changed. Today the world of the American Indian people is filled with activity as we complete college degrees and become doctors, lawyers, pilots, teachers, professors, museum curators, administrators, artists, chiefs, and most everything else. There even is an Indian astronaut. History has pushed us all toward the future, and we're enjoying the ride.

Two years before Charlie passed from the scene in 1926, the American Indian people finally got the vote. That must have made him feel good.

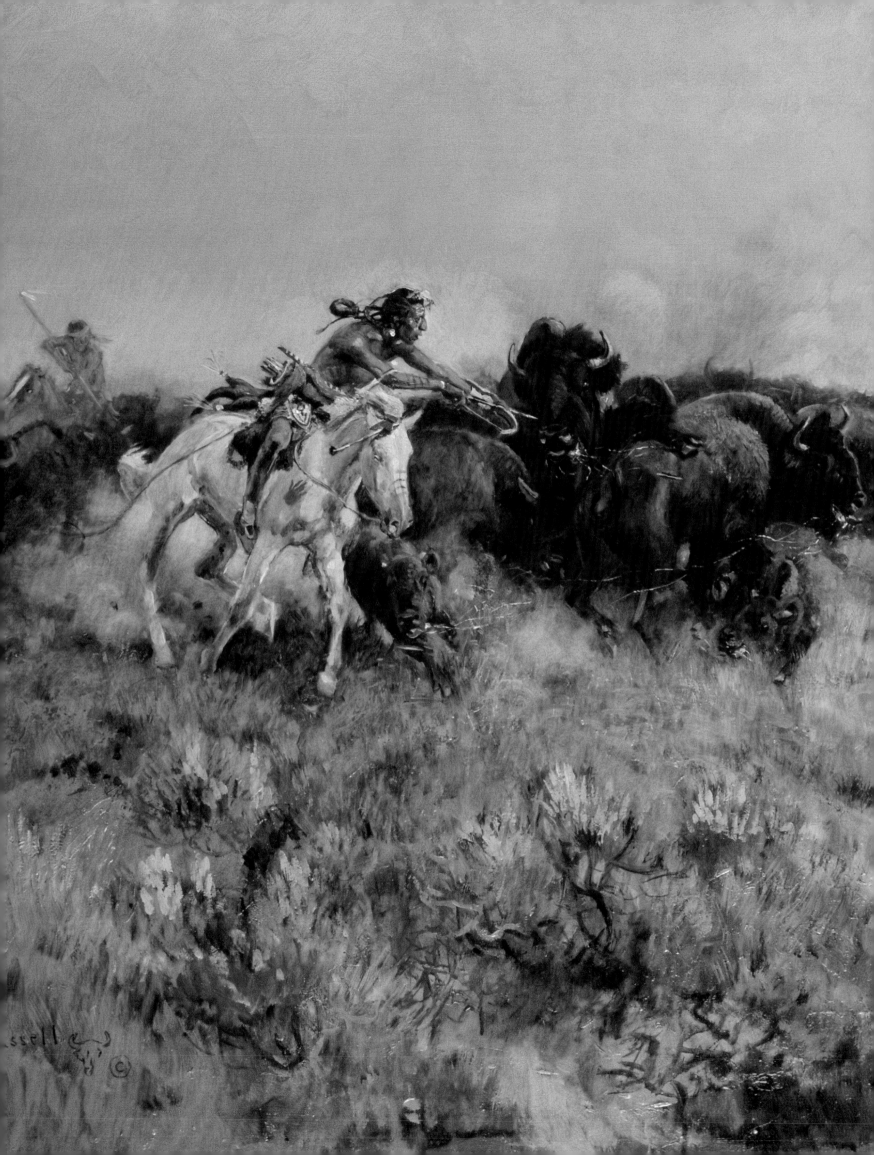

Anne Morand

Charles M. Russell
Creative Sources of a Young Artist
Painting the Old West

S T. LOUIS, MISSOURI, was the best possible place for Charles M. Russell to have been born, given that many now consider him to be among the foremost painters of the American West. By 1864, when Russell was born, St. Louis had played host to most western artists of note, and the city was a sort of sketchbook or classroom of the West. Early images of Indian life, painted by those who had witnessed it, offered Russell examples of subject matter and compositions as well as the notion that such art could be of interest to the public. Russell, essentially self-taught, picked and chose his examples from among the enormous onslaught of published images of the West that became available as never before in the latter half of the nineteenth century. Through continuous study and practice, he learned how to paint pictures that were appealing not only to himself but also to the buying public.

This essay explores the motifs, compositions, concepts, and other influences that might have caught Russell's attention—both in his youth before he moved to Montana in 1880 and after he established himself there—and how he synthesized them to create his own works. It is also an examination of the artists from whom Russell drew compositional inspirations and lessons. In many cases, Russell carried early themes and forms through to his mature work in his later career.

As a youth, Russell could have encountered the work of artists such as Titian Ramsay Peale (1799–1885), Peter Rindisbacher (1806–1834), George Catlin (1796–1872), Karl Bodmer (1809–1893), Carl Wimar (1828–1862), and Seth Eastman (1808–1875), all of whom either settled in or passed through St. Louis on their way farther west. These artists went west for diverse reasons, which in themselves may have fascinated Russell as he looked beyond the physical and societal boundaries that encompassed St. Louis. Some artists were compelled by military duty, others were hired expeditionary artists, and a few went out of curiosity about the West and its native peoples.

All of these artists would have appealed strongly to Russell if he could have seen their work. The evidence that he did exists in the paintings and illustrations he produced, not just

(facing)

Buffalo Hunt [No. 40], 1919
(detail)
Oil on canvas, 29½ × 47½ inches,
Petrie Collection, Denver, Colorado

129

in his youth but throughout his career. Growing up in a wealthy, educated St. Louis family, Russell might have had a number of opportunities to see influential works by western artists, such as public exhibitions at annual expositions and fairs, the murals created by Wimar in 1861 for the rotunda of the St. Louis Court House, family visits to collectors' homes, and certainly through illustrations published in books and periodicals on western subjects.

Authors including Peter Hassrick, Brian Dippie, and John Ewers have noted that the young Russell was influenced by and even copied the work of earlier artists; copying the works of others is a traditional method of learning the craft of art for both self-taught and academic artists. Russell's boyhood sketchbook, thought to have been made when Russell was in his teens, includes a drawing titled *Crow Indian in War Dress*.[1] It is a forceful, if crude, adaptation of Swiss artist Karl Bodmer's aquatint *Pehriska-Ruhpa of the Dog Band of the Hidatsa*, an illustration in Prussian Prince Maximilian zu Wied-Neuwied's *Travels in the Interior of North America, 1832–34*. Bodmer had accompanied Prince Maximilian on his journeys, making hundreds of drawings and watercolors of the scenery and people they encountered. Many of these images were reproduced as lavish, hand-colored aquatints in the atlas of illustrations that accompanied the prince's book, first published in 1843. Throughout his career, Russell must have returned to Bodmer's images, as well as Prince Maximilian's written descriptions of the northern plains and its peoples, for inspiration. But Russell rarely made such direct translations as he matured, instead incorporating specific motifs and formal elements from the works of artists he admired into his own compositions.

An investigation of the sources of Russell's oft-repeated themes is best begun with a look at what may have been his favorite subject: the buffalo hunt on horseback.[2] It is possible that Russell witnessed buffalo hunting by cowboys and ranchers in the Judith Basin while a young cowboy, but it is unlikely that he saw Indians conducting a traditional buffalo hunt.[3] By 1880, when he arrived in Montana, systematic slaughter had diminished the once-enormous herds of buffalo nearly to extinction. It is therefore reasonable to assume that Russell's source for Plains Indian buffalo-hunting imagery was the work of previous artists. As Dippie has noted, one of the earliest buffalo-hunt images that Russell could have encountered in printed form is Titian Ramsay Peale's *American Buffaloe* (1832).[4] Published as plate 15 in volume 2 of John and Thomas Doughty's short-lived magazine *Cabinet of Natural History and American Rural Sports* (published 1830–34), it was based on sketches that Peale made during Stephen Long's expedition to the Rocky Mountains in 1819–20. As the assistant to the expedition's naturalist, Peale collected and recorded specimens of birds, mammals, reptiles, fish, and insects. How widely known the periodical or image was in Russell's youth, how influential they were on other artists, and whether Russell saw them himself is unknown, but his composition for *Indians Hunting Buffalo* (1894) is remarkably similar to Peale's.[5]

The similarity of Russell's *Indians Hunting Buffalo* to Peale's *American Buffaloe* supports the idea that Russell knew the earlier image. *Indians Hunting Buffalo* is the only one of Russell's many buffalo hunts in which the hunter is placed ahead of the buffalo while riding in the same direction. There are several works by Russell, such as *Buffalo Hunt* [No. 5] (1892) and *Buffalo Hunt* [No. 6] (1892),[6] in which a hunter appears to be in the lead, but in fact the buffalo has been stopped by another fallen horse and rider. In these works, Russell depicted

the momentum of the surrounding riders moving past the obstructed buffalo, rather than using Peale's composition, which shows the rider who has raced ahead. In other paintings, such as *Meat for the Tribe* (ca. 1891) and *Buffalo Hunt* [No. 2] (1888), the rider approaches from the other direction rather than riding alongside.[7]

George Catlin's images of Plains Indian life exerted a stronger influence on Russell than did the works of any other artist. Catlin made five separate tours of the American West between 1830 and 1836. He not only made sketches from which he produced a huge body of paintings; he also took profuse notes that formed the basis of several important books on American Indian culture, including *Letters and Notes on the Manners, Customs, and Conditions of the North American Indians*, which was first published in 1841 and was reprinted in many subsequent editions. It is plausible that Catlin's experiences would have been known to wealthy St. Louis families such as the Russells, who probably owned copies of some of Catlin's books.

A study of Catlin's works would have been inspirational—and perhaps even necessary—to Russell as he strove to depict the far West as it was before his own arrival there. Much of the culture of the West that Catlin encountered in the 1830s had changed by Russell's time, and the traditional lives of most Native peoples had been devastated by the Indian wars and confinement to reservations. The line engravings in *Letters and Notes*, such as *Buffalo chase, a single death*, would have been good models, easy to trace, for a young artist practicing development of compositions and subjects, as well as for an established one looking for distinctive subjects. In *Buffalo chase, a single death*, Catlin's hunter and horse trail the buffalo but are compositionally layered in front of it, an arrangement Russell adopted in several paintings, including *The Buffalo Hunt* (1896)[8] and *Indian Buffalo Hunt*. Russell even copied Catlin's "hobbyhorse" running stance for both horse and buffalo, as was the standard convention before photographer Eadweard Muybridge documented the true action of quadruped locomotion.[9]

Catlin's image is not the sole example of this motif; there are others by Peter Rindisbacher, Bodmer, and Seth Eastman that Russell could have seen. Rindisbacher, a Swiss immigrant to western Canada in 1821, eventually settled in St. Louis in 1829 and established a studio. Rindisbacher produced more than one hundred images of Plains Indian life based on his own observations. A lithograph after Rindisbacher's *Hunting of the Buffalo* (ca. 1836) appeared as the frontispiece of the second volume of McKenney and Hall's *History of the Indian Tribes of North America* (1836–44). While it is sometimes too easy to find conveniently "matching" motifs, such as the same arrow protruding from the side of the buffalo in Rindisbacher's *Hunting of the Buffalo* and Russell's *Indian Buffalo Hunt*, the importance of the similarity is that it provides additional support for viewing the buffalo hunt as prime subject material for an artist painting the West.

Bodmer also supplied thrilling images of buffalo chases, including *Indians Hunting the Bison* (1843) for Prince Maximilian's *Travels in the Interior of North America*. Bodmer's image is a more elaborate variation on the theme, but it still features the vignette of hunter trailing the prey.[10]

Another likely model for Russell was the work of Seth Eastman. Russell might have come

GEORGE CATLIN
(AMERICAN, 1796–1872)

Buffalo chase, a single death, 1841

Letters and Notes on the Manners, Customs, and Conditions of the North American Indians, vol. 1, plate 107

Image courtesy of Denver Public Library, Denver, Colorado

107

Indian Buffalo Hunt, 1897

Oil on canvas, 35½ × 41⅛ inches, Wichita Art Museum, Wichita, Kansas, The M. C. Naftzger Collection (1973.4)

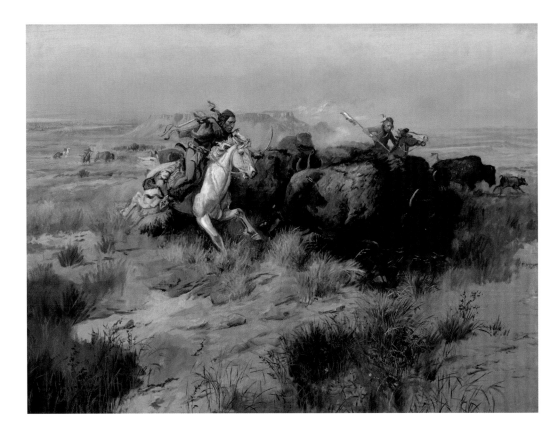

across Eastman's illustrations for Henry Schoolcraft's six-volume *Historical and Statistical Information Respecting the History, Condition, and Prospects of the Indian Tribes of the United States* (1851–57). Eastman, an army officer who served at Fort Snelling (near present-day St. Paul, Minnesota) briefly in 1830 and again from 1841 to 1848, taught drawing at West Point between the postings. During his time in the American West, Eastman recorded in drawings and watercolors the traditional life of the Plains Indians he encountered. This work came to the attention of Schoolcraft, a former Indian agent, who needed suitable illustrations for his monumental study of Native life. Reproduced as engraved plates, Eastman's work enlivened Schoolcraft's lengthy narrative. Informally referred to as *Indian Tribes of the United States*, this was yet another publication that might have been found in a wealthy St. Louis family's library and pored over by a young admirer of the West.

Eastman's painting *Buffalo Chase*, reproduced as plate 9 in volume 4 of Schoolcraft's *Indian Tribes of the United States*, provides yet another variation in figure placement. The hunter is not only trailing the buffalo; he is also aligned behind the animal. For a young artist learning how to place figures in space and create dynamic compositions, visual lessons such as these would have been valuable. Russell's *Piegan Buffalo Hunt* (1902)[11] is one of the few cases in which he, like Eastman, directed his figures' movement slightly away from the viewer. In many more paintings, such as *Buffalo Hunting* (1894),[12] Russell's figures appear to move toward the picture plane.

Russell's selection of secondary motifs offers another hint that he used Catlin as a resource. Russell frequently included cows with calves in his buffalo hunt scenes. *An Old Time Buffalo Hunt* (ca. 1895), *Buffalo Hunt* (1899), and *Running Buffalo*[13] all have calves placed at the forefront of the action. Catlin may have been the first artist to place a buffalo calf in peril, in

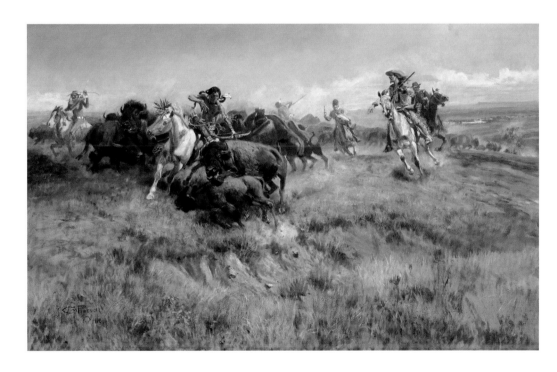

Running Buffalo, 1918
Oil on canvas, 29½ × 47½ inches, Gilcrease Museum, Tulsa, Oklahoma (0137.2266)

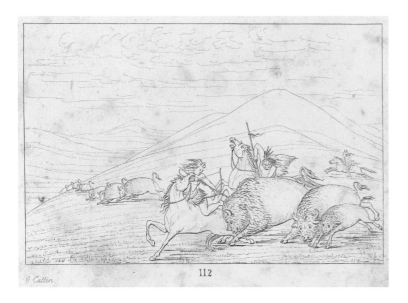

112

G Catlin

Buffalo chase, bull protecting cow and calf, but Russell adopted the motif and used it frequently in increasingly sophisticated compositions.

Carl Wimar also placed calves in the foregrounds of his impressive works *The Buffalo Hunt* and *Indians Hunting Buffalo,* paintings that Russell could have seen in St. Louis.[14] Wimar came to St. Louis from Germany in 1843 at the age of 15, returned to Düsseldorf for academic training, and then came back to St. Louis, where he spent the remainder of his short life. In addition to sketching the Indians he encountered around St. Louis, Wimar made several extended trips up the Missouri River on fur-trade steamers in the late 1850s. His work was widely acclaimed, and *The Buffalo Hunt* was the highlight of the grand opening of the newly formed Western Academy of Art in 1860 in St. Louis.

Art patron William Van Zandt purchased *The Buffalo Hunt,* but Lord Lyons, British ambassador to the United States, coveted the painting, and Wimar agreed to make the ambassador a replica.[15]

The Buffalo Hunt was one of several Wimar paintings Van Zandt lent to the 1878 St. Louis Fair.[16] In the same year, at the age of 14, Russell painted at least two very ambitious and vividly colored Indian subjects. Though not paintings of buffalo hunts, they were surely inspired by having seen paintings such as Wimar's at the exhibition. Van Zandt's collection was bequeathed to St. Louis's Washington University in 1886, where it was exhibited periodically, offering additional opportunities for Russell to view it on return visits to St. Louis. Russell's *Indian Buffalo Hunt,* painted eleven years after Washington University acquired Wimar's work, compares favorably with the earlier painting. Although Russell removed the foreground calf in his version, he seems to have liked the placement of Wimar's hunters and even the choice of weaponry.

If the young Russell saw Wimar's *Indians Hunting Buffalo,* it would have been in a different venue: the home of Henry T. Blow, the first president of the Western Academy of Art. Blow commissioned the painting, and it may not have been seen in public until 1908, after Charles Reymershoffer had purchased it and then published it in a book he coauthored with William Romaine Hodges, entitled *Carl Wimar, A Biography and Catalogue of Pictures.*[17] Russell knew of the painting by 1907 at the latest, as demonstrated by his correspondence with Reymershoffer regarding the tribal identity of the Indians featured in it.[18]

Russell's paintings often evoke the danger of buffalo hunting, and he could have seen that motif developed in Catlin's work. Horses and riders are shown trampled by buffalo in paintings such as *Buffalo Hunt* [No. 5] (1892), *Buffalo Hunt* [No. 6] (1892), and *Buffalo Hunt* [No. 15].[19] Catlin's *Buffalo chase, bulls making battle with men and horses* reveals a horse trapped under a fallen buffalo, its rider having jumped clear. Several of Russell's adaptations

CHARLES (CARL) FERDINAND
WIMAR (AMERICAN, BORN
GERMANY, 1828–1862)

The Buffalo Hunt, 1860

Oil on canvas, 35⅞ × 60⅛ inches,
Mildred Lane Kemper Art Museum,
Washington University, St. Louis,
Missouri (WU 3411), gift of
Dr. William Van Zandt, 1886

(above)
Buffalo Hunt [No. 15], 1896
Transparent and opaque
watercolor and graphite on paper,
14¼ × 21 inches, Amon Carter
Museum, Fort Worth, Texas (1961.153)

(right)
GEORGE CATLIN
(AMERICAN, 1796–1872)
*Buffalo chase, bulls making
battle with men and horses,* 1841
*Letters and Notes on the Manners,
Customs, and Conditions of the
North American Indians,* vol. 1,
plate 111
Image courtesy of Denver Public
Library, Denver, Colorado

from Catlin are far more frightening; in each, the rider and horse have been downed by the buffalo and are about to be trampled by the massive animal's forward momentum.

A much more ambitious Catlin painting that may have informed not only Russell's dangerous buffalo hunts but also his larger views of the hunt is *Buffalo chase,* which was reproduced as plate 79 in volume 1 of *Letters and Notes.* This "cast of thousands" approach, as well as the inclusion of dead and dying buffalo, can be seen in such Russell works as *The Surround* (1898). Catlin's image later appeared uncredited in a Currier & Ives print, *The Buffalo Hunt: Surrounding the Herd,* from 1870. Prints published by Currier & Ives were a popular source of western subjects during Russell's youth; the lithographic firm published at least fifteen prints based on Catlin images that Russell could have seen and remembered.[20]

As Russell matured as an artist and departed from the iconic buffalo hunt on horseback, he may have been inspired by other Catlin hunting images. Russell's painting *Hunting Buffalo* (1898),[21] which illustrates Plains Indian hunters wearing wolf pelts as camouflage, bears a more-than-coincidental similarity to Catlin's *Buffalo chase under wolf-skin masks* (*Letters and Notes,* volume 1, plate 110). Although Russell may have borrowed the idea from Catlin, modifications from the original composition demonstrate that Russell was much more than a copyist. Russell advanced the storyline: one of the hunters is about to shoot one of the unsuspecting animals.

In the early 1880s, Russell produced a watercolor, *Antelope Hunting in the Little Rockies,*[22] which is a precursor of many of his hunting scenes that feature animals other than buffalo. Again, it appears that Catlin provided a model, *Antelope shooting,* in which the hunter lies prone, hiding in the grass and using a bit of cloth on a stick to entice the curious animals. As with his buffalo-hunt paintings, Russell's compositions in paintings such as *Antelope Hunting* (1889)[23] became more sophisticated as time went on. In variations, he added a second hunter, repositioned figures into kneeling postures, and placed the hunter or hunters on a slight rise instead of on Catlin's flat prairie. In these and other examples, including *Hunting Deer on the South Fork* (ca. 1880–85), *Deer Hunting* (ca. 1880–82), *Crow Indians Hunting Elk* (ca. 1890), and *Antelope Hunt,* there is a line of progression. The later paintings demonstrate Russell's evolution as he improved his skills and revised his prior compositions.[24]

Russell's use of earlier artists' works as prototypes was not limited to hunting scenes. Catlin and Bodmer offered other images and subjects from which Russell could have taken inspiration. For example, both Catlin and Bodmer visited the Mandan Indians and depicted scenes of them. Although Russell painted several historical Mandan subjects, he could not have seen traditional Mandan village life firsthand because the smallpox epidemic of 1837–38 decimated the population. Dippie has noted the direct influence of Bodmer's *Interior of the Hut of a Mandan Chief* (1843) on the setting

GEORGE CATLIN
(AMERICAN, 1796–1872),
Antelope shooting, 1841
Letters and Notes on the Manners, Customs, and Conditions of the North American Indians, vol. 1, plate 40
Image courtesy of Denver Public Library, Denver, Colorado

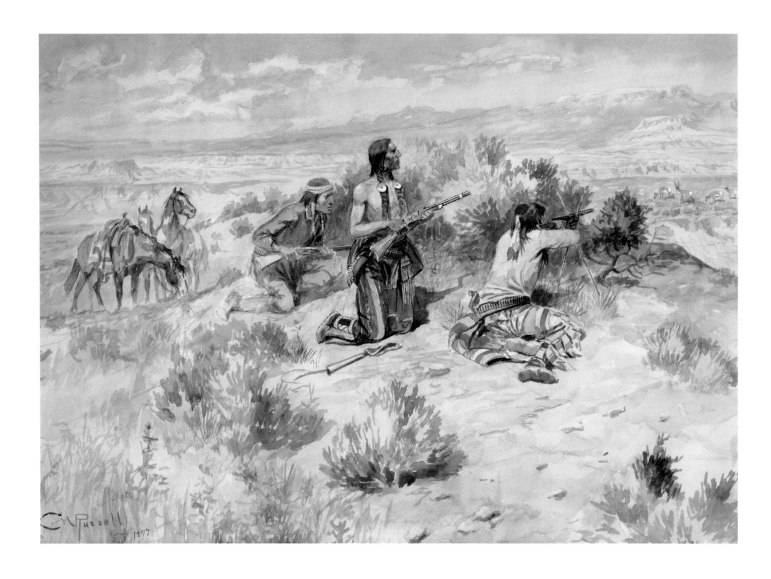

Antelope Hunt, 1897

Watercolor on paper,
18¼ × 26¼ inches, Montana
Historical Society Collection,
Helena (x1974.01.01), bequest
of Louise Treacy Tomlinson,
photograph by John Smart

of Russell's watercolor *York* (1908),[25] and Catlin also depicted such interiors in his *Interior of a Mandan lodge* (*Letters and Notes,* volume 1, plate 46), *Interior of Mandan medicine lodge* (*Letters and Notes,* volume 1, plate 66), and *Pohk-hong, the Cutting Scene* (*Letters and Notes,* volume 1, plate 68), all of which reveal the style and interior details of Mandan architecture.

Additional evidence that Russell knew of Catlin's Mandan imagery lies in a comparison between Russell's *The Mandan Dance* (1904)[26] and Catlin's *Bird's Eye view of the Mandan village,* both outdoor scenes of a Mandan village. Although Russell's composition is not a direct translation, it is informed by Catlin's, particularly the exterior lodge construction and the inclusion of details such as the pole fencing, the bull boats, and the Mandans sitting on top of their lodges.

Bodmer also depicted a Mandan village in his published images, but comparisons of Bodmer's work with Russell's *The Mandan Dance* are not as compelling as comparisons between Catlin and Russell. Bodmer's *Bison Dance of the Mandan Indians in front of their Medicine Lodge. In Mih-Tutta-Hangkusch* (tableau 18 in the *Atlas* of Maximilian's *Travels in the Inte-*

rior of North America, 1843) contains very little architectural detail, only vague shapes in the background. Bodmer detailed the dancers' regalia very specifically, including buffalo masks that are not seen in Russell's painting. Russell, on the other hand, mixed motifs; one figure wears Pehriska-Ruhpa's Hidatsa headdress, borrowed from Bodmer's portrait, and other figures are shown in feather headdresses more reminiscent of those seen in Catlin's images. Bodmer's *Mih-Tutta-Hangkusch. A Mandan Village* shows the village in the distance, including the fencing, but there is little specificity to the architecture. Bearing a stronger resemblance to *Mih-Tutta-Hangkusch* is a pen-and-ink drawing that Russell completed in 1922, *A Mandan Village,*[27] which includes the river, the women and bull boats, and the village on the bluff.

Based on the positive light in which he portrayed

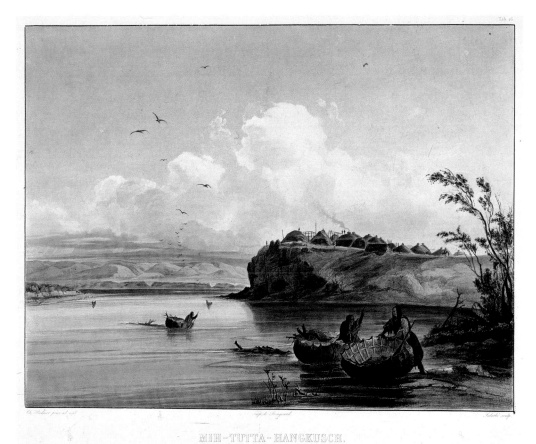

MIH-TUTTA-HANGKUSCH.
Mandan Dorf *Village Mandan.*
A MANDAN VILLAGE.

(above)
GEORGE CATLIN
(AMERICAN, 1796–1872)
Bird's Eye view of Mandan village, 1841
Letters and Notes on the Manners, Customs, and Conditions of the North American Indians, vol. 1, plate 47
Image courtesy of Denver Public Library, Denver, Colorado

FRIEDRICH SALATHÉ
AFTER KARL BODMER
(SWISS, 1809–1893)
Mih-Tutta-Hangkusch. A Mandan Village, 1843
Hand-colored aquatint on paper, 10¼ × 12⅝ inches, Maximilian zu Wied-Neuwied, *Travels in the Interior of North America 1832–34,* tableau 16, *Atlas* (London: Ackermann and Co., 1843), Denver Public Library, Denver, Colorado, Western History Collection

A Mandan Village, ca. 1922

Ink and graphite on paper
mounted on paper, 14 × 22 inches,
Amon Carter Museum,
Fort Worth, Texas (1961.131)

females, Russell must have developed an understanding of the importance of women and family life in Native American society from his earliest years in Montana and when he lived near the Blood Indians in Alberta, Canada, in the summer of 1888.[28] He regularly featured women's activities in his paintings, something for which he might have found models in earlier artists' works, especially those of Catlin. Indian women traveling or moving camp is a subject that Russell began to paint early on and continued to depict throughout his career. For one of his earliest paintings of this theme, *Wanderers of the Trackless Way,*[29] Russell borrowed liberally from Catlin's *Band of Sioux moving camp.* While the main motif of the mother with her baby on her back is seen in many such paintings, including *Following the Buffalo Run* (1894) and *Indian Women Moving,*[30] the secondary motif of children riding the travois is not.[31] Also, Russell chose to use an unusual detail in the Catlin painting: multiple tipi poles attached to each side of the horse. In all his subsequent paintings of this subject, Russell included only a single pole on each side.

In another early experiment with this composition, *Indian Women Moving Camp,*[32] Russell picked up a different feature from *Band of Sioux Moving Camp,* a child riding in front of the lead woman. Such details may seem inconsequential, but they provide evidence of a connection with Catlin's work. Nor is it an indictment to point out that Russell borrowed motifs from others, especially when one considers that Russell's work moved well beyond Catlin's technically, for example in elaborate and sophisticated compositions such as *In the Wake of the Buffalo Runners* (1911; see p. 179).[33]

Catlin recorded other scenes in which women's activities are the center of attention, such as *Comanche*

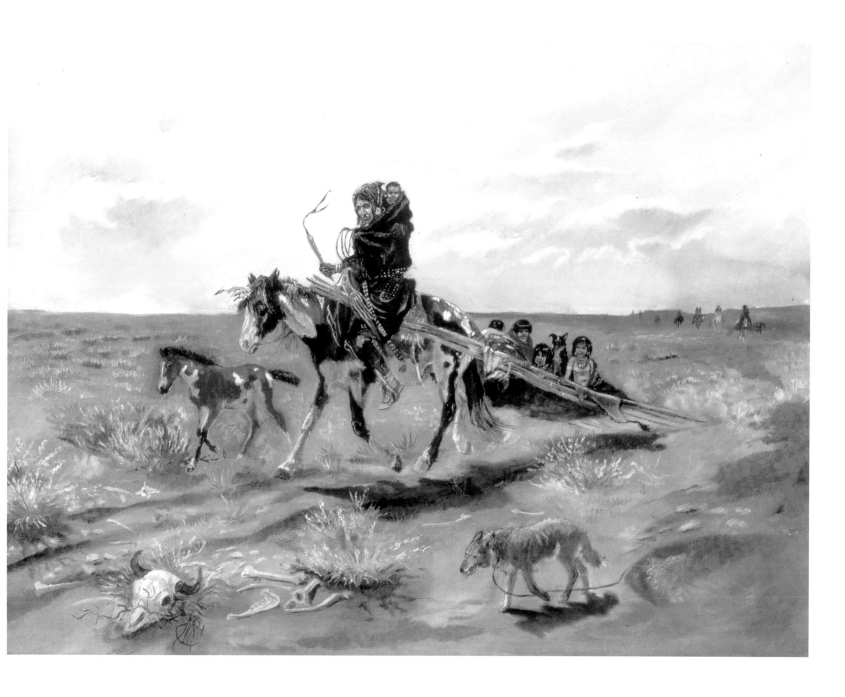

Wanderers of the Trackless Way,
ca. 1887

Oil on canvas, 17⅜ × 21¾ inches,
C. M. Russell Museum, Great Falls,
Montana (958-1-1), gift of C. R. Smith

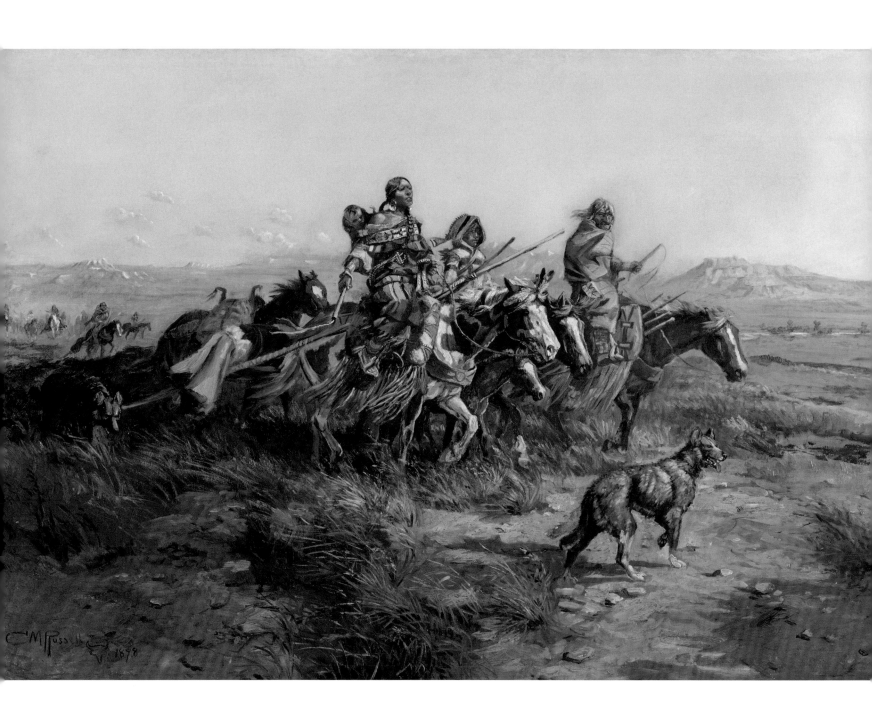

Indian Women Moving, 1898

Oil on canvas, 24¼ × 36 inches, Amon
Carter Museum, Fort Worth, Texas
(1961.147)

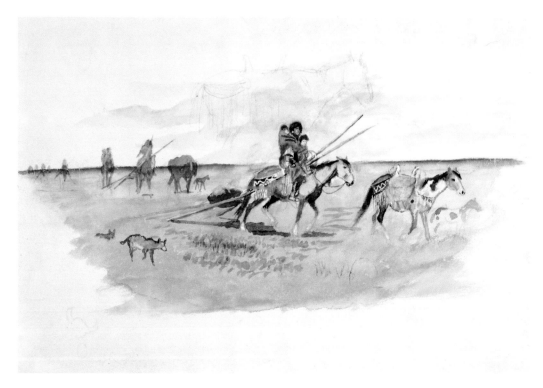

village, women dressing robes and drying meat. Catlin's image may have influenced Russell's choice of both subject matter and compositional details in paintings like *The Silk Robe* (see p. 174), *Indian Life* (1900), and *The Robe Fleshers* (1899).[34] In each, two women are working a hide that is staked out on the ground, although one woman has paused in her labor. Around them is an assortment of men, children, and dogs. In a process of selection and experimentation, Russell adopted and later discarded some of the components of Catlin's composition. Catlin depicted a young girl working on a small hide near the women, which Russell seems to have included only in *The Robe Fleshers.* These paintings came after Russell's time among the Blood Indians in Canada in the summer of 1888, but it is doubtful that he would have witnessed such scenes among them.

Seth Eastman also represented Indian women in activities such as moving camp and working hides. If Russell knew the work of Eastman through Schoolcraft's volume, as I have suggested above, then Russell would have seen such images as *Indians Traveling* (1851). However, none of Russell's work, which is more Romantic—and, frankly, more heroic—seems to have been influenced by Eastman's picture of drudgery.

Eastman and Russell both treated one subject that Catlin did not: Indian attacks on white settlers moving west. Russell's frequent paintings of this subject may have been inspired by Eastman's *Emigrants Attacked*

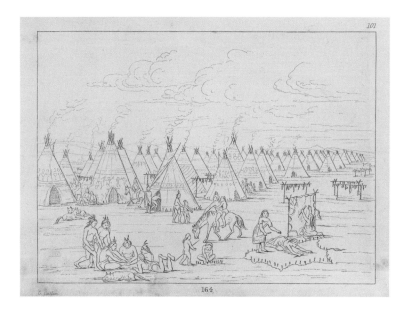

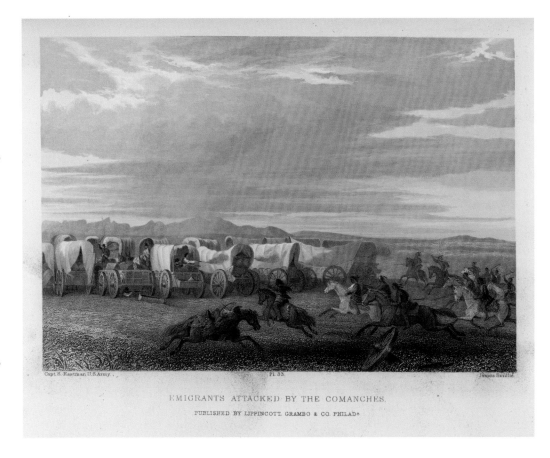

EMIGRANTS ATTACKED BY THE COMANCHES.

PUBLISHED BY LIPPINCOTT, GRAMBO & CO. PHILAD.ᵃ

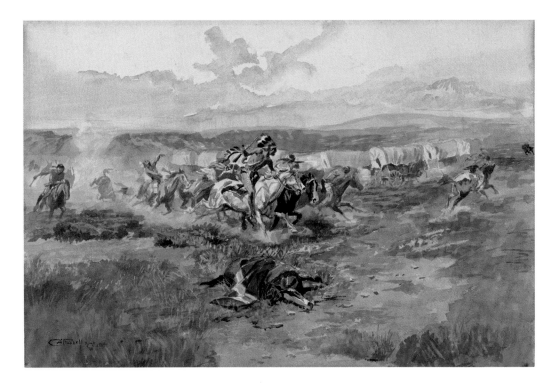

by the Comanches. Other artists, including Wimar,[35] painted Indian attacks, but not in the form that Russell adopted, which became the cinematic norm of the twentieth century. Following Eastman's design of encircled wagons with pioneers fending off native assailants, Russell painted *Breaking Up the Ring* and *Gun Powder and Arrows* (1900).[36] In a style more flamboyant than Eastman's, Russell focused more on the Indian riders, obscuring the wagons in dust and smoke. In what seems to have been an effort to refresh similar subjects, Russell offered adaptations on the theme; in *The Attack of the Wagon Train*,[37] the Indians are just about to reach the wagons, which have not yet begun to circle for defense.

Even though Russell might have sought inspiration for his subjects and compositions in sources other than his own eyewitness experience, after brief experimentation he made his western images his own. As Russell matured as an artist, his paintings became more sophisticated without losing the drama and excitement of his earlier work. Three magnificent examples of buffalo hunts, each a decade apart, demonstrate his development of the subject through three unique compositions and storylines. In *The Buffalo Hunt* [No. 29],[38] the onrush of animals and hunters flows like a wild river over a slight rise, the action ready to pour

The Attack of the Wagon Train, 1904

Oil on canvas, 24¼ × 36 inches, Gilcrease Museum, Tulsa, Oklahoma (0137.902)

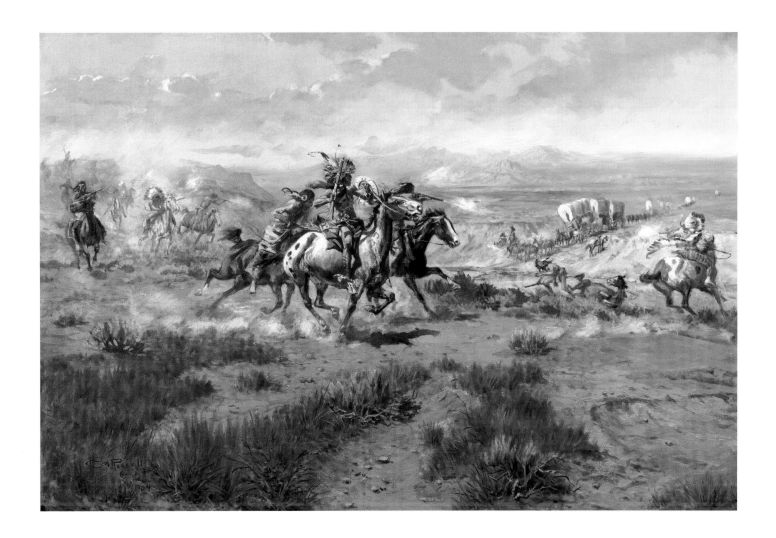

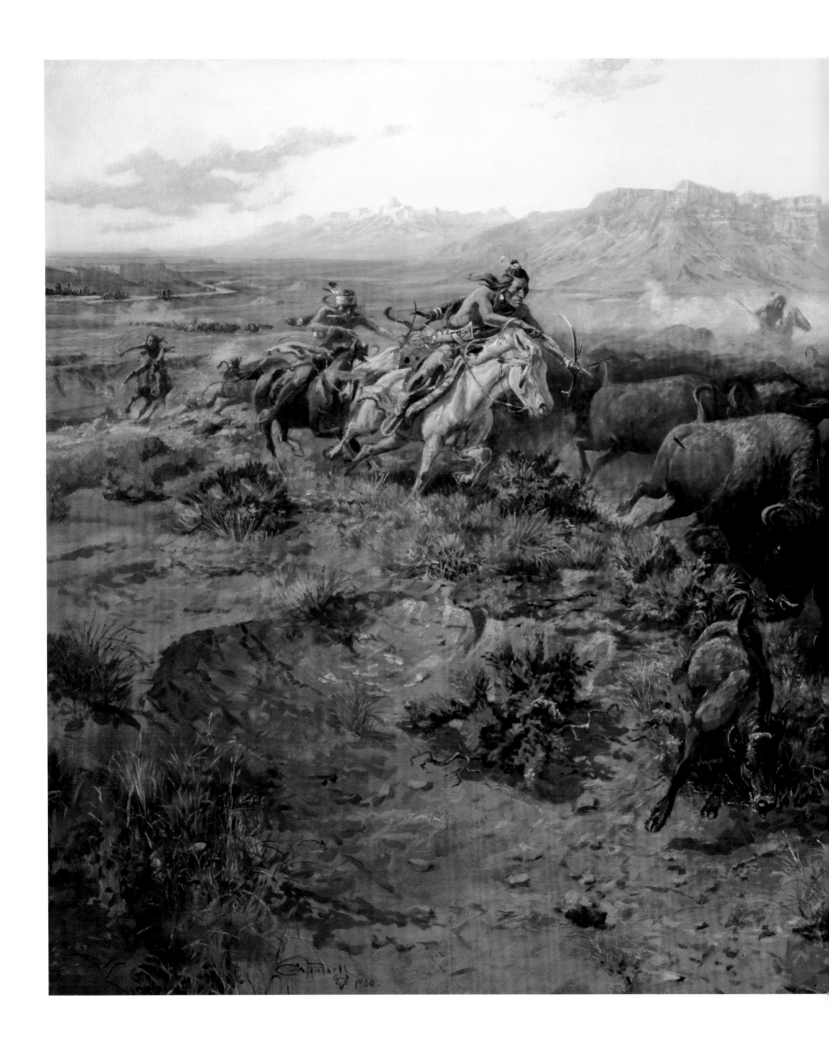

The Buffalo Hunt [No. 29], 1900
Oil on canvas, 48 × 72 inches, Gilcrease
Museum, Tulsa, Oklahoma (0137.2243)

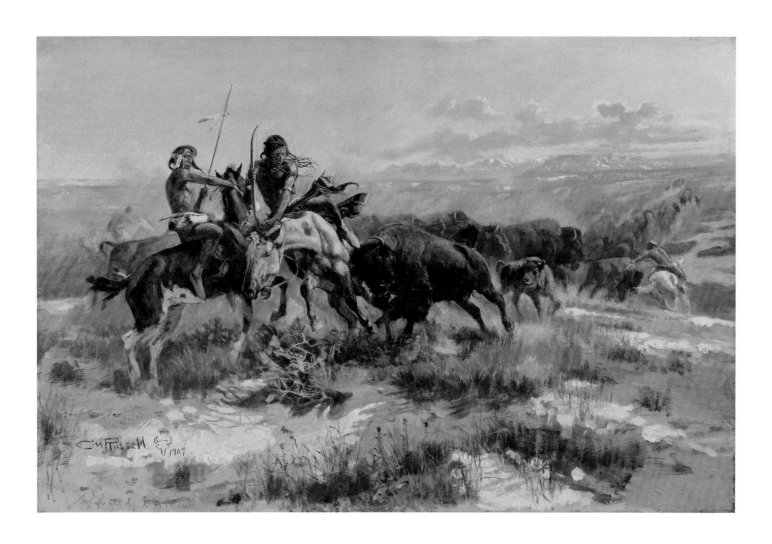

Wounded, 1909
Oil on canvas, 19⅞ × 30⅛ inches,
Sid Richardson Museum,
Fort Worth, Texas (1947.5.0.95)

out of the picture plane. *Wounded*[39] is an unusual, tense vignette of the hunt in which Russell arrested the action of the primary figures at a dangerous moment. The main figures, as well as the viewer, are caught up in the life-and-death moment, while the rest of the hunt races into the background. Finally, in one of the most dynamic of his mature paintings, *Buffalo Hunt* [No. 40],[40] Russell depicted the great chaos that results from the close proximity of men and animals. By segregating the main rider and calf, Russell created both physical and emotional tension. The calf, although it is not the target of the hunter, is nevertheless in danger of being trampled. Russell's command of great distance and space is beautifully expressed by the herd that disappears into the vast landscape.

Ultimately, whatever sources Russell may have used to develop his compositions, his years of study and practice paid off in hundreds of outstanding artworks. In an evolutionary process, he learned from and then moved beyond his predecessors. Russell continued the line of succession from previous generations of artists whose travels and tenancy gave them undeniable title to the subject matter of the American West.

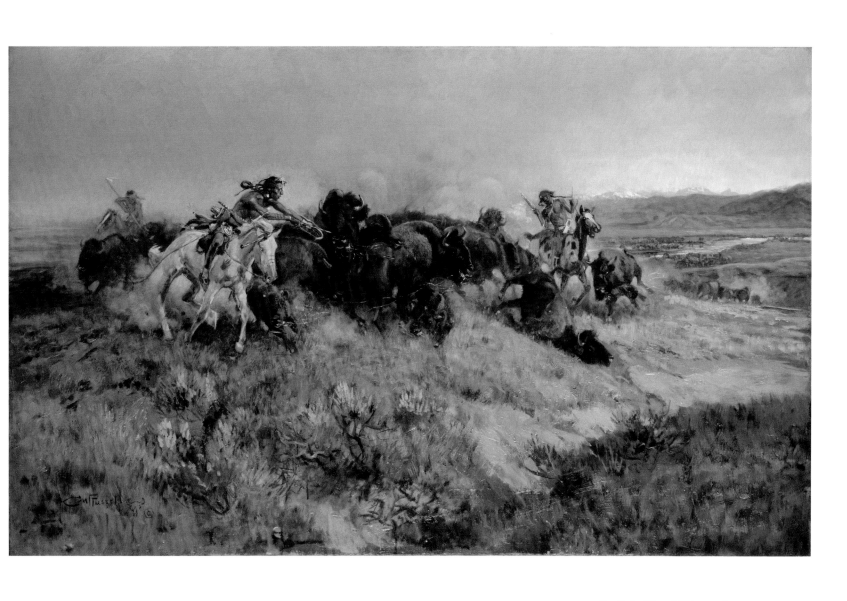

Buffalo Hunt [No. 40], 1919
Oil on canvas, 29½ × 47½ inches,
Petrie Collection, Denver, Colorado

Notes

1. Warden, *C. M. Russell Boyhood Sketchbook*, 25. John Ewers notes Russell's use of Bodmer's image in "Charlie Russell's Indians," 38. The image can also be viewed on the subscription Web site (www.russellraisonne.com) that accompanies the book *Charles M. Russell: A Catalogue Raisonné* (image reference number CR.PC.25x). With its records and images of thousands of Russell's works, the online version of *Charles M. Russell: A Catalogue Raisonné*, administered through the Charles M. Russell Center for the Study of the Art of the American West at the University of Oklahoma in Norman, has made the comparisons in this essay possible.

2. This essay will follow Russell's zoologically incorrect usage of the term *buffalo* instead of *bison*. For an in-depth look at the iconography of buffalo hunts in western paintings, see Dippie, "'Flying Buffaloes.'"

3. In his biography of Russell, John Taliaferro writes: "One of Charlie's biggest regrets in life was that he had never seen an Indian buffalo hunt. The remnant bunches of buffalo he had come across in the Judith Basin in the early 1880s served mostly as depressing reminders of better days." *Charles M. Russell: The Life and Legend of America's Cowboy Artist*, 170–71. An early Russell painting, *Fresh Meat* (ca. 1880, *Catalogue Raisonné* reference number CR.NE.325), depicts a buffalo hunt by a white cowboy.

4. Dippie, *Remington and Russell*, 82.

5. Ibid., 83. *Catalogue Raisonné* CR.SRC.28.

6. *Catalogue Raisonné: Buffalo Hunt* [No. 5], CR.MUS.84; *Buffalo Hunt* [No. 6], CR.UNL.73; *Meat for the Tribe*, CR.PC.333; *Buffalo Hunt* [No. 2], CR.PC.36.

7. A Currier & Ives lithograph after A. F. Tait, *Hunting on the Plains* (1870), shows the hunter ahead, but it is an unlikely model for the Russell painting because the rider is white and carries a rifle.

8. *Catalogue Raisonné* CR.PC.451.

9. Leland Stanford, governor of California, hired Eadweard Muybridge in 1877 to help him prove that all four of a horse's hooves leave the ground at some point during a gallop. Muybridge did this with a single photograph, then went further the next year to capture the entire sequence of the gallop using a series of cameras and trip wires. Although artists had shown all the hooves off the ground before 1877, the benefit of Muybridge's photographs was a more accurate placement of the legs of a running horse. In 1882, Stanford published woodcuts based on Muybridge's photographs in a book by J. D. B. Stillman, *The Horse in Motion as Shown by Instantaneous Photography* (Boston: J. R. Osgood).

10. It is not known whether Bodmer witnessed such a scene. He may himself have drawn on the work of both Catlin and Rindisbacher for guidance. Ruud notes that Bodmer and Maximilian saw works by both artists while in St. Louis: paintings by Catlin, such as *Interior of a Mandan Lodge* and *Buffalo Hunt of Hidatsa* (ca. 1832), in the home of Benjamin O'Fallon in 1833 and 1834; and paintings by Rindisbacher at the artist's studio, where Maximilian acquired *Buffalo Chase* and *War Dance of the Sauk and Fox* (ca. late 1820s). Ruud, ed., *Karl Bodmer's North American Prints*, 185.

11. *Catalogue Raisonné* CR.PC.430.

12. *Catalogue Raisonné* CR.ACM.29.

13. *Catalogue Raisonné: An Old Time Buffalo Hunt*, CR.MUS.27; *Buffalo Hunt*, CR.ACM.27; *Running Buffalo*, CR.GLC.43.

14. Dippie provides an excellent and thorough discussion of Russell's familiarity with Wimar's work and of its influence on Russell in "Two Artists from St. Louis."

15. Rathbone, *Charles Wimar 1828–1862*, 27.

16. Ibid., 42.

17. Ibid., 27–28, 45.

18. Dippie, ed., *Charles M. Russell, Word Painter*,

89. In "Charlie Russell's Indians," 38, Ewers notes the letter to Reymer Shoffer and acknowledges Russell's admiration for Wimar.

19. *Catalogue Raisonné: Buffalo Hunt* [No. 5] CR.MUS.84; *Buffalo Hunt* [No. 6], CR.UNL.73; *Buffalo Hunt* [No. 15], CR.ACM.26.

20. Le Beau, in his study of Currier & Ives subject matter, discusses the firm's reproduction of Catlin's images and the importance of these images as first-hand accounts. *Currier & Ives,* 140–45.

21. *Catalogue Raisonné* CR.PC.381.

22. *Catalogue Raisonné* CR.NE.207.

23. *Catalogue Raisonné* CR.PC.453.

24. *Catalogue Raisonné: Hunting Deer on the South Fork,* CR.PC.414; *Deer Hunting,* CR.PC.551; *Crow Indians Hunting Elk,* CR.ACM.45; *Antelope Hunt,* CR.MHS.3.

25. Dippie, *Looking at Russell,* 58–59.

26. *Catalogue Raisonné* CR.UNL.344.

27. *Catalogue Raisonné* CR.ACM.107.

28. Certainly there are a few unsettling exceptions, but the majority of his work that includes female subjects ranges from sweet to heroic. For a discussion of Russell's time in Canada among the Blood Indians, see Dempsey, "Tracking C. M. Russell in Canada."

29. *Catalogue Raisonné* CR.CMR.161.

30. *Catalogue Raisonné: Following the Buffalo Run,* CR.ACM.60; *Indian Women Moving,* CR.ACM.88.

31. Using the images in the Russell *Catalogue Raisonné* as a basis for comparison, there is only one other that shows children on the travois: *Indian Woman with Travois,* a pen-and-ink drawing from 1889 (CR.PC.475).

32. *Catalogue Raisonné* CR.NE.414.

33. *Catalogue Raisonné* CR.MUS.32.

34. *Catalogue Raisonné: The Silk Robe,* CR.ACM.134; *Indian Life,* CR.WAM.10; *The Robe Fleshers,* CR.UNL.456.

35. Wimar's *The Attack on an Emigrant Train* (1854) was exhibited at the 1878 St. Louis Fair and the 1893 World's Columbian Exposition in Chicago (Rathbone, *Charles Wimar 1828–1862,* 37). Russell might have seen it at the St. Louis Fair, but he certainly did see it at the World's Columbian Exposition, which he visited to see his own work exhibited. Compositionally dissimilar from any of Russell's renderings of the subject, Wimar's painting focuses on a group of pioneers in a single wagon. Wimar painted the subject again in 1856; Russell might have seen it illustrated in W. T. Helmuth's *Arts in St. Louis* (1864) (Rathbone, *Charles Wimar 1828–1862,* 38).

36. *Catalogue Raisonné: Breaking Up the Ring,* CR.SRC.6; *Gun Powder and Arrows,* CR.GLC.26.

37. *Catalogue Raisonné* CR.GLC.3.

38. *Catalogue Raisonné* CR.GLC.16.

39. *Catalogue Raisonné* CR.SRC.52.

40. *Catalogue Raisonné* CR.PC.58.

Mindy A. Besaw

Charlie Russell in Wax

CHARLES M. RUSSELL was well-practiced in the use of beeswax for modeling, and he often surprised and delighted onlookers with his sculpting skills. Russell's sister, Susan, recalled that even as a child, "He always carried a chunk of wax in his pocket & modelled almost incessantly, attracting much attention from grown-ups as well as children."[1] Russell's nephew, Austin, recalled a similar story: "In his pants pocket Charlie always had a lump of beeswax, mottled black from handling and while he was talking he would take it out and work it soft and model a pig or a buffalo or what not, and look at it in an inquiring way and then mash it out with his thumb and make something else."[2]

Modeling wax figures was second nature to Russell, an activity he almost carelessly performed while doing other tasks. But modeling was more than simply a parlor trick to him. Numerous surviving wax sculptures attest to Russell's natural skill, exemplified in the creation of wax models and the innovative use of mixed media to enhance the environment or accessories of the sculpture. To more fully understand and appreciate Russell's work in wax, I will place wax sculpture within the larger context of the recent history of sculpture media, and then I will examine four of Russell's wax sculptures in detail.

Rarely is wax considered a material worthy of "fine art." As a sculpture medium, wax has largely been used in preparatory sketches, as part of the lost-wax bronze-casting process, or by hobbyists. Further adding to wax's reputation as "low art" is the centuries-old practice of making life-size facsimiles of celebrities to be placed in the quintessential kitsch location: the wax museum.[3] While the wax museum did enjoy a brief period as bourgeois entertainment in the late nineteenth century, it had lowly beginnings as a wax cabinet of curiosities and never quite attained a higher level of cultural prestige. Historically, "high art" sculpture was typically created from so-called "finer" materials such as metal, stone, or clay. Perhaps because of this view of wax, Russell's wax and mixed-media models were largely neglected or destroyed when the Russell estate was sold in the 1940s. The bronze sculpture found buyers, but the wax sculpture was dismissed as impermanent and less significant and was grossly undervalued.[4]

Although permanence is not its strong suit, wax does have appealing characteristics that

(facing)
Charlie Himself, ca. 1915
Wax, cloth, plaster, metal, string, and paint, 11⅞ × 6½ × 5⅛ inches, Amon Carter Museum, Fort Worth, Texas (1961.58)

153

have sustained its use over hundreds of years and that most likely attracted Russell to the medium. Wax is a soft modeling material that is easily obtained, easy to prepare, clean to use, and hardens naturally. With a small amount of heat, wax becomes malleable and ready to use. Historically, a small handful of artists used wax successfully in fine-art models. Sixteenth-century artists created portraits from wax and added other materials, such as textiles and beads, to simulate clothing and jewelry. The medium was revived in the nineteenth century when two noted European artists used wax in their sculpture. Celebrated animalier sculptor Antoine-Louis Barye embraced wax for his depictions of animals, taking advantage of the subtleties of the material to portray fur and muscles in a lifelike manner. French Impressionist Edgar Degas modeled several figures—dancers, jockeys, and bathers—in wax and even clothed some of the figures with bits of fabric.[5] Russell likely did not know much about these other artists, especially Barye, but remarkably, he used wax in ways similar to their practice. Russell's skill at capturing the details of the West came less from knowledge of past artists and materials or formal art training than from steady observation and countless drawings and models of figures and animals. The sculptures examined here are exemplary because they depict some of Russell's favorite subjects and provide insights into Russell's biography and personality.

For Russell, the Indian was the "mos[t] picturesque man in the world," embodying the essence of what he admired in the Old West.[6] *Assiniboine Warrior* portrays a mounted Indian sitting proud and still, as if posing for a portrait. The horse and Indian are made of painted wax and are mounted on a plaster base with plant fibers added to mimic rocks and grass. The sculpture is small, but Russell used his fingers and fingernails to coax details from the wax. He then added a variety of additional materials for the accessories: a wooden stick with bits of fabric for the lance; leather reins on the horse; fabric and leather for the Indian's tiny saddlebag, quiver, and blanket; and a piece of string to cinch the horse's tail. The ability of wax to imitate flesh made it a natural choice for rendering the musculature of the Indian and the hide of the horse.

Russell's intent was not only to preserve the minutiae of Indian clothing and equipment but also "to convey the innate dignity and grace of the race" as it existed in the days of the buffalo, before white settlement of the West.[7] During Russell's lifetime, the Assiniboine Indians lived in northeastern Montana. Given their close proximity to him and the fact that Russell maintained personal contacts with several Montana tribes, he most likely met Assiniboines. The buffalo-horn bonnet (a split-horn headdress in this case) was typical of the Northern Plains Indian tribes and was a special symbol of status. The right to wear a buffalo headdress was granted to a man who had defeated an enemy in battle during hand-to-hand combat. A warrior with such a headdress was entitled to marry and establish a household of his own. Russell carefully chose clothing associated with honor for the Indian and further accentuated his strength with the figure's pose. An Indian mounted on horseback provided an immediate connection to heroic equestrian portraits of esteemed white men, which have been painted since ancient times. Russell's work evokes respect for the Indian whether still or in motion. The *Assiniboine Warrior*'s poise and calm convey a sense of strength and dignity. By comparison, in *Assiniboine Chief*, Russell uses a a dynamic, animated pose to emphasize the warrior's power.

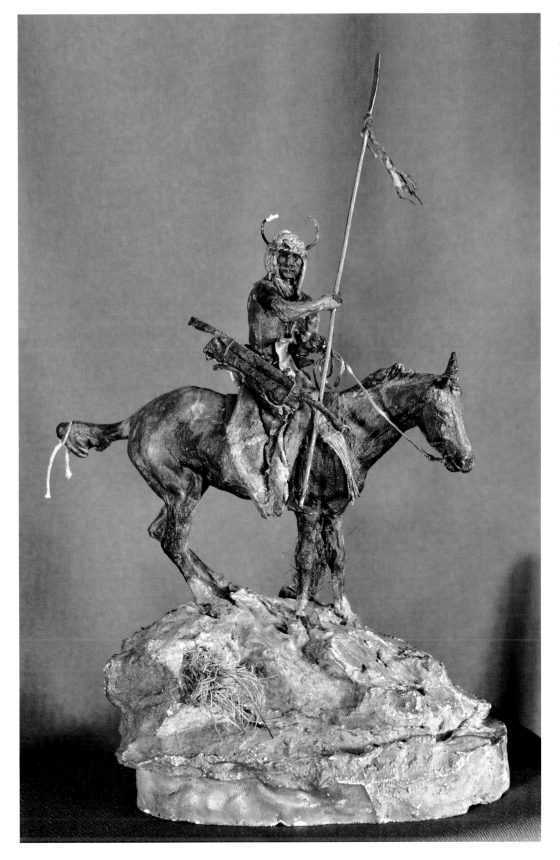

Assiniboine Warrior, 1913
Wax, plaster, and paint,
10¼ × 5½ × 3⅛ inches, Courtesy
of C. M. Russell Museum,
Great Falls, Montana (953-1-37),
gift from the Trigg Collection

Assiniboine Chief, 1900

Gouache, India ink, watercolor, and pen and ink on paper, 12¼ × 9½ inches, Location unknown, photograph courtesy Ginger K. Renner, Paradise Valley, Arizona

Russell's interest in American Indians was not unique among artists during his time, but his fascination with Northern Plains Indians permeated his life in a profound way. Fact and fiction are often intertwined in accounts of Russell's relationships with the Indians of Montana and Canada, but we do know that Russell collected Indian artifacts, befriended Indians, communicated with Indians through sign language, and dressed as an Indian on several occasions. Many friends of Russell gravitated toward fiction and exaggerated his relationship with the Indians, saying that Russell lived among the Blood Indians in the late 1880s. According to one story, Russell listened to tales of hunting and war, learned their traditions and the meanings of their symbols, and "became, in fact, one of the tribe."[8] Russell was sympathetic to the Indians, but it is not likely that he penetrated so far within the inner circle of the tribe. However, it is clear that Russell's interest in the traditional Indian way of life guided much of his art.

Russell further added to his own mythology when he adopted an Indian nickname, Ah Wah Cous (the Blood Indian word for *antelope*), which he often used when he took on the guise of an Indian in photographs or letters. The history behind the name, according to one story, came from a visit with the Blood Indians in 1888. Russell wore "tight blue riding britches, foxed [reinforced] in the seat with white buckskin [that] made him look from behind like the rear view of an antelope."[9] It is unclear whether Russell was really given the name by the Blood tribe; if he was, it is not known whether the name was meant purely as a joke, suggesting that Russell "turned tail" and ran from danger. Regardless of the history of the name, Russell did seem to identify with Ah Wah Cous and used the name often.

Antelope appear regularly in Russell's work, and *Ah Wah Cous* provides a particularly good example. Russell's admiration for the animal was perhaps partially in honor of his Indian name, but the antelope was also closely linked to the Old West of Russell's imagination. The antelope is native to North America and is found mostly in the western United States, but when Russell created *Ah Wah Cous*, the antelope was threatened with extinction. In 1913 two well-respected public figures—naturalist William T. Hornaday, director of the New York Zoological Gardens, and former president Theodore Roosevelt, an ardent conservationist and lover of the West—called for the preservation of America's wild species, including the antelope.[10] Russell would have been acutely aware of the public outcry for preservation, and he likely feared the worst for the wildlife of the West.

Ah Wah Cous shows two wax antelopes, one lying down and one standing, placed in a nat-

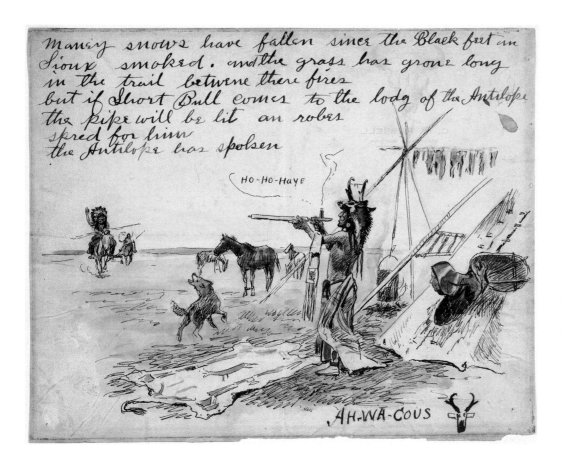

Many snows have fallen since the Black feet an
Sioux smoked. and the grass has grone long
in the trail betwene there fires
but if Short Bull comes to the lodg of the Antilope
the pipe will be lit an robes
spred for him
the Antilope has spoken

HO-HO-HAYE

AH·WA·COUS

uralistic setting of rocks and grass created with plaster and hemp
fibers. Russell most likely observed some of the few antelope still
in their natural setting in the West, as well as at the New York Zoo,
where Hornaday maintained a small captive herd of antelope for
breeding purposes. Russell may have also used photographs of an-
telope for later reference.[11]

Russell was adept at depicting many types of wildlife in his art,
but "[o]f all the animals he portrayed in his sculpture, none sur-
passed the buffalo in significance or frequency of depiction. To
Russell, the buffalo was a primary symbol of 'the West that has
passed.'"[12] There were once millions of buffalo on the Plains, but
by the time Russell arrived in the West the herds were nearly ex-
tinct. Russell's lament for the animal is evident in a 1908 tribute to
the buffalo, written in a letter to his close friend Frank Bird Lin-
derman: "You sleeping relick of the past / if I but had my way / Id
cloth your frame with meat an hide / An wake you up to day."[13]

Russell had the adventure of a lifetime in 1908 and 1909 when
he observed and participated in the Pablo buffalo roundup, in
which the animals were herded (with some difficulty) into pens

and readied for transportation to Canada.[14] Buffalo always played a prominent role in Russell's art, but the roundup fed his imagination for years to come. He portrayed buffalo in a variety of poses, groupings, and settings and in all types of media. In *Buffalo Family*, Russell emphasized the animal as a symbol of the West, strong and unwavering. *Buffalo Family* depicts three wax buffalo—a bull standing protectively over a reclining cow and calf—atop a plaster and mixed-media landscape of rocks and grass. Russell's choice to feature a family of buffalo, united even while facing extinction, would have resonated with the movement for protection of western wildlife in the United States at the time.

It was not the only time Russell created a sculpture of a buffalo family. He modeled *Nature's Cattle*, a bronze of a bull, cow, and calf walking in a line, in 1911. *The Buffalo Family* was modeled in 1921 and cast in bronze about a year later. The wax-and-plaster version was most likely the source of inspiration for the bronze, as evidenced by the subtle improvements Russell made in the composition. In the bronze version, the three buffalo were moved slightly so that the bull stands higher on the base, with the cow and calf closer to his guard. The revised composition emphasizes the bull's monumentality and reflects "the artist's growing understanding of mass and form in fine art sculpture."[15]

Buffalo Family, ca. 1915

Polychrome wax and plaster, 5¼ × 5⅞ × 10 inches, Buffalo Bill Historical Center, Cody, Wyoming (34.59), gift of Dr. Armand Hammer and Charles Stone Jones

All the models examined thus far exemplify Russell's interests and passions through his choice of subject matter, but the sculpture that best reveals the artist's sense of humor and self-reflection is *Charlie Himself.* The figure is made from wax and mixed media: fabric dipped in wax for the jacket and pants, small bits of metal for the tiny rings on the fingers, and pieces of string for the sash. The painting on the figure is loose and quick, providing accents of color on the hat, shirt, jacket, and base. Russell is immediately recognizable. The essence of his looks and personality are translated perfectly into three dimensions: square jaw, full head of blonde hair, and typical accessories of his hat tipped back, high-heeled boots, cigarette held casually in one hand, rings on several fingers, and the famous red sash. Linderman recalled that "Charley's boots and red sash were as much a part of him as his nose and ears."[16] His nephew Austin thought Russell "was strange in every way. He wore high-heeled boots, a big hat, no vest. . . . He held up his pants with a halfbreed sash, a Hudson Bay sash, nine feet long . . . just tucked it like the latigo on a cinch."[17] Russell had lots of practice with self-portraiture, depicting these same characteristics in other sculptures, drawings, and letters.

The Buffalo Family, 1921
Bronze, 6½ × 10⅜ × 5¾ inches, Gilcrease Museum, Tulsa, Oklahoma (0837.4)

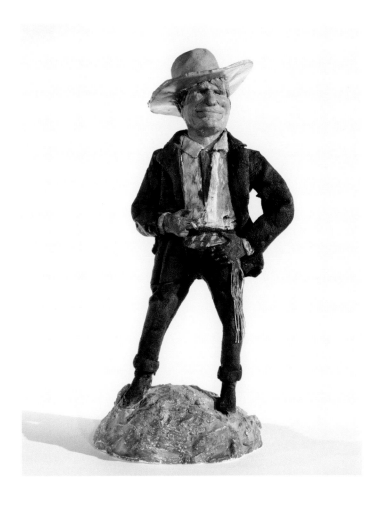

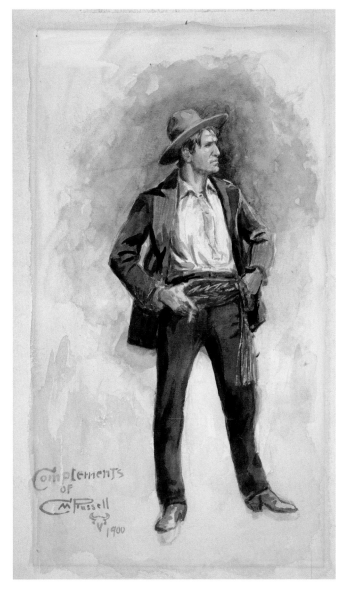

(above, left)
Charlie Himself, ca. 1915

Wax, cloth, plaster,
metal, string, and paint,
11⅞ × 6½ × 5⅛ inches, Amon
Carter Museum, Fort Worth,
Texas (1961.58)

(above, right)
Self-Portrait, 1900

Watercolor on paper,
12⅜ × 6⅞ inches, Buffalo
Bill Historical Center, Cody,
Wyoming (98.60), gift of the
Charles Ulrick and Josephine
Bay Foundation, Inc.

Contemporary reviews of *Charlie Himself* suggest that people viewed it in much the same way as they would view the mannequin-like figures featured in the wax museums: as an excellent substitute for the man himself. Lifelike plaster and wax figures proliferated in many of the cultural venues of late-nineteenth-century urban life—storefront windows, international exhibitions, museum displays—and the middle class of Russell's lifetime was well-practiced in reading a wax figure as a simulation of a real person, suggesting a presence even in the absence. The viewer is constantly reminded of the unreality of the figure—in this case, the small scale and caricatured features of the model remind viewers that it is not really Charlie Russell—but the thrill of being in the presence of a celebrity, even a waxen one, overcame the differences between the mannequin and the real person.[18]

This sculpture, like many of Russell's wax models, was created as a gift. Russell gave *Charlie Himself* to his friend William H. Rance, owner of the Silver Dollar saloon in Great Falls.

The sculpture was immediately hailed by the Great Falls *Daily Tribune*, which trumpeted that "'Russ' is all there. . . . The expression is perfect; the hat sits just as the artist wears it; the coat and tie appear most natural and the sash hangs true to the artist's everyday custom. Its real excellence is best seen by those who have seen Mr. Russell and know his mannerisms and habits."[19] As the *Daily Tribune* suggested, *Charlie Himself* is a true representation of Russell. Although caricatured with a large head, small body, and wide grin, it meets the criteria set for it: "The true definition of representative art is not that the artifact resembles an original . . . but that the feeling evoked by the artifact resembles the feeling evoked by the original."[20] For the residents of Great Falls, *Charlie Himself* evoked the sensation of being in Russell's presence, something that the wax museum mannequins also did for their audiences.

Charles M. Russell's wax and mixed-media models challenge the traditional boundary between "high art" and "low art." As evidenced by the four sculptures examined here, Russell transformed the lowly wax medium into fine art with spontaneous gesture, practiced skill, and innovation with material, while enlivening it with personality and biography. As viewers, we should set aside our prejudice against wax, return to a time when even wax museums enjoyed a period of cultural prestige, and take the time to appreciate these sculptures. They should not be dismissed or overlooked.

Notes

1. Dippie, ed., *Charlie Russell Roundup*, 4.
2. Austin Russell, *C. M. R.*, 93.
3. A life-size wax sculpture of Charles M. Russell can be seen at the Old West Wax Museum in Thermopolis, Wyoming.
4. The original feeling and intent of the wax-and-plaster models from Nancy Russell's estate were destroyed when several were cast posthumously into bronze. See Stewart, *Charles M. Russell*, 117–25.
5. For a brief history of wax in the history of sculpture, see Penny, *The Materials of Sculpture*, 215–18, and Jane Turner, ed., *Dictionary of Art*, volume 33 (Oxford: Oxford University Press, 1996), 2–3. For a discussion of Degas's wax sculpture, see Barbour, "Degas's Wax Sculpture from the Inside Out."
6. Dippie, ed., *Charlie Russell Roundup*, 16.
7. Taliaferro, *Charles M. Russell: The Life and Legend of America's Cowboy Artist*, 100.
8. Adams and Britzman, *Charles M. Russell*, 95.
9. Austin Russell, *C. M. R.*, 67. Frank Linderman tells a similar story in Linderman, *Recollections of Charley Russell*, 52.
10. Stewart, *Charles M. Russell*, 61.
11. Stewart, *Charles M. Russell*, 62. A photograph of an antelope was found in Nancy Russell's estate and is now in the Helen E. and Homer E. Britzmann Collection, Colorado Springs Fine Arts Center, Colorado Springs, Colorado, D.9.96.
12. Stewart, *Charles M. Russell*, 61.
13. Dippie, ed., *Charles M. Russell, Word Painter*, 110.
14. For a detailed description of the roundup and Russell's role, see Taliaferro, *Charles M. Russell: The Life and Legend of America's Cowboy Artist*, 170–74.
15. Stewart, *Charles M. Russell*, 255.
16. Linderman, *Recollections of Charley Russell*, 103.
17. Austin Russell, *C. M. R.*, 92–93.
18. Sandburg, *Living Pictures, Missing Persons*, 5.
19. Great Falls *Daily Tribune*, May 19, 1915.
20. Collingwood, *The Principles of Art*, 52–53.

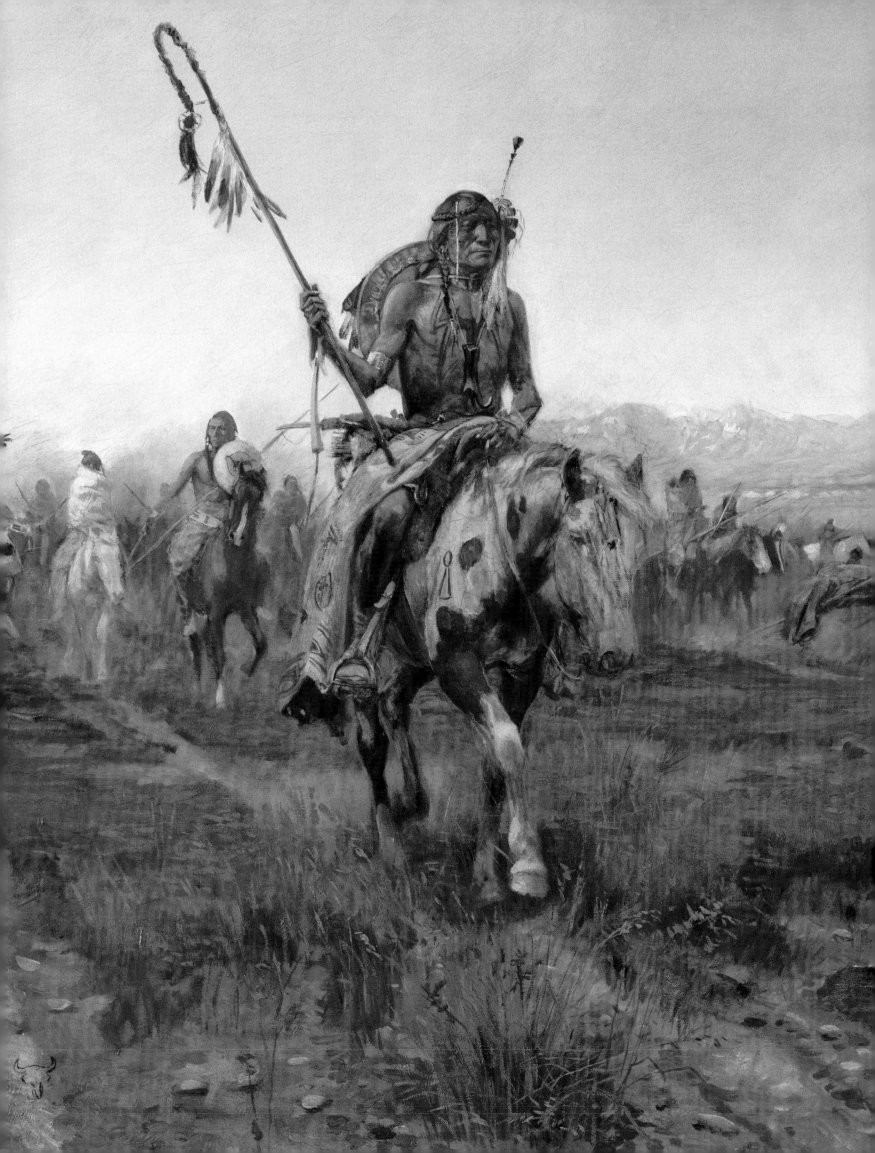

Brian W. Dippie

"What a Pair to Draw to"

Charles M. Russell and the Art of Storytelling Art

O N FEBRUARY 23, 1919, Irvin S. Cobb, one of America's favorite storytellers and humorists in the age of legendary figures like Will Rogers, sent Charles M. Russell a fan letter. "I'd rather meet you than almost any man in this country," he wrote. "I want to tell you what is the truth—that you can do more with camel's whiskers and earthen pigments out of tubes than any man at present residing in this hemisphere. America owes you a lot for putting down on canvas the life of the West that is going so fast." Russell replied at once, and a friendship was formed that saw Cobb, a native Kentuckian known as the Sage of Paducah, spend the summer of 1925 with his family at Lake McDonald in Montana, getting to know more intimately a man he admired as an artist and came to appreciate as a storyteller, too.[1]

In his autobiography, *Exit Laughing*, Cobb reflected on his friendship with Russell and Will Rogers in a chapter titled "What a Pair to Draw to!" As an expert on the subject, he prized both men's gifts as raconteurs. Rogers was a professional trick-rope performer whose stage career made him an American icon—the plainspoken, aw-shucks political and social commentator who hid his barbs in cornpone likability. Russell was an artist whose work appealed to "real men" who liked their pictures direct, clear, and set out of doors, but his "chief forte," Cobb concluded, "was in storytelling and in coining homely epigrams. America knows him as the only rival Frederic Remington had as a painter of the vanished border country, but some of us knew him—and still mourn him—as probably the greatest repository and expositor of the frequently ribald but always racy folklore of forgotten mining camps and plowed-under cattle trails that ever lived."[2]

What Cobb had discovered is that a man whose pictures attracted him because of their ability to tell stories was himself a storyteller. "I make pictures for regular men," Russell explained to Cobb, and in his estimation regular men enjoyed seeing as well as hearing stories. He was utterly consistent on this point. "I have always liked to tell stories with the brush so have tried in a way to keep memories' trails fresh," he informed a New York editor in 1921. And in 1925, the year before he died, he famously declared, "I am an illustrator."[3]

(facing)
The Medicine Man, 1908
(detail)
Oil on canvas, 30 × 48⅛ inches,
Amon Carter Museum, Fort Worth,
Texas (1961.171)

Contemporary critics accepted Russell's self-estimate and judged his work accordingly. Those who held illustrators in low esteem dismissed his paintings; those who found virtue in narrative art accepted his achievements as exceptional. "The vivid, lurid, do-or-die days of the wild west, that have been the subject of the most blood-curdling stories in American history have found in Charles M. Russell a faithful chronicler, a storyteller who uses pigments instead of words, a raconteur whose tales are canvases mirroring the old west," a Santa Barbara journalist wrote in 1923. "Mr. Russell is the illustrator, par excellence, of the wild west. He has chosen the most dramatic and picturesque incidents as his subjects. They tell a story in the life of the Red man, and the cowboy. The story is the thing with this artist. Landscape, decoration, color, harmony, all are subservient to the main issue, the incident. . . . The pictures pique the curiosity as well as arouse the admiration for their delineation of the epic west. One is eager to know all the story [his] paintings tell."[4]

Russell was so often described as an illustrator by detractors and champions alike that he was left bemused when a painting of his titled *Rainy Morning*, an evocative depiction of cow-camp routine, was turned down by the company that commissioned it for use as an advertisement in 1904 because it lacked "sufficiently strong or dramatic action." The painting prominently featured the A. J. Tower Company's waterproof slickers, but "what we must tell in our pictures is a story," the company's manager informed the West's greatest storyteller in paint. Years later, Russell ruefully recalled the rejection: "Tower turned my picture down sa[i]d it did not tell a story."[5]

Cobb's unbeatable pair—professional entertainer and professional artist—came together in 1908 when Will Rogers was touring with a vaudeville company in Montana and chanced upon Russell's comic postcards. He had already met Russell on one of the artist's visits to New York, but the postcards were a revelation. "He is the greatest artist of this kind in the world," Rogers wrote in sending several cards to his future wife. "Remington is not in it with him." One of the cards, which Rogers singled out as "a peach"— titled *Sun shine and shadow*— showed two prospectors resting in the shade of a large rock outcropping. Their horses have stampeded, and the one watching them race away says, "I wonder what's the matter with them fool hosses?" The other, staring straight ahead, sees the shadow of a bear standing on the rock overhead. "I ain't wonderin'!" he replies. "From looks them hosses is wise."[6]

The storytelling devices evident in Russell's postcard naturally appealed to a humorist like Rogers; of the eight Russell cards he selected, seven were cartoons in color. He would also have seen two black and white cards titled *The Initiation of the Tenderfoot* and *Initiated*. They were a matched pair in which an eastern dandy thought to ride a western bronco, with two cowboys serving as an appreciative audience and no doubt egging him on. The postcards demonstrate the simplest narrative sequence—before and after—leaving what happened in between to the viewer's imagination. Of course, Russell loved to show that in-between moment as well. His color postcard *Stay with Him!* (1907) required no elaboration because it featured a hapless dude being bucked off. The before-and-after scenes were another matter. *The Initiation of the Tenderfoot*, by itself, hypothetically could lead to the tables being turned. What if the dude confounded his tormentors and rode the horse to a standstill? The companion card would have to show the cowboys flummoxed and foiled. But because Russell was

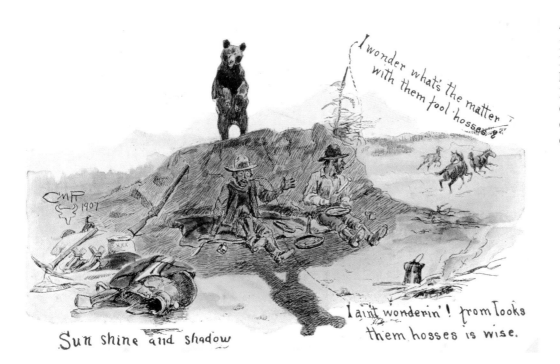

playing to his western audience, *Initiated* predictably shows the dude crumpled in the dust kicked up by the bronco, which is still bucking as the cowboys crack up at the spectacle. The "after" picture removes any ambiguity. The "before" scene, in contrast, permits ambiguity—even if, in Russell's West, there was little doubt about the outcome.

Little doubt, and yet Russell sometimes did show unexpected outcomes. In December 1893 he exhibited a painted wax group of three men playing cards on a blanket spread on the ground: a cowboy, a Chinese, and an Indian. Subsequently, he fashioned a matching group providing a sequel to the first group. Having lost the game, the cowboy has leveled his pistol at the Chinese man, who lifts his hands in surrender. The two waxes were converted into a pair of oils painted in 1894, *The Poker Game at Hop Lees* and *The End of the Poker Game at*

Hop Lees, that were reproduced as advertising prints for a Chicago firm, A. Bauer & Company, distributors of distilled spirits. Russell fleshed out the action by adding a building, Hop Lee's laundry, and the horses belonging to the cowboy and Indian. Because Bauer distributed spirits, the prints also added Sam Toughnut's saloon, with a barrel and a few crates marked Bauer scattered outside.[7]

The resolution offered in *The End of the Poker Game at Hop Lees*, attesting that might makes right, is what one would expect given the prejudice directed at the Chinese in the West. However, the apparent alliance between the cowboy and the Indian introduces a different dynamic, one that Russell would explore in a pair of oils painted about a year later: *Coon-Can—A Horse Apiece* and *Coon-Can—Two Horses*. He simplified the composition, removing the Chinese laundryman who had provided comic relief in his earlier oils, and left just the cowboy and Indian squaring off at cards. The first scene in the pair, including two grazing horses, closely matches *The Poker Game at Hop Lees*. The second, however, introduces an entirely different—and unexpected—outcome. The Indian has won, and with a grin on his face he rides off on the cowboy's horse, wearing the cowboy's hat perched at a jaunty angle and leading his own horse, while the bewildered loser turns away and scratches his head in dismay. What a predicament!

Russell's mature paintings favored anticipation over direct action and aftermath. They have been called "predicament pictures," with *predicament* defined as an unresolved incident, because they involve the viewer in the story by leaving its outcome uncertain.[8] In effect, they break off before the resolution to allow for a range of possibilities. A key to understanding Russell's predicament paintings is to recognize their roots in his habit of thinking sequentially. Usually, they are "before" paintings in an implied sequence made compelling because the "after" painting is not provided. One classic Russell predicament painting actually draws on the second picture in a before-and-after sequence. The *Coon-Can* series concluded with the forlorn figure of a cowboy literally scratching his head. *Meat's Not Meat Till It's in the Pan*, one of the artist's most popular sporting subjects, announces a hunter's predicament by duplicating the cowboy's pose. Here a hunter, having killed a bighorn sheep, is left perplexed. He stands on the edge of a precipice staring down at the bighorn he has killed. It has tumbled onto a ledge, leaving him in a quandary. How can he claim his prize? The melting snow around him is running in rivulets down the slippery rocks at the top of a chasm so deep that eagles soar below. While the hunter ponders his options, his horses go about their business unperturbed, one grazing on a tuft of grass poking through the snow, the other staring off into space. The problem is his, not theirs.[9]

Meat's Not Meat is a masterpiece of sporting art and the very definition of a predicament picture. Interestingly, it was inspired by the second painting in the *Coon-Can* sequence, not the first one. An "after" picture may actually initiate a new story, depending on which tale is being told. Novelist Larry McMurtry, a compelling storyteller, has written prequels and a sequel to his immensely popular novel *Lonesome Dove*, demonstrating that one can imagine backward from a story to what happened before it as readily as one can extend a story by imagining what happens next. *Coon-Can—Two Horses* ends one before-and-after sequence but launches another with a predicament. What next for that hapless, horseless cowboy? And

A contest of races, 1897
Hough, *The Story of the
Cowboy*

Photogravure after *Coon-Can—
A Horse Apiece,* ca. 1895, Image
courtesy of Denver Public Library,
Denver, Colorado

Red wins, 1897
Hough, *The Story of the
Cowboy*

Photogravure after *Coon-Can—
Two Horses,* ca. 1895, Image
courtesy of Denver Public Library,
Denver, Colorado

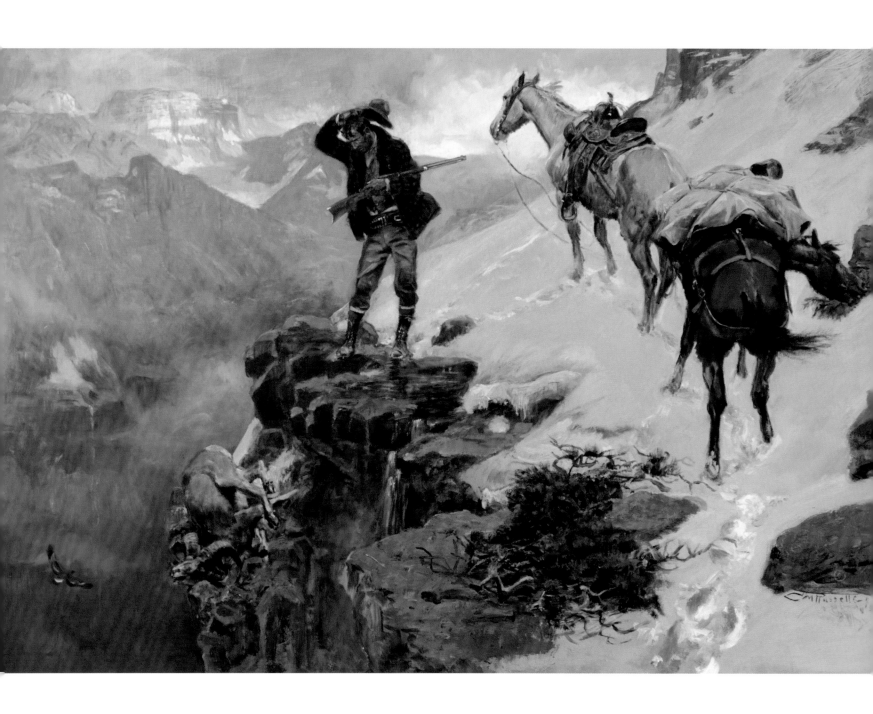

Meat's Not Meat Till It's in the Pan, 1915

Oil on canvas, mounted on masonite,
23 × 35 inches, Gilcrease Museum,
Tulsa, Oklahoma (0137.2244)

what next for that perplexed hunter? When that question is asked, both of these paintings become predicament pictures.

The "before" pictures in before-and-after sequences should thus not be taken as sure predictors of Russell's strategy in predicament paintings. But his penchant for companion pieces—especially prior to his 1904 visit to New York City, when he learned tricks of the professional illustrators' trade—offers a useful insight into his narrative strategies. A matched set of paintings might simply have a decorative function, of course, as when Russell paired Indian and cowboy subjects in circular oils painted about 1894, *On the Brink* and *Sunfishing*. That year Russell also painted a pair of circular oils for a Great Falls saloon showing mounted Indians, one armed with a rifle (*The Hunter*), one with a spear (*The Warrior*). In the same year he matched a scene of an Indian riding away from his village (*Indian Camp*) with another titled *Buffalo Hunt*, both painted on circular glass mirrors.

These were stylized, decorative works, as were Russell's matched pairs of Indian men and women. In the middle 1890s and again in 1901 he painted companion-piece oils known as *Indian Buck* and *Indian Squaw*. All four pieces feature brightly costumed standing figures. The Indian men both carry rifles and display similar tobacco pouches, blankets, and jewelry. Quirts dangle from their wrists. One smokes a pipe, and the other does not. But the most obvious difference between the pieces is in their backgrounds. One man rests against a stone wall, while the other poses in the open. The costumes of the two women are also similar, and their activities and settings are identical. Each carries a fleshing tool and stands on the hide she is scraping. Tipis form both backdrops, locating the women in a domestic sphere, while the men are out and about in the world. These seemingly straightforward companion pieces, equivalent to matched prints of *Blue Boy* and *Pinkie* on the parlor wall, imply something more.[10]

Charlie Russell was a man of his times, with a conventional understanding of gender roles, when he married Nancy Cooper in 1896. In that day, women were seen as more or less good or bad, angels or whores. Cowboys lived a free-roaming existence that tipped toward the dissolute, so they knew the bad ones. Russell was never shy about the facts of life, in his stories or (while he was still a bachelor) in his art. His erotic pictures were intended for patrons in the male-only world of saloons, and they were explicit. A pair of oils done about 1890, titled *Anticipation* and *Exasperation,* show a sexual encounter on the open plains between a cowboy and an Indian woman who are being interrupted by her dog and his horse. *Joy of Life*, a watercolor painted a few years later, depicts an Indian man sitting outside a tipi. Something is up: two children pause in their play; a dog rests on its haunches, ears pricked; and a horse, its saddle draped with cowboy gear, draws back, sensing a problem. The reins trail into the tipi, where a flap lifts to reveal a cowboy and an Indian woman having sex. *Joy of Life* is a single picture that functions as a pair, constituting a before-and-after peepshow for barroom patrons willing to pay for a glimpse behind the tipi cover.[11]

Less explicit was a four-picture sequence Russell painted at the end of 1897 that has attained some currency as the least offensive of his forays into erotica. Each of the four watercolors stands alone. *Just a Little Sunshine* (the cowboy resting on a pretty day in the shadow of his horse) and *Just a Little Rain* (the cowboy earning his pay on a miserable, gray day) begin

the sequence innocently enough. *Just a Little Pleasure*, however, shows the cowboy, drunk and free-spending, frolicking with a sporting woman, while *Just a Little Pain* shows him hopping about, a bottle of medication on the ground, trying to cure what his encounter has caused. There is more horseplay here: the animal that has served him faithfully in sunshine and in rain was not invited in for the evening of pleasure, and thus can only look on with disdain when it is time for his master to suffer "a little." There is also a hint of a moral in the sequence, which references the artist's own well-documented dalliances with prostitutes in his bachelor days. Things changed when he married, as he informed William H. Rance through a pair of drawings that would join *Joy of Life* and the *Just a Little* series in Rance's downtown Great Falls emporium, the Silver Dollar.[12]

 As I Was and *As I Am Now* announced themselves as a before-and-after sequence illustrat-

ing the artist's personal circumstances following his marriage, but there is a larger message here as well. Life has changed forever for the former cowboy; like the old West, he has been tamed. Where he had once eaten alone in a bare room on the kitchen table, hat and jacket tossed on the floor under his unmade bed, the coffee pot at his feet, spearing what he wanted directly from the cooking pot, he now dressed up for dinner and ate at a table covered with linen and set with the silver service given as a wedding gift by the Silver Dollar crowd. Russell carved a chicken while Nancy, perfectly groomed, poured coffee for the two of them in a room graced by a feminine touch.[13]

This transformation was in keeping with Russell's notions of good women and the domestic sphere. While his erotic art might have put Indian women in an unflattering light, he saw them as performing the same essential functions in Indian society that white women performed in white society, and through the 1890s he ordinarily depicted them with a bow to Romantic ideals. Indian maidens were American odalisques, exotic and alluring, while Indian mothers were classic Madonnas. Russell especially doted on courtship scenes. In a pair of watercolors painted before his marriage, *Contemplation* and *The Brave Returns for His Answer* (both ca. 1895), he offered a conventional interpretation of the shy maiden and her importuning suitor. These matching single-figure vertical studies were linked by *The Proposal* (ca. 1895), a horizontal composition showing the man and woman together, forming with the pair a triptych of sorts. With the centerpiece in place the storyline is complete, though the outcome is left unresolved. The man has made his pitch to the woman, allowing us to understand her reaction (*Contemplation*) and his (*The Brave Returns for His Answer*). The viewer is free to decide what she decides. But when Russell settled into his own domestic routine, the artist tipped his hand by frequently picturing family life inside a tipi.[14]

Russell was a sentimentalist where marriage was concerned. Though he told the bluest of tales with relish in male company, in mixed company he could balance a teacup on a saucer in his lap and project refinement as he paid women deference. "If the hive was all drones thair d be no huney," he wrote Nancy in 1919. "Its the lady bee that fills the combe with sweet niss its the same with humans if the world was all hes it would sour and spoil." Despite his appreciation of the importance of women in the scheme of things, his cowboy subject matter offered limited opportunities to depict them. He might show cowboy courtship—and his own fumbled proposal to Nancy on a moonlit night—but to him cowboy-

As I Was, ca. 1896

Pen and ink on paper, 7½ × 9½ inches, Montana Historical Society Collection, Helena (1986.06.04)

As I Am Now, ca. 1896

Pen and ink on paper, 7½ × 9½ inches, Montana Historical Society Collection, Helena (1986.06.05)

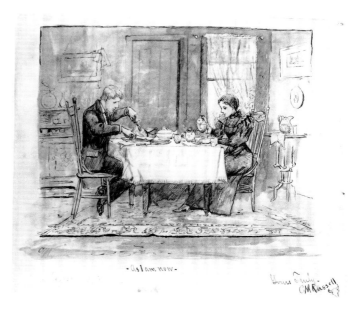

ing was a young man's game. Cowgirls appeared infrequently in his work, except when he was commissioned to illustrate novels like Frances Parker's *Hope Hathaway* (1904) and B. M. Bower's *Flying U* stories or was asked to portray women rodeo contestants. Taking no interest in western homesteaders and townsfolk, Russell ignored white women and the family life he associated with settlers. They did not fit into his vision of "the West that has passed." Indian women, in contrast, were integral to that vision, and he featured them prominently in his art.[15]

When it came to gender roles, Russell adhered to a "separate spheres" ideology; but while the white domestic sphere did not concern him, the world of Indian women did. "Indian Buck" and "Indian Squaw" go about their separate tasks, each contributing to an integrated way of life that vanished with the buffalo. Separate spheres equate logically with halves that make a whole. Consequently, scenes showing women and children in camp or trailing across the plains, dragging their possessions behind them on travois, complemented Russell's many pictures of parties of Indian men on the move. Some of these male-oriented and female-oriented pieces were intended to partner one another. For instance, in 1894 Russell painted two large watercolors, *Indian Women Crossing Stream* and *Indian Hunting Party*. Viewed in that order, the viewer first sees a party of women and children entering a stream from the left, and then a party of men exiting it on the right. The division of the sexes is absolute in the separate paintings, though one could imagine joining them to create a single unified picture.

Two years earlier, Russell completed an ambitious pair of oil paintings of men and women at work. One, *The Buffalo Runners*, shows a hunter on a pinto shooting a second arrow into a massive buffalo. Russell utilized the landscape to good effect, as the flow of action from right to left carries the buffalo herd down a steep embankment into the river valley below. The matching painting, *The Silk Robe*, shows two men relaxing by a tipi, smoking and talking, while two women flesh a buffalo hide stretched out on the ground. An infant playing with the tail of the robe and a camp kettle over an open fire complete the inventory of their chores. A journalist who saw the paintings on display in a Chinook saloon in December 1892 mocked the "lazy" men for "lounging around, as is their wont," while the women did "all the work." Of course, hunting buffalo was the men's work, and they had done it well enough that the women now had their own jobs to do. That was the point of Russell's paintings. Perhaps his compositions confused his meaning. Placing the oils in the correct before-and-after sequence would put them back to back, with *The Buffalo Runners* carrying the viewer's eye to the left and *The Silk Robe* to the right, where the village extends into a sunlit valley. Russell may not have cared how the paintings were hung on their owner's wall in Kalispell. They showed Indian men and women equally hard at work, and that was what mattered.[16]

However, when Russell created another matched set of oils on a related theme in 1901, he paid close attention to their composition. *Buffalo Hunt* shows two Indians on either flank of a herd of buffalo thundering toward the viewer in a wedge-shaped mass. The companion painting, *Returning to Camp*, shows the women and children who have trailed the hunters heading back with travois laden with hides and meat. They are seen from behind, moving in a wedge-shaped procession away from the viewer and toward the village situated in a river bottom. Here Russell's artistry bolsters his message. Coming and going, Indian men and women had

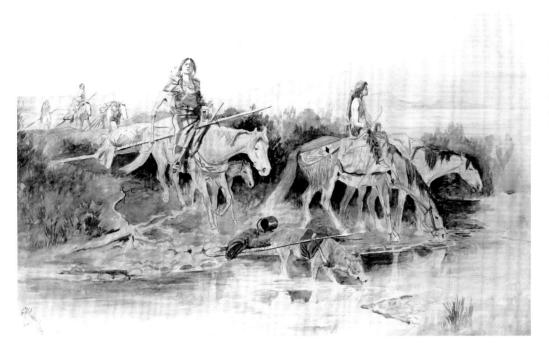

Indian Women Crossing Stream, 1894
Watercolor on paper,
20¾ × 33½ inches, Frederic G.
and Ginger K. Renner Collection,
Paradise Valley, Arizona

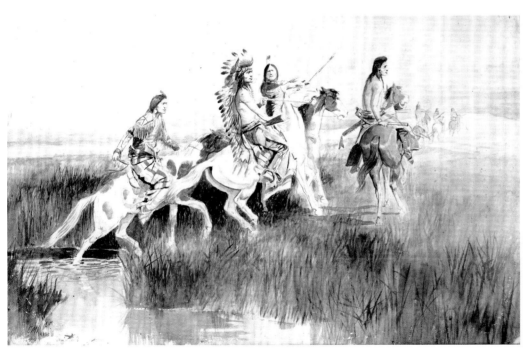

Indian Hunting Party, 1894
Watercolor on paper,
20¾ × 33½ inches, Frederic G.
and Ginger K. Renner Collection,
Paradise Valley, Arizona

The Buffalo Runners,
ca. 1892

Oil on canvas, 27⅝ × 39⅜
inches, Sid Richardson
Museum, Fort Worth, Texas
(1942.4.0.84)

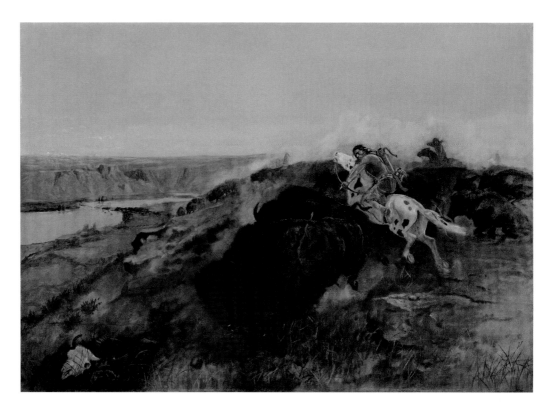

The Silk Robe, ca. 1890

Oil on canvas, 27⅝ × 39⅜
inches, Amon Carter Museum,
Fort Worth, Texas (1961.135)

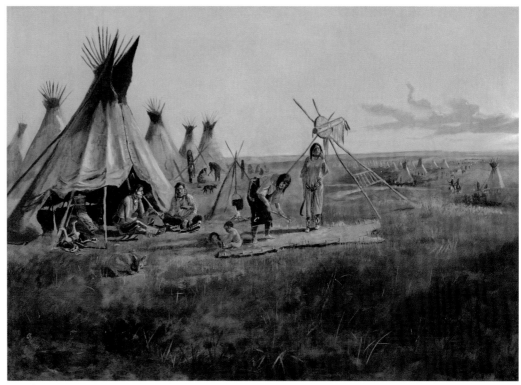

their distinct roles. They occupied separate spheres, but in his art those spheres were equally important.[17]

The habit of thinking sequentially carried over into Russell's mature work. Two watercolors done for advertising purposes in 1910, *An Old Story* and *Life Saver*—illustrating the superiority of the Life Saver Seat Lock Company's product when horses spooked and a wagon left the road—may have been the last real companion pieces he painted, but his art remained rooted in the before-and-after strategies he had relied on through the 1890s. Russell's twentieth-century subject matter was shaped by the demands of calendar companies and the tastes of his patrons. Wildlife and hunting scenes became more prominent in his oeuvre, and other subjects were dropped. Indians outnumbered cowboys in his major exhibitions after 1911, but his range of Indian themes narrowed. Conflict was minimized, for example, and Remington-like scenes of white pioneers making a desperate stand against attacking warriors disappeared entirely. Through the 1890s Russell had often showed parties of Indians skulking about, using rocky outcroppings, trees, and the like to conceal themselves from sight, thus creating an aura of menace. Before-and-after pairs were well suited to his narrative ends, whether he was showing a war party (the oils *Scouting an Enemy Camp* and *Driving off the Stolen Herd*, 1890) or a hunting party (the ink washes *Preparation for the Buffalo Hunt* and *Buffalo Hunt*, ca. 1894).[18]

An impressively large pair of oils from 1893, *Plunder on the Horizon* and *Trouble on the Horizon*, demonstrate Russell's less enlightened attitude toward Indians in the very year he quit cowboying to take up his art full time. In *Plunder*, four well-armed braves are hidden from view as they study a trio of unsuspecting prospectors panning for gold. Their intention, as the title affirms, is hostile. In the companion piece, two prospectors stand on a mountain ledge surveying an Indian camp in the valley below, apparently plotting a strategy to skirt by it without incident. They want to avoid trouble, not make it. In contrast, in Russell's mature paintings it is the Indians who park themselves in the open on a promontory with what seems a relaxed, end-of-the-day contentment as they contemplate the puzzling symbols of white encroachment below: a steamboat, a wagon train, a railroad train. It is their country, and they have nothing to hide. Russell's many paintings showing parties of warriors watching from a bluff or moving across an open, unfenced land express his fully evolved perspective on Indians as "the onley real Americans" and the most powerful symbols of his master theme, the West that was no more.[19]

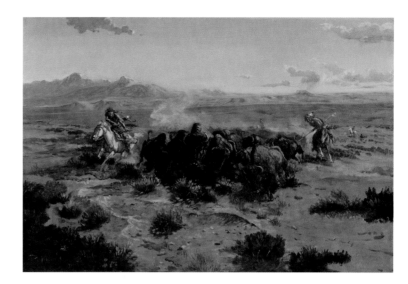

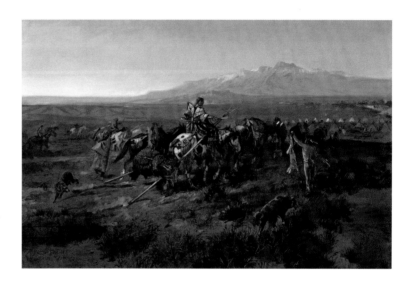

Buffalo Hunt, 1901
Oil on canvas, 24⅛ × 36⅛ inches,
Sid Richardson Museum,
Fort Worth, Texas (1942.5.2.81)

Returning to Camp, 1901
Oil on canvas, 24⅛ × 36 inches,
Sid Richardson Museum,
Fort Worth, Texas (1942.5.1.80)

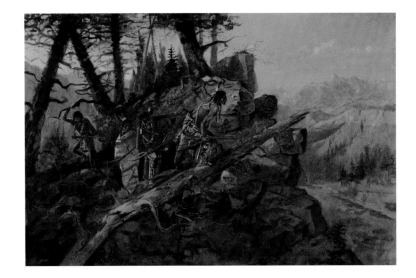

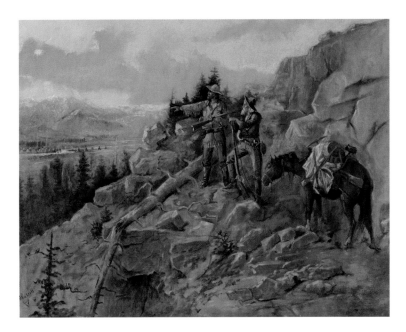

Plunder on the Horizon, 1893

Oil on canvas, 24 × 36 inches,
Sid Richardson Museum,
Fort Worth, Texas (1946.11.7.92)

Trouble on the Horizon, 1893

Oil on canvas, 26⅛ × 34 inches,
Sid Richardson Museum,
Fort Worth, Texas, (1946.11.6.89)

In the 1870s Russell's West was a fantasyland derived from dime novels and adventure stories, as his boyhood sketches show. In the 1880s, after he moved to Montana, his primary mode was documentary. Young, impressionable, and enamored of new experiences, he piled details into his sketches to create a comprehensive record of the life around him. When looking at his earliest published works, one gets a sense of his eagerness to capture every phase of that life. His first lithograph was a montage of seven cowboy scenes printed in Chicago in 1887, while a full page of cowboy sketches based on his work appeared in *Frank Leslie's Illustrated Newspaper* in 1889. Three of the plates in his first book of pictures, *Studies of Western Life* (1890), were montages, and two other plates combined separate paintings. Eager to crowd everything in, he included twenty-four sketches of cowboy and Indian life with a letter he sent to a former cowboy in 1889. One sketch is divided in two; it is particularly interesting because it constitutes a before-and-after sequence that explores his own assumptions by contrasting *A Picture* (a depiction of how Russell imagined Indians before he went to Montana) with *An Indian* (his representation of the reality he encountered after his arrival).[20]

In the 1890s, Russell's West gravitated to the historic and symbolic. This was evident by 1899 in *Pen Sketches*, a book of Russell's pen drawings published in Great Falls. It included first appearances of both *The Initiation of the Tenderfoot* and *Initiated*, but the book's overall tone was commemorative, not comic. It opened with *The Indian of the Plains as He Was*, showing a party of mounted warriors in their own country, and concluded with *The Last of His Race*, an allegorical drawing in which an old Indian kneels on the ground sadly contemplating a buffalo skull, while the modern world passes him by and the smoke billowing from a giant stack across the river forms a spectral buffalo hunt in the sky. *The Last of His Race* symbolizes displacement; in conjunction with *The Indian of the Plains as He Was*, it traces the arc of Indian decline. "Years ago, when no white men were here save a few fur traders and trappers, the Indian believed the plains were his," the caption for the first drawing read. "The artist has represented him as bold, self-reliant, and like a knight-errant of old, ready to meet all foes. He little dreams that ere long, in the westward march of empire, this splendid domain will pass from his control to that of another race." This description makes a crucial point about symbolism in Russell's art: works like *The Indian of*

the Plains as He Was, portraying the Indian at the height of his power, are also implicitly allegorical. They are the "before" images in an understood sequence.[21]

At the same time that Indian men affirmed their rightful place in Russell's art, Indian women receded from it. This must have been a market-driven decision, and an ironic one at that, because Nancy Russell, who had assumed management of her husband's career by 1900, flourished in the male world of commerce outside the domestic sphere. Whatever the explanation, in the twentieth century Russell painted fewer pictures of life inside the camp and the tipi or of women and children trailing the men on a buffalo hunt. When families did appear, they were often part of a procession led by a male, as in *When the Plains Were His* (1906), *The Medicine Man* (1908), *His Wealth* (1915), *Salute to the Robe Trade* (1920) (see p. 85), and *When White Men Turn Red* (1922). In these paintings Russell effectively united the two spheres of Indian life, joining, as it were, the watercolor pair *Indian Women Crossing Stream* and *Indian Hunting Party*.

There was one major exception to this trend. In 1911 he finished a striking oil that hearkened back to the many pictures he had painted of women and children trailing the hunters and scanning the horizon, hoping for a glimpse that would spell success. Titled *In the Wake of the Buffalo Runners*, it is a masterpiece of coloring that represents the pinnacle of Russell's work on this theme. Utilizing the lighting effect he favored in this period—"Russell light," it might be called—the foreground is cast in deep shadow, while one woman, perched high on her pony for a better view, glows in the late afternoon sunlight that illuminates the valley below and, in the distance, a buffalo hunt. That same year, Russell completed an ambitious oil (2½ feet × 4 feet in size), *The Surround*, showing Indian hunters and a milling herd of buffalo. *The Surround* provides a close-up view of what the woman saw from a distance; thus, it complements *In the Wake of the Buffalo Runners*. Whether or not Russell conceived of the paintings as companion pieces, seen together they suggest that old pairings, like old habits, die hard.[22]

The same logic applies to Russell's cowboy subjects. In 1923 he painted *Men of the Open Range*. Steeped in nostalgia, at once heroic and touching, it is an inspired tribute to the cowboys of the artist's youth that parallels his many paintings of parties of Indian men on the move across the unfenced plains. Like his Indian subjects, it, too, conveys a deeper meaning about the passing of a way of life. In narrative terms, it is the "after" picture in an implied sequence that can be reconstructed from the visual evidence provided. The blindfold on the lead rider's horse and the spur tracks visible

The Indian of the Plains as He Was, 1899
Russell, *Pen Sketches*, 10¼ × 13 inches, reproduction of a ca. 1899 drawing by Charles M. Russell, Brian W. Dippie Collection, Victoria, British Columbia, Canada

The Last of His Race, 1899
Russell, *Pen Sketches*, reproduction of an 1899 drawing by Charles M. Russell, Brian W. Dippie Collection, Victoria, British Columbia, Canada

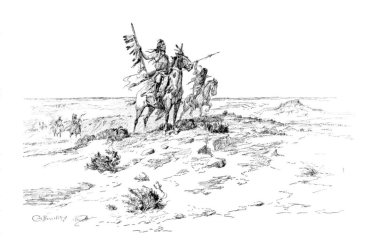

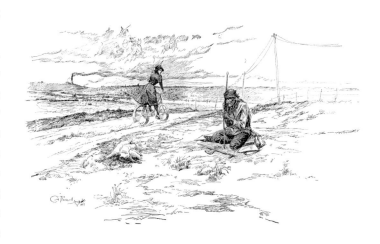

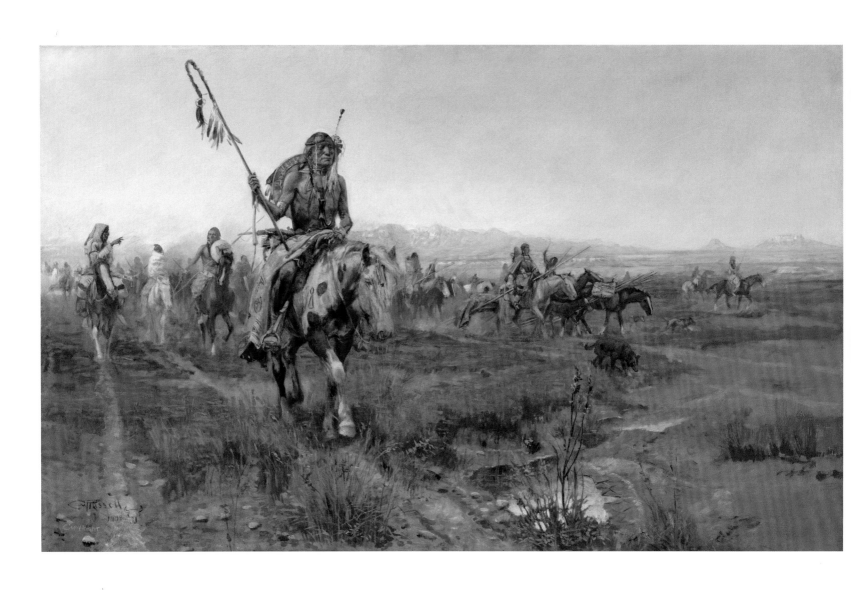

The Medicine Man, 1908

Oil on canvas, 30 × 48⅛ inches,
Amon Carter Museum, Fort Worth,
Texas (1961.171)

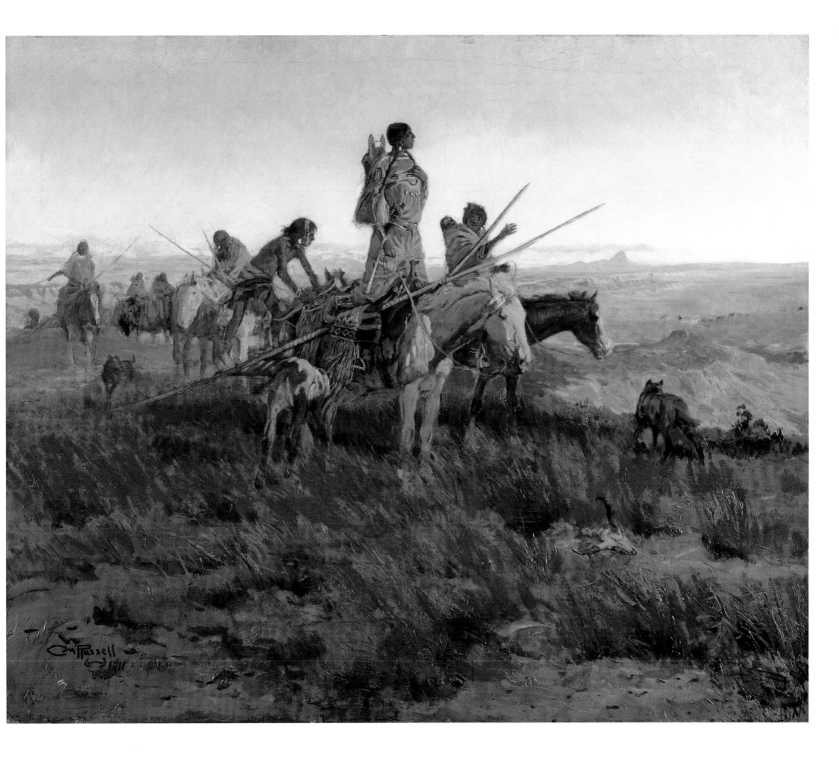

In the Wake of the Buffalo Runners, 1911

Oil on canvas, 25½ × 35½ inches,
Private collection, photograph
courtesy of Michael Bodycomb

on its shoulder tell of jolting action not shown here but vividly portrayed elsewhere in action paintings like *A Bad Horse* (1920). If we back up one more step to the moment before the cowboy mounts that bad horse, the sequence begins with a great predicament picture with a storytelling title, *When Horses Talk War There's Slim Chance for Truce* (1915) (see pp. 44–45). These paintings were not intended to form a sequence, but they are interlocking pieces in a familiar Russell story. Taken together, they show prelude, action, and aftermath.

In Russell's most ambitious cowboy paintings from the 1880s, all these elements were present in rudimentary form. His 1887 oil *Cowboy Camp During the Roundup* spaces discrete incidents across the foreground like so many beads on a string. Viewed from left to right, they constitute the very sequence just discussed: balky horse, rider mounting, explosive action, and fellow cowboys enjoying the spectacle before heading out for a day's work. Sequential art, according to a master of the comic book genre, is "a means of creative expression, a distinct discipline, an art and literary form that deals with the arrangement of pictures or images and words to narrate a story or dramatize an idea." *Cowboy Camp During the Roundup* fits that definition. So do the Russell paintings done years later that isolate each of these incidents in separate works of art, with the narrative sequence implied rather than stipulated. Such paintings, steeped in documentary particulars, lent themselves to allegorical ends. *Men of the Open Range*, like *The Indian of the Plains as He Was*, is as much a tribute to a vanished way of life as *The Last of His Race*.[23]

Sequential storytelling through pictures was well established by the 1890s in works considered the predecessors to comic strips and comic books. Russell enjoyed cartooning, as his illustrated letters prove. He met the comic strip artists Frank "Hop" Hopkins and Jimmy Swinnerton, and he befriended the gifted pen-and-ink illustrator Will Crawford, whose cartoon style particularly influenced his own. Russell was especially attuned to the humor magazines that flourished in the nineties, like *Puck*, *Judge*, and *Life*. Besides Crawford, who contributed to both *Puck* and *Life*, Russell's New York acquaintances included Joseph Keppler, Jr., Louis M. Glackens, Frank Nankivell, and Albert Levering, all *Puck* illustrators. Humor magazines and slick monthlies used single-panel cartoons to get a laugh or make a point, much like editorial cartoons today. Russell saved one example from *Life* titled *Paradise Lost* (undated), which showed two seated Indians mournfully studying a buffalo skull while the clouds overhead assume the shape of a mighty herd of bison. *Paradise Lost* directly parallels *The Last of His Race*. Indeed, at the close of the nineteenth century Russell was smitten with the allegorical potential of art, which is hardly surprising for someone who had made a buffalo skull part of his signature to express in shorthand form his unvarying thematic concerns.[24]

Russell's most famous allegorical work remains a miniature watercolor he dashed off in 1887. *Waiting for a Chinook* told a complex story through a simple sketch of a starving cow and hungry wolves. By illustrating present conditions on the cattle range in a literal manner, it summed up the past and the future of the entire open-range cattle industry in the West. Its power derives from its documentary claim. It appears to be an unvarnished statement of fact that rises to the symbolic, while Russell's purposeful allegories can seem earthbound to modern tastes. *The Last of His Race* is poignant, but it drives its message home. More subtly,

Waiting for a Chinook
[To Lewis E. Kaufman],
1887
Watercolor on paper, 2½ × 4⅜
inches, Used with permission
from the Montana Stockgrowers
Association, Helena

Mothers under the Skin (1900) exposes racism by contrasting the circumstances of a white woman and an Indian woman, each with a child and a dog, but one living a pampered life and the other peddling buffalo-horn relics to feed her family.

Russell also painted a pair of matched watercolors in 1898 to protest how Montana's Indian population had been debased by the white man's vaunted progress. *Blackfoot Brave of 1858* and *Blackfoot Brave of 1898* were before-and-after images spanning forty years in which the splendidly dressed plains warrior clutching a bow, a shield strapped on his left arm and an eagle feather standing upright in his hair, was reduced to wearing a white man's shirt and hat, a feather drooping from its crown. Humbled, the buffalo-hunting freeman of 1858 now held a buffalo-horn hat rack in the hand that once held a bow, and with the other he indicated a price: two dollars for what remained of his proud heritage.[25]

It was common in allegorical art to show a cavalcade of types arranged in chronological order to represent the march of progress. The theme of America's western settlement almost cried out for such a treatment, with its easily choreographed movement from the Atlantic to the Pacific and its distinctive figures from each era, beginning with the Indian and culminating in soldier, teacher, or statesman. Russell's pervasive nostalgia prevented him from embracing what was essentially a triumphalist interpretation of civilization's advance. He preferred to show a collection of frontier types gathered for the Old West's last rites, an approach enshrined in his 1898 drawing *Wild West*. With haughty disdain, Dame Progress—carrying a book of Science and a scroll labeled "Law / No Gambling," and sporting a sash embroidered with the word "Civilization"—dismisses the representatives of yesterday. Father Time, with sickle and hourglass, points off to the distant ocean, where the clouds are shaded by spectral images of a freight wagon, a pack train, a stagecoach, grazing cattle, and a buffalo hunt. Indian, road agent, cowboy, stagecoach driver, bull whacker, fur trapper, gambler, freighter—they had

Blackfoot Brave of 1858, 1898
Watercolor on paper, 13⅝ × 9⅛ inches,
Montana Historical Society Collection,
Helena (1990.53.01)

1858

Blackfoot Brave of 1898, 1898
Watercolor on paper, 13⅞ × 9⅛ inches
Montana Historical Society Collection,
Helena (1990.53.02)

1898

no part to play in the West's future. At Civilization's feet are a reel of barbed wire and a young woman in bloomers photographing the old-timers—western curios, as she saw them—while the bespectacled young man beside her rests a hand on his bicycle seat. They are tomorrow; behind them looms a factory and a smokestack, while a legion advances under the banner of "Salvation." There will be no salvation for the Old West; its coffin rests on the ground beneath Civilization, a message draped over it—"Wild West loved by all who knew her"—and buffalo skulls propped up against it. Russell's allegory turns celebration on its head. Progress might be inevitable, but it need not be applauded.[26]

His perspective—the consistent core of his storytelling art—made Russell a poor choice to paint a mural in 1926 whose theme was a celebratory "History of the West" beginning with Pilgrims and Indians (another artist was hired for this portion) and culminating in the triumph of the industry that had enriched his patron, California oil man Edward L. Doheny. Oil derricks represented the new West, as surely as Russell's frontier types represented the old. He began his half of the mural with a cattle roundup and then depicted a stagecoach, a pack train, and prospectors. He joined the individual episodes with foreground landscape filler featuring wildlife, from antelope and a bear to deer and—presumably intentionally—as one neared the oil derricks, a rattlesnake. The West might still be a land of opportunity for some, but for the cowboy, the pick-and-shovel prospector, and the wild animals that haunted Russell's paintings, there was no future. Progress had banished them, just as Russell had shown a quarter of a century earlier in *Wild West*. Like *Cowboy Camp During the Roundup*, *The History of the West* was essentially sequential art on a grand scale, with a message to convey.[27]

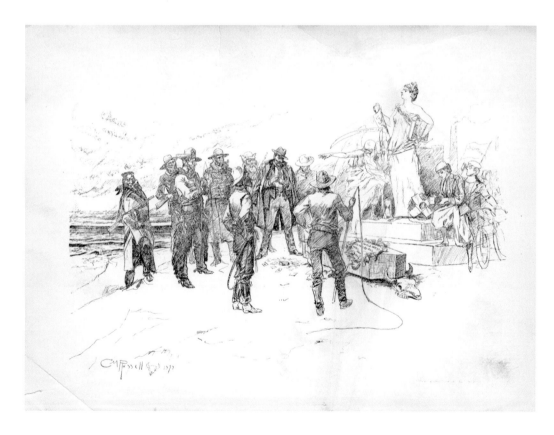

Wild West, 1899

Coburn, *Rhymes from a Round-up Camp*

Reproduction after an 1898 drawing by Charles M. Russell, Brian W. Dippie Collection, Victoria, British Columbia, Canada

 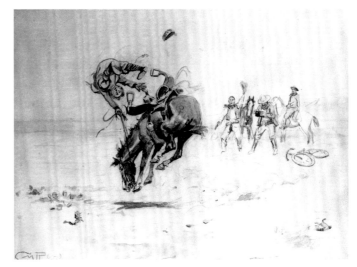

(clockwise, from top left)

The Cyclist and the Cowboys
[No. 1], ca. 1898
Watercolor on paper, 10½ × 14½ inches,
William S. Hart Museum, Newhall,
California

The Cyclist and the Cowboys
[No. 4], ca. 1898
Watercolor on paper, 10½ × 14½ inches,
William S. Hart Museum, Newhall,
California

The Cyclist and the Cowboys
[No. 2], ca. 1898
Watercolor on paper, 10½ × 14½ inches,
William S. Hart Museum, Newhall,
California

The Cyclist and the Cowboys
[No. 3], ca. 1898
Watercolor on paper, 10½ × 14½ inches,
William S. Hart Museum, Newhall,
California

Russell usually limited his sequential art to pairs, but in 1898 he painted four matched watercolors that told a story he wanted others to hear. Progress would win, but the Old West would not fade away quietly. *The Cyclist and the Cowboys* elaborates on the theme of westerners initiating easterners into their way of life, and it takes revenge on that rather precious bicyclist in *Wild West*, drawn the same year. The story line is simple enough. Three cowboys talk a dude into abandoning his bicycle for a horse. They stack the odds against him by clamping a prickly pear under the horse's tail; then they stand back to whoop with laughter as the bronc takes him for a mercifully short ride. One of the cowboys uses the dude's own Kodak to snap a picture of him as he flies through the air (so much for the young woman who wanted a souvenir photograph of the Wild West's funeral). In the last panel a curious gopher pops out of his hole to observe the bicyclist's humiliation as he nurses his bruises and wounded pride while the cowboys race away, two of them towing the third on the tenderfoot's bicycle. The rough justice meted out by the cowboys was proportionate to the disdain Dame Progress had showered on the old-timers in *Wild West*. Cosmic revenge deserved four pictures, not just a pair.[28]

IN PREPARING A PROFILE OF CHARLES M. RUSSELL published in 1917, Edward Cave interviewed Philip R. Goodwin, an accomplished sporting artist who had spent two summers at Bull Head Lodge on Lake McDonald. He confirmed Cave's impression that Russell "has the true old-time plainsman's and trapper's gift at spinning yarns. . . . He is decidedly human, with a very keen sense of humor and daring imagination, is naturally droll, has perfect control of his remarkably striking features, has a pleasingly mellow bass voice, excellent power of description and tells a story as a gambler plays poker." That metaphor is apt. Russell dealt his storytelling cards with measured skill, revealing just enough to entice others to join him in the game before he showed his hand. Irvin Cobb, who described him as "a supreme word painter," marveled that "one man could possess in such degree two gifts so closely related and yet so wide apart." Will Rogers also praised Russell as "a great story-teller": "Bret Hart[e], Mark Twain or any of our old traditions couldn't paint a word picture with the originality that Charlie could. He could take a short little yarn and make a production out of it. . . . It's like his Pictures. He never painted a Picture that you couldn't look closely and find some little concealed humor in it." Rogers was right. Russell's gifts were intertwined, not "wide apart." Before he met Irvin Cobb, Russell told him that "this old world has picture painters and picture writers I think a good pen pusher has a brush man skin[n]ed to the dew claws." What he did not say was that he himself was adept at both. He might tell writers that "the man that makes word pictures is the greater," but he also observed that "betwine the pen and the brush there is little diffornce." The writer and the painter conjured up images that existed only in their minds until they gave them form. For word painter and painter alike, storytelling was a single art.[29]

Will Rogers's choice of a Russell "peach," *Sun shine and shadow*, pointed unerringly to a great 1915 predicament picture, *When Shadows Hint Death*. By then, as noted, Russell frequently employed in his major oils a distinctive lighting effect, a brilliant, raking light that

When Shadows Hint Death, 1915
Oil on canvas, 30 × 40 inches,
The Duquesne Club, Pittsburgh,
Pennsylvania

illuminates peaks, valleys, and figures behind the foreground action, which plays out in shadow. Russell's control of color allowed particulars to be visible in the lower register of tones. In a few paintings sunlight and shadow were central elements. For example, in *The Sun Worshippers* (1910) the Indians' reverence for the source of creation mandates that all three men be fully bathed in the sun's rich glow. The same holds true for *The Signal Glass* (1916), in which the sun flashes off the mirror held up by an Indian signaling to his tribesmen. In contrast, *When Shadows Hint Death* depends on deep shade to conceal the foreground figures who look across a gully at the shadows of a procession of Indians moving in single file along the top of the bluff above them. This was Russell at his most cinematic, the sun literally serving as a projector casting shadows on a screen. The joke in *Sun shine and shadow* has become a fully realized work of narrative art.[30]

Rogers had another favorite Russell cartoon, the only cartoon postcard among the ones he chose that did not tell a joke. It shows Russell toasting a group of old-time westerners (including the mandatory horse) above the words, "I savvy these folks" (1907). A prospector, a bull whacker, a stagecoach driver, a gambler, even a Chinese laundryman crowd around Russell. On either side, with a hand on his shoulder, stand a cowboy and an Indian. Rogers was delighted. "These are the characters he draws," he wrote beside the picture, "this is him and his friends." Fifteen years later, in 1922, Russell painted a "poster" known as *Charles M. Russell and His Friends*. Reveling in his role as the West's storyteller in paint, Russell sits astride his horse facing the viewer and gesturing toward the cowboys and Indians sweeping up the draw behind him. They inhabit a shimmering, open land that will never be fenced or settled. His art suspends time, allowing the past to live on in a perpetual present. This poster constituted Russell's personal "History of the West," not the ornate mural completed on commission for

I Savvy These Folks, 1907
Pen and ink with watercolor on paper, 7½ × 12 inches, Gilcrease Museum, Tulsa, Oklahoma (0237.1585)

The Price of His Hide, 1915
Oil on canvas, 23 × 26 inches,
William C. Foxley Collection,
La Jolla, California

the oil man Doheny in 1926. Heartfelt and intimate, it was true to the spirit of *I Savvy These Folks*. Both cartoon and poster cut through to the deeper story Russell wanted to tell.[31]

For Russell, life was a narrative populated by a colorful cast of characters in a specific setting, a specific time and place. As he told a Saskatoon reporter when he attended the Stampede there in 1919:

> I have confined myself entirely to historical work. That is, I have attempted to record in the form of paintings what little I could of the old life on the great ranches in the northwestern states. . . . It is largely a thing of the past now—gone as a result of the country filling up with people from the east. The big ranches have gone and the Indians and the buffalo have gone. The stampede is an attempt to show the people of this generation by actual example something of this life that is fast disappearing from the continent. Some day the stampede itself will be a thing of the past. It is against that day that I am painting. Then the only record of the wild, untamed life of the plains and prairies will be that written on canvas.

Irvin Cobb understood what Russell meant. He had made the artist's acquaintance in the year that he gave the interview in Saskatoon. In a tribute Cobb drafted for Nancy Russell in 1929, he described Charlie as "the last of the men who knew the oldtime range, the old wild life, the old cowhand, the old Indian. And he was the only one of them who had the God-sent gift of recording the scene that is gone and gone for ever."[32]

The two paintings that first attracted Cobb to the man behind the art affirmed the storytelling power of Russell's gift. One, *The Price of His Hide* (1915), narrated an entire tale through its denouement: a man, literally tattered and torn, sits on a log next to a dead grizzly, his rifle lying on a rock in the foreground. An armed companion has arrived, too late to save him but in time to patch him up. That would be one interpretation of the story. But the painting's alternative title, *Who Killed the Bear?*, suggests another. The hunter, having lost his rifle in a death struggle with the grizzly, has been saved by his companion's well-placed shot. The only horse in the picture, warily keeping its distance, offers no clue as to which version is true.[33]

Carson's Men (1913) (see p. 210), the other oil that captivated Cobb, is devoid of dramatic incident, but not of drama. Nothing much is happening. A party of trappers is crossing a river. The sky is golden, the scene serene. Alert and ready, they are advancing into the unknown. Wolf tracks and a buffalo carcass hint at danger ahead. The picture is all portent. It holds its breath and lets the viewer's imagination do the work. It is a great storytelling painting.

In a young neighbor's copy of *Indian Why Stories*, a book by Frank B. Linderman that Russell illustrated, Russell sketched Indian paraphernalia and a buffalo skull. Below he wrote:

> The West is dead my Friend
> But writers hold the seed
> And what they sow
> Will live and grow
> Again to those who read.

To those who read—and those who look. Charles M. Russell, storyteller.[34]

Notes

1. Adams and Britzman, *Charles M. Russell*, xiii–xiv.

2. Cobb, *Exit Laughing*, 403. On June 9, 1929, Cobb wrote a tribute to Russell for Nancy's use that included the observation, "What a story-teller he was and what a gift for metaphor and apt comparison he displayed and what a fund of frontier folklore and romance and drama he had stored up in his mind. . . . Those of us who enjoyed the privilege of man-to-man communion with him, will forever reverence him also as one of the real humorists and as one of the real historians of his day and time" (The Helen E. and Homer E. Britzman Collection, Colorado Springs Fine Arts Center, Colorado Springs, Colorado [hereafter Britzman Collection, CSFAC]). A letter from Cobb to Russell dated December 23, 1921 (Montana Newspaper Association insert, Britzman Collection, CSFAC), served as an endorsement for Russell's first published collection of stories, *Rawhide Rawlins*. "It is full of good local color, good character-drawing, and good lines," Cobb wrote. Russell's storytelling ability has inspired a fairly substantial literature focused on his published work. Brunvand's "From Western Folklore to Fiction in the Stories of Charles M. Russell" is useful in showing Russell's close adherence to folkloric conventions in many of his short stories. Gale's *Charles Marion Russell* explores the connections between Russell's narrative strategies as a painter and as a writer, and it offers an assessment of each Russell story in *Trails Plowed Under* (1927). Hearing the stories told, as Cobb and Rogers did, might have altered some of Gale's judgments. Gale's assertion that the best of Russell's published stories equal those of Mark Twain, Bret Harte, and Will Rogers, and surpass those of Bill Nye, James Whitcomb Riley, and Irvin S. Cobb, is thought-provoking, as is his conclusion (24): "The main virtues of Russell's writings are the same as those which distinguish his best art work: authenticity, detail, suspense, and humor." For the publishing history of Russell's stories, see Dippie, "Introduction," in Charles M. Russell, *Trails Plowed Under*, v–xix. The standard study is Cristy, *Charles M. Russell*, which also makes useful connections between Russell's stories and his art.

3. Dippie, ed., *Charles M. Russell, Word Painter*, 275; Nancy C. Russell to J. H. Chapin, February 21, 1921, Britzman Collection, CSFAC; Charles M. Russell, *More Rawhides*, 3.

4. Litti Paulding, "Russell's Paintings Tell Story of the Fast Passing Old West," Santa Barbara *Morning Press*, February 20, 1923.

5. Walter S. Barker to C. M. Russell, May 9, 1904, Britzman Collection, CSFAC; C. M. Russell note to Joe De Yong, ca. 1916, Joe De Yong Collection. Nancy added her opinion to the note: the Tower Company would not meet her asking price for the artwork and found a pretext to reject it.

6. Rogers to Betty Blake, June 17 1908, *The Papers of Will Rogers*, 434–35. The postcard is reproduced in Collins, *Will Rogers*, 166.

7. Untitled note from the Great Falls (Mont.) *Tribune*, reprinted in the *Fergus County Argus*, December 28, 1893; "The 'Cowboy Artist,'" Helena (Mont.) *Weekly Herald*, December 28, 1893, indicating that the wax group would soon be displayed there. See Stewart, *Charles M. Russell*, 18–19, for the wax groups and the prints. For the paintings, see the online subscription Russell *Catalogue Raisonné* (http://russellraisonne.com/), reference numbers UNL.408 and PC.318. Also see Peterson, "Painting the Town."

8. The term "predicament picture" is now established in discussions of Russell's art. For a recent example see Hassrick, "Charles Russell, Painter," 105. The usage finds a source in Russell's 1908 oil *The Range Mother*, which was first published as a color print by Brown & Bigelow under the title *A Serious Predica-*

ment. Gale likens Russell's predicament paintings to films in which the director, at "the dramatic moment at the height of suspense, with the outcome uncertain," slows "the motion to an agonizing freeze while the audience, captivated, wonders what will happen next, when the heartbeat picks up again" (*Charles Marion Russell,* 14). Russell's good friend Philip R. Goodwin and other masters of western and sporting art specialized in similarly unresolved moments in the outdoorsman's life. See Rattenbury, *The Art of American Arms Makers,* and Peterson, *Philip R. Goodwin.*

9. A full essay could be devoted to the role of the horse in Russell's art. In introducing a book of stories by Frederic Remington, J. Frank Dobie, no mean storyteller himself, reproduced a quiet Russell pen-and-ink drawing of a cowboy taking a midday nap in the shadow of his horse, "the only shade there is. The horse is not used to a man stretched out on the ground under him and is not contented." This, for Dobie, was evidence for his case that while Remington "knew more than he understood," Russell understood. See Dobie, "A Summary Introduction to Frederic Remington," in Frederic Remington, *Pony Tracks* (Reprint, Norman: University of Oklahoma Press, 1961), xix–xx. To Russell, horses were never simply set dressing. Their instinctive reactions made them active participants in every situation Russell envisioned. At the same time they were his eternal innocents, uncorrupted by human conniving yet capable of expressing a full range of emotions. They do not just stand around in his paintings; they advance the plotline of his story, whether the situation is comic or deadly serious. Works like *When the Nose of a Horse Beats the Eyes of a Man* (1916) and *Bruin, Not Bunny, Turned the Leaders* (1924) put horses at the center of the action. Perspective was critical to pictorial storytelling. *Innocent Allies* (1913) shows how perspective could be used to manipulate the audience's response. Russell was of the opinion that old Montana "was a lawless land but seldom dangerous. We had outlaws but they were big like the country they lived in" (Nancy Russell to Chapin, February 21, 1921, Britzman Collection, CSFAC). Most people wouldn't find stagecoach robbers sympathetic, but the same could not be said for their saddle horses, waiting patiently on a rocky bluff above the scene of the crime. It took an artist fully confident of his storytelling abilities to pull off a picture like *Innocent Allies,* and it took horses to win the audience over to Russell's point of view.

10. Online *Catalogue Raisonné: On the Brink* and *Sunfishing,* ca. 1894 (UNL.400, UNL.510); *The Hunter* and *The Warrior,* 1894 (PC.368, PC.367); *Indian Camp* and *Buffalo Hunt,* ca. 1895 (CMR.67, CMR.9); *Indian Buck* and *Indian Squaw,* ca. 1895 (MUS.7, MUS.8); and *Indian Buck* and *Indian Squaw,* 1901 (PC.139, UNL.284). Asked to paint two subjects on an oval panel and an octagonal panel on a bank vault's door in Lewistown in 1891, Russell chose cowboy (*On Day Herd*) and Indian (*Flagging Antelope*) themes. They can be seen in place in a photograph from the period: see McCracken, *The Charles M. Russell Book,* 145–47; and Peterson, *Charles M. Russell: Printed Rarities from Private Collections,* 77.

11. Russell's bluest stories were never published, though his male friends considered him a master of the ribald tale. On January 27, 1930, Irvin Cobb wrote down one of Russell's mildly off-color stories for John Wilson Townsend, who published it in 1947 as *Piano Jim and the Impotent Pumpkin Vine; or "Charley Russell's Best Story—to My Way of Thinking."* Will Rogers declined to do the same, his note serving as a postscript to Townsend's booklet, while Nancy Russell let Townsend know that only Charlie Russell could tell a Charlie Russell story. See *Charlie Russell Rides Again,* a single-sheet printing of Nancy's letter to Townsend of March 5, 1930. More of Russell's bawdy stories, retold and sanitized, were collected in *Rawhide Rawlins Rides Again.*

Anticipation and *Exasperation* (*Catalogue Raisonné* UNL.21 and UNL.21a) make an interesting pair. The cowboy in the first oil does not conform to Russell's usual style, while the figures and animals in the second do. The paintings date to a period when Russell liked to paint companion pieces, which is evidence for the argument that they are both his work.

12. "'The Cowboy Artist': Russell Paints Four Pictures for William H. Rance," Great Falls *Tribune*, January 14, 1898. The moral of the *Just a Little* series can be loosely linked to Russell's personal transformation after his marriage. Early in 1908, he made a watercolor of three cowboys meeting at a fork in the road. One, with a shiny red nose and a bottle in hand, has a decision to make. The road leading to a temperance lecture is virtually untraveled, while that leading to "Poker Jake's Palice" is heavily used. So much for New Year's resolutions, the accompanying poem states. But Russell had reached that very fork in his own road, and while he would never preach reform to others, he had decided to give up drinking himself (Dippie, ed., *Word Painter*, 93). A less personal lesson informed a major oil he painted in 1921, *The Wolf and the Beaver*. A throwback to his earlier explicitly allegorical art, it shows a wanted man on a bleak winter's night, pulling back out of sight from the valley below, where a home's beckoning lights mock his forlorn circumstances. Cut off from the rewards of honest toil, he symbolizes the price to be paid for living outside the law. Posted on a blasted tree stump is a notice: "$1000 REWARD Dead or Alive" for "Four Duce," the "wolf" in this picture. Wagon ruts in the snow leading down to the valley show the road "beavers" take—the main-traveled road that wolves must avoid.

13. The pair in question resembles another, painted a few years earlier, known as *Contrast in Artist's Salons*. The first picture, *Charlie Painting in His Cabin*, closely resembles *As I*

Was in its sketchy quality mimicking the barebones nature of bachelor life. The matching image in each pair is more fully elaborated to suggest the refinement marriage has brought in *As I Am Now* and the inflated assumptions about the opulence of an artist's lifestyle in *My Studio as Mother Thought*. See Dippie, *Looking at Russell*, iv, 89.

14. All three paintings (*Catalogue Raisonné* UNL.436, UNL.131, UNL.54) were together when James B. Rankin saw them in the 1930s. He described them as "Barbara May Sullivan's Indian Love Trilogy" and noted they were "painted when CMR had shack near Broadwater Bay on Missouri River in G. F. [Great Falls], not married. Mr. Kyle tried to contract for a group of paintings but in vain. Trilogy was made for him & bought from Mrs. Kyle in 1935 by Mrs. Wm. Sullivan as a high school graduation present for her daughter B.M.S." (Notebook, Rankin Collection). Some of Russell's pairs may have been conceived with a centerpiece in mind, but the only per se triptych of which I am aware was a three-panel watercolor Russell did for Nancy in 1920, *I Drink Not to Kings*, which combined an 8¾ in. × 11¼ in. scene of a knight and a jester flanked by two 8¾ in. × 4⅞ in. paintings of castles. The centerpiece was mounted above a poem in Russell's hand, "I Drink Not to King in Castle Strong." The work attests to Russell's abiding affection for historical romances and the lingering influence of his trip to England with Nancy in 1914. For the panels in place with the poem, see Hammer, *The Works of Charles M. Russell and Other Western Artists*, 22.

15. Dippie, ed., *Word Painter*, 271; and see "Necked," a poem written on the marriage of Selden and Eleanor Rodgers, *Word Painter*, 178.

16. Untitled note, Fort Benton *Weekly River Press*, December 21, 1892.

17. Through 1901 Russell was still painting thematically related works that, at the least, consti-

tuted companion pieces. An article in his local paper, "Charles Russell and His Work," Great Falls *Tribune*, July 28, 1901, observed:

> Two of Russell's paintings should always be exhibited together, although they are entirely different in conception. One of them is a small picture of three Indians, sitting on their horses, on a high roll of the prairie, one of whom, in true Indian fashion, is shading his eyes with one hand and is earnestly scanning the country ahead. . . . It requires no label for the observer to know that they are in search of horses—anybody's horses.
>
> The other painting referred to is a representation of three Indians driving a good sized band of horses along the bank of a small stream. They are hurrying forward and one can easily imagine their fears and hopes of reaching a place of safety before the deadly rifle of the swiftly pursuing white man is heard, for the painting makes it plain that they did not purchase the horses they are driving.

The article then turned to "two of Russell's best and most recent works" on display in the Park Hotel. Both wildlife subjects, known today as *The Elk* (1900) and *To the Victor Belong the Spoils* (1901), were unusually ambitious paintings, at nearly 32 in. × 45 in. each. But the direct companion piece to *The Elk* was actually another painting of identical size titled *The Lone Wolf* (1900). They likely hung together in Bill Rance's Silver Dollar saloon before it was closed with the coming of Prohibition. Today both oils hang in the C. M. Russell Museum, while *To the Victor Belong the Spoils* is in the collection of the National Museum of Wildlife Art in Jackson, Wyoming. See *Russell's West* 4, no. 1 (1996): 22.

18. *Catalogue Raisonné*: *Scouting an Enemy Camp* and *Driving off the Stolen Herd*, 1890 (UNL.481, UNL.162); *Preparation for the Buffalo Hunt*,

ca. 1894 (UNL.431). It and its companion piece, *Buffalo Hunt*, are reproduced in *Kennedy Quarterly* 13 (June 1974): 72–73.

19. Dippie, ed., *Word Painter*, 188.

20. Twenty-three of the twenty-four sketches enclosed with Russell's letter to William W. "Pony Bill" Davis of May 14, 1889, are reproduced in Dippie, ed., *Word Painter*, 18–23. The twenty-fourth, *Branding Scene*, is in the Gilcrease Museum collection (*Catalogue Raisonné* GLC.13). Russell's first mural is also worth mentioning, almost six feet long and a foot and a half high, painted in 1885 for a saloon in Utica. It consists of a scene on the left of Indians firing on a wagon train, and on the right of antelope being flagged by distant hunters, while the centerpiece is a wildlife scene of elk. Because there is no sequence implied, it anticipates Russell's montages of the 1880s rather than his storytelling pictures, and it merits its generic title, *Western Scene*. See Dippie, *Remington and Russell*, 68–69.

21. Charles M. Russell, *Pen Sketches*.

22. The woman standing on her horse for a better view had precedents in Russell's work reaching back more than twenty years to the oil *Four Generations* (ca. 1889–90), at 18½ in. × 37 in. an important early painting, and to the 1896 oil *In the Wake of the Buffalo Hunters* (23 in. × 35 in.). The recurring elements in Russell's art, refined over time, are critical to understanding his work's thematic consistency.

23. Eisner, *Comics and Sequential Art*, 5; Dippie, "'. . . I Feel That I Am Improving Right Along.'"

24. See Beerbohm, West, and Olson, "Origins of Early American Comic Strips Before the Yellow Kid," which discusses comic strips and books published from 1646 to 1900; and Harvey, *Children of the Yellow Kid*, 17–32, especially the observation on page 27: "By the 1890s, the ingredients for the comic strip form had been around for awhile, but it was the newspaper

cartoonist who combined them all to create a durable new form."

25. Russell's indignation over the treatment of Montana's landless Indians involved him in reform activity. In 1913 he crafted an allegorical cartoon that could have stepped from the pages of *Puck*, with its representation of Uncle Sam and Miss Montana commiserating over the heartless activities of corpulent land hogs who expelled the natives from their land to make room for newcomers able to pay a price. An Indian family is shown directed by the figure of Death to follow the buffalo to extinction. See Dippie, ed., *Word Painter*, 174. *Mothers under the Skin* served as an advertisement in 1901 for an unidentified product above the caption "Home Comforts 'Then and Now'" (Rankin Collection).

26. Coburn, *Rhymes from a Round-up Camp*, facing page 9. The drawing has come to be known as *Dame Progress Proudly Stands*, but its original title was simply *Wild West*. Its elaborate symbolism can be explained by the fact it illustrated Coburn's poem of the same title, "Wild West." For *Wild West*'s importance to an understanding of Russell's perspective, see Dippie, "Charlie Russell's Lost West." For allegorical representations of the Indian's destiny, see Dippie, "The Moving Finger Writes: Western Art and the Dynamics of Change," in Jules David Prown, ed., *Discovered Lands, Invented Pasts: Transforming Visions of the American West* (New Haven, Conn.: Yale University Press / Yale University Art Gallery, 1992), 89–115; Dippie, "One West, One Myth."

27. See Silva and Silva, "Charlie Russell's Last Legacy," for Russell's portion of *The History of the West*. For the first portion of the mural, painted by Detleff Sammann in 1910, see *The Estelle Doheny Collection* (New York and Beverly Hills: Christie, Manson & Woods International, 1988), 85. I am grateful to Patricia M. Burnham for detail photographs of the Russell mural.

28. *Just a Little* and *The Cyclist and the Cowboys* (*Catalogue Raisonné* NE.74-77) are Russell's only four-picture narrative sequences of which I am aware. He also did four watercolors for Nancy Russell in 1899 that used the seasons as a metaphor for the stages of life, a conventional motif to which Russell gave a western twist with Indian figures. Spring is represented by a youth standing in a gentle rain; Summer by a maiden resting on the bank of a stream with a bird, a butterfly, and flowers to inspire her reverie; Fall by an older man smoking his pipe in an autumnal setting under a harvest moon; and Winter by a cadaverous ancient man moving into the teeth of a winter gale with a pack of wolves as his companions. It ends the series on a bleak note—starving times with death in the offing—that closely anticipates a bronze Russell modeled just six months before he died, *The Spirit of Winter*. See Stewart, *Charles M. Russell*, 303–307.

29. Cave, "Recreation Men," 12; Irvin S. Cobb, "Charles M. Russell—An Appreciation," Marshall, Mo., *Democrat-News*, December 16, 1934; Will Rogers, "Introduction," in Russell, *Good Medicine*, 15–16; Dippie, ed., *Word Painter*, 275, 287.

30. Two of the other cartoon cards Rogers bought in 1908 were precedents for paintings. *Where Ignorance Is Bliss* anticipated the 1910 watercolor *Unexpected Guest*, and *All Who Know Me—Respect Me* anticipated the 1915 oil *Man's Weapons Are Useless When Nature Goes Armed*.

31. Russell was never a detached observer. He emotionally occupied the scenes he imagined. This storytelling device—explicit in his letters and some of his paintings—is implicit in all of them, which helps explain why he made himself so prominent in his work. It was his West that he portrayed. Consequently, he is a participant observer in *The Christmas Dinner* (1898) (originally called *Self-Invited Guests at Christmas Time*), *Calling the Horses (Get Your Ropes)* (1899), *Utica* (1907), *Bronc to Breakfast* (1908), *Laugh Kills Lonesome* (1925), and, as will be

discussed, *Charles M. Russell and His Friends* (1922).

32. "Stampede Will Be the Livest Show Pulled Off in Saskatoon," Saskatoon *Daily Star*, September 9, 1919; Cobb to Nancy Russell, June 9, 1929, Britzman Collection, CSFAC.

33. Russell's other major prime-period oils of man-bear confrontations, reaching back to *A Disputed Trail* (1908), favored the setup over the resolution: *A Dangerous Cripple* (1913), *Whose Meat?* (1914), and *When the Nose of a Horse Beats the Eyes of a Man* (1916). Only *Up against It* (1912), drawing on Russell's watercolor *A Wounded Grizzly* (1906), depicts the actual death struggle. It is difficult to sympathize with the embattled hunter who, having killed a cub, is being mauled by the sow grizzly while the male charges in.

34. Dippie, ed., *Word Painter*, 310.

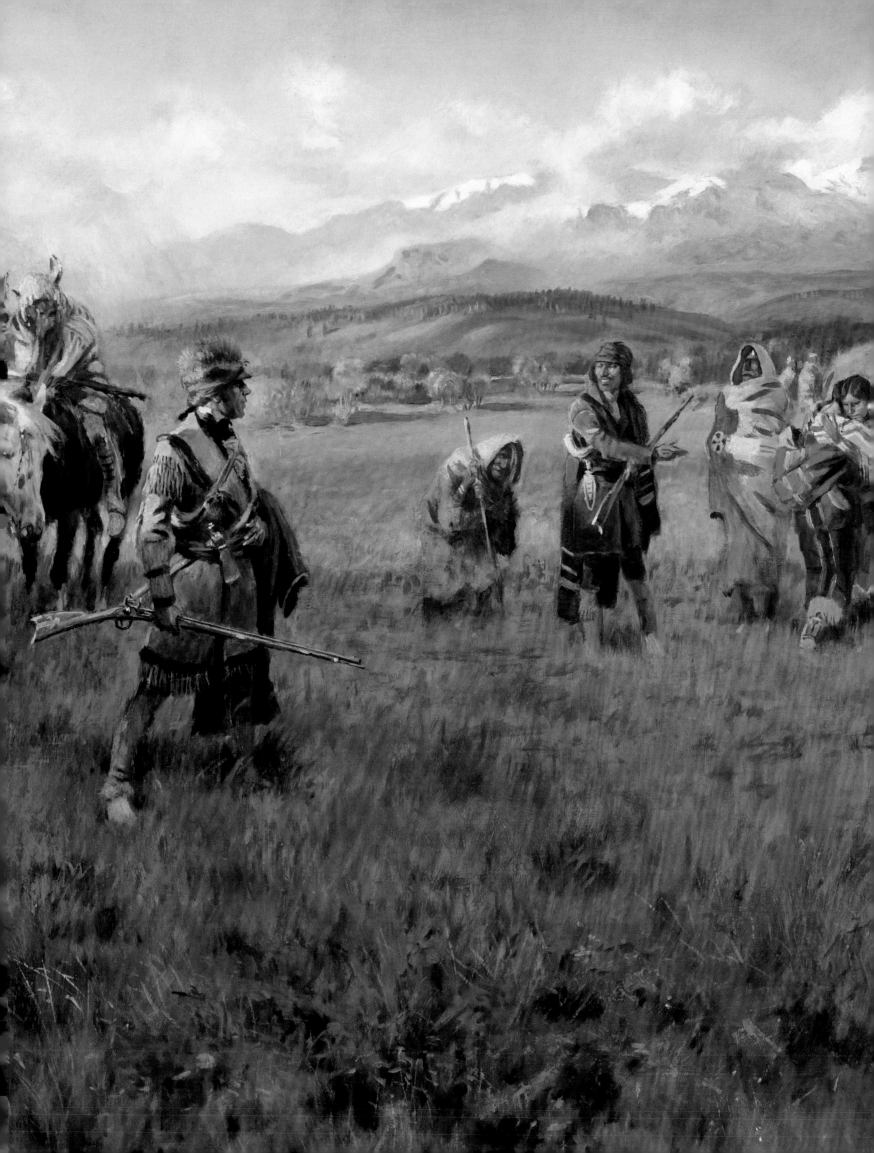

James P. Ronda

Charlie Russell Discovers Lewis and Clark

Charles M. Russell never claimed to be a historian. Spending endless hours in archives puzzling over fading documents held no charm for him. Writing to his friend Guy Weadick, Russell insisted that "I am not a historian."[1] At another time he confessed, "Im sum hazy on history."[2] While Russell was influenced by history painters like Eugène Delacroix and Horace Vernet, he did not choose to portray grand historical events or glorious national heroes.[3] Charlie did not do history with a capital *H*; the daily life of Montana cowboys and plains Indians was at the center of his artistic imagination. But one piece of western history captured his imagination like no other: the Lewis and Clark expedition.

Over his lifetime Russell portrayed the great expedition some nineteen times in oil, water-color, bronze, and magazine and book illustrations.[4] Official histories did not inspire him; Lewis and Clark did. The sources for that inspiration are not hard to find. As much as he loved Montana, Russell never escaped his St. Louis heritage—not that he ever wanted to. Every family has a storehouse of myth and legend, and the Russells were no exception. Perhaps young Charlie heard stories about Charles and William Bent, his grandmother Lucy Bent's famous brothers. Throughout the 1830s and 1840s the Bents were at the center of the often violent life of the Southwest and the southern Great Plains. Charles's partnership with St. Louis trader Ceran St. Vrain and William's work building Bent's fort on the Arkansas River made the brothers powerful players in a complex world of trade, diplomacy, and imperial expansion. Charles moved to Taos and married Maria Ignacia Jaramillo, and William married a Cheyenne named Owl Woman. After Owl Woman died, William married her sister, Yellow Woman. William's sons George and Charles grew up as Cheyennes. When war exploded between Mexico and the United States in 1846, William Bent, Sr., became the first American governor of New Mexico and paid for the post with his life in the Taos Revolt of 1847.

Any talk about St. Louis's past surely led to the Louisiana Purchase and Lewis and Clark, but it also led to Montana itself. The expedition spent more time on its journey in present-day Montana than in any other place. From 1874 to the present, the state's capital has been firmly planted in Lewis and Clark County. And there was Great Falls, Charlie's adopted home and site of the expedition's epic portage around the falls. Russell depicted expedition events

(facing)
The Lewis and Clark Expedition, 1918 (detail)
Oil on canvas, 30 × 47¾ inches, Gilcrease Museum, Tulsa, Oklahoma (0137.2267)

around the falls five times. For all those reasons—and others beyond knowing—Charlie found the Lewis and Clark story irresistible. Perhaps he knew in some mysterious way that the journey was the nation's first "road story." The path of the American odyssey ran right through the country Russell called his own.

Charlie Russell lived in an age that celebrated the American conquest of the West. Russell's America wanted a simple Lewis and Clark story, a tale of adventure in a dangerous, empty wilderness. Russell's take on that narrative, however, was radically different. He knew that Lewis and Clark did not travel through an empty country; they traveled through Indian country. When Russell told the Lewis and Clark story, he shifted the center of attention from Jefferson's explorers to Native people. In nearly every depiction of the expedition, the viewer's eye is drawn to Indians. They are the central figures; they initiate the action; they are the storytellers. The work of St. Louis artist Carl Wimar may have prompted Russell to locate Indians in the foreground, but it was the "cowboy artist" who placed Indians front and center.[5] Long before modern scholars put Lewis and Clark among the Indians, Russell changed the prospect: he literally and figuratively changed the place from which to see the action and appreciate the story.

One of Russell's earliest Lewis and Clark paintings established that narrative framework. Set on the upper Missouri in the summer of 1805, *Indians Discovering Lewis and Clark* (1896) asks the viewer to see the story through Indian eyes. From the time they left Fort Mandan in the spring of 1805 until they met the Lemhi Shoshones in August, the expedition had not encountered any Indians. But the Corps of Discovery had not gone unobserved. High on a bluff overlooking the river, three mounted Plains Indians, perhaps Blackfeet, watch the expedition's fleet of pirogues and canoes make its way upstream. At the center of the painting, one Indian points to the action below, but Russell clearly depicts the real action as being with the Indians. They are the discoverers. The Lewis and Clark navy is little more than six specks on the canvas. No member of the expedition, including Lewis and Clark, can be easily identified. Russell asks viewers to turn the traditional story upside down. It is the Indians who are the explorers as they discover something new in their world.[6]

Indians Discovering Lewis and Clark tells the story of the West in a way few of Charlie's contemporaries were prepared to embrace. White men like Lewis and Clark were not the only actors on the broad western stage: the drama of the West involved many players speaking from many scripts. No Russell painting expresses this idea more powerfully than the one simply titled *York* (1908). Russell was not above rearranging history for dramatic effect, and so it was with the events of March 9, 1805. Reading the Biddle-Coues (1893) edition of the Lewis and Clark journals, Russell came upon an extraordinary moment.[7] Sometime during that March day at the Hidatsa village of Menetarra along the Missouri River in present-day North Dakota, Hidatsa chief Le Borgne told the captains that "some foolish young men of his nation had informed him that there was a black man in the party & wished to know if it was true."[8] This was not the first time Indians had been puzzled by York's blackness. Eager to satisfy the curiosity of a chief who kept the Americans at arm's length, Lewis and Clark sent for York. Surprised by York's appearance, Le Borgne spit on his hand and tried to rub off what he thought was paint on York's skin. When York took off the hankerchief wrapped around his

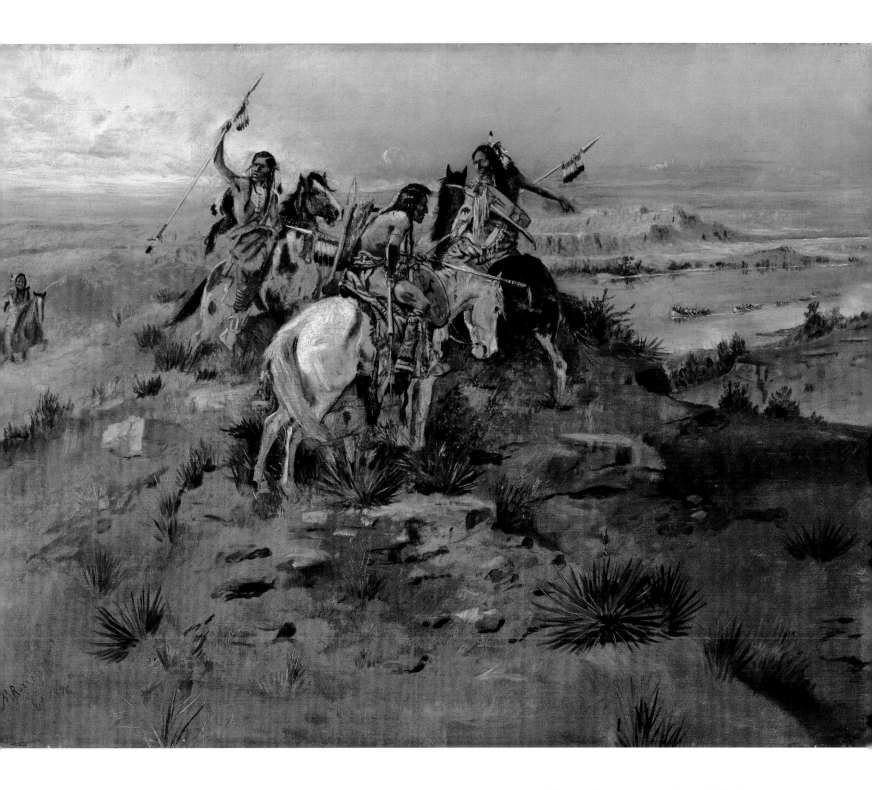

Indians Discovering Lewis and Clark, 1896
Oil on canvas, 25¼ × 34 inches, Montana Historical
Society, Helena, Mackay Collection (x1953.03.01),
photograph by John Reddy

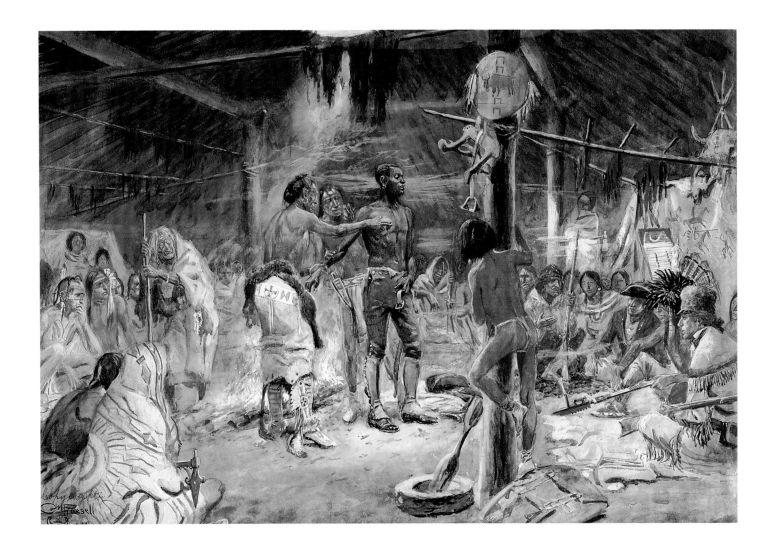

York, 1908

Watercolor on paper,
18¼ × 25 inches, Montana
Historical Society, Helena
(x1909.01.01), gift of the artist,
photograph by John Reddy

head and "showed his short hair," Le Borgne was convinced that the person standing before him was "not a painted white man."[9]

Out of fewer than a dozen lines of text and an event the captains did not even think important enough to record in the expedition's official journals, Russell created a compelling scene of cultural encounter. First he changed the location of the action. Although the meeting took place at Fort Mandan, the artist moved the story inside a Hidatsa earth lodge. Drawing on paintings by Karl Bodmer and George Catlin, Russell set the stage with all sorts of Indian goods, everything from a parfleche to a war axe. At the center of the painting, Le Borgne reaches out to touch York, perhaps suggesting a reach across the cultural divide. Lewis, Clark, and interpreter Toussaint Charbonneau sit at the edge of the painting, actors waiting in the wings while York and Le Borgne hold center stage. It is as if Russell's painting asks: Do we really know the Lewis and Clark story? Whose story is this? Who tells the tale?

Russell's imagination was not captured by the Corps of Discovery simply traveling through western lands. What drew his attention were those emotion-charged meetings between Jefferson's adventurers and Native people. Always looking to put a human face on history, Russell must have been drawn to the events of August 17, 1805. Those events are brought to life in a painting variously titled *The Lewis and Clark Expedition*, *Sacajawea Meets the Shoshones*, *Lewis and Clark Reach Shoshone Camp Led by Sacajawea*, and *Sacajawea Meeting Her People* (1918). During much of that summer the expedition plodded through present-day Montana in a fruitless search for Indians and horses. Without horses and Indian guides, Lewis and Clark knew they would surely be trapped on the wrong side of the Continental Divide. To better scout the country, Lewis went ahead while Clark remained with the main expedition party. On August 13, Lewis met Cameahwait and his band of Lemhi Shoshones. Four days later, Lewis retraced his steps to rendezvous with Clark at what the explorers called Camp Fortunate. Located at the junction of the Beaverhead River and Horse Prairie Creek, the site is now under water at Clark Canyon Reservoir near Dillon, Montana.

On that clear, cold Saturday morning, there was another of those remarkable expedition encounters. Clark had sent Toussaint Charbonneau and Sacagawea ahead to find Lewis and the Shoshones. Russell made this reunion into a dramatic moment by composing an image in the shape of an inverted triangle. At the left side are Cameahwait and the Shoshones. Lewis is at the tip of the triangle, pointing at what Russell wants viewers to see as the real story. On the right stands Charbonneau pointing to Sacagawea and a Shoshone woman known as Pop-pank. Sometime in the fall of 1800 the two women had been captured at Three Forks by Hidatsa raiders, but in the confusion Pop-pank managed to escape. Now the two were reunited in what Lewis described as a "really affecting" moment.[10] Never mind that Sacagawea was Cameahwait's sister; Russell humanized the moment by making it a remarkable homecoming—two women kidnapped by chance and now reunited by chance. Russell used Lewis as the silent witness reminding us that the larger stories are best expressed in those small, intimate moments that embody deeper meanings.

Sacagawea gave Russell the perfect storyteller as he sought to humanize the encounters between Jefferson's explorers and Native peoples. As always, Charlie was not above bending history to make a point and a dramatic painting. *Lewis and Clark on the Lower Columbia* (1905) is just such a painting. What Russell offered here seems simple enough. Near the end of their western trek, on what so many maps called the Great River of the West, Lewis and Clark met Chinook Indians riding in magnificent canoes. Sacagawea stands in the bow of a crude expedition canoe offering signs of peace and friendship. But what actually happened on November 5, 1805, was much less dramatic. Lewis and Clark did meet a party of Chinooks in four canoes. As Clark wrote later, "one of those Canoes is large, and ornamented with Images on the bow & Stern. That in the Bow the likeness of a Bear, and in the Stern the picture of a man."[11] If Sacagawea played any role in the meeting, it went unrecorded. But Charlie had a point to make: it was an Indian woman who mediated between two cultures. Sacagawea's presence did on occasion convince Indians that the expedition was not a war party. Here again Russell offered a larger story about meetings in a crowded wilderness.

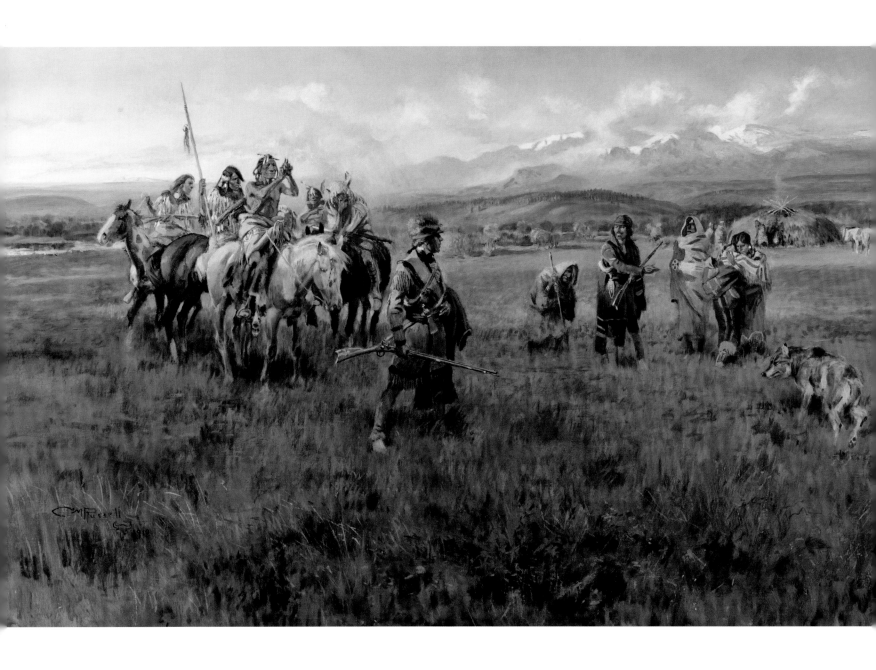

The Lewis and Clark Expedition, 1918

Oil on canvas, 30 × 47 ¾ inches, Gilcrease Museum, Tulsa, Oklahoma (0137.2267)

Perhaps no single painting more fully expresses Russell's vision of Lewis and Clark and the meaning of the expedition than his monumental *Lewis and Clark Meeting Indians at Ross' Hole* (1912). The story the picture relates is as large as the painting itself. After leaving the Lemhi Shoshones in the first week of September 1805, the explorers entered the upper reaches of the Bitterroot Valley in what is now Ravalli County, Montana. At a place later named Ross's Hole, some four hundred Salish people greeted the expedition. At first wary of the explorers' intentions, the people Lewis and Clark called "Flatheads" soon welcomed the strangers. What most attracted the captains were the "elegant horses"—as many as five hundred—scattered across that part of the valley.[12] It was those horses and their Salish riders that Charlie made the centerpiece of the painting.

Beyond his sense of loss for "the West that has passed," as he put it, Charlie Russell avoided making grand, sweeping generalizations about the meaning of the West in American life. He left arguments about "The Significance of the Frontier in American History" to contemporaries like Frederick Jackson Turner (who wrote the famous essay of that title) and Teddy Roosevelt. But perhaps because *Lewis and Clark Meeting the Indians at Ross' Hole* was commissioned by the state of Montana and destined to hang in the state's legislative chambers, Russell seemed determined to use it to make a public statement about the history of the West. The composition of the painting makes that statement. At the visual center is a Salish man reining in an elegant white horse. All around him is a swirl of Salish riders. On the

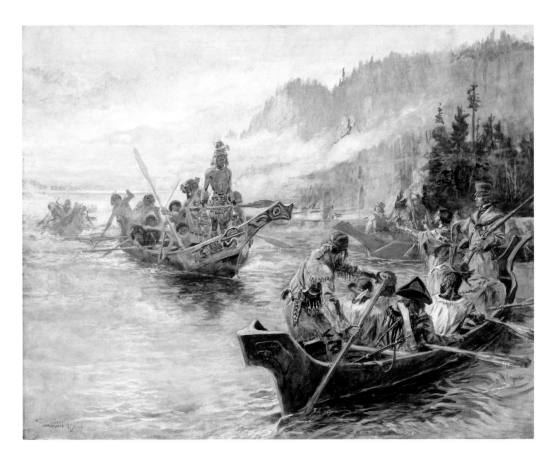

Lewis and Clark on the Lower Columbia, 1905
Opaque and transparent watercolor over graphite underdrawing on paper, 18¾ × 23⅞ inches, Amon Carter Museum, Fort Worth, Texas (1961.195)

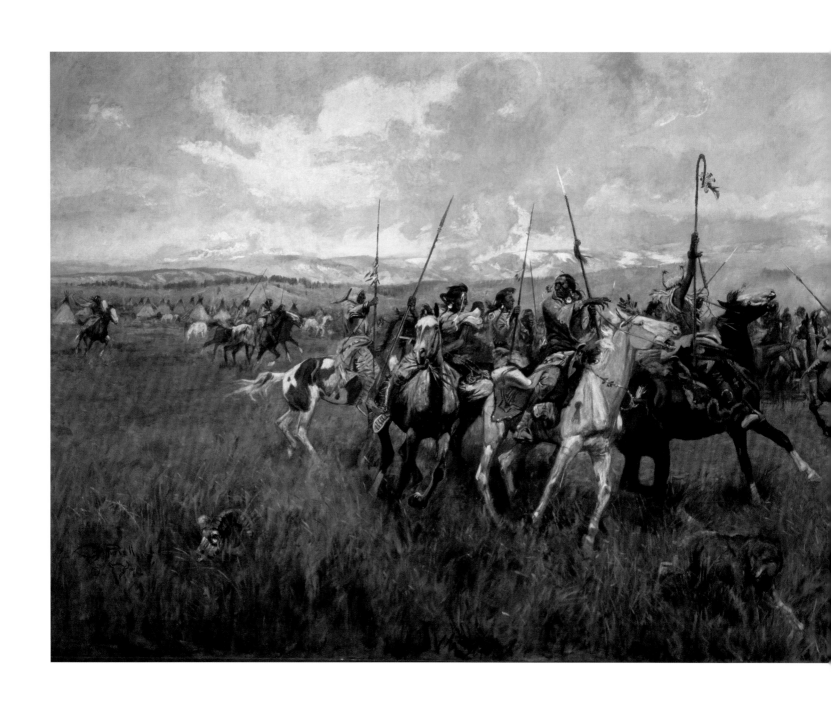

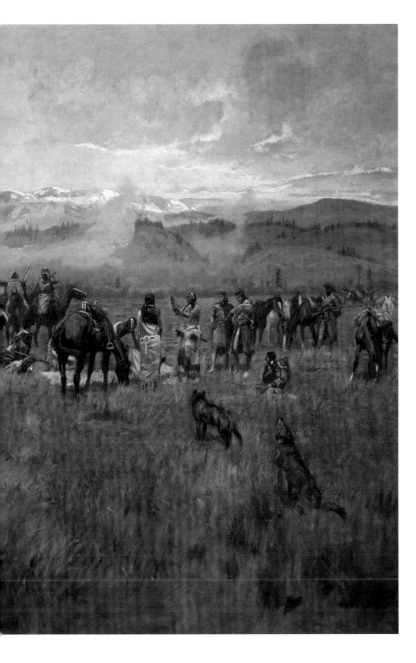

*Lewis and Clark Meeting
Indians at Ross' Hole,* 1912
Oil on canvas, 140 × 296 inches,
Montana Historical Society
Collection, Montana State
Capitol, Helena (x1912.06.01),
photograph by Don Beatty

far right, almost lost in the painting, stand Lewis, Clark, York, and the expedition's Shoshone interpreter. The Salish and their horses are the narrative focal point for this very public painting. Russell created a visual reminder that Indians were an essential part of the state's story. Before Lewis and Clark arrived in what later became Montana, people with a history were already living there. In this most visible of Russell's Lewis and Clark portrayals, Indians are at the center of the action. *Lewis and Clark Meeting the Indians at Ross' Hole* is a celebration not of the American explorers but of Salish wealth and power, but a sense of the tragic is never far from Russell's work. Here, as in several of Russell's other Lewis and Clark paintings, an old, hunchbacked woman stands nearby as if to say, beware, dark days are coming.

Plenty of other artists were drawn to the familiar, iconic images that said "West": majestic mountain landscapes, adventuresome fur traders, cavalry troopers locked in battle with Indian warriors. Russell, however, was most drawn to Lewis and Clark. In the larger story of the expedition Charlie found a subject worthy of all the color, adventure, and drama he sought to express in paint, bronze, and print. Russell's opinion of the expedition, what he thought it meant, deserves our thoughtful attention. His Lewis and Clark art was not intended to be one more celebration of American empire in the West. By placing Indians at the center of his most significant expedition paintings and making Native people tell the story, Russell offers us a lesson in balance and honesty. The artist who claimed he was not a historian proved to be just that: a provocative, tough-minded interpreter of the nation's first road story.

Notes

1. Dippie, ed., *Charles M. Russell, Word Painter*, 323.
2. Ibid., 177.
3. Dippie, *Looking at Russell*, 88–102.
4. The best guide to Russell's representations of the Lewis and Clark expedition is Dear, *The Grand Expedition of Lewis and Clark as seen by C. M. Russell*.
5. Hassrick, "Charles Russell, Painter," 90–91.
6. Russell used this compositional framework in a number of paintings, including *The Coming of the White Man* (1899), *Planning the Attack on the Wagon Train* (1900), two versions of *Planning the Attack* (1900 and 1901), *The Fireboat* (1918), *Wagons* (1921), and the autobiographical *Charles M. Russell and His Friends* (1922).
7. It is sometimes said that Russell used the Lewis and Clark journals as a source for his art, but this is misleading. The first publication of the original journals of the Lewis and Clark expedition came out in 1904–1905 under the direction of Reuben Gold Thwaites. The story of York and Le Borgne is not in the original manuscript journals kept by expedition members. Had Russell used the Thwaites edition, he would not have found the York–Le Borgne story. Russell's information came from a different, but reliable, source. In 1810 William Clark met with Nicholas Biddle, who was then preparing a paraphrase of the journals for publication. At that April meeting Clark related the York–Le Borgne story, which then became part of what was published in 1814 as the expedition journals. That paraphrase was reedited and annotated in 1893 by Elliott Coues. Russell owned or had access to a copy of the 1893 work, which is now referred to as "Biddle-Coues." It would have been his principal documentary source for this and other depictions of Lewis and Clark.

8. "The Nicholas Biddle–William Clark Notes, April 1810," in Donald Jackson, ed., *The Letters of the Lewis and Clark Expedition with Related Documents 1783–1854,* 2nd ed. (Urbana: University of Illinois Press, 1978), 2:539.

9. Biddle, ed., *History of the Expedition under the Command of Lewis and Clark* (repr., New York: Dover Books, 1964), 1:243.

10. Moulton, ed., *The Journals of the Lewis and Clark Expedition,* 5:109.

11. Ibid., 6:26. Russell would have read essentially the same words in Biddle-Coues.

12. Ibid., 5:188. For the most comprehensive analysis, see Burnham, "Lewis and Clark at Ross's Hole."

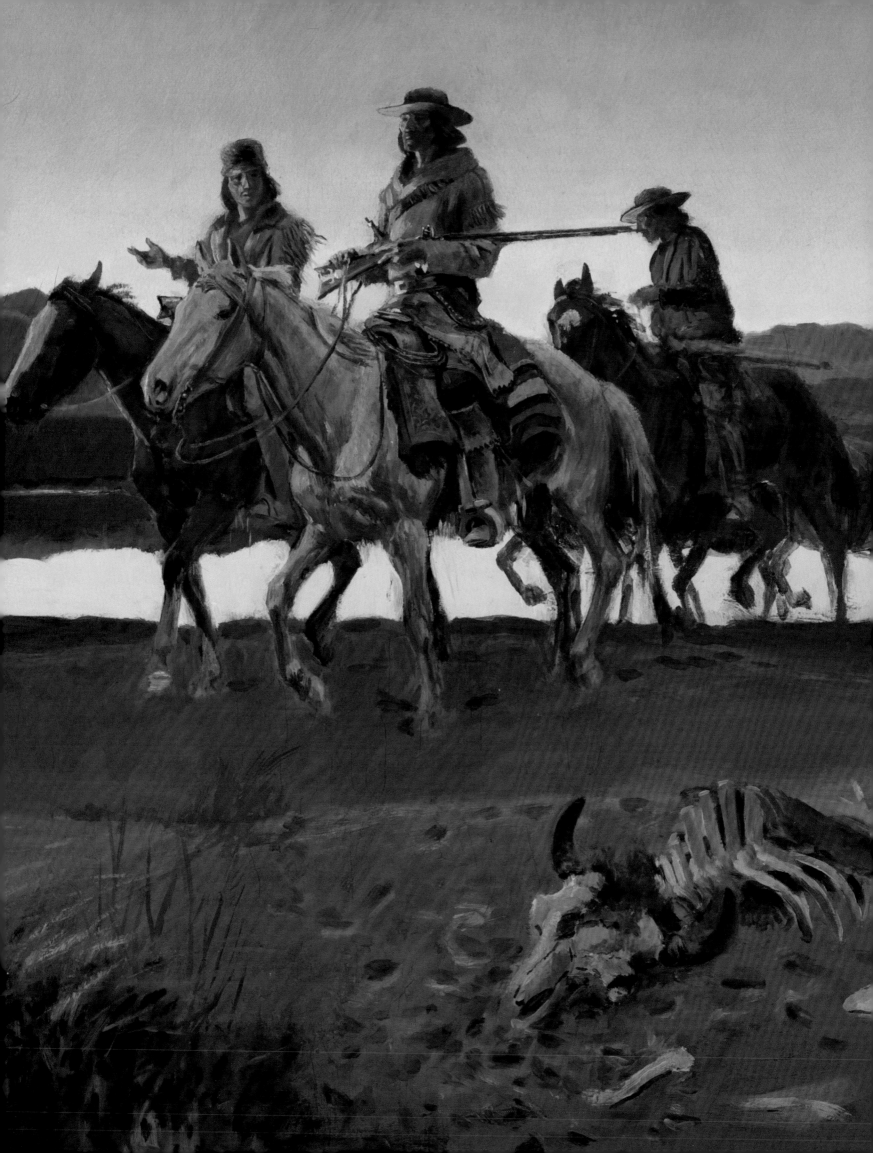

Emily Ballew Neff

Who Are Carson's Men?

Charles Russell's *Carson's Men* (1913) and Edward Sheriff Curtis's *Canyon de Chelly* (1904), both classics in the art of the American West, have much in common. In both painting and photograph, human figures make their journey across a panoramic landscape in ways that make them and their movement through the West appear slow and timeless. Both artists create dream-world effects: persistent horizontal lines of eerie color in Russell's painting; hulking, otherworldly land forms and shimmering linear patterns of water in Curtis's photograph, captured with a Pictorialist aesthetic that made photographs of the period look like Tonalist paintings in sepia tones. Suspended in place and time, both painting and photograph anoint the West with a quality of refined beauty and melancholic mood.

During their long careers, Russell and Curtis mined that vein of American art that portrays the West as "vanishing," a dominant social construct in turn-of-the-century American culture that considered the widely perceived heroism of western land and life, including its indigenous peoples, to be on the edge of extinction.[1] This concept was nurtured, promoted, and ultimately defined by the artistic means used by such artists as Russell and Curtis—panoramic spaces and their emphatic horizontal lines, vibrant colors in otherworldly hues, and soft-focus pictorial effects in which blurred figures nearly disappear—to create ethereal artworks of the American West that continue to cast their mesmerizing effects on viewers today.

It is something of a paradox, however, that *Carson's Men* and *Canyon de Chelly* share stylistic affinities. The paradox comes from what we know about the legendary western figure Kit Carson (1809–1868), the source of Russell's eponymous copyrighted title. Born in Kentucky, reared in Missouri, and closely associated with Taos, New Mexico, Christopher Houston Carson, known as "Kit," has entered the history books as a legendary mountain man, fur trapper, scout, federal Indian agent, and military officer.[2] His arrival on the scene of national consciousness occurred in popularized reports of John C. Frémont's expeditions to the Rocky Mountains, the Great Basin, Oregon, and California, where Carson fulfilled perfectly the role of a popular American type: the rugged, courageous, unflappable mountain man. He is also remembered, infamously, for his later occupation as a colonel in the New Mexico volunteer

(facing)
Carson's Men, 1913 (detail)
Oil on canvas, 24 × 35½ inches,
Gilcrease Museum, Tulsa,
Oklahoma (0137.2245)

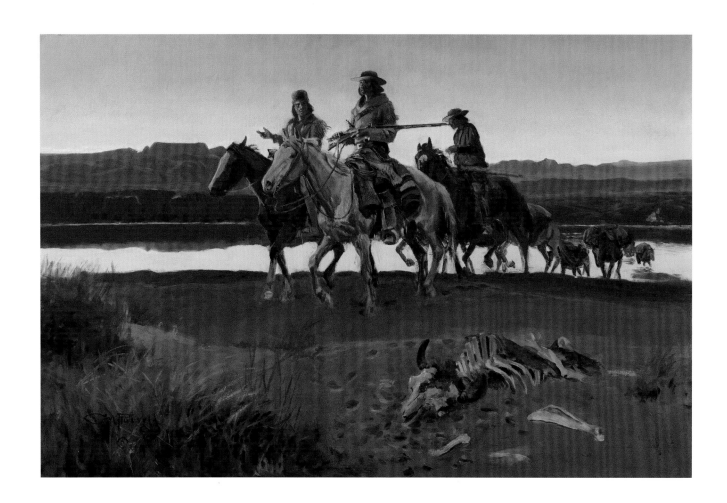

(above)

Carson's Men, 1913

Oil on canvas, 24 × 35½ inches,
Gilcrease Museum, Tulsa,
Oklahoma (0137.2245)

(right)

EDWARD SHERIFF CURTIS
(AMERICAN, 1868–1952)

Canyon de Chelly, 1904

Toned gelatin silver print,
5⅞ × 7¾ inches, Amon Carter
Museum, Fort Worth, Texas
(P1979.54.3)

infantry, playing a key role in destroying the very landscape and peoples pictured in Curtis's *Canyon de Chelly*.

Curtis's canonical image depicts a site in the heart of Navajo country in what is now the Four Corners area, where the borders of the states of Arizona, Utah, Colorado, and New Mexico meet in four corners that intersect in a single point. Canyon de Chelly was a holy place in Navajo history and culture, a fertile land for raising corn, peaches, and livestock. It was also a stronghold, its winding, maze-like canyons a strategic site for the many violent conflicts that took place there over hundreds of years among the Navajos, Spanish, Utes, Mexicans, and Anglos. The years 1863–64 witnessed the worst depredations yet, when Kit Carson employed a scorched-earth policy of destroying corn and livestock to starve the Navajos into submission. Later, in a symbolic act of utter annihilation, Carson was responsible for destroying three thousand prized peach trees. Biographer Hampton Sides said Carson's act was "pure aggression" and "the Navajo would never forgive him for it."[3]

During the subsequent forced march or "Long Walk," some eight thousand Navajos walked more than three hundred miles to Fort Sumner along the Pecos River east of their homeland, an endeavor reminiscent of the Cherokee Trail of Tears twenty-five years prior. Disease, starvation, and devastation characterize this chapter in Navajo history, but the U.S. government eventually took responsibility for the disasters of Fort Sumner; the Navajos were restored to their homeland in 1868, the same year Carson died. By 1904, when Curtis photographed Canyon de Chelly, nearly four decades after the Navajos had returned, he could capture a better, more peaceful moment: a group of Navajos make their way eastward toward Wild Cherry Canyon, presumably after a day of trading at nearby Chinle.

It may come as a surprise that *Carson's Men* has nothing to do with Canyon de Chelly or Taos, New Mexico, the two places most closely associated with the life and lore of Kit Carson. In fact, the landscape of the painting is clearly that of Montana. More precisely, we see Charlie Russell's Montana, marked in the background by the familiar landmark, Square Butte, which by the mid-1890s became a stock figure in Russell's art, as familiar as a bucking bronco or an Indian buffalo hunter. Kit Carson did travel to Montana Territory in his fur-trapping days, and one can imagine his inhabiting the landscape pictured in Russell's *Trappers Cordelling the Missouri* (1896), with Square Butte outlined in the background, the Missouri River winding its way through the foreground, and fur trappers on shore dragging their boat through the river's shallow passages. Still, the landscape we see in *Carson's Men* has little to do with what we know of Carson. Further, it is likely that the painting has little to do with Carson himself, apart from conjuring his name and associations with him through the device of identifying the western types in the painting as "his" men.

CHARLES DEFOREST FREDRICKS
(AMERICAN, 1823–1894)

Christopher Houston Carson,
ca. 1863

Albumen silver print, $3\frac{1}{4} \times 2\frac{3}{16}$ inches, National Portrait Gallery, Smithsonian Institution, Washington, D.C. (NPG.2005.115), photograph courtesy of National Portrait Gallery, Smithsonian Institution/Art Resource, New York

Trappers Cordelling the Missouri River, 1896

Watercolor, pen, and ink on paper, 6¾ × 8 inches Frederic G. and Ginger K. Renner Collection, Paradise Valley, Arizona

Most scholars have asserted or assumed that the central figure is a representation of Kit Carson. Some of the painting's cursory brushstrokes may indeed suggest the angular features seen in photographs of the legend, but this passing similarity of features is not sufficient to identify the figure as Carson. In fact, recent evidence strengthens the argument against our seeing Carson in this painting at all.[4] Rather, we see a generic western mountain-man type, one we have seen from Russell's hand before in such images as *Men That Packed the Flintlock* (1903) and *Bridger's Men* (1905), to name just two.[5] By removing the figure (but not the legend) of Carson from the picture, we can begin to consider another way of seeing the painting, and we can understand how Russell, his patrons, and legends of the West blurred together and merged into one myth.

Jim Bridger, Kit Carson, Jedediah Smith, and John Colter are well-known figures that have long dominated the history of trapping and the American fur trade, a business whose relatively short heyday roughly lasted from the 1820s to the 1840s. Less well-known is the name Walter Cooper, who at age fifty-nine wrote *A Most Desperate Situation: Frontier Adventures of a Young Scout, 1858–1864,* a sprawling manuscript that documented—or fictionalized—Cooper's experiences in the West. Cooper depicts himself as a scrappy teenager, out on his own, who gets by on his wits, good manners, hard work, modesty, bravery, and tenacity. For example, he wins a grueling competitive footrace in Council Grove, Kansas; he lives with and learns from fur trapper Jim Bridger in what is now Wyoming; he meets and befriends Kit

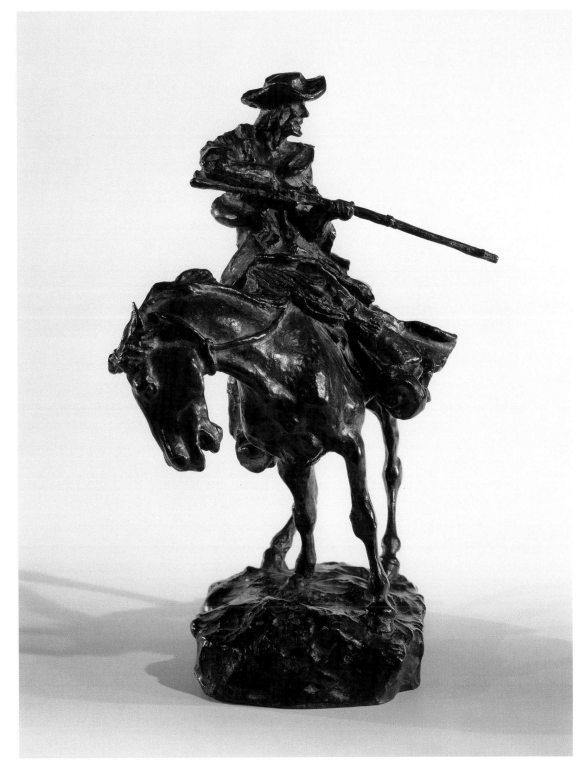

Jim Bridger, 1926
Bronze, 14⅜ × 13 × 9¾
inches, Petrie Collection,
Denver, Colorado

Carson in Taos, New Mexico; and he finds himself the hero in many dramatic conflicts involving Apaches, Comanches, Mexicans, Navajos, and even the charms of a young señorita.

Later, Cooper became a wealthy businessman, entrepreneur, and philanthropist in Bozeman, Montana, but this was not the stuff of dime novels or penny dreadfuls, so Cooper's story ends in 1864 with the protagonist heading to Alder Gulch to pan for gold. Cooper's subsequent successful (if prosaic) business adventures in gold, coal, a flour mill, railroad ties, and real estate are left out of the story.[6] Perhaps Cooper simply ran out of steam when his manuscript reached the fifteen-hundred-page mark.

In 1913, Cooper commissioned Russell to provide pen-and-ink illustrations for *A Most Desperate Situation*. The author's increasingly dire financial straits may explain why the manuscript was not published in Cooper's lifetime. A version of the novel was published in 2000, edited by Rick Newby and with a foreword by Larry Len Peterson. This edition contained the first publication of the pen-and-ink drawings Russell created for the novel. It also presented the correspondence between Nancy Russell, Charlie's shrewd wife and business manager, and Walter Cooper, whose younger brother, Ransom Cooper, a lawyer in Great Falls, likely introduced him to the artist and his wife. These letters confirm the connection between Cooper and Russell, and they help to make clear that the painting was conceived in the images Russell created for Cooper's *A Most Desperate Situation* and that the substance of the Cooper project resulted in the painting *Carson's Men*.[7]

Two of the most influential and well-known figures in Cooper's autobiographic novel are Jim Bridger and Kit Carson. In 1859, Cooper travels with Bridger on a winter fur-trapping expedition along the Green River, taking packhorses, grub, supplies, and a bedroll. As we learn from Cooper, a frontier adventurer's schooling consisted of setting traps for beaver, otter, mink, and silver-gray fox, and of learning the spoken and sign languages of local Native American tribes. Cooper seemed to agree with Bridger that "this is a great life."[8]

Later in the story, when Cooper meets another mentor, Kit Carson, the two immediately become friends through Cooper's association with Bridger. Carson and Bridger form a mutual admiration society based on the recognition of one another's frontier skills and already-legendary character. As Cooper says of Carson, he is "one of the most famous mountain men and so celebrated as a trapper and hunter. The mountains, plains, and deserts were as familiar to him as the well-beaten trails and roads of commerce are to others."[9] Carson, at the time a federal Indian agent, introduced Cooper to adobe architecture, fandangos, and life in Taos, a lawless area filled with desperadoes and "mostly men from Texas."[10] When the time comes for Cooper to leave Carson in early 1861, Carson gives counsel in his farewell words: "Never cease your watchfulness. Take this advice from a man whose lifelong habit has been constant watchfulness."[11] Two Russell sketches relate to this part of the story. One, *Into the West,* depicts Walter Cooper as a hunter with a newly acquired dog shortly before his encounter with Carson. The other, *Kit Carson's Farewell,* shows the Indian agent shaking hands with Cooper and putting a protective hand on his shoulder.[12]

Cooper's experience with Carson predates by about two years the events that reframed Carson as the cause of Navajo privation. In the story, Cooper celebrates Carson's role as a mountain man and does not reflect on Carson's later military exploits. The golden age of fur

*Into the West
(The Young Prospector),* 1913
Pen and ink on paper, 16⅞ × 12⅝
inches, Big Sky Collection,
Larry and LeAnne Peterson

trading in the West is characterized by a mountain man living a life filled with freedom, danger, hardship, natural beauty, and camaraderie, where long expeditions into the wilderness are relieved by trips to the trading post, the West's emblem of civilization. Russell's pen-and-ink sketch *Into the West* enhances Cooper's narrative. Cooper is dressed in hat and buckskins, with his rifle nestled by his saddle horn and a packhorse and mule behind him. His dog, Lion, looks to the right, and his mount drinks water from the stream. The motif derives from Cooper's role as a hunter on a gold-mining expedition, shortly before Cooper encounters Carson. As Cooper pauses at the stream, he searches westward, perhaps looking for game, but the motif also suggests a new frontier experience (with Carson, as it turns out) just on the horizon.

In *Carson's Men,* Russell turns the narrative sketch *Into the West* into a twilight elegy. Here, Russell focuses on Cooper's history as a mountain man (as opposed to a gold miner) and distills two ideas about the mountain man and his trade into his canvas. First, the painting evokes the fur trade's relative brevity, as beaver populations dwindled from overhunting and fickle fashion began to use silk for hats instead of American fur. Fur trading takes on the hues of evening in Russell's canvas. The life of a mountain man is clearly a thing of the past, emphasized by the deteriorating cow bones that occupy the painting's foreground. Second, *Carson's Men* emphasizes the nomadic existence of the fur trapper as he moves in and out of the wilderness, an activity that recalls an Old Testament hermit who retreats from civilization to realize a higher self.

As if to portray Cooper's comments about Carson and his knowledge of scouting, Cooper and his fellow adventurers—all designated as "Carson's Men"—wholly inhabit the landscape that is their highway. They have crossed a river, and a sunset glow surrounds their upper bodies and is reflected in the shimmering river below, which sets off animal legs moving in shadow. These mountaineers, the links between sky and land, are glorified by resplendent color, even as sunset signals the end of a chapter. Today we might recognize the cliché in this device, but nearly one hundred years ago, in the hands of Russell, the results were both current and striking. Russell's sense of the expressive possibilities of color were enhanced by his oft-noted familiarity with the work of Maxfield Parrish (1870–1966) and, more specifically, Frederic Remington (1861–1909), whose earlier well-known painting and published print, *Coming to the Call* (ca. 1905), shares the same patterned striping effect and the same vibrant palette of lavender and gold.

By giving this group of western types the title *Carson's Men,* Russell promotes the legend of Carson and of the mountain-man type—a type already established in Russell's art as early as 1903 and extended to his work in the medium of sculpture—without having to show Carson himself. But the artist also includes himself in this fraternity by inserting his signature Square Butte into the painting, a feature that appears in many of Russell's paintings and sketches—and, more importantly, in those few images in which he himself is portrayed, such as *Self-Portrait of C. M. Russell and Grey Eagle* (1899) and *Charles M. Russell and His Friends* (1922). *Carson's Men* thus elevates the artist himself and his beloved Montana into the legend, implying that Russell is also one of Carson's men.

And indeed he was.[13] As enormous as the American West was, it could sometimes dramatically shrink through the close links in its histories of places and people, throwing into stark

relief its many contradictions. Russell's grandmother, Lucy Bent, had two brothers, Charles
and William, Russell's grand-uncles and famous traders along the Santa Fe Trail. In 1826,
Charles Bent enlisted the young Kit Carson into his New Mexico–based trading outfit. They
soon became friends, and Carson would later become Charles's brother-in-law when the two
men married a pair of Toaoseña sisters, Maria Jaramillo Bent and Josefa Jaramillo Carson.
Russell's half-Cheyenne second cousins, Charles and George Bent, fought on the Cheyenne
side in Colorado at the criminal Sand Creek Massacre of 1864. Their older brother, Robert,
was forced to be a scout for Colonel John M. Chivington, a Methodist minister who had or-
dered the deaths of a band of Cheyenne who had camped under an American flag and a white
flag of truce.[14] From his vantage point at Texas's Adobe Walls, where he had been sent to fight
Kiowas, Comanches, and Cheyennes, Carson openly condemned Chivington's actions. A few
years later, Carson died a Colorado rancher at age fifty-eight.

Russell undoubtedly knew the convoluted history of his western past, and he claimed as
his own—for himself, for Cooper, and for Montana—a part of what turns out to be a very com-
plicated legend.

FREDERIC REMINGTON
(AMERICAN, 1861–1909)
Coming to the Call, ca. 1905
Oil on canvas, 27¼ × 40¼ inches,
Image courtesy of William I. Koch
Collection, Palm Beach, Florida

Notes

1. The concepts of vacancy and vanishing as they apply to painting and American culture in general are discussed in the author's earlier work. See Neff, "The End of the Frontier." Helpful sources for the literature on Russell and *Carson's Men* include Price, "Charles M. Russell: Icon of the West," 216–18 (*Catalogue Raisonné* reference number CR.GLC.18); Cooper, *A Most Desperate Situation*, ix; Nemerov, "'Doing the "Old America"': The Image of the American West, 1880–1920," especially 326–29; Hassrick, *Charles M. Russell*, 110; and Hassrick, *Treasures of the Old West*, 90–91. In the voluminous literature on Curtis, helpful resources include Goetzmann, "The Arcadian Landscapes of Edward Sheriff Curtis"; Graybill and Boesen, *Edward Sheriff Curtis*; Davis, *Edward S. Curtis*; Gidley, *Edward S. Curtis and the North American Indian, Incorporated*; Cardozo, ed., *Sacred Legacy*; Worswick, *Edward Sheriff Curtis*; and Egan, "'Yet in a Primitive Condition.'"

2. Helpful sources in the Kit Carson literature include Carter, *Dear Old Kit;* Dunlay, *Kit Carson and the Indians;* Roberts, *A Newer World;* and, more recently, Sides, *Blood and Thunder.*

3. Quoted in Sides, *Blood and Thunder*, 357. It is worth noting that Kit Carson did not organize or participate in the Long March, but he did promise the Navajos they would come to no harm; around five hundred died along the way. And while Carson never set foot inside Canyon de Chelly, he has always been linked to the destruction there.

4. Asserted by Peterson in his introduction to Cooper, *A Most Desperate Situation*, ix. Peterson additionally identifies the central figure as Walter Cooper. For additional information on Walter Cooper, see Peterson, "The Footrace." In a letter and document dated May 14, 1930, Nancy Russell wrote to Dr. Philip G. Cole, the subsequent owner of *Carson's Men*, and included a brief description of the painting (The Helen E. and Homer E. Britzman Collection, Colorado Springs Fine Arts Center, Colorado Sprngs, Colorado [herafter Britzman Collection, CSFAC], C.5.505). Her description does not mention Kit Carson but merely states: "They are free trappers, romance-makers or forerunners of civilization in our West." This brief commentary suggests that she—and by extension, Russell—considered these figures to be western types rather than a representation of Kit Carson himself.

5. For his help in identifying other free trappers depicted by Russell, I thank Brian Dippie. *Men That Packed the Flintlock* appears in Price, ed., *Charles M. Russell: A Catalogue Raisonné.* The work can be viewed on the subscription Web site (www.russellraisonne.com) that accompanies the book (image reference number CR.PC.338). The work is also illustrated in Dippie, ed., *Charles M. Russell: Word Painter,* 55, along with an illustrated letter by Russell that connects the painting to "trappers in the days [of] Kit Carson and Jim Bridger." *Bridger's Men* (also known by its alternate title, *One More Wiped Out*) appears in Price, ed., *Charles M. Russell: A Catalogue Raisonné* (CR.PC.265). The type continued with Russell's illustration *Free Traders* in W. T. "Wild Bill" Hamilton's *My Sixty Years on the Plains* (1905) (*Catalogue Raisonné* CR.PC.100, also known by the title *The First Trappers*) and in sculptures such as *Jim Bridger* and *Romance Makers* (1918, *Catalogue Raisonné* CR.MUS.6; also known by its alternate title, *The World Was All before Them*). The type also appeared in Russell's illustration *Back-Trailing on the Old Frontiers: Carson Defeats French Bully in Horseback Duel* (1922), in the story "Kit Carson," and in *Fink Kills His Friend* (1922) in "Three Musketeers of the Missouri" (*Catalogue Raisonné* CR.CHF.8 and CR.DR.38 respectively).

6. As outlined by Peterson in Cooper, *A Most Desperate Situation*, v.

7. The artworks and correspondence between Nancy Russell and Walter Cooper descended in the Cooper family from Walter Cooper to his daughter, Mariam, and then to her daughter Virginia Barnett, who died in 1999. Some of the artworks entered the art market around 2000. The location of the extensive original letters between Nancy Russell and Walter Cooper is not stated in the volume, but a few are reproduced in Cooper, *A Most Desperate Situation*, x–xi. *Carson's Men* was not a commission by Walter Cooper. Inspired by the Cooper project, it seems to have remained in Russell's inventory from the time it was painted in 1913 until it appeared in public exhibitions. *Carson's Men* appeared in two 1916 solo Russell exhibitions, both titled "The West That Has Passed," at Thurber's Galleries in Chicago (February 1916) and at the Folsom Galleries in New York (March 1916). The painting was included in two exhibitions in Canada in 1919, including the "Special Exhibition" at the Calgary Stampede, Calgary, Alberta, Canada (August 1919) and again at the Saskatoon Stampede, Saskatoon, Saskatchewan, Canada (September 1919). Mr. W. B. Campbell acquired *Carson's Men* at the close of the exhibition in Saskatoon (per correspondence between Nancy Russell and Campbell, Britzman Collection, CSFAC, c.5.258). The painting remained in Campbell's collection until sometime after 1933, when it once again entered the market. According to a letter to Nancy Russell from Ralph Kendall, sergeant in the city police of Calgary, dated April 15, 1933, "Also there is a Mr. Campbell, who is fortunate enough to own three splendid originals. 'Carson's Men' is one of them. But the depression has hit Calgary cruelly, and many who possessed fortunes are now broken men—perilously near the bread-line" (Britzman Collection, CSFAC, c.4.89a). Sometime

in 1934–35, Nancy was able to broker the sale of *Carson's Men* to Dr. Philip Cole. Then the painting and the Cole estate were acquired by Thomas Gilcrease in 1944, who gave *Carson's Men* to the city of Tulsa in 1955. I thank Joan Troccoli and Brian Dippie, who generously shared their research in the Britzman Collection as well as their research on Russell in general.

8. Cooper, *A Most Desperate Situation*, 60.

9. Ibid., 127.

10. Ibid., 128.

11. Ibid., 129–30. A pen-and-ink sketch by Russell, titled *Kit Carson's Farewell,* accompanies this passage. The sketch is also included in Price, ed., *Charles M. Russell: A Catalogue Raisonné* (CR.DR.399).

12. Regarding *Into the West*, see Price, ed., *Charles M. Russell: A Catalogue Raisonné* (CR.DR.166), which notes the title as *The Young Prospector*, with alternate titles included (*Into the West* and *Exploring New Country*). The pencil drawing for the pen-and-ink sketch is also noted as *The Young Prospector (Preliminary Drawing)*, with the alternate title *Into the West*, in Price, ed., *Charles M. Russell: A Catalogue Raisonné* (CR.PC.489). Both preliminary drawing and pen-and-ink sketch are reproduced as *Into the West* in Cooper, *A Most Desperate Situation*, viii and 118, under the same titles used in this essay.

13. In addition to biographical and genealogical information in Sides, *Blood and Thunder*, 10, see Taliaferro, *Charles M. Russell: The Life and Legend of America's Cowboy Artist*, 12–16.

14. This description of the Sand Creek Massacre—one of several in a discussion of the subject of massacres—is paraphrased from Lopez, "Out West," 2.

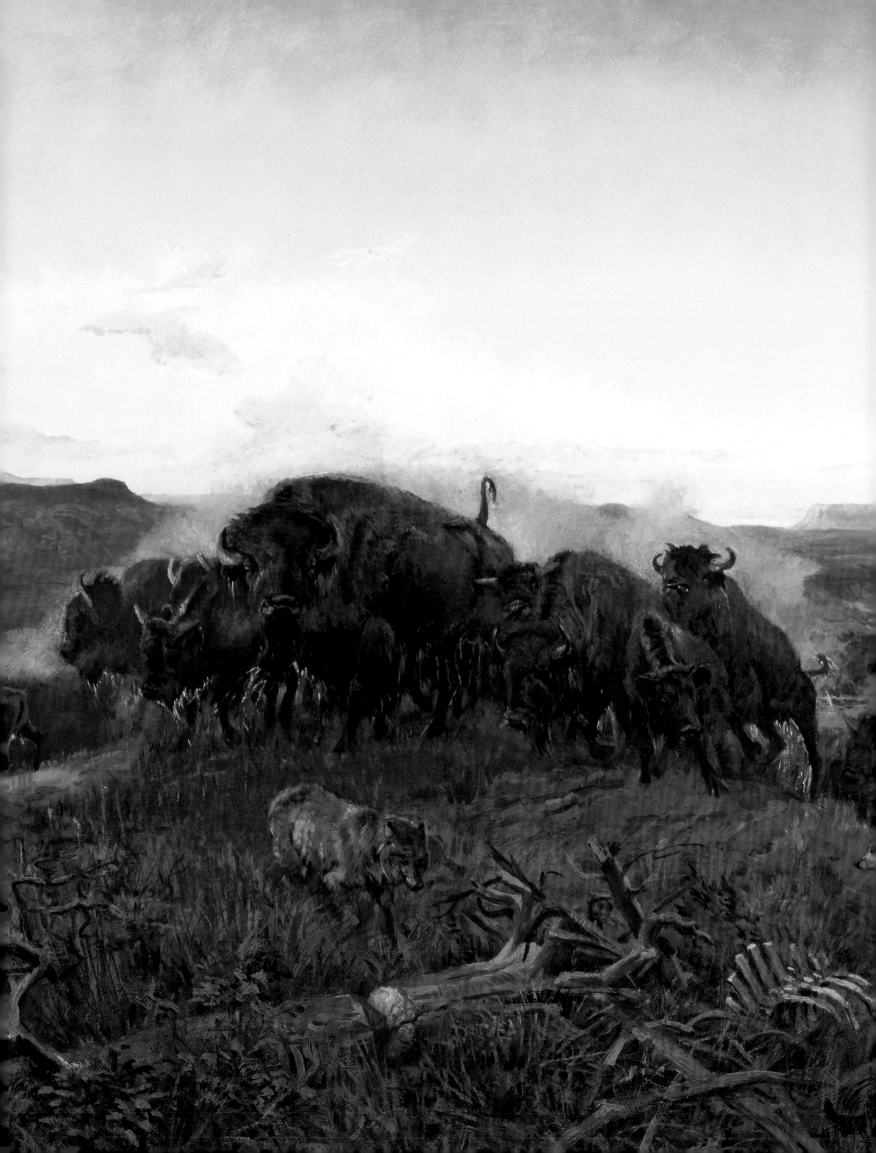

Kirby Lambert

Montana's Magnificent Russell

*In my book, this is the greatest of all Russells and I hope
it never leaves Montana.*

FREDERIC G. RENNER, 1969

IN DECEMBER 1975 the Montana Historical Society launched an intensive campaign to purchase Charlie Russell's masterpiece, *When the Land Belonged to God*, from the painting's original owner, Helena's storied Montana Club. Seventeen months later, a triumphant newspaper headline announced, "Montana keeps its 'Magnificent Russell.'" The accompanying article went on to report: "When the land belonged to God, Charlie Russell was there to preserve it on canvas. When the legislature decided public funds should be spent to keep Russell's product in Montana, Gov. Thomas Judge was there to endorse it. On Tuesday, Judge signed into law a legislative act [purchasing *When the Land Belonged to God*].... Sitting at a small Victorian-style table in front of the painting at the [Montana Historical Society's] Russell gallery across the street from the state capitol, Judge put a borrowed pen to the bill and said, 'This makes it possible for the state of Montana to keep this magnificent Russell.'"[1]

While the headline's reference to Montana's "magnificent Russell" was directed specifically toward his bisontine masterwork, the same sentiment could easily be applied to the artist himself. No painting better exemplifies Russell's genius as an artist than *When the Land Belonged to God*. And no person better personifies Montana's perception of its colorful past than does the Cowboy Artist. In every respect, Russell belongs to Montana—"our Charlie as Montanans think of him"—and to most citizens of the Treasure State he still unquestionably merits the accolade "magnificent."[2] As poet and author Grace Stone Coates succinctly wrote in 1936, "OF COURSE Russell was glorious—who doesn't think so?"[3]

Today, *When the Land Belonged to God* has a permanent place of honor in the Montana Historical Society, drawing visitors from around the world and dominating its surroundings by its physical size and visual force. But the painting was originally commissioned for a much different sort of institution, and the history of its creation, former home, and eventual journey to the state museum is a story that reveals much about the artist, his career, and his place in Montana's heart.

(facing)
*When the Land Belonged
to God*, 1914 (detail)
Oil on canvas, 42½ × 72 inches,
Montana Historical Society,
Helena (x1977.01.01)

221

That story began more than a century ago when "Kid Russell" first arrived in Montana Territory, stopping briefly in the capital city of Helena en route to the Judith Basin.[4] While Helena would never be his permanent home, Russell would be a frequent visitor there, often staying for months at a time, until he married in 1896 and settled permanently in Great Falls soon thereafter. The young Russell had come west seeking a life of adventure on a remote frontier. As sculptor Gutzon Borglum noted, "Montana . . . meant something to Charles Marion Russell. And my own thought is that Montana meant the heart, the source of the source, of the great drama. Custer had been killed with his entire command; it was, therefore, the . . . hunting ground of tribes of real Indians who had successfully destroyed the American army. . . . Montana, too, with its water and rich, grassy valleys, was much heard of in that connection [as the ultimate destination for longhorns and cowboys trailing north from Texas]. Young Russell knew all this, as all boys of those days out there knew it, but he knew it better. Charles Russell went straight to the stage where the game was being played."[5]

In 1880, most regions of Montana would have met Russell's expectations of wildness, but Helena—self-titled "Queen City of the Rockies"—perceived itself quite differently. Although not on par with Russell's native St. Louis or other eastern cities, by 1880 Helena boasted a population of six thousand and was well established as the political center of the burgeoning territory. Situated on the southwestern edge of the Prickly Pear Valley nestled against the foothills of the Rocky Mountains, its immediate environs were "picturesque and magnificent [while] its geographical position—central to the principal towns and mineral districts of the Territory" helped secure its role as one of the region's most important commercial centers.[6] The Queen City was "a place where deals were made and schemes were hatched. It was the place to provision for a trip, grubstake a claim, or finance a herd."[7]

After the Northern Pacific Railroad fully connected Helena to the outside world in 1883, the capital city's crooked main street—a former streambed where gold was discovered in 1864—was lined with an ever-growing number of ornate business blocks, built of brick and granite as a testament to the city's increasing wealth and prominence. By the middle of the decade, Helena was "peculiarly cosmopolitan," boasting federal, territorial, and county offices, nine churches, two hospitals, five stage lines, one transcontinental railroad, thirty mining companies, three dance clubs, and thirty-one societies including the Masons, the Oddfellows, the Knights and Ladies of Honor, the Hebrew Benevolent Society, and the Gesang Verein Harmonia.[8] It was in this milieu that the Montana Club was born.

On the evening of December 20, 1884, seven men, all of whom numbered among Helena's leading citizens, gathered in the law offices of E. W. Toole to create "an institution in which membership would be sought not only because of its pleasures but as an honor as well."[9] The following spring, the Montana Club of the City of Helena was incorporated "for literary, mutual improvement and social purposes."[10] When the doors opened in April on leased club rooms, newly renovated, on the third floor of a downtown business block, the club's one-hundred-plus charter members represented a true "cross-section of Helena's social, political, and economic elite."[11]

From the beginning, the club's members viewed its furnishings as essential elements in

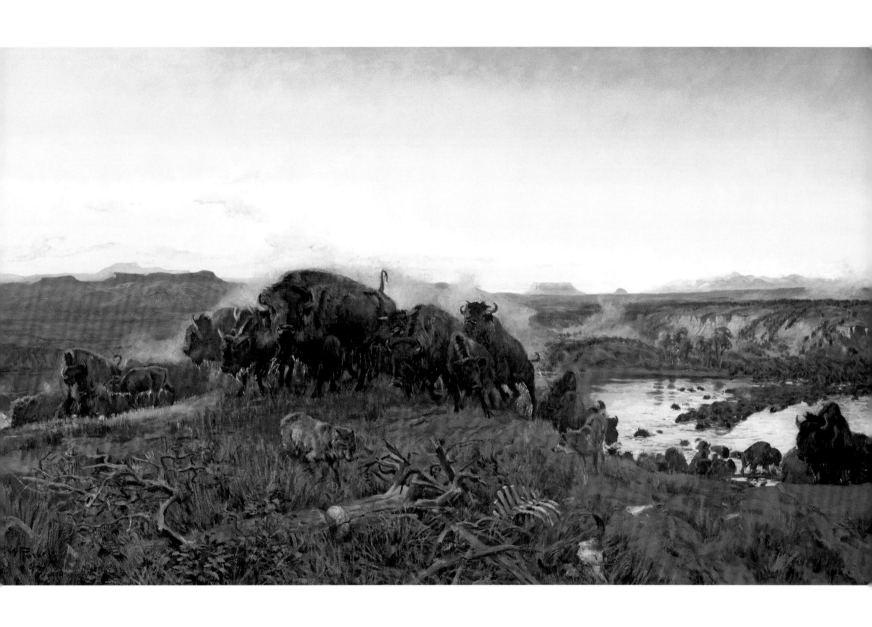

When the Land Belonged to God, 1914
Oil on canvas, 42½ × 72 inches,
Montana Historical Society, Helena
(x1977.01.01), photograph by John Reddy

creating the desired atmosphere of a "secluded resort."[12] Its new rooms were "most hand-somely" appointed with ornate chandeliers, Brussels carpets, and marble-topped tables, while the walls were "decorated with the most handsome designs in wall paper and orna-mentation."[13] When the club moved to more commodious (but still rented) accommodations three years later, the decoration was even more lavish and now included a significant collec-tion of fine art. The morning following the gala that christened the new space, the Helena *Daily Herald* reported: "Entering the club rooms the visitor was struck with the brilliancy of the scene. . . . Pieces of statuary, sculpture, rare etchings, engravings, paintings and choice articles of bric-a-brac afford numerous objects upon which the eye can rest with pleasure. The mural decorations are throughout upon a scale of artistic elegance it would be hard to surpass."[14]

The founders of the Montana Club modeled their new fraternity upon the exclusive gen-tleman's clubs then popular in more established parts of the country. As a reporter for the *Daily Herald* observed, "Every city of any note has one or more such organizations."[15] To gain membership in the prestigious new association, candidates had to be nominated and sec-onded in writing by an established member of the club. The Board of Governors then voted on the nominee by written ballot—"absolutely secret and inviolate"—with one negative vote being enough to preclude membership.[16] Any member who willfully violated the rules and

J. M. MORIARTY
Montana Club Dinner,
ca. 1900
Printing out paper, 7½ × 9½
inches, Photograph Archives,
Montana Historical Society,
Helena (953-298)

regulations of the Club or conducted himself "in a manner unbecoming a gentleman" was subject to expulsion.[17]

Ironically, while Charles M. Russell—as a member of a wealthy St. Louis family—would have been an ideal candidate to join the ranks of the Montana Club, "Kid Russell," with his adopted cowboy persona, was not. And that, by all accounts, suited Russell perfectly. In coming to and staying in Montana, he had consciously chosen a lifestyle markedly different from the one into which he was born. After an unsuccessful stint at sheep herding and an instructive interval with mountain man Jake Hoover, Charlie ultimately became a nighthawk, keeping watch over horses while others slept. As a worker he was only passable, but he excelled at entertaining his fellow cowboys and for that reason was always welcomed at the many camps that dotted central Montana.[18] "For when all is done and said," one cowpuncher observed, "[even if Charlie] could not have painted any kind of a picture he would have been just as popular for he was a good mixer & could reel all kinds of yarns and that was something need[ed] in a cow country."[19]

Accounts of Russell's skill as an entertainer abound. For example:

One summer they [the Gilman family and other visitors from Davenport, Iowa] lived in tents at Jake Hoover's place in Pig Eye Basin. . . . Now Charlie was a poor

UNKNOWN PHOTOGRAPHER

Breakfast on the Roundup,
Utica, Montana, ca. 1885
Charlie Russell seated front row,
third from left.

Silver gelatin print, 4¾ × 9
inches, Photograph Archives,
Montana Historical Society,
Helena (946-387)

lad. And very amusing then as always. Kept the place in uproar all the time. At night
he would come in, flop on his belly, and paint a water color in the very sight of all
assembled. When the Gilmans started home he gave each of the girls two or three
of his sketches. And Mrs. Gilman asked him what she should send him. He said,
"I need paints and brushes and paper for my sketches." And upon her return she
filled the order generously and Charlie never forgot it. You see he had amused those
visitors. All summer. And they were all indebted to him for many and a many a good
laugh. Course we often get laughs for nothing. But every one is worth money. And
everybody who ever knew Charlie Russell, I claim is his debtor. And oh, how many,
many happinesses he has given me.[20]

Beyond his ability to simply entertain, however, it was the profundity of the friendship he
offered that formed the nucleus of Charlie Russell's popularity in Montana. The conviction
that "if he liked a friend there was nothing he would not do for them" was frequently reiter-
ated, and the artist himself recognized, "I had friends when I had nothing else."[21] Even his
wife, Nancy, whom Charlie's rougher cohorts greatly resented for the impact that marriage
had on his ability to socialize, understood this. "It makes me very happy indeed," she wrote
would-be biographer James B. Rankin in 1937, "to know that you who do not know Charlie,
should feel the depth of his friendship for people. Any one who knew him at all loved him and
I don't know any one who has as many friends as he had."[22]

While Russell himself was the primary attraction for Montanans who knew the Cowboy

Artist personally, his art eventually began to reach a much larger audience. This was increasingly true after he married Nancy and she assumed control of the business side of his career. In 1937, California artist Maynard Dixon wrote, "I first began to hear about 'Charlie Russell, the cowboy artist' as far back as 1890, and from then on with fair regularity in almost any part of the West wherever pictures of western life might be mentioned."[23] Lila Houston, sister of New York artist John Marchand, substantiated Russell's growing name recognition—and his charismatic personality—when she wrote that Russell "came east with my brother. On the long train ride, the men in the train gathered about this interesting cowboy—at first not knowing who he was, but fascinated by his interesting personality, for he was as wonderful a story teller as he was an artist. 'Who is this fellow?' they asked, and when told it was 'Charlie' Russell, the cowboy artist, they had a great thrill. They had heard of him, and had admired his western pictures, now they found the artist was just the kind of man one would like a cowboy artist to be."[24]

As his artistic ability continued to develop over the first two decades of the twentieth century, Russell's reputation spread in ever-widening circles. Exhibits in New York and Europe led to growing fame, as did publications of his illustrations in books and magazines; but to people of the Treasure State, one of Russell's most endearing qualities was the fact that he remained true to Montana and his cowboy "roots." Throughout his life Russell's most enthusiastic admirers would include those who knew him best and loved him most as a youth who rode the range. Even the state's newspapers reported that, although "the cowboy's fame extends far into the world of art he is a true Montanan . . . [who] would rather live among friends in the West than be lionized in strange lands. . . . For his own reasons—no man has been able to glean them—he has refused steadfastly to permit a painting of his to travel east of Montana."[25] While this latter statement is blatantly untrue, the fact that the newspaper and its readers found it believable is a significant testament to Montanans' ongoing regard for their favorite son and his devotion to his adopted home state.

As Russell's status as an artist continued to grow, so did the distinction of the Montana Club. By 1893 the organization had purchased property and built its own building, a seven-story Victorian Gothic edifice that was later hailed as "the most sumptuous building ever erected in Montana."[26] Thus situated, the club was now positioned to assume the role of the Treasure State's leading social institution. As the Anaconda *Standard* reported in 1900, "Unquestionably of all the clubs in the state the famous Montana Club at Helena stands at the front. . . . Hardly a famous man has visited Montana without being entertained by the club and [thereafter] departing singing the praises of the splendid building and the delightful hospitality of the members."[27] In addition to its social importance, the Montana club also played a significant, if unofficial, role in the larger story of Montana history. Because membership privileges were extended to all state lawmakers, critics claimed that "more legislative decisions were concluded in the Montana Club than on the floor of either house."[28]

Unfortunately, in spite of the grandeur of the Montana Club's first permanent home, the building would prove to have a relatively short life. On April 27, 1903, the "most magnificent building this side of Chicago devoted to club purposes" burned to the ground.[29] All contents were lost. An investigation revealed that the fire had been intentionally set by Harry Ander-

son, the fourteen-year-old son of the club's most beloved and long-termed employee. Harry had been motivated by an "uncontrollable desire to see the [fire] horses run and to help the fireman work."[30] Club members relocated temporarily to a mansion on Helena's prosperous West Side until a new structure, erected on the site of the former building, opened its doors two years later. The club's art collection, which had been destroyed in the fire, would take much longer to replace. Ultimately, the club's most significant acquisition in its effort to re-build its art holdings would be "Montana's magnificent Russell," *When the Land Belonged to God*.

The record detailing the commissioning of *When the Land Belonged to God* is sketchy. The principal source of extant information comes from Frank Bird Linderman, a close friend and kindred spirit of Russell's who played an instrumental role in securing the commission for the Cowboy Artist. A notable Montanan in his own right, Linderman is best known as an advocate of Indian rights and chronicler of Indian culture. Like Russell, he was born in the East and came West as a youth in search of adventure. He worked as a trapper in the Flathead Valley, an assayer in Butte, and a newspaperman in Sheridan before coming to Helena in 1903 as a state representative from Madison County. At the close of his second term in the legis-lature, Linderman stayed in the capital city, serving as assistant secretary of state until 1907. Thereafter he worked for the Guardian Insurance Company of America and became increas-ingly serious in his effort to become a full-time writer.[31] Ad-ditionally, he was an active member of the Montana Club.

Because they shared a common philosophy of life and love of the West, Linderman and Russell were close friends. As editor H. G. Merriam noted in the introduction to Lin-derman's posthumously published *Recollections of Charley Russell:* "In sum, Charles Marion Russell and Frank Bird Linderman took to one another because of their natures and their experiences, their love of 'unspoiled' country and 'un-spoiled' people, especially Indians, and because both had a passion for preserving Western life as it was twenty years and more before the turn of the century. No doubt Linder-man joined Russell heartily in saying, 'I'm glad I lived when I did—not twenty years later. I saw things when they were new.' This was not quite true—but both thought it was—for by 1880 'unspoiled' life in the West was on the wane."[32]

The prominence that the Cowboy Artist had attained by the second decade of the twentieth century would make a Russell commission seem like an obvious choice for a presti-gious Montana organization seeking to rebuild its art collec-tion. Some club members enthusiastically backed the idea, but the record indicates that there was also some skepticism. As both an intimate of Russell's and a member of the Club, Linderman was in a unique position to encourage the pur-

DRAWN BY R.C. REAMER AND A.C. RALEIGH

chase and facilitate the process. "I had no financial interest in the picture's acceptance," Linderman later reminisced. "I simply wanted the satisfaction of having served both my friend and my Club."[33] For the Russells' part, they acknowledged that the commission "would never have gone through" without Linderman's assistance.[34]

Perhaps the skeptics' reluctance was caused by the fact that Charlie's emblematic western scenes did not fit all members' notion of what was appropriate for their stately décor. Admirers generally marveled at Russell's ability to convincingly portray action, but in this case that ability was viewed as a deterrent rather than a selling point. As Linderman related, "The fussy chairman of the Club's Board of Governors warned me when I secured this commission for Charley, 'Now Frank, get him once in his life to paint something that is standing still. I cannot live in a room with the usual Russell paintings, they make me nervous.'"[35]

Frank Bird Linderman and Charlie Russell at the Linderman Home, Helena, Montana, November 1913

Maureen and Mike Mansfield Library, The University of Montana-Missoula, Linderman Collection (007-VIII-375)

Most likely the growing price of Russell's work—which by this point had reached four figures per piece—also contributed to club members' reluctance. "Now honest Injun," Nancy wrote Linderman, "do you think there will be a bunch at that club have heart failure? You have an idea what we have been getting for paintings. . . . Tell me what the club will stand for and not think we are doing them. If it isn't enough for this painting we just won't say anything about this one and Chas. can do something with less work this spring."[36]

Despite these concerns, status-conscious club members were no doubt impressed by Russell's epic mural, *Lewis and Clark Meeting Indians at Ross' Hole,* which by the fall of 1913 had been hanging in the House chambers of the state capitol for a little more than a year (see pp. 204–205). The grand painting depicted a critical encounter with the Salish Indians that would supply the explorers with enough horses to continue their trek westward before winter snows made the Bitterroot Mountains impassable. In choosing his subject, Russell had selected an episode that was not only important to Montana history but one that also "offered excellent pictorial potential: beautiful scenery, 'picturesque' Indians, and visually interesting rituals governing the meeting [between the explorers and the Salish people]."[37] Russell made the most of all these possibilities and, in completing the largest painting of his career, achieved a result even "grander than could have been anticipated."[38]

The mural measured twelve feet high by twenty-five feet wide, and Russell was obliged to raise the roof of his log-cabin studio in order to accommodate the canvas. He received five thousand dollars and a commendation from the legislature for his efforts. For its part, the state received a monumental work of art that would serve as "a lasting source of pride for the people of this commonwealth."[39] Unlike other paintings in the capitol and other artworks from that period devoted to Lewis and Clark, Russell told his story from the viewpoint of the Native Americans, diminishing the role of the explorers and reminding viewers that the

S. J. CULBERTSON

The Reading Room of the Montana Club Before "When the Land Belonged to God" Was Installed, ca. 1910

Silver gelatin print, 6 × 7¾ inches, Photograph Archives, Montana Historical Society, Helena (PAC 88-39)

Indians were "the onley real American[s]"; those who came after were the interlopers.[40] In early-twentieth-century Montana, few people other than Russell could have—or would have—expressed that idea so boldly, especially in such a prominent place.

Lingering reservations notwithstanding, the club's Board of Governors acquiesced and agreed to give Russell a chance, tentatively commissioning a painting but maintaining the right to refuse it upon inspection. Consequently, at Linderman's invitation, Charlie and Nancy took the train to Helena in the fall of 1913. Russell visited the club's second-floor reading room, one of the building's most handsome spaces and the intended home of his new painting.[41] While Russell had completed the massive capitol mural in less than three months, it would take more than a year before a finished painting was delivered to the Montana Club for its assessment.

Following the Russells' trip to Helena that fall, Charlie set to work on the painting, which would prove difficult to execute. In January 1914, Nancy wrote Linderman, "Chas has lots to do on the buffalo picture but it is just coming along fine. It is the most peaceful thing and that dear old river, you sure will like it."[42] The following month she wrote, "The Buffalo picture is not quite finished but coming fine."[43] In reality, however, the painting was not progressing smoothly. "Of all the pictures he ever painted I believe that the canvas above the mantel in the reading room of the Montana Club at Helena gave Charley the most trouble," Linderman wrote. "Charley simply could not make the big buffalo bull stand still. . . . '[I] had to fight hell out of that damned bull,' Charley told me disgustedly."[44]

Ultimately, of course, Russell mastered the recalcitrant bull. When the painting was finished, Linderman retrieved it from Great Falls and, in late 1914 or early 1915, installed it over the mantel in the Montana Club reading room. Excited to have the painting in place, Linderman wrote an article for a Helena newspaper praising the depiction of "Montana long ago as seen by artist's eyes . . . [as] a wonderful picture—full of interest—full of the mystery of an unknown land—the mystery that beckoned the sturdy and strong and before it one stands impressed with the love that Russell bears Montana."[45] Subsequently, Nancy wrote their friend, "We are so pleased to know that the Club members like their picture. You have done almost the impossible in arousing so much enthusiasm."[46]

In spite of its initial reception, however, official acceptance of the painting would not come until March. "For days pending the Board's decision I was touchy as a porcupine," Linderman reminisced. "Late in the afternoon of the momentous day not more than an hour before the Board's final meeting I was in the reading room with two of the Governors when one of the older members [Colonel Tatem] entered. He had once been a Governor and felt his importance."[47] Upon viewing the painting, Tatem dismissed the central figure as a "miserable bull." Linderman continued the story:

Colonel Tatem's speech stung me deeply, especially when I remembered having seen Charley paint this same buffalo over and over again. The huge beast would one day be seemingly perfect; then next he'd be gone, painted out entirely. "I've fought that bull for six months," Charley told me, when finally the painting was finished and turned over to me. And yet, after all this, after the master himself . . . had worked so long with the bull in the foreground, Col. Tatem pronounced it a miserable figure. I told Charley what the Colonel had said and shall never forget his reply. "Well, mebby it is a bum bull, but it's the best damned buffalo bull I ever painted," he said evenly.[48]

Fortunately, Tatem's opinion was not widely shared, and on March 6, the "House Comm[ittee was] Ordered to offer C. M. Russell $3,000 for picture, 'When the Land was God's.'"[49] Linderman telegrammed the news to Nancy, who was with Charlie in New York for an exhibition at the Folsom Gallery, and by March 20, the committee was able to report that their offer had been accepted. The Montana Club was now the owner of one of the greatest of all Russell treasures.

When the Land Belonged to God is set on the Missouri River at daybreak, a few miles downstream from the town of Fort Benton. Having just crossed the river, a small group of bison—with steaming backs and dripping fur—stand momentarily paused on a rocky knoll, filling the center of the image and dominating the painting's foreground. Behind them, a never-ending stream of buffalo trails downs the far hills and across the river. The rising sun strikes the faces of the lead buffalo and the distant bluffs, lending drama and brilliant color to the scene. Distinctive geographic landmarks—Frenchman's Ridge, Square Butte, Round Butte, and the Highwood Mountains—can be seen clearly in the distance.[50] As reminders of nature's adversity, hungry wolves, a bison skeleton, and a fallen, beaver-scarred snag complete the picture's central elements. A sage grouse is hidden in the foreground, adding a sense of Russell's inescapable whimsy for those who study the painting carefully enough to discern the camouflaged bird. No matter how thoroughly the canvas is studied, however, the hand of man is nowhere to be seen.

Other than asking for "a quiet painting," there is no indication that the club's Board had dictated the content of the picture. The choice was apparently the artist's alone, and the subject he chose reveals two important facts about Russell that help to explain his role as Montana's favorite son: his ability to paint wildlife, an endeavor in which he exhibited "a genius of high order,"[51] and his all-encompassing love of and fascination with "the West that has passed."

Taken at face value, *When the Land Belonged to God* is a magnificently realized portrayal

of one of the American West's most celebrated icons. For Plains Indians, the vast bison herds that had once roamed the region had been integral to both physical survival and spiritual well-being. As non-Indians expanded onto the Great Plains, the shaggy beasts were virtually annihilated at the same time that they were being adopted as romanticized emblems of the West. Thus, bison were frequently the subject of Russell's artistic pursuits, even in his childhood, and they were one of his most favored subjects throughout his career. More important than the frequency with which Russell portrayed buffalo, however, was the skill with which he depicted them in oil, watercolor, ink, and clay. As Linderman observed, "in painting buffalo he was a master."[52]

In addition to being a preeminent portrayal of wildlife, *When the Land Belonged to God* is also a testament to Russell's belief in the superiority of life in Montana before it was irrevocably altered by the farmers and boosters who closed the open range and brought modernity to life under the Big Sky. Russell's preference for the West as it had been was inherent in the majority of his artworks, but no place was it more beautifully depicted than in the Montana Club's masterpiece. Paired with the majestic beasts he had captured so expertly on canvas, the painting's evocative title leaves little room to question where Russell's sentiments lay. Given his Montana Club audience—the apex of the very citizenry who, in Russell's opinion, had permanently spoiled his beloved country—the painting does not make an overt statement, but it does convey a clear message to anyone familiar with Charlie's views.[53]

While Russell's closest Montana friends shared his beliefs about the West and appreciated his technical skill, many of them most valued his work for the way in which it chronicled their personal memories. Other artists might have talent, they reasoned, but Charlie was the one whose paintings were true because he had lived and worked in the West that he so lovingly depicted. "I have long missed him as the sole portrayer of the west that we both knew and loved," one admirer recalled. "Those illustrators and painters who attempt to portray what has been would better copy Charlie Russell to the least detail if they want to be accurate."[54] Nancy echoed this sentiment when she wrote that if anyone wanted "to know of the life in the West during the period Charlie painted it they will have to turn to his pictures to get authentic information."[55]

This belief in and regard for the authenticity of Russell's work held sway no matter the subject being depicted or the romance instilled into it. In actuality, of course, *When the Land Belonged to God* portrays a scene that Russell could not have personally witnessed. Such sights were at one time familiar on the Great Plains, and as one historian observed, "Stories are legion of the countless pioneer travelers who were stranded for hours—even days—while a great brown flood [of bison] flowed endlessly past."[56] By the time that Kid Russell arrived in Montana, however, the immense wild herds were gone, and the shaggy beasts were all but extinct. Any remaining bison Charlie encountered in the Judith Basin in the early 1880s would have "served mostly as depressing reminders of better days."[57]

Although Russell enthusiasts preferred to believe that he painted strictly from firsthand experience without outside influence, in truth part of his artistic genius lay in his ability to observe, remember, and learn from others. Russell would of course have heard many stories about the halcyon days of the buffalo from the old-timers who had seen such vast herds and

were still living when he arrived in the territory. He was also an avid reader and would have been familiar with accounts like those recorded in the journals of Lewis and Clark. In addition to written sources, Russell was also a great student of the works of artists—especially Carl Wimar, Karl Bodmer, and George Catlin—who, preceding him into the West by several decades, had personally witnessed and recorded such scenes as the one depicted in *When the Land Belonged to God*.[58]

In the case of Charlie's bison-themed pictures painted after 1908, however, there was an additional source of inspiration derived from a memorable experience for Russell and a unique occurrence in Montana history. By the close of the nineteenth century, the great, wild herds of buffalo lived only in memory, but there were a few privately owned herds scattered throughout the West. One such group was the Pablo-Allard herd on the Flathead Reservation in western Montana. Michel Pablo, a cattleman of mixed Blackfeet and Mexican heritage, and his partner, Charles Allard, had started their herd in the mid-1880s with thirteen head. Allard died in 1896, and thereafter Pablo retained his half of the pair's holdings—which now numbered about three hundred—while Allard's heirs sold their portion "in small lots to a number of buyers. Directly or indirectly, these animals were the forebears of many present day herds in this country."[59]

In 1906, knowing that the Flathead Reservation would soon be opened to non-Indian homesteaders, Pablo sought grazing rights for his herd so that it would be assured a place to roam. When this failed, he attempted to sell his bison to the U.S. government outright, but that effort proved no more successful. Pablo repeated his offer, this time to the Canadian government, which proved a more willing buyer. In 1906 he signed a contract promising to deliver his buffalo, by rail, to southern Alberta for two hundred dollars per animal. Pablo anticipated that it would take two years to complete the project. It ultimately took six.

What sounded simple in theory—hazing the buffalo into pens and then driving them onto rail cars as if they were cattle—proved to entail "one of the wildest and woolliest round-ups the West has ever seen. . . . A hell-for-leather, rough and tough event never attempted on such a scale before or since."[60] The lure of such an undertaking was of course too much for Charlie to resist, and he made two visits to the roundup, the first in the fall of 1908, when he served primarily as an observer. When he returned the following spring, he took a much more active role, this time riding in the roundup. "Whenever the opportunity presents itself he always goes to see anything that pertains to the old west," Nancy later reported. "This was the best chance in the world to study because there was not only horse and man action, but . . . wild buffalo that hardly knew what a man looked like. . . . Mr. Russell rode as one of the men and in that way saw a great deal that was priceless."[61]

Described as "a cordial companion who brought a certain elegant seasoning to the outdoor setting," Russell was in his element on the roundup and, characteristically, served as part of the entertainment for others who had come to watch.[62] "Camping with Charlie was the best way to get to know him," photographer N. A. Forsyth wrote. "Gathered around the campfire at night he would keep us all entertained . . . and he never ran out of stories."[63] Most importantly, however, the roundup offered Russell an opportunity to observe bison up close and in action. While the seven hundred animals that Pablo eventually shipped north in no

N. A. FORSYTH

The King of American Wild Animals, Pablo-Allard Round Up, Flathead Reservation, 1908

Silver gelatin print on stereograph mount, 3¼ × 3¼ inches, Photograph Archives, Stereograph Collection, Montana Historical Society, Helena

way matched the numbers that had once congregated on the open plains, it was the closest that residents of early-twentieth-century Montana could come to reliving this aspect of the Treasure State's colorful past.

Charlie Russell died in 1926, seventeen years after he had participated in the Pablo-Allard bison roundup and eleven years after the club's Board of Governors voted in favor of purchasing the "buffalo picture" he had completed for them. Over the following decades, any thought of a "miserable bull" was forgotten as Russell's masterpiece became the Montana Club's most prized and highly celebrated possession. However, by the 1950s the painting's monetary value had risen so high that insurance premiums were causing concern for the organization's fiscally conservative governors.

In 1953, the Montana Historical Society moved into new headquarters that featured a "Russell Room," a state-of-the art gallery honoring Montana's favorite son. Not coincidentally, in that same year the museum acquired the extraordinary Malcolm S. Mackay Collection of Charlie's art. Following on the heels of that successful acquisition, Society director K. Ross Toole soon saw another opportunity to attract the multitude of visitors who never tired of the Cowboy Artist and his vibrant canvases. In April 1954, Toole wrote the Montana Club asking for the loan of their painting for the summer, promising that "some 100,000 people will see this fine work of art between July 1 and Labor Day. It is the best kind of advertising for Montana and the club's generosity would be greatly appreciated by Montanans in general."[64] He promised that the painting would be transported in a Federal Reserve bank truck, kept under guard, and insured for $25,000. Additionally, the Society offered to have the painting cleaned by a professional conservator, John Pogzeba of Denver, who was already scheduled to be in Helena that summer working on the Russell mural in the capitol. Following "a lengthy discussion," the Board agreed to the loan, with one governor dissenting.[65] Although it had been appreciated by countless luminaries over the years, *When the Land Belonged to God* could now be viewed by the general public for the first time in its history.

Over the next twenty years, Russell's masterpiece would move back and forth between the Montana Historical Society and the Montana Club in a succession of loans. Unlike the value of the painting, which continued to rise, the fortunes of the club ebbed and flowed. At the conclusion of World War II, the club—flush with revenue generated through the operation of illegal slot machines—had purchased the Green Meadow Country Club on the outskirts of town, providing Helena with its "first really fine, all-grass golf course."[66] By 1969, however, the slot machines had fallen victim to reformers, and the organization could no longer afford to operate two facilities. Consequently, a long-range planning committee proposed that the

club dispose of both its historic downtown building and its prized Russell, which had recently been appraised at $250,000. The resulting proceeds would be used to construct "a new club house . . . [at] the Green Meadow Country Club, and for the construction, reconstruction and expansion of the golf and other facilities located thereat."[67]

The Board of Governors supported the committee's recommendation and prepared to present the proposal to a vote of the full membership. When word of the painting's impending sale reached the public, however, the reaction was not favorable. Local resident John Quigley typified the community's response when he stated, "The founders of the Montana Club . . . would turn over in their graves if they knew the club was trying to get rid of that picture in order to punch a few holes in the ground."[68] For their part, officials of the Montana Historical Society expressed wholehearted interest in acquiring the painting, should it be sold, but also doubted their ability to secure the necessary funding. Michael Kennedy, acting director of the museum, told reporters, "It is probable the only persons with enough cold cash to afford the painting are those of the Texas-Oklahoma wheeler-dealer oil clan. Should members vote to sell, the painting in all likelihood would leave the Treasure State forever."[69]

At a "stormy meeting" on June 29, the club's membership voted to keep both their painting and their historic headquarters, ultimately separating themselves from the Green Meadow Country Club. Financial difficulties continued to plague the club, however, and rumors re-

L. H. JORUD

Birthday Party at the Montana Club with Group Posed before "When the Land Belonged to God," February 19, 1948

Silver gelatin print, 8 × 10 inches, Photograph Archives, Montana Historical Society, Helena (953-303)

garding the possible sale of the painting persisted. Believing that a sale was inevitable, Ken Korte, director of the Montana Historical Society, sent a letter in December 1975 to club president George Beall, offering to purchase the painting for $200,000. Korte wrote: "For many years the Montana Historical Society has housed on loan the Montana Club painting *When the Land Belonged to God* by Charles M. Russell. It has been the wish of the many patrons of this institution that at some point in time we would be in a position to negotiate with the Montana Club for the purchase of this famous painting. It goes without saying that we feel that the painting should stay in the state of Montana and it is appropriate that this great work of art should belong to the people of Montana whom we, as an agency of state government, represent. We feel that the time has come."[70]

Without waiting for an official response from the club, the museum began fundraising efforts, tying the purchase to Montana's celebration of the U.S. bicentennial. Several groups joined the cause, and pleas were made statewide appealing to Montanans' sense of duty. A typical editorial in the Havre *Daily News* said, "If enough Montanans who claim they are imbued with pride can match their feeling with dollars one of Charles M. Russell's oils, *When the Land Belonged to God*, will remain in Montana. . . . It would almost be a sin if Montanans do not make an all-out effort to purchase the painting. Taking that oil permanently to a gallery in another state would be like taking out a big chunk of Montana's soul."[71]

Learning that the sale of the painting would be put to a vote of the club's full membership on May 4, 1976, Korte reiterated the Society's desire to buy the painting and explained that the $200,000 was only a suggested price; the museum was willing to negotiate.[72] At their meeting, however, members voted to sell *When the Land Belonged to God* to the highest bidder, hoping to realize at least $400,000 from the venture. Shortly thereafter, the club changed its position, saying that it would give the museum thirty days to match any other offer received. In May, a statewide committee was formed to negotiate with the Montana Club, and supporters of the purchase received a huge boost that June when Governor Judge announced that, should the attempt to raise private funds fall short, he would seek state funding when the legislature convened the following January.

While the Society continued its efforts to raise private funds, it would indeed need to call upon the legislature to reach its goal. In February 1977, the Montana Club governors passed a resolution officially offering to sell *When the Land Belonged to God* to the state, only now the price had risen to $500,000. The club also resolved "that in recommending and approving this sale at this price the board is recognizing the desire of the membership to have the painting remain as property of the state for the benefit of her people, and recommends to the membership the withdrawal of all other conditions of the sale, including options of first refusal rights, if this offer is not accepted."[73] The museum countered with an offer of $450,000, stipulating that the purchase was dependent upon a hoped-for appropriation from the forty-fifth legislature.

Ultimately, the Society was able to raise $150,000, and the legislature was asked to appropriate the remaining $300,000 from state funds. In an atypically bipartisan show of support, the appropriation was, relatively speaking, easily secured. By March, Korte was able to say that "it now appears that the Montana Club painting is going to be purchased by the legis-

lature and the buffalo will continue to pasture in Montana."[74] In the official roll call taken in mid-April, only one senator responded in opposition to the bill, and he was taken to task for his "vote against Charlie."[75] In their discussions promoting the purchase, however, senators had included one caveat, spurred no doubt by envy over Russell's grand mural in the House: they wanted *When the Land Belonged to God* to hang above the Senate rostrum whenever the legislature was in session.[76]

On May 10, 1977, with Governor Judge's signature, *When the Land Belonged to God* was officially secured for the "use and benefit of the citizens of the State of Montana."[77] When he signed the bill, Judge said, "The work of Charlie Russell and a handful of other artists and writers has kept those of us who were not fortunate enough to know the Old West firsthand from forgetting her. . . . His paintings—their color, drama and size—bring home to us forcefully the dreams of independence and reverence for nature which underlie the quality of life we Montanans work hard to nurture and defend."[78]

And no Montanan revered nature more than Charlie Russell. Reminiscing about the wildness of his adopted home as he had initially encountered it, he wrote that "at that time bar[r]ing the Indians an[d] a few scatered whi[tes] the country belonged to God."[79] Russell spent his life portraying God's country as he had first known and cherished it. In return, Montana loved him for doing so. While his friends praised the authenticity of his detail, modern critics debate the documentary value of his paintings. What is not debatable, however, is the fact that Russell truly captured the essence of an earlier time and place. In reviewing a Russell exhibit at the Folsom Gallery, a reporter for the *New York Times* wrote, "It is necessary to remember that historical documents in art mean the record not merely of facts and incidents but of the spirit of a vanished time."[80] As one of Charlie's young friends plainly stated, "He captured the spirit of things always."[81]

The spirit of the West and of the artist who so expertly captured it on canvas still loom large in the Treasure State. "I wish that Charlie could come back and see how much we all appreciate him and his wonderful pictures," N. A. Forsyth mused shortly before his death in 1949, adding as an afterthought, "Perhaps he does know."[82] The Cowboy Artist may be gone, but one thing is certain: Charlie Russell still belongs to Montana.

Notes

1. Garry J. Moes, "Montana Keeps Its 'Magnificent Russell,'" Helena (Mont.) *Independent Record,* May 11, 1977, 19.

2. Samuel E. Johns to James B. Rankin, December 31, 1938, 1. Rankin Collection, MC 162, box 2, folder 13.

3. Grace Stone Coates to James B. Rankin, November 20, 1936, Rankin Collection, box 1, folder 7.

4. For complete biographical information on Russell, including his initial trip to and arrival in Montana, see Taliaferro, *Charles M. Russell: The Life and Legend of America's Cowboy Artist.*

5. Gutzon Borglum, "The End of the Trail: Charles M. Russell, Cowpuncher, Lone Hunter and Painter of the Wild West, Is Gone with the Life He Painted." ca. 1926, 2. Rankin Collection, box 1, folder 12.

6. *Second Annual Report of the Secretary of the*

Helena Board of Trade for the Year 1879 (Helena, Mont.: Woolfolk, MacQuaid & Lacroix, 1880), 23–24.

7. Taliaferro, *Charles M. Russell: The Life and Legend of America's Cowboy Artist*, 32.

8. *Helena Illustrated: Montana's Capital, the Queen City of the Mountains* (Helena, Mont.: 1889), 11; D. Allen Miller, comp., *Helena City Directory 1886–7* (Helena, Mont.: George E. Boos, 1886).

9. Montana Club minutes, Phillip Barbour Papers, Montana Historical Society Archives, Helena, Mont., MC 95, box 27, folder 22. One of the men present at this initial gathering of Montana Club founders was Louis Stadler, co-owner of the Bar R herd, to which the starving cow of *Waiting for a Chinook* fame belonged.

10. *Constitution, Rules, Officers and Members of the Montana Club, of Helena, Montana* (Helena, Mont.: Montana Club, 1890), 13.

11. Dave Walter, "Montana Club: Survival through Adaptation," Helena (Mont.) *Independent Record*, February 25, 1999, 6A. Because membership included both resident and nonresident categories, this statement could be expanded to include a cross-section of the entire state's elite as well the elite of Helena.

12. "The Montana Club, Its Apartments and Membership," Helena (Mont.) *Daily Herald*, April 14, 1885, 3.

13. Ibid.

14. "Society's Night. The Largest Reception Ever Held in Helena Given by the Montana Club," Helena (Mont.) *Daily Herald*, December 20, 1888, 8.

15. "The Montana Club," Helena (Mont.) *Daily Herald*, April 14, 1885, 3.

16. *Constitution, Rules, Officers and Members of the Montana Club*, 18.

17. Ibid., 28. Club rules officially forbade gambling, but most sources suggest that this regulation was almost universally ignored.

18. More than one person who knew "Kid Russell" remarked on his laziness. For example,

Grace Stone Coates wrote, "Don't think when I say Russell was reputedly lazy, that I mean it as a criticism. It was a fact." Coates to James B. Rankin, December 14, 1936, 1. Rankin Collection, box 1, folder 7.

19. Earl Talbott to James B. Rankin, May 22, 1939. Rankin Collection, box 4, folder 6.

20. Judge J. W. Bollinger to James B. Rankin, September 30, 1938, 2. Rankin Collection, box 1, folder 4.

21. Ernest T. Spencer to James B. Rankin, February 22, 1937, 2. Rankin Collection, box 4, folder 5; Charles M. Russell, "A Few Words about Myself," in *Charlie Russell Roundup* (Helena, Mont.: Montana Historical Society Press, 1999), 317.

22. Nancy Russell to James B. Rankin, May 5, 1937. Rankin Collection, box 3, folder 15. In 1936 Rankin began gathering information from people across the nation who had known Russell or owned his art, in preparation for a definitive biography he hoped to write. His goal was never realized, but the information he gathered provides extremely valuable insights into Russell and those who admired him.

23. Maynard Dixon to James B. Rankin, January 15, 1937. Rankin Collection, box 1, folder 13.

24. Lila Marchand Houston, "Charlie Russell," December 3, 1936, 2. Rankin Collection, box 2, folder 9.

25. "Russell Is an Artist," Anaconda (Mont.) *Standard*, September 30, 1901, 7.

26. Dennis McCahon, "A Thoughtful Mix of Architectural Styles," Helena (Mont.) *Independent Record*, February 25, 1990, 7A.

27. "Montana's Social Clubs: In Stately Mansions or in Snug Retreats," Anaconda (Mont.) *Standard*, December 16, 1900, section 2, 8.

28. Walter, "Montana Club."

29. Helena (Mont.) *Independent*, April 28, 1903, 1.

30. Baumler, "Up in Smoke," 147. Harry Anderson's father, Julian, was employed as a bartender at the Montana Club from 1893 to 1953. Upon his retirement, the "Master of Mixers,"

as he was affectionately known, was given a lifetime club membership in appreciation of his years of dedicated service.

31. In 1917, Linderman left Helena and moved to Flathead Lake, where he devoted his full attention to writing. He eventually published numerous articles and more than a dozen books, several of which were illustrated by Russell.

32. Linderman, *Recollections of Charley Russell,* xii. In a letter to Linderman suggesting the possibility of Linderman's reincarnation from an earlier life as Indian, Russell wrote: "You wore a clout an smoked with the sun. He was your God an you asked no better. . . . You were a heathen but your prayers were longer and more frequent than your Christian bothers[.] In this life your wants were few[.] buffalo that roamed your country in millions gave meat clothes and a good house[.] baring a few roots and berries you were as carniverious as your brother the wolf who followed the heards like yourself. . . . you are not quite as raw now Frank as you were when you were on earth before but still show strong croppings of the savig. . . . I am your kind myself." Dippie, ed., *Charles M. Russell, Word Painter,* 169.

33. Linderman, *Recollections of Charley Russell,* 95.

34. Nancy Russell to Frank Bird Linderman, March 26, 1915, 1. Linderman Collection, ms. 007, series II, box 3, folder 42 (hereafter "Linderman Collection").

35. Linderman, *Recollections of Charley Russell,* 95.

36. Nancy Russell to Frank Bird Linderman, January 27, 1914, 1–2. Linderman Collection.

37. Burnham, "The Paintings," 64.

38. Ibid.

39. Senate Joint Resolution no. 3, March 18, 1913, *Laws of Montana, 13th Session, 1913,* 557.

40. Dippie, ed., *Charles M. Russell, Word Painter,* 188. Although none are depicted in *When the Land Belonged to God,* Charlie's writings testify to the fact that he included Native Americans as rightful citizens of the natural world.

41. Dave Walter, "'When the Land Belonged to God' Remains a Montana Treasure," Helena (Mont.) *Independent Record,* March 11, 1999, 6A.

42. Nancy Russell to Frank Bird Linderman, January 27, 1914, 1. Linderman Collection.

43. Nancy Russell to Frank Bird Linderman, February 16, 1914, 1. Linderman Collection.

44. Linderman, *Recollections of Charley Russell,* 94.

45. Frank B. Linderman, "New Canvas by Russell," newspaper clipping, newspaper and author unknown, ca. 1915. Curator's research files, Amon Carter Museum, Ft. Worth, Tex.

46. Nancy Russell to Frank Bird Linderman, January 14, 1915, 1. Linderman Collection.

47. Linderman, *Recollections of Charlie Russell,* 95.

48. Linderman, *Montana Adventure: The Recollections of Frank B. Linderman,* ed. H. G. Merriam (Lincoln: University of Nebraska Press, 1968), 154.

49. Montana Club minutes, March 6, 1915, 5. Phillip Barbour Papers, Montana Historical Society Archives, Helena, Mont., box 29, folder 12. The Montana Club would continue to use this erroneous title until corrected by Fred Renner in 1969.

50. As any good painter would do, Russell took liberties with the topography to make it fit his artistic vision. Not all agree on this point, but most Russell scholars believe that the vantage point depicted in *When the Land Belonged to God* is just downriver from Fort Benton, where Shonkin Creek flows into the Missouri. If this is correct, Russell moved Frenchman's Ridge farther to the east (left) to reveal Square Butte and Round Butte; they are not actually visible from this point. A 1959 memorandum written by Fort Benton resident J. N. Blankenbaker recounting a visit he made to this spot with Russell in 1919 supports this location, as does a personal interview with Fort Benton historian John G. "Jack" Lepley (Montana Historical Society Museum, file x1977.01.01). According to Lepley, there are spots farther downriver—for example, the mouth of Arrow Creek—where

these features are visible from the bluffs along the river. While these locales are not accessible by automobile, Russell floated the Missouri in the fall of 1913 with Linderman and two other men, so the topography of the entire area would have been fresh in his mind.

51. Daniel Carter Beard to James Brownlee Rankin, November 10, 1936. Rankin Collection, box 1, folder 6.

52. Linderman, *Montana Adventure*, 154.

53. Russell frequently expressed these sentiments in writing as well as in his artwork. For example, he wrote: "You wouldent know the town [Lewistown] or the country eather its all grass side down now[.] where once your rod circle an I night rangled a gopher couldn't graze now[.] the boosters say it's a better country than it ever was. but it looks like hell to me. I liked it better when it belonged to God[.] It was shure his country when we knew it." Dippie, ed., *Charles M. Russell, Word Painter*, 175.

54. Harry P. Stanford to James B. Rankin, undated. Rankin Collection, box 4, folder 2.

55. Nancy Russell to James B. Rankin, December 1, 1936. Rankin Collection, box 3, folder 15.

56. Kidder, "Montana Miracle," 55.

57. Taliaferro, *Charles M. Russell: The Life and Legend*, 170–71.

58. For an extensive discussion on the influence of these and other artists on Russell's work, see Dippie, *Looking at Russell*.

59. Kidder, "Montana Miracle," 59.

60. Kidder, "Montana Miracle," 52, 60.

61. "Close View of Artist Russell," Great Falls (Mont.) *Tribune*, March 1, 1914, 4. For Charlie's own perspective on the roundup, see Dippie, ed., *Charles M. Russell, Word Painter*, 112–16, 130–31, 138, 164.

62. Taliaferro, *Charles M. Russell: The Life and Legend*, 172.

63. "Dillon Man Tells Story of Riding Wild Buffalo Bull Which His Friend Charles Russell Painted," Dillon (Mont.) *Daily Tribune*, October 18, 1947, 1.

64. K. Ross Toole to the Director of the Board of Governors of the Montana Club, April 5, 1954. Montana Historical Society Archives 2, box 13, folder 4.

65. Excerpt from Montana Club minutes, 1954. Montana Historical Society Museum, file x1977.01.01.

66. Myers, "The Montana Club," 46.

67. Montana Club Resolution, June 1969, Montana Historical Society Museum, file x1977.01.01.

68. "Quigley Wants to Keep Painting in Montana," Helena (Mont.) *Independent Record*, June 15, 1969, 8.

69. "Montana Club Members Considering Sale of CMR Painting, Concerned about Buyer," newspaper clipping, newspaper and author unknown, 1969. Montana Historical Society Museum, file x1977.01.01. Even in the 1970s, Montana art lovers were still smarting over the state's failure to acquire the famed Mint Collection, which was sold to Amon Carter of Fort Worth, Texas (DeVore, "Saloon Entrepreneurs"). Ongoing regret over the loss of the Mint Collection contributed to the state's successful purchase of *When the Land Belonged to God* and accounted for the fundraising campaign's battle cry, which centered on keeping the painting in Montana.

70. Ken Korte to George Beall, December 30, 1975. Montana Historical Society Museum, file x1977.01.01.

71. "Keep Great Russell Painting in Montana," Havre (Mont.) *Daily News*, April 30, 1976, 12.

72. Ken Korte to John R. Cronholm, April 28, 1976. Montana Historical Society Museum, file x1977.01.01.

73. Montana Club Resolution, February 8, 1977. Montana Historical Society Museum, file x1977.01.01.

74. Ken Korte to Emily Vucanovich, March 1, 1977. Montana Historical Society Museum, file x1977.01.01.

75. "Senate Okays Purchase of Charlie Russell Painting," Billings (Mont.) *Gazette*, April 17, 1977, 5C.

76. While the senators' desire to have the paint-

ing hang in their chamber during legislative sessions was made clear, it was not actually included as part of the bill's official language. Due to concerns about the painting's safety and long-term preservation, Society officials were able, with difficulty, to convince senators to abandon this idea after the 1979 session. Instead, an exact-sized reproduction was hung in the Senate, and a similar reproduction was given to the Montana Club to hang in the painting's original location over the fireplace in the room that now serves as the club's formal dining room. The Senate's reproduction was replaced in 2006 by the Eugene Daub bronze relief *We Proceeded On*.

77. Bill of sale, Montana Historical Society Museum, file x1977.01.01.

78. "Senate Okays Purchase of Charlie Russell Painting," Billings (Mont.) *Gazette*, April 17, 1977, 5c.

79. Dippie, ed., *Charles M. Russell, Word Painter*, 172.

80. *New York Times*, March 19, 1911, as quoted in Taliaferro, *Charles M. Russell: The Life and Legend of America's Cowboy Artist*, 181–82.

81. Linderman, *Recollections of Charley Russell*, 127.

82. Dillon (Mont.) *Daily Tribune*, October 18, 1947, 1.

May 4 1914

Friend Bill we received your
was shure glad to here from you
on is quite a sisabol camp.
hase many ttings of Interist
k in a futurist show the other day
kined away
go seen
the Fates
e around
eplaned
ng it as
as London
uts was bilt
wine bottle
lady like
ore a thin
d. I think
ad off regular
that might
naughty eys

rung a string
that sounded
n you an Mazy
kull off
ue up to something
aue that looked like an enlarged slice of
summer sausig And said this is not
tegration of Simultaneousness but
mie dynamism. An it did look like
. Another he showed as near as I could
from his talk represented the feeling
had stomach after a day by

an it might
dident smell
We v been

us lo

Peter H. Hassrick

Russell Meets Russolo

IN THE SPRING OF 1914, the Russells embarked on their first and only transatlantic adventure. Nancy, convinced that Charlie's reputation would be enhanced by exhibiting works abroad, arranged for a one-man show at London's venerable Doré Gallery. Titled "The West That Has Passed," the exhibition comprised twenty-five oils and watercolors representing Russell's latest pictorial reveries of a vanished frontier.

The ocean crossing had been difficult for both Russells. Charlie moaned that their ship did the "tango" all the way over and that he never found his sea legs until they arrived on England's shore. On March 30, two days before the show opened, he was still complaining, but now about his land legs, which had given up on him. Even on terra firma, he was in shaky condition.[1]

One of the more interesting experiences Russell had in London, no doubt made more "interesting" by his prolonged queasiness, involved a brief encounter with a fellow exhibitor at the Doré Gallery, an unidentified Italian Futurist painter thought to be Luigi Russolo. Known today (and in 1914) as much for his writings on and experiments in music as for his poetic paintings that reflected the timbre of modern life, Russolo was in London to accompany an exhibition of his and his compatriots' artworks at the Doré Gallery.[2] Titled "Exhibition of the Works of the Italian Futurist Painters and Sculptors," the show featured eighty works, primarily paintings. The bombastic founder of the Futurist movement, Filippo Tommaso Emilio Marinetti, was present to help supervise the installation and promote the group and its exhibition through public readings and lectures. Russolo had come for similar reasons, but also to present a series of musical concerts at the London Coliseum and Albert Hall. When Russell visited the Futurist exhibition in galleries adjacent to his at Doré, Russolo could have volunteered to serve as his guide. From the looks of the painting that is shown in a letter from Russell to his friend and fellow painter William Krieghoff, Russolo appears to stand in front of an oil painting by another member of the Futurist fraternity, Umberto Boccioni, possibly his homage to male athleticism *The Dynamism of a Soccer Player*.[3]

Russell's reactions to Russolo as a man and fellow artist and to Boccioni's explosion of color and action on canvas were patently predictable and mildly humorous as well as

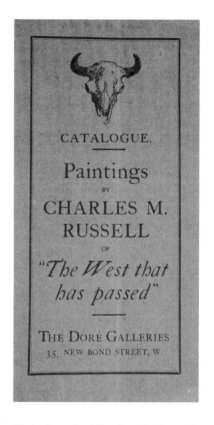

Paintings by Charles M. Russell of "The West that has passed"
Cover, exhibition catalog, 8 × 4 inches (London: The Doré Galleries, 1914), Jim Combs Collection, Great Falls, Montana

(facing)
Friend Bill [William G. Krieghoff], May 4, 1914 (detail)
Pen, ink, and watercolor on paper, 6⅝ × 8⅞ inches, William C. Foxley Collection, La Jolla, California

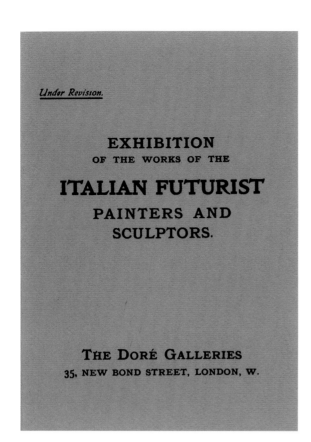

Exhibition of the Works of the Italian Futurist Painters and Sculptors

Cover, exhibition catalog, 6¹⁄₁₀ × 4⁷⁄₁₀ inches (London: The Doré Galleries, 1913), Photograph courtesy of the Frick Art Reference Library, New York

Friend Bill [William G. Krieghoff], May 4, 1914

Pen, ink, and watercolor on paper, 6⅝ × 8⅞ inches, William C. Foxley Collection, La Jolla, California

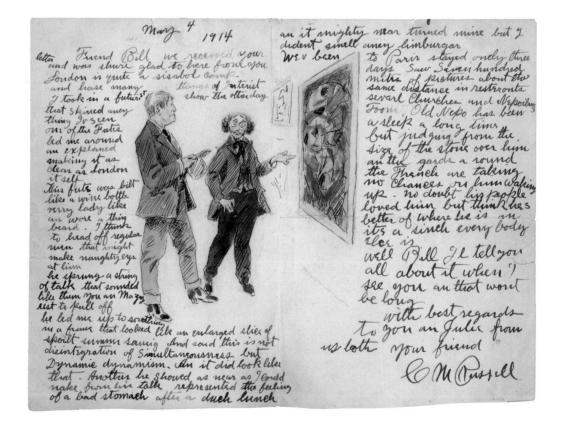

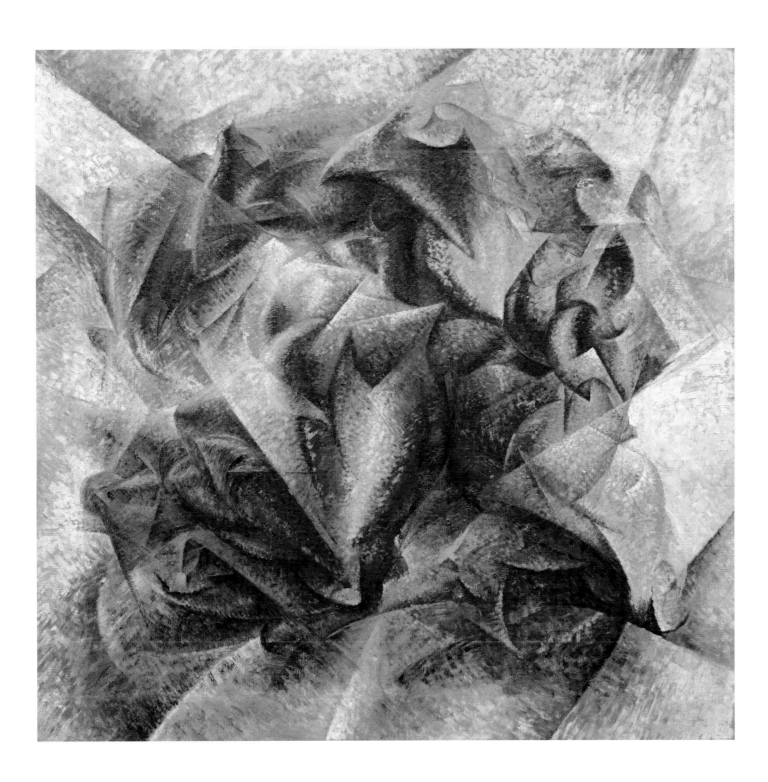

UMBERTO BOCCIONI (ITALIAN, 1882–1916)

The Dynamism of a Soccer Player, 1913

Oil on canvas, 76⅛ × 79⅛ inches, The Museum
of Modern Art, New York, The Sidney and
Harriet Janis Collection (580.1967), The Museum
of Modern Art/Licensed by SCALA/Art Resource,
New York

personally revealing and somewhat ironic. Russell and Russolo had come to England on similar errands—to expand their respective audiences and convey a specific message through their art. Russell hoped to convince the British of America's uniqueness (as graciously as possible, given that he was seeking patrons) by showing that the Old West, its history, and its spirit mattered and were unparalleled in world culture. The Futurists, on the other hand, strove—in overtly pugnacious terms—to liberate Britain from its staid Edwardian stuffiness by thrusting the machine age into the heart of a nation where old-fashioned thinking, such as John Ruskin's notions of ideal beauty in nature, still held considerable sway. Philosophically, Russell and Russolo stood in direct opposition: one disdained progress and extolled the virtues of the past, while the other wanted to obliterate long-held tradition through a total rejection of history's relevance, replacing it with a bold, cacophonous paean to modernity.

Most of Charlie's letters home, and there were many, revealed a fascination with English history and its ancient stone castles, Norman conquerors, and charging knights. He often inserted himself into those bygone narratives as if he were one of Mark Twain's Connecticut Yankees in King Arthur's court.[4] In his letter to Krieghoff, Russell sought to distance himself from Russolo and his ilk by convincing his colleague that his "Fute" guide was effeminate as well as pedantic. Certainly the two men, as depicted by Russell, were miles apart in stature, gesture, and demeanor. Russell's broad shoulders, square jaw, and height contrasted with Russolo's sloping shoulders, knock knees, unkempt hair, thin Van Dyck beard, and bulging eyes. Yet Russell, with his bowed legs, high-heeled cowboy boots, Cree/Métis sash, and stringy mop of honey-colored hair was just as out of place as Russolo in such precincts. In demeaning his new Italian acquaintance to his American pen pal, Russell was attempting to conceal his own insecurities and valorize his own eccentricities. He was also attempting to denigrate Boccioni's avant-garde work by portraying Russolo, his compatriot, as a sissy. In truth, the term fit neither Russolo nor Russell.[5]

On the contrary, both Russell and the Futurists were distinctly macho in their outlook. At that time, Russell was focusing his work on "predicament" paintings—pictorial narratives like *Crippled but Still Coming*, which was in his London exhibition—that showed men testing their mettle against nature or one another. Similarly, Boccioni's painting, in front of which Russell stands with hat in hand, depicts a soccer player in a furious display of aggressive action. Both Russell and the Futurists compulsively celebrated physicality and kinetics in their work. Boccioni's footballer bursts with energy, his movement a synthesis of color and light; Russell's *When Blackfeet and Sioux Meet* (also shown in London), though a figurative representation rather than an abstract design, is no less dynamic or spontaneous (see p. 98). Both are depictions of circular, centralized movement and the unleashing of dramatic force through extraordinary human agility. Both establish momentum and the exertions of the male body as signal themes.[6]

Russell and the Futurists produced something of a local stir with their exhibits, and they each attracted followers to their respective sides as a result. The Great Falls *Tribune* said, "It is doubtful if any artist, exhibiting for the first time, ever created the furore that Russell did."[7] His twenty-five paintings attracted an enthusiastic popular audience, along with "scores of titled Englishmen" and the Queen Mother herself.[8] The Futurists, who openly disdained hoi

Crippled but Still Coming, 1913

Oil on canvas, 30 × 48 inches,
Courtesy of the Eiteljorg Museum
of American Indians and Western
Art, Indianapolis, Indiana, The Gund
Collection of Western Art, Gift of the
George Gund Family (2002.15.56)

polloi and royalty alike and felt general scorn for a host of other British "maladies" (which they referred to as "passé-isms"), kindled their own positive and negative uproar.[9] While Russell is known to have inspired only one London artist, the society painter John Young-Hunter, the Futurist crowd engaged a full cadre of British modernists, especially C. R. W. Nevinson and Wyndham Lewis, who soon founded Vorticism, a whole school of modernist painting that was a British offshoot of Futurism. Within a year or two, Young-Hunter was living and practicing his art in the American West, and the Vorticists were exhibiting together at the Doré Gallery.

Both Russell and the Futurists garnered mixed press during the spring of 1914. Despite one Montana newspaper's claim that "no critic in all that merry England could find one fault with Russell's marvelous productions on canvas," his exhibition gathered its share of detractors. The London *Observer* extolled his draftsmanship but pointedly criticized his palette and paint-handling as having essentially "no quality." Most critics, however, were fundamentally charitable, excusing technical shortcomings in recognition of Russell's consummate skills as a painter of action and exotic western life.[10] As for the Futurists, they generated a full measure of hostility caused as much by the "impertinence" of their polemical denunciations of established English art as by the experimental sensationalism and abstracted kinetics of painters like Boccioni.

Russell and the Futurists did share a few philosophical traits, however. The first two provisions of the "Initial Manifesto of Futurism," published in 1909, proclaimed: "We shall sing the love of danger, the habit of energy and boldness. . . . The essential elements of our poetry shall be courage, daring, and rebellion."[11] Russell, especially in his youth, had followed these exhortations to the letter. But other tenets of Futurist doctrine would not have sat well with the Montana artist. The Futurists called for a celebration of speed, which might seem to fit with Russell's galloping horses, but the Futurist epitome of speed was the "roaring motorcar," an icon totally anathema to Russell. The Futurists also glorified war, sneered at history, and harbored a profound contempt for women. Russell's worldview and artistic imperatives fundamentally contradicted the Futurist line.

Russell's encounter with the Futurists in London was not his first exposure to a modernist movement in art. He and Nancy had attended the famous Armory Show in New York the year before, and his friend Krieghoff had been known to lecture him on the virtues of modern art. Russell was just as critical of the Futurists—who, ironically, did not exhibit at the Armory Show, thinking that they had better prospects for patronage in Italy at the time—as of the Cubists and Post-Impressionists whose work he confronted in New York. Russell is recorded as saying that the work of Marcel Duchamp and Pablo Picasso "may be art . . . but I can't savvy it." For him, such art was merely a confection of the artist's imagination, what he would call "dreamy stuff."[12] He was thus prepared to see more of the same in London, and Boccioni and his friends did not disappoint.

Americans in London were so impressed with Russell's showing at the Doré Gallery that they invited him to extend his exhibition by displaying part of it at the Anglo-American Exposition that ran from May to October 1914. The Exposition was sponsored by the American Society in London and celebrated one hundred years of peace between Britain and the United States. A Montana newspaper referred to the Exposition as a "miniature world's fair"

in which Russell was given a special small pavilion of his own. His stature at home was such that his fellow Montanans accorded him the distinction of being "one of the greatest living artists of the English speaking race" who was also "one of the big men in international circles."[13] Such recognition may have made even the internationally renowned Marinetti a trifle envious. When the Futurists finally exhibited in America, at San Francisco's Panama-Pacific Exposition in 1915, their work essentially passed unnoticed. The war had taken several turns for the worse, and its agonies, not the passionate modernist sensations of the Italians, now absorbed the attention of Americans.

Notes

1. Dippie, ed., *Charles M. Russell, Word Painter*, 192–93.

2. Russolo's book on Futurism and music, *L'arte dei rumori*, was first published in 1913.

3. There is a chance, too, that the painting shown in Russell's letter to Krieghoff is an oil by Gino Severini titled *Sea Dancer*, several versions of which were included in the 1914 London Futurist exhibition. Russell, who had suffered from severe and prolonged seasickness during his ocean crossing, likely would have been especially put off by Severini's rendition of waves. For an image and discussion of the Severini painting, see Hanson, *Severini futurista*, 43.

4. Russell refers to Twain's story in a letter to his friend Percy Raban, April 20, 1914. See Dippie, ed., *Charles M. Russell, Word Painter,* 200. Twain's story was originally published in 1889 by Charles Webster Publishing Company of New York. Coincidentally, Twain, who visited England in 1872, wrote in his journals that the thing that fascinated him most in London was the Doré Gallery and Gustave Doré's mammoth painting *Christ Leaving the Praetorium.* See *Mark Twain's 1872 English Journals* online at http://www.marktwainproject.org. Russell also admired Doré's *Christ Leaving the Praetorium.*

5. Russolo was at least man enough to volunteer for the Italian army during World War I and was injured in action. Russell, some twenty years Russolo's senior, could not, to his regret, join the American troops because of his age. Nonetheless, Russell admitted that if he were a younger man, it would be "shame not bravery that would send me to the front." See Russell's letter to Churchill B. Mehard, October 22, 1918, The Helen E. and Homer E. Britzman Collection, Colorado Springs Fine Arts Center, Colorado Springs, Colorado.

6. See Coen, *Umberto Boccioni*, 172–73, and Taliaferro, *Charles M. Russell: The Life and Legend of America's Cowboy Artist*, 195.

7. Robert J. Horton, "Britons, Enraptured by Russell's Art, Accord Him Rare Honors on Exhibit," Great Falls (Mont.) *Daily Tribune*, June 7, 1914.

8. Ibid.

9. Quoted in "A Futurist Manifesto: Vital English Art," London *Observer*, June 15, 1914.

10. Horton, "Britons, Enraptured by Russell's Art."

11. Quoted in the catalog *Exhibition of the Works of the Italian Futurist Painters and Sculptors* (London: The Doré Gallery, 1913), 4.

12. Russell was quoted in the Chicago *Evening Post*, March 6, 1914. For a carefully considered discussion of Russell and his reactions to the Armory Show and modern art, see Taliaferro, *Charles M. Russell: The Life and Legend of America's Cowboy Artist*, 191–95.

13. "London's Tribute to Artist Russell," Great Falls (Mont.) *Daily Tribune*, May 20, 1914.

Exhibition Checklist

Cowboys on and off the Range

Breaking Camp, ca. 1885, oil on canvas, 22 × 39 inches, Amon Carter Museum, Fort Worth, Texas (1961.145)

The Tenderfoot [No. 1], 1900, oil on canvas, 14⅛ × 20⅛ inches, Sid Richardson Museum, Fort Worth, Texas (1947.1.0.73)

A Strenuous Life, 1901, oil on canvas, 24 × 36¼ inches, Gilcrease Museum, Tulsa, Oklahoma (0137.908)

The Broken Rope, 1904, oil on canvas, 24 × 36 inches, Petrie Collection, Denver, Colorado

Smoking Up, 1904, bronze, 13 × 7½ × 5 inches, Frederic G. and Ginger K. Renner Collection, Paradise Valley, Arizona

Jerked Down, 1907, oil on canvas, 22½ × 36½ inches, Gilcrease Museum, Tulsa, Oklahoma (0137.2246)

In Without Knocking, 1909, oil on canvas, 20⅛ × 29⅞ inches, Amon Carter Museum, Fort Worth, Texas (1961.201)

A Bronc Twister (*The Weaver*), 1911, bronze, 18⅛ × 14½ × 11¼ inches, Petrie Collection, Denver, Colorado

The Camp Cook's Troubles, 1912, oil on canvas, 29 × 43 inches, Gilcrease Museum, Tulsa, Oklahoma (0137.913)

When Horses Talk War There's Slim Chance for Truce, 1915, oil on canvas, 24½ × 36½ inches, Montana Historical Society, Helena, Mackay Collection (x1952.01.08)

Round-Up on the Musselshell, 1919, oil on canvas, 24 × 36 inches, William C. Foxley Collection, La Jolla, California

A Tight Dally and a Loose Latigo, 1920, oil on canvas, 30¼ × 48¼ inches, Amon Carter Museum, Fort Worth, Texas (1961.196)

A Bad One, 1920, oil on canvas, 24¼ × 35½ inches, Gilcrease Museum, Tulsa, Oklahoma (0137.910)

Outlaws and Lawmen

The Hold-Up, 1899, oil on canvas, 30 × 48 inches, Petrie Collection, Denver, Colorado

The Cinch Ring, 1909, oil on canvas, 24 × 36 inches, The Anschutz Collection, Denver, Colorado

When Horseflesh Comes High, 1909, oil on canvas, 24 × 36 inches, Petrie Collection, Denver, Colorado

Call of the Law, 1911, oil on canvas, 24 × 36 inches, National Cowboy & Western Heritage Museum, Oklahoma City, Oklahoma (1975.20.01)

Single-Handed, 1912, oil on canvas, 29⅞ × 32⅞ inches, Mr. and Mrs. William D. Weiss Collection, Jackson Hole, Wyoming

Innocent Allies, 1913, oil on canvas, 24 × 36 inches, Gilcrease Museum, Tulsa, Oklahoma (0137.2324)

Cultural Collision and Cooperation

Caught in the Act, 1888, oil on canvas, 20½ × 28¼ inches, Montana Historical Society, Helena, Mackay Collection (x1952.03.03)

Cowboy Bargaining for an Indian Girl, 1895, oil on canvas, 19⅛ × 28¼ inches, Hood Museum of Art, Dartmouth College, Hanover,

New Hampshire (P961.261), gift of J. Shirley Austin, Class of 1924

Caught in the Circle, 1903, oil on canvas, 24 × 36 inches, National Cowboy & Western Heritage Museum, Oklahoma City, Oklahoma (1975.020.09)

Jumped, 1914, oil on canvas, 29½ × 48 inches, William C. Foxley Collection, La Jolla, California

When Shadows Hint Death, 1915, oil on canvas, 30 × 40 inches, The Duquesne Club, Pittsburgh, Pennsylvania (Denver Art Museum only)

The Fireboat, 1918, oil on board, 15½ × 24½ inches, C. M. Russell Museum, Great Falls, Montana (956-2-1), gift from the Trigg Collection

The Lewis and Clark Expedition, 1918, oil on canvas, 30 × 47¾ inches, Gilcrease Museum, Tulsa, Oklahoma (0137.2267)

Salute to the Robe Trade, 1920, oil on canvas, 29½ × 47¼ inches, Gilcrease Museum, Tulsa, Oklahoma (0137.1625)

Native Peoples: Women and Domestic Life

The Silk Robe, ca. 1890, oil on canvas, 27⅝ × 39⅜ inches, Amon Carter Museum, Fort Worth, Texas (1961.135)

Indian Maid at Stockade, 1892, oil on canvas, 30 × 20 inches, JPMorgan Chase Art Collection, New York (23002)

Waiting and Mad, 1899, oil on board mounted on masonite, 11⅞ × 17¾ inches, Indianapolis Museum of Art, Indianapolis, Indiana (73.104.5), gift of the Harrison Eiteljorg Gallery of Western Art

Indian Hunters' Return, 1900, oil on canvas, 23¾ × 35½ inches, Montana Historical Society, Helena, Mackay Collection (x1954.02.01)

In the Wake of the Buffalo Runners, 1911, oil on canvas, 25½ × 35½ inches, Private Collection

Her Heart Is on the Ground, 1917, oil on canvas, 23¾ × 35¾ inches, Gilcrease Museum, Tulsa, Oklahoma (0137.907)

Native Peoples: Hunters and Warriors

The Buffalo Runners, ca. 1892, oil on canvas, 27⅝ × 39⅜ inches, Sid Richardson Museum, Fort Worth, Texas (1942.4.0.84)

Buffalo Hunt [No. 7], ca. 1895, oil on canvas, 21⅞ × 34⅜ inches, Petrie Collection, Denver, Colorado

The Buffalo Hunt [No. 29], 1900, oil on canvas, 48 × 72 inches, Gilcrease Museum, Tulsa, Oklahoma (0137.2243)

Counting Coup [No. 1], 1905, bronze, 11 × 17¾ × 12 inches, Gilcrease Museum, Tulsa, Oklahoma (0837.19)

Scalp Dance, 1905, bronze, 13½ × 9 × 6¾ inches, Petrie Collection, Denver, Colorado

The Medicine Man, 1908, oil on canvas, 30 × 48⅛ inches, Amon Carter Museum, Fort Worth, Texas (1961.171)

When Blackfeet and Sioux Meet, 1908, oil on canvas, 20½ × 29⅞ inches, Sid Richardson Museum, Fort Worth, Texas (1949.2.1.42)

Bringing Home the Spoils, 1909, oil on canvas, 15⅛ × 27¼ inches, Buffalo Bill Historical Center, Cody, Wyoming (19.10)

Assiniboine Warrior, 1913, wax, plaster, and paint, 10¼ × 5½ × 3⅛ inches, C. M. Russell Museum, Great Falls, Montana (953-1-37), gift from the Trigg Collection

The Scout, 1915, oil on canvas, 16¾ × 21½ inches, Petrie Collection, Denver, Colorado

Piegans, 1918, oil on canvas, 24 × 36 inches, Petrie Collection, Denver, Colorado

Buffalo Hunt [No. 39], 1919, oil on canvas, 30⅛ × 48⅛ inches, Amon Carter Museum, Fort Worth, Texas (1961.146)

The Enemy's Tracks, 1920, bronze, 12⅞ × 10½ × 5¾ inches, Amon Carter Museum, Fort Worth, Texas (1961.75)

In the Enemy's Country, ca. 1921, oil on canvas, 24 × 36 inches, Denver Art Museum, Denver, Colorado, gift of the Magness Family in memory of Betsy Magness (1991-751)

Meat for Wild Men, 1924, bronze, 11½ × 37⅝ × 20⅝ inches, Petrie Collection, Denver, Colorado

Secrets of the Night, 1926, bronze, 12⅛ × 6¾ × 5¾ inches, Gilcrease Museum, Tulsa, Oklahoma (0837.18)

Trappers and Hunters

Carson's Men, 1913, oil on canvas, 24 × 35½ inches, Gilcrease Museum, Tulsa, Oklahoma (0137.2245)

Crippled but Still Coming, 1913, oil on canvas, 30 × 48 inches, Eiteljorg Museum of American Indians and Western Art, Indianapolis, Indiana, The Gund Collection of Western Art, gift of the George Gund Family (2002.15.56)

Meat's Not Meat Till It's in the Pan, 1915, oil on canvas mounted on masonite, 23 × 35 inches, Gilcrease Museum, Tulsa, Oklahoma (0137.2244)

The Price of His Hide, 1915, oil on canvas, 23 × 35 inches, William C. Foxley Collection, La Jolla, California

Where Tracks Spell Meat, 1916, oil on canvas, 30⅜ × 48⅜ inches, Gilcrease Museum, Tulsa, Oklahoma (0137.914)

Jim Bridger, 1926, bronze, 14⅜ × 13 × 9¾ inches, Petrie Collection, Denver, Colorado

Wildlife and Wilderness

To the Victor Belong the Spoils, 1901, oil on canvas, 31½ × 44½ inches, National Museum of Wildlife Art, Jackson Hole, Wyoming, JKM Collection (J1987.126)

Ah Wah Cous (Antelope), 1911, wax, plaster, and paint, 7 × 6¾ × 4 inches, C. M. Russell Museum, Great Falls, Montana (970-3-1), gift of Frederic G. Renner

His Heart Sleeps, 1911, oil on canvas, 6⅞ × 11⅞ inches, Buffalo Bill Historical Center, Cody, Wyoming (89.60.1)

When the Land Belonged to God, 1914, oil on canvas, 42½ × 72 inches, Montana Historical Society, Helena (x1977.01.01)

The Buffalo Family, 1921, bronze, 6½ × 10⅜ × 5¾ inches, Gilcrease Museum, Tulsa, Oklahoma (0837.4)

The Spirit of Winter, 1926, bronze, 10⅛ × 10⅛ × 6½ inches, The Harry Ransom Humanities Research Center Art Collection, The University of Texas at Austin (Dobie 17)

"Charlie Himself"

A Dream of Burlington, 1880, graphite and watercolor on paper, 5 × 2¾ inches, Petrie Collection, Denver, Colorado

Wolves Attacking in a Blizzard, ca. 1890, watercolor on paper, 20 × 30 inches, National Cowboy & Western Heritage Museum, Oklahoma City, Oklahoma (1977.035) (The Museum of Fine Arts, Houston, only)

Self-Portrait, 1900, watercolor on paper, 12⅜ × 6⅞ inches, Buffalo Bill Historical Center, Cody, Wyoming (98.60), gift of the Charles Ulrick and Josephine Bay Foundation, Inc.

Friend Young Boy, March 1, 1902, ink and watercolor on paper, letter, 8½ × 11 inches, envelope, 3 9/16 × 6⅜ inches, Gilcrease Museum, Tulsa, Oklahoma (0237.1583)

Last of Five Thousand (Waiting for a Chinook), 1903, watercolor on paper, 20½ × 29 inches, Buffalo Bill Historical Center, Cody, Wyoming (88.60) (Denver Art Museum and Gilcrease Museum only)

When I Was A Kid, 1905, watercolor and gouache on paper, 14¼ × 11 inches, Frederic G. and Ginger K. Renner Collection, Paradise Valley, Arizona

I Savvy These Folks, 1907, pen and ink with watercolor on paper, 7½ × 12 inches, Gilcrease Museum, Tulsa, Oklahoma (0237.1585)

Friend Trigg [Albert J. Trigg], April 20, 1907, watercolor and pen and ink on paper, 6¹¹⁄₁₆ × 10¹¹⁄₁₆ inches, C. M. Russell Museum, Great Falls, Montana, Trigg Permanent Collection (953-1-53)

Friend Goodwin [Philip R. Goodwin], ca. January 1909, pen, ink, and watercolor on paper, 6½ × 10¹⁄₁₆ inches, Stark Museum of Art, Orange, Texas (11.106.19) (Denver Art Museum only)

The Trail is Long [Letter to Will Crawford], 1909, pen, ink, and watercolor on paper, 7¹³⁄₁₆ × 9¾ inches, Stark Museum of Art, Orange, Texas (11.106.27) (Gilcrease Museum only)

Letter to Friend Goowin [Philip R. Goodwin], 1910, pen, ink, and watercolor on paper, 7¾ × 10 inches, Stark Museum of Art, Orange, Texas (11.106.23) (The Museum of Fine Arts, Houston, only)

Friend Bill [William G. Krieghoff], May 4, 1914, pen, ink, and watercolor on paper, 6⅝ × 8⅞ inches, William C. Foxley Collection, La Jolla, California

Joshing Moon, 1918, oil on canvas, 8½ × 13½ inches, Petrie Collection, Denver, Colorado

C. M. Russell to E. C. "Teddy Blue" Abbott, May 13, 1919, watercolor and ink on paper, 10 × 17 inches, Eiteljorg Museum of American Indians and Western Art, Indianapolis, Indiana, The Gund Collection of Western Art, gift of the George Gund Family (2002.15.50)

The Horse Wrangler, ca. 1924, bronze, 13½ × 13⅛ × 7¾ inches, Petrie Collection, Denver, Colorado

Letter to Philip Cole, September 26, 1926, ink and watercolor on paper, 8½ × 11 inches, Gilcrease Museum, Tulsa, Oklahoma (0237.1583)

Bibliography

Archival Collections

Britzman, Helen E. and Homer E. Collection. Taylor Museum for Southwestern Studies of the Colorado Springs Fine Arts Center, Colorado Springs, Colorado.

De Yong, Joe. Collection. C. M. Russell Museum, Great Falls, Montana.

———. Papers. Joe De Yong/Richard J. Flood Collection. Donald C. and Elizabeth M. Dickinson Research Center, National Cowboy & Western Heritage Museum, Oklahoma City, Oklahoma.

Flood, Richard J. Permanent Collection. C. M. Russell Museum, Great Falls, Montana.

Linderman, Frank Bird, Memorial Collection. K. Ross Toole Archives. Maureen and Mike Mansfield Library, University of Montana, Missoula.

Rankin, James Brownlee, Research Collection. Montana Historical Society Archives, Helena.

Published Sources

Abbott, E. C., and Helen Huntington Smith. *We Pointed Them North: Recollections of a Cowpuncher.* 1939. Reprint, Norman: University of Oklahoma Press, 1955.

Acceptance of the Statue of Charles M. Russell Presented by the State of Montana: Proceedings in the Congress and in the Rotunda, United States Capitol. Washington, D.C.: U.S. Government Printing Office, 1959.

Adams, Andy. *The Log of a Cowboy: A Narrative of the Old Trail Days.* 1903. Reprint, with a foreword by Elmer Kelton. Lincoln: University of Nebraska Press, 1964.

Adams, Ramon F. *Cowboy Lingo: A Dictionary of the Slack-Jaw Words and Whangdoodle Ways of the American West.* 1936. Reprint, New York: Houghton Mifflin, 2000.

———, and Homer E. Britzman. *Charles M. Russell, the Cowboy Artist: A Biography.* 3rd ed. Pasadena, Calif.: Trail's End Publishing Co., 1957.

Allen, Douglas, and Douglas Allen, Jr. *N. C. Wyeth: The Collected Paintings, Illustrations & Murals.* New York: Crown Publishers, 1972. Reprint, Avenel, N.J.: Wings Books, 1996.

Allen, Frederick. *A Decent Orderly Lynching: The Montana Vigilantes.* Norman: University of Oklahoma Press, 2004.

Allen, Gene, and Bev Allen. "L. A. Huffman: Photographer of the West." *Montana The Magazine of Western History* 54 (Spring 2004): 76–77.

Archibald, Robert. "C. M. Russell and Montana: The End of the Frontier." In *Charles M. Russell: American Artist,* edited by Janice K. Broderick, 36–43. St. Louis: Jefferson National Expansion Historical Association, 1982.

Back-Trailing on the Old Frontiers. Illustrated by Charles M. Russell. Great Falls, Mont.: Cheely-Raban Syndicate, 1922.

Barbour, Daphne S. "Degas's Wax Sculpture from the Inside Out." *The Burlington Magazine,* December 1992, 798–805.

Barsness, Larry. *The Bison in Art: A Graphic Chronicle of the American Bison.* Fort Worth, Tex.: The Amon Carter Museum of Western Art / Northland Press, 1977.

———. *Heads, Hides & Horns: The Compleat Buffalo Book.* Fort Worth, Tex.: Texas Christian University Press, 1985.

Barton, Fred. *Charles M. Russell: An Old-Time Cowman Discusses the Life of Charles M. Russell.* Los Angeles: Fred Barton, n.d. [1961].

Baumler, Ellen. "Up in Smoke." In *More from the Quarries of Last Chance Gulch,* 2:144–47. Helena, Mont.: Helena Independent Record, 1996.

Beerbohm, Robert Lee, Richard Samuel West, and Richard D. Olson. "Origins of Early American Comic Strips before the Yellow Kid." In *Official Overstreet Comic Book Price Guide,* no. 38, edited by Robert

M. Overstreet, 330–50. New York: Gemstone Publishing, 2008.

Blevins, Win. *Dictionary of the American West.* Seattle: Sasquatch Books, 2001.

Bollinger, James W. *Old Montana and Her Cowboy Artist: A Paper Read before the Contemporary Club, Davenport, Iowa, January Thirtieth, Nineteen Hundred Fifty.* Shenandoah, Iowa: World Publishing Co., 1963.

Bower, B. M. *Chip of the Flying U.* New York: G. W. Dillingham, 1906. Reprinted with an introduction by Mary Clearman Blew. Lincoln: University of Nebraska Press, 1995.

Broderick, Janice K. "Charles Marion Russell and St. Louis." In *Charles M. Russell: American Artist,* edited by Janice K. Broderick, 12–19. St. Louis: Jefferson National Expansion Historical Association, 1982.

———, ed. *Charles M. Russell: American Artist.* St. Louis: Jefferson National Expansion Historical Association, 1982.

Bruce, Chris. "Charles Russell's Home Turf." In *Myth of the West,* edited by Chris Bruce, 125–37. Seattle: Henry Art Gallery, University of Washington, 1990.

Brunvand, Jan Harold. "From Western Folklore to Fiction in the Stories of Charles M. Russell." *Western Review* 5 (Summer 1968): 41–49.

Burnham, Patricia M. "Lewis and Clark at Ross's Hole: The Story behind Charles M. Russell's 1912 Painting." *We Proceeded On: The Journal of the National Lewis and Clark Trail Heritage Foundation* 26 (2000): 18–25.

———. "The Paintings." In *Montana's State Capitol: The People's House,* edited by Kirby Lambert, Patricia N. Burnham, and Susan M. Near. Helena: Montana Historical Society Press, 32–75.

Busch, Jason T., Christopher Monkhouse, and Janet L. Whitmore, eds. *Currents of Change: Art and Life Along the Mississippi River 1850–1861.* Minneapolis: Minneapolis Institute of Arts, 2004.

Cadbury, Warder H. "Alfred Jacob Miller's Chromolithographs." In *Alfred Jacob Miller: Artist on the Oregon Trail,* edited by Ron Tyler, 447–49. Fort Worth, Tex.: Amon Carter Museum, 1982.

Campbell, Suzan. *Out of the West: The Gund Collection of Western Art.* Indianapolis: Eiteljorg Museum of American Indians and Western Art, 2005.

Cardozo, Christopher, ed. *Sacred Legacy: Edward S. Curtis and the North American Indian.* New York: Simon and Schuster, 2000.

Carter, Harvey L. *Dear Old Kit: The Historical Christopher Carson, with a New Edition of the Carson Memoirs.* Norman: University of Oklahoma Press, 1968.

Catlin, George. *Letters and Notes on the Manners, Customs, and Conditions of the North American Indians.* London: privately published, 1841. Reprint, New York: Dover Publications, 1973.

"Caught in the Act." *Harper's Weekly,* May 12, 1888, 340.

Cave, Edward. "Recreation Men IV—C. M. Russell, the Cowboy Artist." *Recreation,* July 1917, 11–13.

Clayton, Lawrence, Jim Hoy, and Jerald Underwood. *Vaqueros, Cowboys, and Buckaroos.* Austin: University of Texas Press, 2001.

Cobb, Irvin S. *Exit Laughing.* Garden City, N.Y.: Garden City Publishing, 1942.

Coburn, Wallace D. *Rhymes from a Round-up Camp.* Great Falls, Mont.: W. T. Ridgley Printing, 1899.

[Cody, William F.] *The Life of Hon. William F. Cody, Known as Buffalo Bill, the Famous Hunter, Scout, and Guide: An Autobiography.* Hartford, Conn.: Frank E. Bliss, 1879. Reprinted with a foreword by Don Russell. Lincoln: University of Nebraska Press, 1978.

Coen, Ester. *Umberto Boccioni.* New York: The Metropolitan Museum of Art, 1988.

Collingwood, R. G. *The Principles of Art.* New York: Oxford University Press, 1958.

Collins, Reba. *Will Rogers: Courtship and Correspondence, 1900–1915.* Oklahoma City: Neighbors and Quaid, 1992.

Constitution, Rules, Officers and Members of the Montana Club, of Helena, Montana. Helena, Mont.: Montana Club, 1890.

Cooper, Walter. *A Most Desperate Situation: Frontier Adventures of a Young Scout, 1858–1864.* Edited by Rick Newby, with an introduction and afterword by Larry Len Peterson. Helena, Mont.: Falcon Publishing, 2000.

Craze, Sophia. *Charles Russell.* New York: Knickerbocker Press, 1998.

Cristy, Raphael. *Charles M. Russell: The Storyteller's Art.* Albuquerque: University of New Mexico Press, 2004.

———. "Charlie's Hidden Agenda: Realism and Nostalgia in C. M. Russell's Stories about Indians." *Montana The Magazine of Western History* 43 (Summer 1993): 2–15.

———. "Finding Modern Times in Charlie's Published Writings." In *Charles M. Russell: A Catalogue Raisonné,* edited by B. Byron Price, 141–71. Norman: University of Oklahoma Press, 2007.

Cutler, Laurence S., Judy Goffman Cutler, and the National Museum of American Illustration. *Maxfield Parrish and the American Imagists.* Edison, N.J.: Wellfleet Press, 2004.

Davis, Barbara A. *Edward S. Curtis: The Life and Times of a Shadow Catcher.* San Francisco: Chronicle Books, 1985.

Dear, Elizabeth A. *C. M. Russell's Log Studio.* Great Falls, Mont.: C. M. Russell Museum, 1995.

———. *The Grand Expedition of Lewis and Clark as Seen by C. M. Russell.* Great Falls, Mont.: C. M. Russell Museum, 2000.

Deloria, Philip J. *Playing Indian*. New Haven, Conn.: Yale University Press, 1998.

Dempsey, Hugh A. "Tracking C. M. Russell in Canada, 1888–1889." In *Charlie Russell Roundup: Essays on America's Favorite Cowboy Artist*, edited by Brian W. Dippie, 221–38. Helena, Mont.: Montana Historical Society Press, 1999.

Dentzel, Carl S. "The Roots of Russell: The Earliest Known Frontier Sketches of Charles Marion Russell." In *Westerners Brand Book* no. 14, 103–121. Los Angeles: Westerners Los Angeles Corral, 1974.

Devore, Paul T. "Saloon Entrepreneurs of Russell's Art and the Pilgrimage of One Collection." *Montana The Magazine of Western History* 27 (Autumn 1977): 24–53.

Dippie, Brian W. *Charles M. Russell and the Art of Counting Coup*. Fort Worth, Tex.: Sid Richardson Museum, 2008.

———. "Charles M. Russell and the Canadian West." In "Capturing Western Legends: Russell and Remington on the Canadian Frontier," edited by Lorain Lounsberry. *Alberta History* 52 (Spring 2004): 4–26.

———, ed. *Charles M. Russell, Word Painter: Letters 1887–1926*. Fort Worth, Tex.: Amon Carter Museum, 1993.

———, ed. *Charlie Russell Roundup: Essays on America's Favorite Cowboy Artist*. Helena, Mont.: Montana Historical Society Press, 1999.

———. "Charlie Russell's Lost West." *American Heritage* 24 (April 1973): 4–21, 89.

———. "'Flying Buffaloes': Artists and the Buffalo Hunt." *Montana The Magazine of Western History* 51 (Summer 2001): 2–19.

———. *From Frog Lake to Saskatoon: Charlie Russell's Canadian Connections*. The Whelen Lecture, University of Saskatchewan, Saskatoon, 2006.

———. "'. . . I Feel That I Am Improving Right Along': Continuity and Change in Charles M. Russell's Art." *Montana The Magazine of Western History* 38 (Summer 1988): 40–57.

———. "In the Enemy's Country: Western Art's Uneasy Status." In *Western Passages*, edited by Peter Hassrick, 14–27. Denver, Colo.: Denver Art Museum, 2007.

———. "'It Is a Real Business': The Shaping and Selling of Charles M. Russell's Art." In *Charles M. Russell: A Catalogue Raisonné*, edited by B. Byron Price, 1–67. Norman: University of Oklahoma Press, 2007.

———. "'I Want It Real Bad': The Charles M. Russell–Malcolm Mackay Collaboration." *Montana The Magazine of Western History* 54 (Summer 2004): 32–55.

———. *Looking at Russell*. Fort Worth, Tex.: Amon Carter Museum, 1987.

———. "One West, One Myth: Transborder Continuity in Western Art." *The American Review of Canadian Studies* 33 (Winter 2003): 509–41.

———, ed. *"Paper Talk": Charlie Russell's American West*. New York: Alfred A. Knopf / Amon Carter Museum, 1979.

———. *Remington and Russell: The Sid Richardson Collection*. Rev. ed. Austin: University of Texas Press, 1994.

———. "Two Artists from St. Louis: The Wimar-Russell Connection." In *Charles M. Russell: American Artist*, edited by Janice K. Broderick, 20–35. St. Louis: Jefferson National Expansion Historical Association, 1982.

———. *The Vanishing American: White Attitudes and U.S. Indian Policy*. Lawrence: University Press of Kansas, 1982.

———. "Western Art Don't Get No Respect: A Fifty-Year Perspective." *Montana The Magazine of Western History* 51 (Winter 2001): 68–71.

Dobie, J. Frank. "Charles M. Russell." In *An Exhibition of Paintings and Bronzes by Frederic Remington [and] Charles M. Russell*, n.p. Tulsa, Okla.: Thomas Gilcrease Foundation, 1950.

Dryfhout, John. *The Work of Augustus Saint-Gaudens*. Hanover, N.H.: University Press of New England, 1982.

Dunlay, Tom. *Kit Carson and the Indians*. Lincoln: University of Nebraska Press, 2000.

Edelstein, Debra, ed. *American Traditions: Art from the Collections of Culver Alumni*. Indianapolis: Indianapolis Museum of Art, 1993.

Edwards, Holly. *Noble Dreams, Wicked Pleasures: Orientalism in America, 1870–1930*. Princeton, N.J.: Princeton University Press / Sterling and Francine Clark Art Institute, 2000.

Egan, Shannon. "'Yet in a Primitive Condition': Edward S. Curtis's North American Indian." *American Art* 20, no. 3 (Fall 2006): 58–83.

Egerton, Judy. *Wright of Derby*. London: Tate Gallery Publications, 1990.

Eidelberg, Martin, Nina Gray, and Margaret K. Hofer. *A New Light on Tiffany: Clara Driscoll and the Tiffany Girls*. New York: New-York Historical Society / D Giles Limited, 2007.

Eisner, Will. *Comics and Sequential Art*. Tamarac, Fla.: Poorhouse Press, 2005.

Elofson, Warren M. *Frontier Cattle Ranching in the Land and Times of Charlie Russell*. Seattle: University of Washington Press, 2004.

The Estelle Doheny Collection from the Edward Laurence Doheny Memorial Library. New York: Christie, Manson & Woods International, 1988.

Ewers, John C. *Artists of the Old West*. New York: Promontory Press, 1982.

———. *The Blackfeet: Raiders on the Northwestern Plains*. Norman: University of Oklahoma Press, 1958.

Ewers, John C. "Charlie Russell's Indians." *Montana The Magazine of Western History* 37 (Summer 1987): 36–53.

Exhibition of the Works of the Italian Futur-

ist Painters and Sculptors. London: Doré Gallery, 1913.

Fifty Years, Fifty Favorites from the C. M. Russell Museum. Great Falls, Mont.: C. M. Russell Museum, 2003.

Forrest, James T. *Bill Gollings: The Man and His Art.* Fort Worth, Tex.: Amon Carter Museum / Northland Press, 1979.

——. "Robert Ottokar Lindneux: Last of Cowboy Artists." *Great Plains Journal* 6 (Fall 1999): 32–35.

Frost, Lawrence A. *The Custer Album: A Pictorial Biography of General George A. Custer.* Seattle: Superior Publishing Company, 1964. Reprint, Norman: University of Oklahoma Press, 1990.

Gale, Robert L. *Charles Marion Russell.* Western Writers Series 38. Boise, Idaho: Boise State University, 1979.

Garcia, Andrew. *Tough Trip through Paradise 1878–1879.* Edited by Bennett H. Stein. Boston: Houghton Mifflin, 1967. Reprint, Moscow: University of Idaho Press, 2001.

Gelo, Daniel J. "The Bear." In *American Wildlife in Symbol and Story,* edited by Angus K. Gillespie and Jay Mechling, 133–62. Knoxville: University of Tennessee Press, 1987.

Gidley, Mick. *Edward S. Curtis and the North American Indian, Incorporated.* Cambridge: Cambridge University Press, 1998.

Gilbert, Alma M. *Maxfield Parrish: Master of Make-Believe.* Washington, D.C.: Trust for Museum Exhibitions, 2005.

Girouard, Mark. *The Return to Camelot: Chivalry and the English Gentleman.* New Haven, Conn.: Yale University Press, 1981.

Gneiting, Teona Tone. "Literature and Art for the Masses: The Dime Novel." In *The American Personality: The Artist-Illustrator of Life in the United States, 1860–1930,* edited by E. Maurice Bloch, 23–26. Los Angeles: Grunwald Center for the Graphic Arts, University of California at Los Angeles, 1976.

Goetzmann, William N. "The Arcadian Landscapes of Edward Sheriff Curtis." In *Perpetual Mirage: The Arid West in Photographic Books and Prints,* edited by May Castleberry, 83–91. New York: Whitney Museum of American Art, 1996.

Grafe, Steven L., Susan Hallsten McGarry, Charles E. Rand, Richard C. Rattenbury, and Donald W. Reeves. *A Western Legacy: The National Cowboy & Western Heritage Museum.* Norman: University of Oklahoma Press, 2005.

Graulich, Melody. "Monopolizing *The Virginian* (or, Railroading Wister)." *Montana The Magazine of Western History* 56 (Spring 2006): 30–41.

Graybill, Florence Curtis, and Victor Boesen. *Edward Sheriff Curtis: Visions of a Vanishing Race.* New York: Thomas Y. Crowell and Company, 1976.

Hajic, Maria, comp. *National Wildlife Art Museum.* Jackson Hole, Wyo.: National Wildlife Art Museum, 1992.

Hammer, Victor J. *Charles M. Russell Centennial Exhibition 1864–1964.* New York: Hammer Galleries, 1964.

——. *The Works of Charles M. Russell and Other Western Artists.* New York: Hammer Galleries, 1962.

Hanson, Anne Coffin. *Severini futurista: 1912–1917.* New Haven, Conn.: Yale University Art Gallery, 1995.

Harvey, Robert C. *Children of the Yellow Kid: The Evolution of the American Comic Strip.* Seattle: Frye Art Museum / University of Washington Press, 1998.

Hassrick, Peter H. *Charles M. Russell.* New York: Harry N. Abrams, 1989. Reprint, Norman: University of Oklahoma Press, 1999.

——. "Charles Russell, Painter." In *Charles M. Russell: A Catalogue Raisonné,* edited by B. Byron Price, 69–111. Norman: University of Oklahoma Press, 2007.

——. *Remington, Russell, and the Language of Western Art.* Washington, D.C.: Trust for Museum Exhibitions, 2000.

——. *Treasures of the Old West: Paintings and Sculpture from the Thomas Gilcrease Institute of American History and Art.* New York: Harry N. Abrams, 1984.

——, Brian W. Dippie, Rudolf Wunderlich, Gerald Peters, and Kellie Keto. *Charles M. Russell: The Artist in His Heyday, 1903–1926.* Santa Fe: Gerald Peters Gallery / Mongerson-Wunderlich, 1995.

Helena Illustrated: Montana's Capital, the Queen City of the Mountains. Helena, Mont.: 1889.

History of the Expedition under the Command of Lewis and Clark. 2 vols. Edited by Nicholas Biddle. Philadelphia: 1814. Reprinted in 4 vols. with annotations by Elliott Coues. New York: Harper, 1893. Reprinted in 3 vols., New York: Dover Books, 1964.

Hoeber, Arthur. "The Painter of the West That Has Passed." *The World's Work,* July 1911, 14626–35.

[Hoeber, Arthur]. "Cowboy Vividly Paints the Passing Life of the Plains." *The New York Times Magazine,* March 19, 1911, n.p.

Hogue, Michel. "Disputing the Medicine Line: The Plains Crees and the Canadian-American Border, 1876–1885." *Montana The Magazine of Western History* 52 (Winter 2002): 2–17.

Honour, Hugh. *The European Vision of America.* Cleveland, Ohio: The Cleveland Museum of Art, 1975.

Hough, Emerson. *The Story of the Cowboy.* 1897. Reprint, New York: D. Appleton and Company, 1914.

——. *The Story of the Outlaw: A Study of the Western Desperado.* New York: Grosset & Dunlap, 1905.

——. "Wild West Faking." *Collier's Weekly,* December 19, 1908, 18–19, 22.

Jennings, Kate F. *N. C. Wyeth.* Avenel, N.J.: Crescent Books, 1992.

Johnston, Jeremy. "A Wilderness Hunter in the White House: Theodore Roosevelt, the Western Sportsman." *Colorado Heritage* (Autumn 2005): 2–13.

Joyner, J. Brooks. *Legends of the West: The Foxley Collection.* Omaha, Neb.: Joslyn Art Museum, 2007.

——. "The Remarkable Collection of Dr. Philip G. Cole and How It Came to Gilcrease." *Gilcrease Journal* 9 (Summer 2001): 34–49.

Ke Mo Ha [Pat Patterson]. *Woolaroc Museum.* Bartlesville, Okla.: Frank Phillips Foundation, 1965.

Ketchum, William C., Jr. *Remington and Russell: Artists of the West.* New York: Todtri, 1997.

Kidder, John. "Montana Miracle: It Saved the Buffalo." *Montana The Magazine of Western History* 15 (April 1965): 52–67.

Lambert, Kirby. "Montana's Last Best Chance: The Malcolm S. Mackay Collection of Charles M. Russell Art." *Montana The Magazine of Western History* 54 (Summer 2004): 56–63.

——, Patricia M. Burnham, and Susan M. Near. *Montana's State Capitol: The People's House.* Helena, Mont.: Montana Historical Society Press, 2002.

Lawton, Rebecca E., with Patricia Junker, Barbara McCandless, Jane Myers, John Rohrbach, and Rick Stewart. *An American Album: Highlights from the Collection of the Amon Carter Museum.* Fort Worth, Tex.: Amon Carter Museum, 2005.

Le Beau, Bryan F. *Currier & Ives: America Imagined.* Washington, D.C.: Smithsonian Institution Press, 2001.

Lepley, John G. *Blackfoot Fur Trade on the Upper Missouri.* Missoula, Mont.: Pictorial Histories Publishing, 2004.

Linderman, Frank Bird. *Montana Adventure: The Recollections of Frank B. Linderman.* Edited by H. G. Merriam. Lincoln: University of Nebraska Press, 1968.

——. *Recollections of Charley Russell.* Edited and with an introduction by H. G. Merriam. Norman: University of Oklahoma Press, 1963.

Lopez, Barry. "Out West." In *The Modern West: American Landscapes, 1890–1950,* by Emily Ballew Neff, with an essay by Barry Lopez, 1–9. New Haven, Conn.: Yale University Press / The Museum of Fine Arts, Houston, 2006.

Lounsberry, Lorain, ed. "Capturing Western Legends: Russell and Remington and the Canadian Frontier." Special issue, *Alberta History* 52 (Spring 2004).

Mac, 'Tana. "The Heritage of Charlie Russell." *True West,* May-June 1963, 6–11.

MacTavish, Newton. "The Last Great Round-Up. Article II." *The Canadian Magazine* 34 (November 1909): 25–35.

Marzio, Peter C. *The Democratic Art: An Exhibition on the History of Chromolithography in America, 1840–1900.* Fort Worth, Tex.: Amon Carter Museum, 1979.

McCracken, Harold. *The Charles M. Russell Book.* Garden City, N.Y.: Doubleday and Company, 1957.

McHugh, Tom. *The Time of the Buffalo.* New York: Alfred A. Knopf, 1972. Reprint, Edison, N.J.: Castle Books, 2004.

Miller, D. Allen, comp. *Helena City Directory, 1886–7.* Helena, Mont.: George E. Boos, 1886.

Mills, Enos A. *The Grizzly: Our Greatest Wild Animal.* 1919. Reprint, with an afterword by R. L. Grosvenor. Sausalito, Calif.: Comstock Books, 1973.

Milner, Clyde A., II, and Carol A. O'Connor. *As Big as the West: The Pioneer Life of Granville Stuart.* Oxford and New York: Oxford University Press, 2009.

The Mint Collection Comes Home. Great Falls, Mont.: C. M. Russell Museum Complex, 1989.

Moulton, Gary, ed. *The Journals of the Lewis and Clark Expedition.* 13 vols.

Lincoln: University of Nebraska Press, 1983–2001.

Myers, Rex C. "The Montana Club: Symbol of Elegance." *Montana The Magazine of Western History* 26 (Autumn 1976): 30–51.

Naylor, Maria, and Geoffrey Gund. *The Gund Collection of Western Art: A History and Pictorial Description of the American West.* Cleveland, Ohio: Gund Collection of Western Art, 1980.

Neff, Emily Ballew. "The End of the Frontier: Making the West Artistic." In *The Modern West: American Landscapes, 1890–1950,* by Emily Ballew Neff, 50–95. New Haven, Conn.: Yale University Press / The Museum of Fine Arts, Houston, 2006.

Nemerov, Alex. "Doing the 'Old America'": The Image of the American West, 1880–1920." In *The West as America: Reinterpreting Images of the Frontier,* edited by William H. Truettner, 285–343. Washington, D.C.: Smithsonian Institution Press, 1991.

"The Nicholas Biddle–William Clark Notes, April 1810." In *The Letters of the Lewis and Clark Expedition with Related Documents 1783–1854,* edited by Donald Jackson. 2nd ed. Vol. 2, 497–545. Urbana: University of Illinois Press, 1978.

Paladin, Vivian A. *C. M. Russell: The Mackay Collection.* Helena, Mont.: Montana Historical Society, 1979.

——. "*Looking at Russell* by Brian W. Dippie." *Western Historical Quarterly* 20 (February 1989): 68.

Parkman, Francis, Jr. *The Oregon Trail.* 1849. Reprint, edited and with an introduction by David Levin. New York: Penguin Books, 1982.

Paxson, William Edgar, Jr. *E. S. Paxson: Frontier Artist.* Boulder, Colo.: Pruett Publishing, 1984.

Penny, Nicholas. *The Materials of Sculpture.* New Haven, Conn.: Yale University Press, 1993.

Peterson, Larry Len. *Charles M. Russell:*

Legacy. Helena, Mont.: Falcon Publishing / C. M. Russell Museum, 1999.

——. *Charles M. Russell: Printed Rarities from Private Collections.* Missoula, Mont.: Mountain Press Publishing Company, 2008.

——. "The Footrace: From the Adventures of Walter Cooper." *Montana The Magazine of Western History* 50 (Summer 2000): 50–62.

——. *L. A. Huffman: Photographer of the American West.* 2nd ed. Missoula, Mont.: Mountain Press Publishing Company, 2005.

——. "Painting the Town: C. M. Russell's 47th Lifetime Cast." *Russell's West* 4, no. 1 (1996): 5–9.

——. *Philip R. Goodwin, America's Sporting & Wildlife Artist.* Foreword by Brian W. Dippie. Missoula, Mont.: Mountain Press Publishing Company, 2007.

——. *Philip R. Goodwin: America's Sporting & Wildlife Artist.* Hayden, Idaho: Coeur d'Alene Art Auction, with Settlers West Galleries, 2001.

Price, B. Byron, ed. *Charles M. Russell: A Catalogue Raisonné.* Norman: University of Oklahoma Press, 2007.

——. "Charles M. Russell: Icon of the Old West," in B. Byron Price, ed., *Charles M. Russell: A Catalogue Raisonné.* Norman: University of Oklahoma Press, 2007, 195–221.

Quimby, George I. *Indians of the Western Frontier: Paintings of George Catlin.* Chicago: Chicago Natural History Museum, 1954.

Rathbone, Perry T. *Charles Wimar 1828–1862: Painter of the Indian Frontier.* St. Louis: City Art Museum, 1946.

Rattenbury, Richard C. *The Art of American Arms Makers: Marketing Guns, Ammunition and Western Adventure During the Golden Age of Illustration.* Oklahoma City:

National Cowboy & Western Heritage Museum, 2004.

Reiger, John R. *American Sportsmen and the Origins of Conservation.* Rev. ed. Norman: University of Oklahoma Press, 1986.

Remington, Frederic. *Pony Tracks.* 1895. New edition with a preface by J. Frank Dobie. Norman: University of Oklahoma Press, 1961.

Renner, Frederic G. *Charles M. Russell (1864–1926): Paintings, Drawings, and Sculpture in the Collection of the R. W. Norton Art Gallery.* Shreveport, La.: R. W. Norton Art Foundation, 1979.

——. *Charles M. Russell: Paintings, Drawings, and Sculpture in the Amon Carter Museum.* Rev. ed. New York: Harry N. Abrams, 1974. Reprint, New York: Harry N. Abrams, 1984.

——. *Charles Marion Russell, Greatest of All Western Artists.* Washington, D.C.: Westerners Potomac Corral, 1968.

Renner, Ginger K. *A Limitless Sky: The Work of Charles M. Russell in the Collection of the Rockwell Museum, Corning, New York.* Foreword by Robert F. Rockwell. Flagstaff, Ariz.: Northland Press, 1986.

——. *Charles M. Russell: The Frederic G. Renner Collection.* Preface by James K. Ballinger. Phoenix: Phoenix Art Museum, 1981.

——. "Charlie and the Ladies in His Life." In *Charlie Russell Roundup: Essays on America's Favorite Cowboy Artist,* edited by Brian W. Dippie, 133–53. Helena, Mont.: Montana Historical Society Press, 1999.

——. "Frederic G. Renner: On the Trail of Charlie Russell." In *Charles M. Russell: A Catalogue Raisonné,* edited by B. Byron Price, 173–93. Norman: University of Oklahoma Press, 2007.

Roberts, David. *A Newer World: Kit Carson, John C. Frémont, and the Claiming of the*

American West. New York: Simon and Schuster, 2001.

Rogers, Will. *The Papers of Will Rogers.* Vol. 2, *Wild West and Vaudeville: April 1904–September 1908.* Edited by Arthur Frank Wertheim and Barbara Bair. Norman: University of Oklahoma Press, 2000.

Rollins, Philip Ashton. *The Cowboy: An Unconventional History of Civilization on the Old Time Cattle Range.* 1922. Revised and enlarged edition, with a foreword by Richard W. Slatta. Norman: University of Oklahoma Press, 1997.

Roosevelt, Theodore. *Ranch Life and the Hunting Trail.* 1888. New York: Century, 1901. Reprint, Lincoln: University of Nebraska Press, 1983.

Russell, Austin. *C. M. R.: Charles M. Russell, Cowboy Artist, a Biography.* New York: Twayne Publishers, 1957.

Russell, Charles M. *Good Medicine: The Illustrated Letters of Charles M. Russell.* Introduction by Will Rogers and biographical note by Nancy C. Russell. Garden City, N.Y.: Doubleday, Doran, 1929.

——. *More Rawhides.* Great Falls, Mont.: Montana Newspaper Association, 1925.

——. *Pen Sketches.* Great Falls, Mont.: W. T. Ridgley, 1899.

——. *Rawhide Rawlins Rides Again, or Behind the Swinging Doors: A Collection of Charlie Russell's Favorite Stories.* Edited by Homer Britzman. Pasadena, Calif.: Trail's End Publishing, 1948.

——. *Trails Plowed Under.* Garden City, N.Y.: Doubleday, Page & Company, 1927. Reprinted with an introduction by Brian W. Dippie. Lincoln: University of Nebraska Press, 1996.

Russell, Nancy C. *Charlie Russell Rides Again.* Lexington, Ky.: Blue Grass Book Shop, 1949.

Russolo, Luigi. *L'Arte dei rumori.* Milan: 1916.

Ruud, Brandon K., ed. *Karl Bodmer's North American Prints.* Omaha, Nebr: Joslyn Art Museum/University of Nebraska Press, 2004.

Sandberg, Mark B. *Living Pictures, Missing Persons: Mannequins, Museums, and Modernity.* Princeton, N.J.: Princeton University Press, 2003.

Scott, Walter. *Ivanhoe.* 1819. Edited and with an introduction by Graham Tulloch. New York: Penguin Books, 2000.

———. *Rob Roy.* 1817. Reprint, New York: Penguin Books, 1995.

Second Annual Report of the Secretary of the Helena Board of Trade for the Year 1879. Helena, Mont.: Woolfolk, MacQuaid & Lacroix, *Daily* and *Weekly Independent,* 1880.

Sharp, Paul F. *Whoop-Up Country: The Canadian-American West, 1865–1885.* Minneapolis: University of Minnesota Press, 1955. Reprint, Helena, Mont.: Historical Society of Montana, 1960.

Sides, Hampton. *Blood and Thunder: An Epic of the American West.* New York: Doubleday, 2006.

Silliman, Lee. "The Cowboy on Canvas." *Montana The Magazine of Western History* 21 (Winter 1971): 40–49.

Silva, Lee A., and Susan Silva. "Charlie Russell's Last Legacy." *Wild West,* December 2005, 38–45.

Slatta, Richard W. *Cowboys of the Americas.* New Haven, Conn.: Yale University Press, 1990.

Slotkin, Richard. *Gunfighter Nation: The Myth of the Frontier in Twentieth-Century America.* New York: Harper Perennial, 1993.

Steele, Ray W., and Pam Yascavage. *The C. M. Russell Museum Permanent Collection Catalogue.* Great Falls, Mont.: C. M. Russell Museum, 1989.

Stewart, Rick. *Charles M. Russell, Sculptor.* Fort Worth, Tex.: Amon Carter Museum, 1994.

———. *The Grand Frontier: Remington and Russell in the Amon Carter Museum.* Fort Worth, Tex.: Amon Carter Museum, 2001.

———. "Modeling in Clay, Plaster, and Wax: The Wellspring of Russell's Art." In *Charles M. Russell: A Catalogue Raisonné,* edited by B. Byron Price, 113–39. Norman: University of Oklahoma Press, 2007.

Stuart, Granville. *Forty Years on the Frontier.* 1925. Edited by Paul C. Phillips and with an introduction by Clyde A. Milner II and Carol A. O'Connor. Lincoln: University of Nebraska Press, 1977.

Taft, Robert. *Artists and Illustrators of the Old West 1850–1900.* Princeton, N.J.: Princeton University Press, 1953.

Taliaferro, John. "Charles M. Russell and 'Piano Jim.'" *Montana The Magazine of Western History* 45 (Spring 1995): 56–63.

———. *Charles M. Russell: The Life and Legend of America's Cowboy Artist.* Boston: Little, Brown, 1996. Reprint, Norman: University of Oklahoma Press, 2003.

Tottis, James W., Valerie Ann Leeds, Vincent DeGirolamo, Marianne Doezema, and Suzanne Smeaton. *Life's Pleasures: The Ashcan Artists' Brush with Leisure, 1895–1925.* With contributions from Michael E. Crane and Kirsten Olds. Detroit: Detroit Institute of Arts / Merrell Publishers Limited, 2007.

Townsend, John Wilson. *Piano Jim and the Impotent Pumpkin Vine; or "Charley Russell's Best Story—to My Way of Thinking."* Lexington, Ky.: Blue Grass Book Shop, 1947.

"The Treasures of Gilcrease." Double special issue, *American Scene* 3, nos. 28–29 (1978).

Tyler, Ron. "Alfred Jacob Miller's Western Prints." In *Prints of the American West: Papers Presented at the Ninth Annual North American Print Conference,* edited by Ron Tyler, 56–66. Fort Worth, Tex.: Amon Carter Museum, 1983.

Warden, R. D. *C. M. Russell Boyhood Sketchbook.* Introduction by Frederic G. Renner. Bozeman, Mont.: Treasure Products, 1972.

Warren, Louis S. *Buffalo Bill's America: William Cody and the Wild West Show.* New York: Alfred A. Knopf, 2005.

White, G. Edward. *The Eastern Establishment and the Western Experience: The West of Frederic Remington, Theodore Roosevelt, and Owen Wister.* Austin: University of Texas Press, 1989.

Wilson, Kathryne. "An Artist of the Plains." *Pacific Monthly,* December 1904, 339–44.

Wister, Owen. "The Evolution of the Cow-Puncher." *Harper's Monthly,* September 1895, 602–17. Reprint, Owen Wister, *Red Men and White.* New York: MacMillan, 1928. Reprint, edited and with an introduction by Robert Murray Davis, *Owen Wister's West: Selected Articles,* edited by Robert Murray Davis, 34–53. Albuquerque: University of New Mexico Press, 1987.

———. *The Virginian, a Horseman of the Plains.* 1902. Reprinted with an introduction and notes by John Seelye. New York: Penguin Books, 1988.

Woodcock, Lyle S. "The St. Louis Heritage of Charles Marion Russell." *Gateway Heritage,* Spring 1982, 2–15.

The Works of C. M. Russell, Artist of the Old West: Paintings, Drawings, and Sculptures on Display in Helena, Montana, Mackay Collection. Kansas City, Mo.: McGrew Color Graphics, n.d.

Worswick, Clark. *Edward Sheriff Curtis: The Master Prints.* Santa Fe: Arena Editions, 2001.

Yost, Karl, and Frederic G. Renner, comps. *A Bibliography of the Published Works of Charles M. Russell.* Lincoln: University of Nebraska Press, 1971.

Young-Hunter, John. *Reviewing the Years.* New York: Crown Publishers, 1963.

Young, Joseph E. "The American Frontier." In *The American Personality: The Artist-Illustrator of Life in the United States, 1860–1930,* edited by E. Maurice Bloch, 59–62. Los Angeles: Grunwald Center for the Graphic Arts, University of California at Los Angeles, 1976.

Yount, Sylvia. *Maxfield Parrish, 1870–1966.* New York: Harry N. Abrams / Pennsylvania Academy of the Fine Arts, 1999.

Zurier, Rebecca, Robert W. Snyder, and Virginia M. Mecklenburg. *Metropolitan Lives: The Ashcan Artists and Their New York.* Washington, D.C.: National Museum of American Art, 1995.

Index

The initials CMR and NCR are used to indicate Charles M. Russell and Nancy Cooper Russell. Page numbers for illustrations are indicated with **bold** type.

Copyedited by Brent Winter
Design and composition by BW&A Books, Inc.
Image prepress by University of Oklahoma Printing Services
Jacket design by Tony Roberts
Printed and bound by CS Graphics Pte. Ltd., Singapore